MAGNA GRAECIA

To Richard E. Perry

ἔξοχον ἡρώων (*Iliad* 18.437)

"Outstanding among heroes"

Organized by the Cleveland Museum of Art and the Tampa Museum of Art

▴MAGNA▴

GRAECIA

Greek Art from South Italy and Sicily

Michael Bennett and Aaron J. Paul
in collaboration with Mario Iozzo

Bruce M. White, photographer

The Cleveland Museum of Art 2002
Distributed by Hudson Hills Press, New York and Manchester

Organized by the Cleveland Museum of Art and the Tampa Museum of Art. The Cleveland showing is sponsored by National City. The exhibition and catalogue have also received generous support from the National Endowment for the Arts, James E. and Elizabeth J. Ferrell, The Hellenic Preservation Society of Northeastern Ohio, Adelphia Communications, and Shelby White and Leon Levy. The exhibition is supported by an indemnity from the Federal Council on the Arts and the Humanities. The museum receives general operating support from the Ohio Arts Council.

Published on the occasion of the exhibition *Magna Graecia: Greek Art from South Italy and Sicily.*

The Cleveland Museum of Art
27 October 2002–5 January 2003

Tampa Museum of Art
2 February–20 April 2003

Published by the Cleveland Museum of Art

Distributed by Hudson Hills Press, LLC
Manchester, Vermont 05254
Paul Anbinder, founder and publisher

Distributed in the United States, its territories and possessions, and Canada through National Book Network. Distributed in the United Kingdom, Eire, and Europe through Windsor Books International.

Library of Congress Control Number: 2002108448

ISBN: 0-940717-71-9 (cloth)

ISBN: 0-940717-72-7 (paper)

Cover: *Youth of Agrigento* (detail) [72]

Editing: Barbara J. Bradley, Kathleen Mills

Design: Thomas H. Barnard

Digital imaging: David Brichford, Janet Burke, Bruce Shewitz

Illustrations: Carolyn K. Lewis

Digital photography: Gary Kirchenbauer

Production: Charles Szabla

Printing: Great Lakes Lithograph, Cleveland

Photography: Cover and cat. nos. 1–6, 27–81 by Bruce M. White

The photographs of works of art in the exhibition are published here with the permission of the lending Italian museums.

CONTENTS

Art exhibitions require the focused vision, energy, and skill of numerous professionals, contributing to a shared goal, often seeing it from different perspectives. Through the art exhibition, the museum becomes a rallying point for a wide array of talented individuals, whose concerted efforts are given a greater resonance in the company of others. One of the great strengths of the art museum is precisely in this collaborative process, drawing together skilled specialists and creating a fertile environment for new ideas and bold creativity. The diversified contributions to the exhibition allow it to reach multiple audiences and, at the same time, to educate and entertain, to advance knowledge and introduce new subjects. In this way, the art museum becomes an open forum in which the works of art invite all visitors to participate in the discussion.

Magna Graecia: Greek Art from South Italy and Sicily dramatically extends this principle of collaboration and gives it an international dimension. It represents a partnership between two American museums, the Cleveland Museum of Art and the Tampa Museum of Art, and eight Italian archaeological museums: Agrigento, Gela, Paestum, Palermo, Reggio Calabria, Sybaris, Syracuse, and Taranto. We are grateful to these institutions for their generous support of the project, which was unprecedented in its scope. In addition to sharing some of the most important works from their collections, our Italian colleagues also made it possible for new photographs to be taken of each work of art in the exhibition, and contributed the catalogue entries on these objects.

The curatorial team also reflects this spirit of American and Italian cooperation. The organizers, Michael Bennett of the Cleveland Museum of Art, and Aaron J. Paul of the Tampa Museum of Art, in collaboration with Mario Iozzo of the Center for Conservation in Florence and the Archaeological Museum of Chiusi, have demonstrated the tremendous potential of such international partnerships. Through their persistent efforts the exhibition brings masterworks of Greek art from South Italy and Sicily to America for the first time. These powerful works of ancient western Greek art were of fundamental importance in shaping the development of the well-known artistic achievements of Rome and the Italian Renaissance. We are proud to bring the story of the Greek colonization of South Italy and Sicily to American audiences, embodied in objects of great aesthetic presence and historical significance.

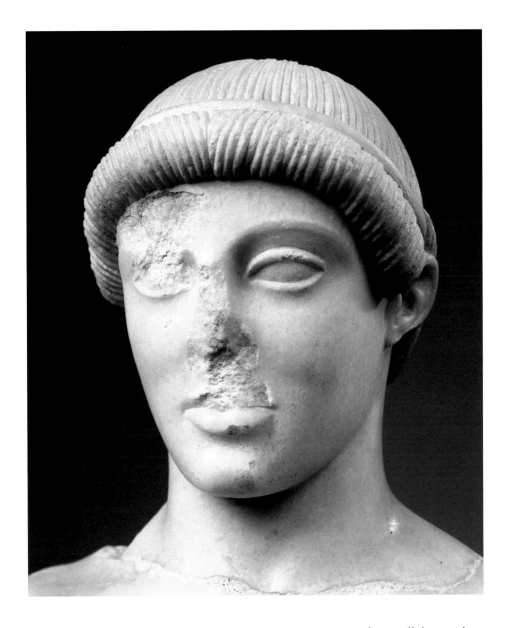

The Cleveland Museum of Art and the Tampa Museum of Art collaborated on this exhibition both for reasons that they had in common, and for others that are particular to each institution. Each museum is nationally and internationally recognized for its permanent collections of Greek, Etruscan, and Roman art. In addition, both museums have organized or hosted major exhibitions of classical antiquities. The Cleveland Museum of Art provided the resources and seasoned experience required to organize a large international loan exhibition of this kind. The Tampa Museum of Art's history with the project has been seminal, and has been encouraged and sustained by a large number of Tampa Bay area residents who trace their ancestry to the Mediterranean region, particularly to Italy and Greece. It is our hope that exhibitions of this type will continue to forge new ties between American art museums and those abroad, for the benefit of the American people and the wider international community.

KATHARINE LEE REID
Director
The Cleveland Museum of Art

EMILY S. KASS
Director
Tampa Museum of Art

ACKNOWLEDGMENTS

The international endeavor that resulted in this exhibition and its catalogue benefited from many hands at work and much good advice in this country and Italy. To our colleague Mario Iozzo, Direttore del Centro di Restauro, Firenze and Direttore del Museo Archeologico Nazionale di Chiusi, we owe a lasting debt for his collaboration. He offered sage guidance that led to the success of this project, bringing these magnificent and fascinating works of art to the United States, where they are now seen for the first time.

It also gives us great pleasure to thank our colleagues abroad for their generosity in agreeing to loan these objects to our country, so that Americans might appreciate, firsthand, ancient Greek masterworks of the highest quality from South Italy and Sicily. We are grateful to our Italian colleagues for allowing us to take new photographs, for granting us permission to publish these photographs in this catalogue, and for contributing the entries. For approving the loans we sincerely thank Prof. Giuliano Urbani, Ministro per i Beni e le Attività Culturali della Repubblica Italiana. For supporting the loan of objects from the museums of Sicily we especially thank Dott. Fabio Granata, Assessore ai Beni Culturali, Ambientali e della Pubblica Istruzione della Regione Sicilia; Dott. Gaetano Bordone, Segreteria Tecnica, Assessore ai Beni Culturali, Ambientali e della Pubblica Istruzione della Regione Sicilia; Dott. Marco Salerno, Capo di Gabinetto dell'Assessorato ai Beni Culturali, Ambientali e della Pubblica Istruzione della Regione Sicilia; Dott. Giuseppe Grado, Direttore Generale dell'Assessorato ai Beni Culturali, Ambientali e della Pubblica Istruzione della Regione Sicilia; and Dott.ssa Rosalba Panvini, Dirigente del Servizio per i Beni Archeologici della Regione Sicilia. For loans from all of the Italian museums we thank Dott. Giuseppe Andreassi, Soprintendente Archeologo della Puglia; Dott. Giuseppe Castellana, Direttore del Museo Archeologico Regionale di Agrigento; Dott.ssa Marina Cipriani, Direttore del Museo Archeologico Nazionale di Paestum; Dott.ssa Concetta Ciurcina, Direttore del Museo Archeologico Regionale "Paolo Orsi" di Siracusa; Dott.ssa Antonietta Dell'Aglio, Direttore del Museo Archeologico Nazionale di Taranto; Dott.ssa Elena Lattanzi, Soprintendente Archeologo della Calabria; Dott.ssa Maria Costanza Lentini, Direttore del Museo Archeologico Regionale di Gela; Dott.ssa Silvana Luppino, Direttore del Museo Nazionale Archeologico della Sibaritide; Dott.ssa Laura Masiello, Museo Archeologico Nazionale di Taranto; Dott. Claudio Sabbione, Direttore del Museo Archeologico Nazionale di Locri; Dott.ssa Giuliana Tocco Sciarelli, Soprintendente Archeologo per le Province di Salerno, Avellino e Benevento; Dott.ssa Rosalia Camerata Scovazzo, Soprintendente ai Beni Culturali e Ambientali di Palermo e Direttore del Museo Archeologico Regionale "A. Salinas" di Palermo; Dott.ssa Agata Villa, Dirigente Archeologo Classico,

Museo Archeologico Regionale "A. Salinas" di Palermo; Dott. Giuseppe Voza, Soprintendente ai Beni Culturali e Ambientali di Siracusa.

For support given to the exhibition, we are indebted to the American Embassy in Rome: the U.S. Ambassador to Italy, the Honorable Mel Sembler, Mrs. Betty S. Sembler, and Cultural Attaché Anne Callaghan.

In our own country, we are grateful to the members of the exhibition's academic advisory committee who supported our ideas from their inception and offered their experienced advice: Ariel Herrmann, John Herrmann, David Gordon Mitten, Gregory Nagy, and J. Michael Padgett. For national funding of the exhibition we acknowledge the support of the National Endowment for the Arts, and an indemnity from the Federal Council on the Arts and the Humanities. We thank Shelby White and Leon Levy for their support. Dr. Jerome M. Eisenberg kindly provided appraisals.

We thank the Cleveland Museum of Art's director, Katharine Lee Reid, for her steadfast enthusiasm and confidence,.which was crucial to the project's success. Many skilled staff members at the museum contributed their time and talents and met the many challenges of the exhibition with meticulous professionalism. David Smart, Andrew W. Mellon Curatorial Fellow, was indispensable in his tenacious and resourceful management of many details of the catalogue's production, including object files, bibliographies, interlibrary loans, and illustrations. Rachel Rosenzweig, curatorial assistant for the Department of Greek and Roman Art, efficiently administered the departmental "nerve-center" with good sense and good humor. We thank Elisabetta Erickson for her in-house translations. Roberto Prcela removed many obstacles, and was a great resource for his fluency in the Italian language. Lina Brunetti and Andrea Castrovillari helped with the NEA grant application. Lindsay Ash, Teddy Marks, Abby Richlovsky, and Megan Strobel also contributed generous assistance. The Exhibitions Office, administered by Heidi Domine and staffed by Marlene Kiss and Jane Panza, kept the project moving forward. In the Publications Department, headed by Laurence Channing, editor Barbara Bradley and designer Thomas Barnard turned the catalogue's texts and pictures into a visually handsome work of scholarship. Freelance editor Kathleen Mills also worked on the project, and Carolyn K. Lewis redrew many of the maps. Kathleen McKeever, curatorial assistant, Paintings Department, offered valuable suggestions. Janet Burke, David Brichford, and Bruce Shewitz of Photography and Imaging Services, under the supervision of Howard Agriesti, produced the scanned images used in the catalogue. The catalogue could not have been produced without the services of the Ingalls Library: Ann Abid, Louis Adrean, Christine Edmonson, Jennifer Vickers, Barbara Billings, Fredrick Freidman-Rommel, and Christopher Handy. Karen

Pinson and Amy Banko of the Finance Department patiently and persistently made sure that international payments were made. The Design and Installation Department's Jeff Baxter, JoAnn Dickey, and Jeff Falsgraf, led by Jeffrey Strean, executed the installation and design of the exhibition with great flair and precision. The New Media Department worked with us and the design staff to develop the multimedia elements in the exhibition, and the Magna Graecia Web site. The staff of the Registrar's Office, Jeanette Saunders and Beth Gresham, directed by Mary Suzor, expertly handled preparations for the indemnity application and all aspects of packing and shipping. Chief Conservator Bruce Christman, with Pat Griffin and Larry Sisson, were responsible for condition reporting in collaboration with the Italian couriers. Joellen DeOreo and Seema Rao of the Education Department managed educational programming, under the direction of Marjorie Williams. Diana Borcz and Martha Lattie created fun and beautiful objects for the museum store. Denise Horstman, Karen Ferguson, and Julie Limpach worked skillfully with the media. Kim McCarty and Jack Stinedurf, supervised by Susan Stevens Jaros, successfully secured necessary financial support. Karen Carr and Linda Lee planned special events. Michael R. Cunningham, curator of Japanese and Korean Art, and Arielle P. Kozloff, former curator of Ancient Art, were sources of much good advice.

We wish to thank National City for its generous support of the Cleveland venue, and James E. and Elizabeth J. Ferrell for their gift in support of the exhibition catalogue. The members of the Hellenic Preservation Society of Northeastern Ohio also contributed generously toward the production of the catalogue, as well as educational programming in Cleveland. We also thank Adelphia Communications for its contribution to the Cleveland venue.

Good fortune brought us to work with the photographer Bruce M. White and his assistant, Giovanni Maccabei, on a photography expedition in Italy during the month of November 2001. His exquisite photographs for this catalogue are works of art in themselves. We could not have collaborated with a more creative artist in the medium of photography, nor had a more pleasant traveling companion. We thank Giovanni Maccabei, a true *cicerone,* for his guidance and spirited tutorials in Italian.

At Harvard University, Amanda Ricker-Prugh, Abby Smith, and Rachel Vargas located research material and references necessary for the writing of this catalogue. For assistance with photographs, we are obliged to Olaf Dräger, Deutsches Archäologisches Institut, Rome; Dr. Vera Slehofer, curator, and Dr. Margot Schmidt, curator emerita, Antikenmuseum und Sammlung Ludwig, Basel; Dott. Antonio De Siena, Direttore del Museo Archeologico Nazionale di Metaponto; and Dott.ssa Costanza Gialanella, Direttore del Museo Civico Archeologico di Pithecusae, Lacco Ameno d'Ischia.

In Tampa, we thank the Tampa Museum of Art's director, Emily S. Kass, for her support from the early planning stages of the exhibition to its implementation. We are also grateful to members of the Magna Graecia Steering Committee. With the determination and resolve of Dr. Richard E. Perry and Monroe Berkman, they achieved a resounding success in a Herculean effort, raising funds necessary to bring the exhibition to the Tampa Bay region. Monroe and Suzette Berkman, Dr. Richard E. and Mary B. Perry, and William Suddaby supported the exhibition in its early stages of development, for which we are espe-

cially grateful. The greatest single gift to support the exhibition came from an anonymous donor at this same crucial time, which made it possible to proceed with the planning. Characteristically, his keen vision recognized the beauty of these objects and how much they have to tell us. Continuing the philhellenic spirit engendered by the late Costas Lemonopoulos, Bobbye Lemonopoulos contributed a major gift to support the exhibition. A very generous donation from St. Petersburg, Florida, was given anonymously. The William R. Hough Company and Republic Bank also supported the exhibition. To the American Foundation for Greek Language and Culture, Gilda and Joseph Capitano Sr., Len Kizner, Professor Beatrice Litt, Ambassador David Litt, Sally Ordway, Jeffrey W. Tucker, L'Unione Italiana, Jeanne R. Winter, William Knight Zewadski, and the additional donors who contributed to making the Tampa venue a success, we express our deepest thanks.

We thank the staff of the Tampa Museum of Art whose work contributed to the exhibition's success: in particular Lani Czyzewski, public information officer; Kathryn Dunathan, intern for Greek and Roman Art; Suzanne Ebbert, special events coordinator; Jose Gelats, assistant curator; Leslie Hammond, registrar; Robert Hellier, chief designer and preparator; Bob Huntress, exhibit technician; Lisa Kahn, curator of education; Tom Kettner, preparator; Steven Klindt, director of development; Joanne Laios, grants manager; Claude Sapp, intern for Greek and Roman Art; Stephanie Saunders, museum store manager; Aimee Towey, special projects assistant; and John Wissinger, preparator. We also thank the members of FOTA (Friends of the Arts), who continued their longstanding tradition at the Tampa Museum of Art by enthusiastically supporting our efforts.

Beatrice Litt provided Italian translation, instruction, and wise advice, which brought us closer to our Italian colleagues through a knowledge of their rich language and culture. The support of the Italian-American and Greek-American communities was invaluable, as was the early funding provided by a Florida State Millennium Grant through the Association of Sister Cities of Florida and the Schultz Foundation, Inc. Grants were also received from the Arts Council of Hillsborough County and the Hillsborough County Board of County Commissioners, the Hillsborough County Tourist Development Council, and the State of Florida International Cultural Exchange.

Aaron Bennett was a wellspring of youthful inspiration. We are deeply grateful to Josephine Bennett and Randall L. Trespacz for their unwavering encouragement and support, which brought us along throughout all of the adventures in this modern Odyssey.

MICHAEL BENNETT
Curator of Greek and Roman Art
The Cleveland Museum of Art

AARON J. PAUL
Richard E. Perry Curator of
Greek and Roman Art
Tampa Museum of Art

The first part of this book consists of six thematic essays on the art and culture of Magna Graecia and Sicily. They represent points of departure or windows onto the vast landscape of the Western Greek world.

The second part of the book is a catalogue of the objects in the exhibition, grouped by museum collection and following the sequence of the installation in Cleveland (Paestum, Taranto, Reggio Calabria, Sybaris, Syracuse, Gela, Agrigento, and Palermo). Each entry provides the object's date, material and technique, dimensions in centimeters, inventory number, and findspot as far as can be determined. A description of the object follows this information. Published works that discuss the object are given at the end of each entry. Because the bibliographic citations are complete, no bibliographic section or list of abbreviations is provided. The entries were prepared by Italian museum personnel and translated into English by Cleveland staff. Initials at the end of each entry identify the author.

Giuseppe Castellana	GC
Concetta Ciurcina	CC
Marina Cipriani	MC
Amelia D'Amicis	AD'A
Antonietta Dell'Aglio	ADA
Maria Teresa Iannelli	MTI
Maria Costanza Lentini	MCL
Silvana Luppino	SL
Laura Masiello	LM
Alessandra Merra	AM
Rosalba Panvini	RP
Gemma Russo	GR
Claudio Sabbione	CS
Giuliana Sarà	GS
Ermelinda Storaci	ES
Laura Trombetta	LT

Maps of the Mediterranean region, Greece, and South Italy and Sicily show most place names that appear in the essays and catalogue entries. The maps use the most common English, Greek, Latin, or Italian spellings; alternate spellings appear in the Glossary. Foreign words that have become part of the English language are set in roman type; other foreign words are italicized and defined the first time each is used and then appear in roman type. The Glossary includes many unfamiliar words and also has a section identifying the deities, creatures, and mortals that are mentioned in the essays and catalogue entries.

"Magna Graecia" is the Latin translation of the original Greek name "Megale Hellas," which initially referred to South Italy specifically and over time possibly came to include Sicily. The Western Greeks themselves initiated the use of the term to describe their lands. This terminology probably developed in intellectual circles at the beginning of the fifth century BC.

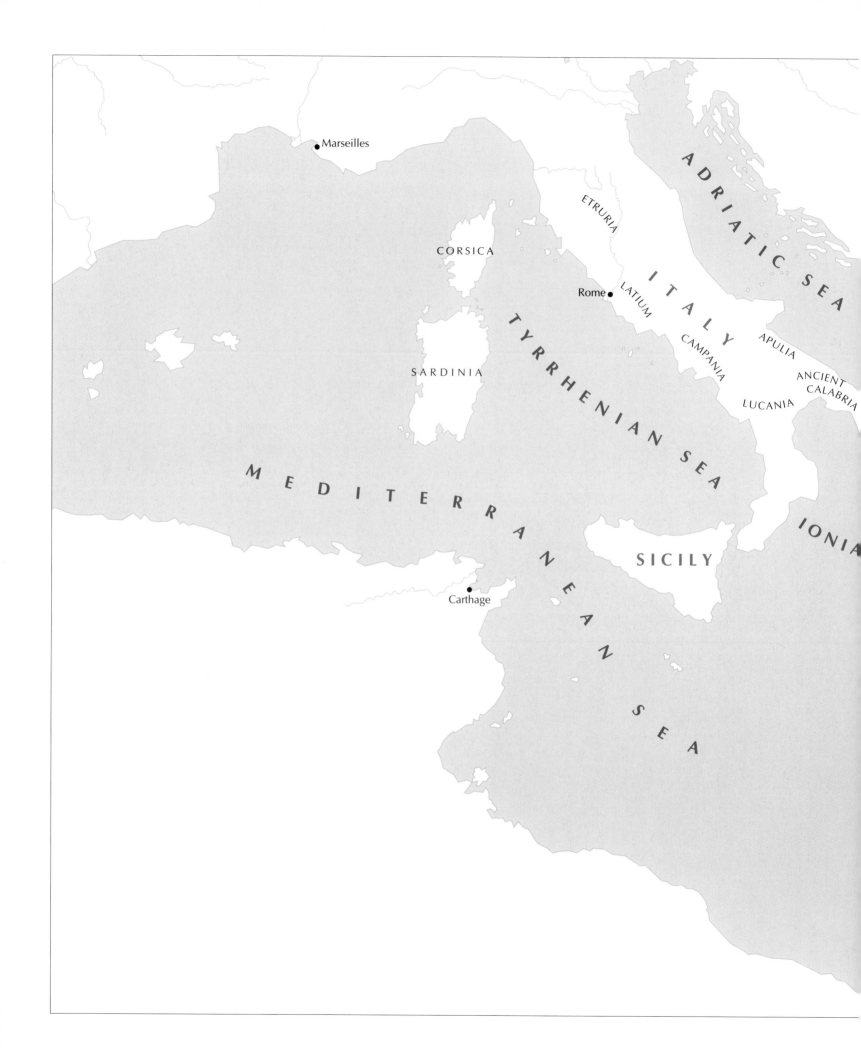

Marseilles

ADRIATIC SEA

ETRURIA

ITALY

CORSICA

Rome LATIUM

APULIA

CAMPANIA

ANCIENT
CALABRIA

SARDINIA

TYRRHENIAN SEA

LUCANIA

IONIA

MEDITERRANEAN

SICILY

Carthage

SEA

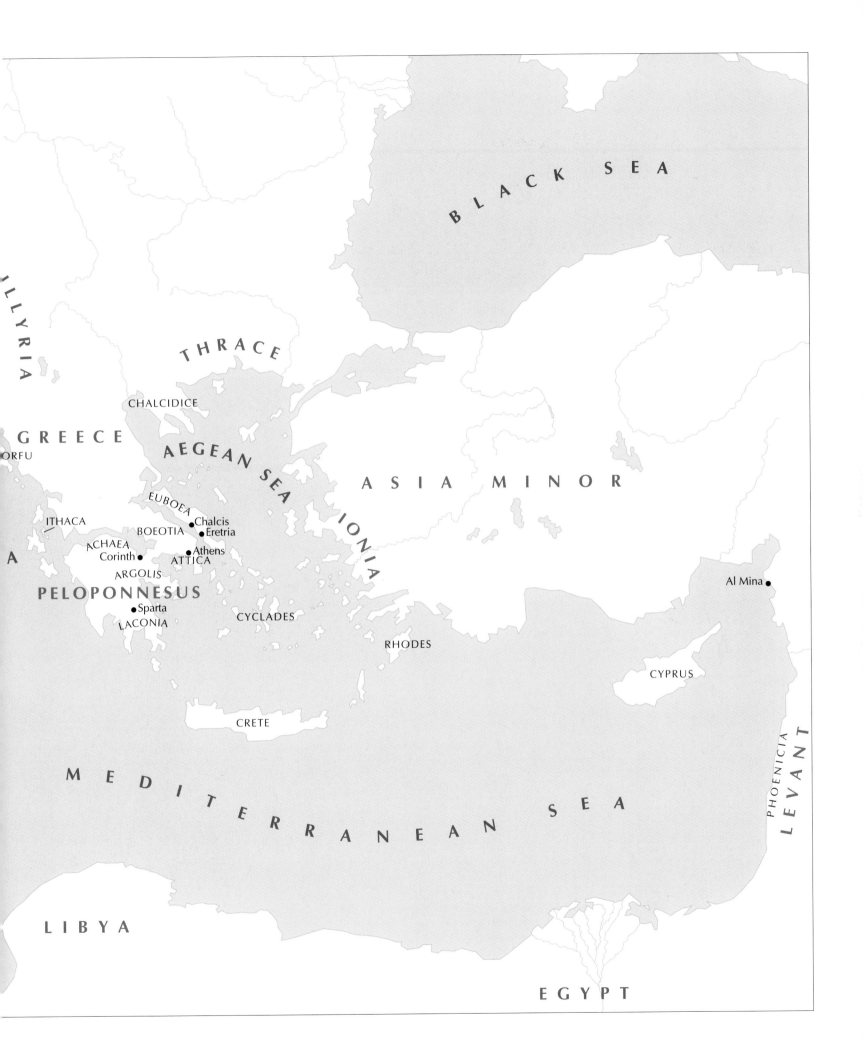

BLACK SEA

ILLYRIA

THRACE

CHALCIDICE

GREECE

ORFU

AEGEAN SEA

ASIA MINOR

EUBOEA

ITHACA

BOEOTIA • Chalcis
 • Eretria

ACHAEA

A Corinth • • Athens
 ATTICA

ARGOLIS

IONIA

Al Mina •

PELOPONNESUS

• Sparta

LACONIA

CYCLADES

RHODES

CYPRUS

CRETE

MEDITERRANEAN SEA

PHOENICIA
LEVANT

LIBYA

EGYPT

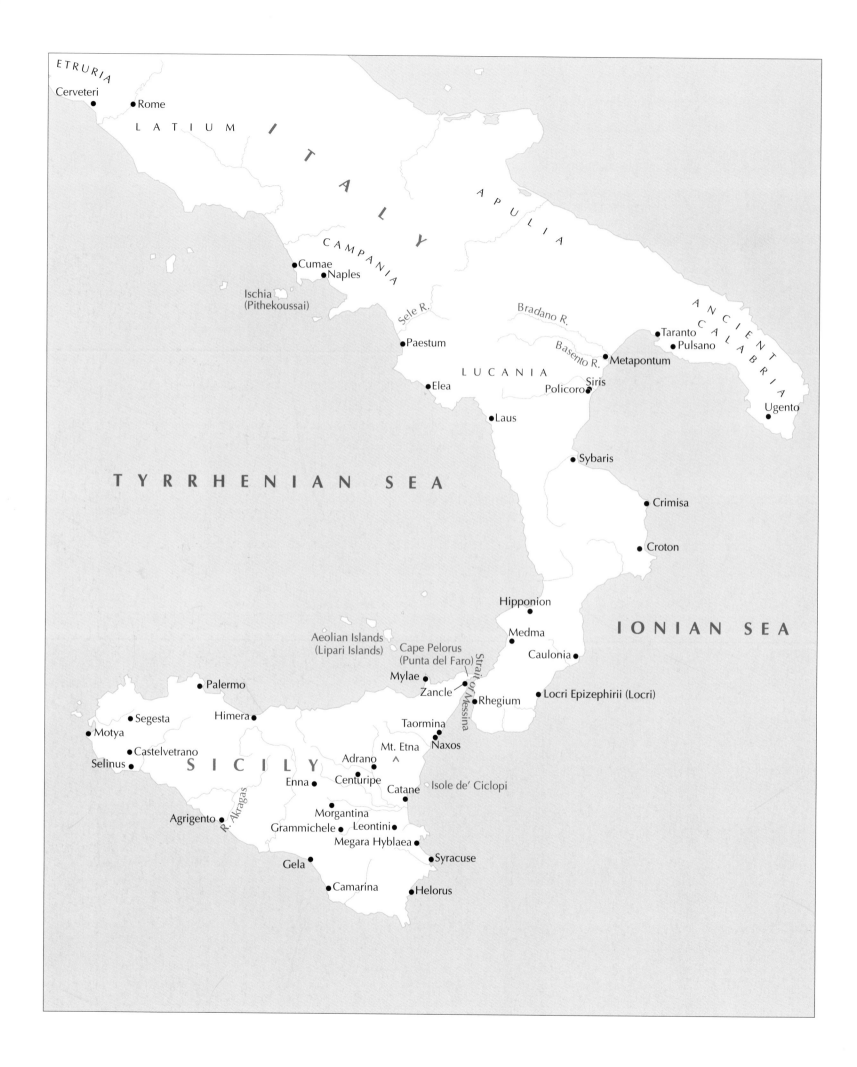

ETRURIA

Cerveteri

Rome

LATIUM

ITALY

CAMPANIA

APULIA

Cumae

Naples

Ischia
(Pithekoussai)

Sele R.

Bradano R.

ANCIENT

Taranto

Pulsano

CALABRIA

Paestum

Basento R.

Metapontum

LUCANIA

Elea

Siris

Policoro

Laus

Ugento

Sybaris

TYRRHENIAN SEA

Crimisa

Croton

Hipponion

IONIAN SEA

Aeolian Islands
(Lipari Islands)

Medma

Cape Pelorus
(Punta del Faro)

Caulonia

Mylae

Strait of Messina

Zancle

Palermo

Rhegium

Locri Epizephirii (Locri)

Himera

Segesta

Taormina

Motya

Naxos

Castelvetrano

Mt. Etna

SICILY

Adrano

^

Selinus

Isole de' Ciclopi

Enna

Centuripe

Catane

R. Akragas

Morgantina

Agrigento

Grammichele

Leontini

Megara Hyblaea

Gela

Syracuse

Camarina

Helorus

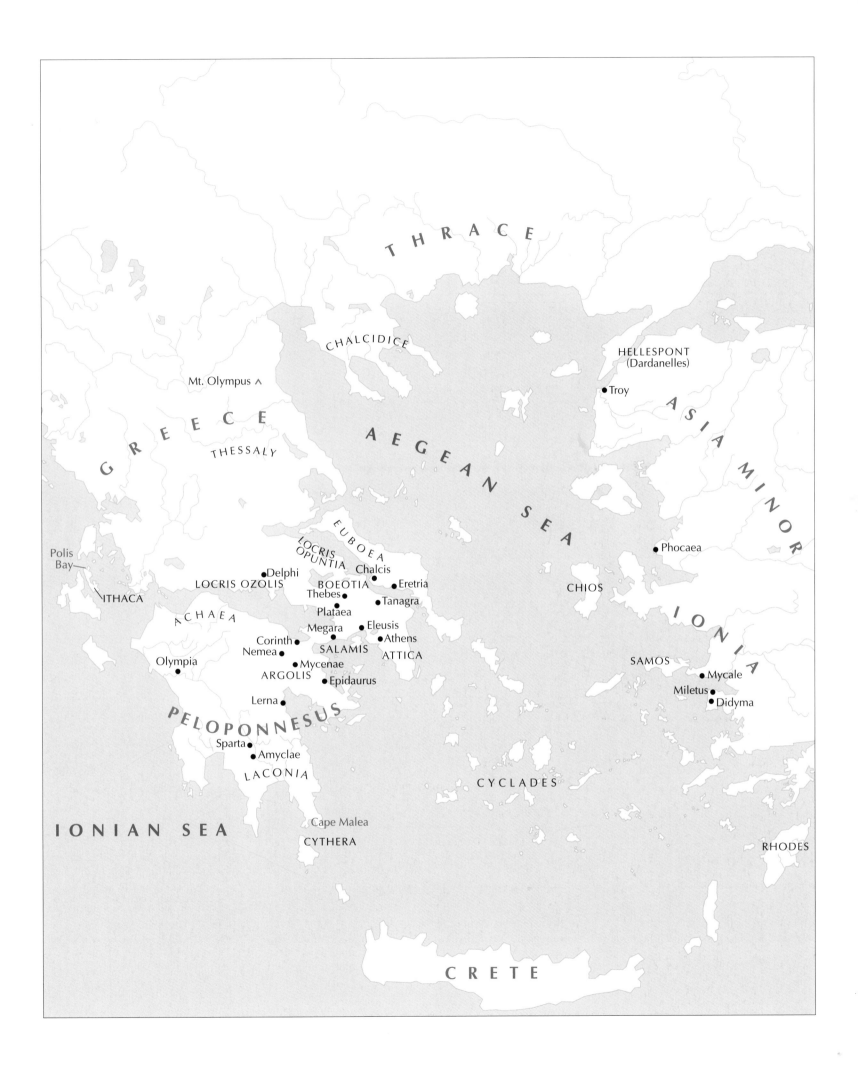

THRACE

CHALCIDICE

HELLESPONT
(Dardanelles)

Mt. Olympus ∧

• Troy

GREECE

ASIA MINOR

THESSALY

AEGEAN SEA

Polis
Bay

EUBOEA

LOCRIS
OPUNTIA

• Phocaea

• Delphi
LOCRIS OZOLIS

Chalcis

CHIOS

ITHACA

BOEOTIA
Thebes •
Plataea

• Eretria
• Tanagra

IONIA

ACHAEA

Megara
Corinth •
Nemea •

• Eleusis
Athens •

Olympia

SALAMIS
Mycenae •
ARGOLIS
• Epidaurus

ATTICA

SAMOS

• Mycale

Miletus •
• Didyma

Lerna •

PELOPONNESUS

Sparta •
• Amyclae

LACONIA

CYCLADES

IONIAN SEA

Cape Malea

CYTHERA

RHODES

CRETE

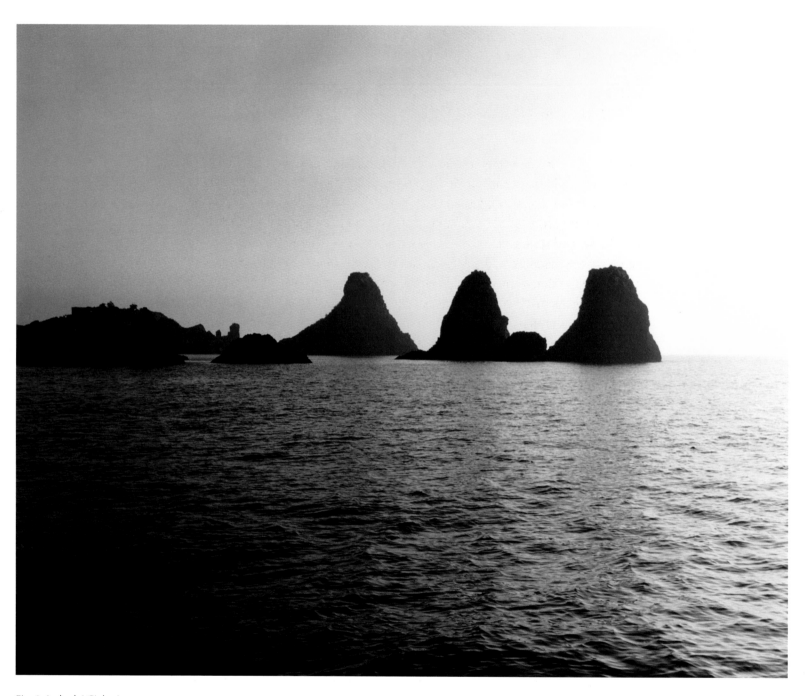

Fig. 1. Isole de' Ciclopi.

The Euboeans and the West: Art, Epic Poetry, and History

MICHAEL BENNETT

From that place godlike Nausithoös took up and led [the people]
into Scheria, far from men who eat bread,
and drove a wall about the city, and built the houses,
and made the temples of the gods, and apportioned the farmland.[1]
—*Odyssey*, 6.7–10

None of the Greek works in this exhibition are as early as the excavated material from Pithekoussai, the pioneering Euboean settlement on the island of Ischia in the Bay of Naples. Several of the objects found at the site harbinger important aspects of Greek culture as it spread and matured in South Italy and Sicily, and thus a few of the most significant finds from Pithekoussai will be discussed here in detail. Although the Euboeans of Chalcis and Eretria can be credited with founding the first Greek colonies in the West, they were not the first Greeks to travel to the western Mediterranean and do business there. Earlier contacts were made in the Bronze Age, and we can detect faded memories of them in myth, legend, and the epic tradition.

EARLY CONTACTS AND EPIC GEOGRAPHY

The quantity and distribution of Mycenaean pottery found in South Italy, Sicily, and Sardinia, dated from the sixteenth through the eleventh centuries BC, suggest that Bronze Age Greeks had been sailing west from an early period.[2] However, Mycenaean pottery cannot tell us how tales of seafaring in the West were preserved through the Dark Ages following the collapse of Mycenaean rule in Greece in the twelfth century BC. For the transmission of this knowledge we might assume an oral tradition handed down through generations of mariners. An oral tradition—in the form of the Homeric epics, the *Iliad* and the *Odyssey*—did in fact preserve transmitted memories of a Mycenaean past. Composed and performed orally, these monumental poems were part of a long tradition rooted and set in the Bronze Age, but which accumulated material in each successive generation until reaching a fixed form, perhaps as late as the sixth century BC.[3] Sorting fact from fiction while maintaining historical context is the job of the historian, not the poet. It is notoriously difficult to untangle the dense web of history, folktale, myth, and fantasy that underlies the epic oral tradition. References or allusions to the central and western Mediterranean that we may detect in Homeric poetry are therefore a mixed blessing, and should be used with this reservation.

One well-known Bronze Age journey from Crete to Sicily with Homeric associations is allegorical fiction. Escaping from King Minos and flying on waxen wings, the legendary craftsman Daedalus, mentioned in the *Iliad*,[4] headed for Sicily with his impetuous son Icarus. The spirited Icarus flew too high toward the sun, melting his wings and dropping from the sky to his death in the Aegean Sea. The more prudent Daedalus arrived safely and was taken in by the Sicanian king Kokalos. While a resident of Sicily, Daedalus was said to have designed several architectural wonders.[5]

The story of another celebrated epic voyage is narrated by its main protagonist. Odysseus, while a guest in the court of the Phaeacian king Alkinoös, recounts in the first person how the north wind blew his ship from a point near Cape Malea, past the island of Cythera, and into unknown waters.[6] The account, contained in books 9–12 of the *Odyssey*, may have been inspired partly by misty poetic memories of perilous Mycenaean excursions on the western Mediterranean's high seas. Yet the world of the Lotus-Eaters, Polyphemos, Aeolus's windy island, the Laistrygonians, Circe, the entry to Hades, the Sirens, Skylla, Charybdis, Helios's cattle, and Calypso falls outside the circuit of the rising and setting sun, in an untimed realm of the imagination.[7]

Even though Odysseus's route cannot be charted on any known map, tradition, as reflected by modern guidebooks and place names, long has persisted in locating much of it in South Italy and Sicily.[8] Hence, the Isole de' Ciclopi (Islands of the Cyclopes) on the eastern coast of Sicily in the shadows of Mt. Etna are identified as the gigantic boulders that the blinded Polyphemos heaved at the ships of Odysseus and his men (fig. 1).[9] So too, somewhere among the Aeolian Islands—Lipari, Salina, Stromboli, Panarea, Vulcano, Alicudi, and Filicudi—Aeolus, the keeper of the winds, is believed to have compressed the gales into a bag.[10] Likewise, the Laistrygonians were considered residents of Sicily,[11] Circe's magical lair on the island of Aeaea was identified with Monte Circeo in southern Lazio,[12] and the opening to Hades was sited at Cumae.[13] Most attractive is the traditional association of Skylla and Charybdis[14] with the Strait of Messina—the rock of Skylla near the village of Scilla on the coast of southern Calabria, and Charybdis somewhere on the Sicilian shore opposite. On an island nearby, Odysseus says that the Sirens sang their beguiling song of death.[15] Although the heroic vistas of land and sea characteristic of the western Mediterranean encourage these epic associations, proving them is difficult.

Lending some support for situating Odysseus's far-fetched adventures in the West, the poet of the *Odyssey* does allude to sea travel between Ithaca and South Italy and Sicily.[16] Having returned to Ithaca and not wanting to reveal his identity, Odysseus tells his father, Laertes, that he is from Alybas and that his name is Eperitus.[17] He adds that he was headed for Sicania (Sicily) but was driven off course by a divine power, landing instead on Ithaca.[18] This disclosure suggests that Alybas is somewhere near Sicily, possibly in South Italy. Odysseus, posing as Eperitus, reports that he had welcomed the wandering Odysseus as a guest five years earlier, and that they had hoped to stay in touch and to exchange gifts of friendship.[19] Other references to Sicel slaves also betray a familiarity with Sicily.[20] As suggestive as these passages

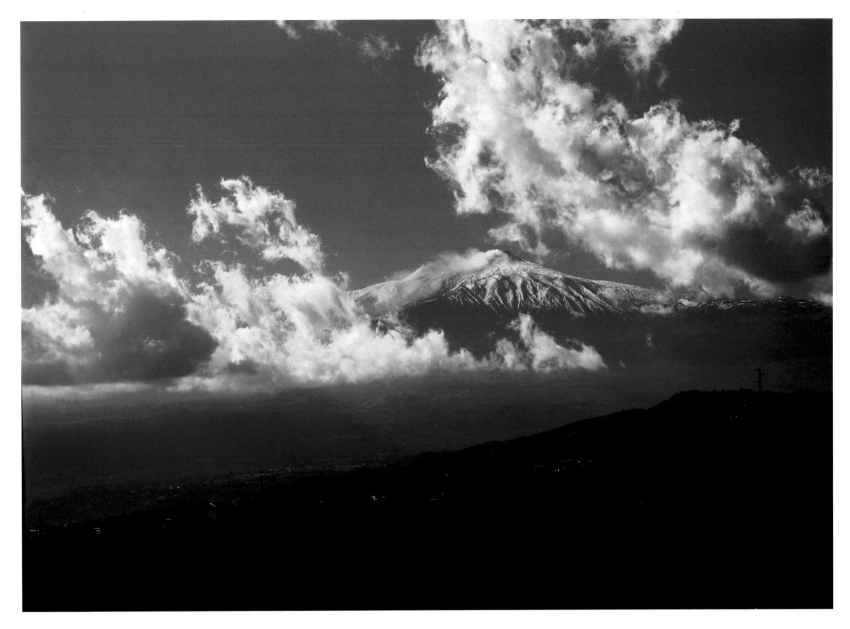

Fig. 2. Mt. Etna.

are, dating them is another problem, because the oral tradition synthesizes aspects of society and the material world from the Bronze Age to the Archaic period.[21] In fact, they may say more about the eighth century BC than the Bronze Age.

The Boeotian farmer-poet Hesiod, who wrote in hexameter verse, the meter of epic, had acquired a more precise knowledge of South Italian and Sicilian geography than the poet of the *Odyssey*. Hesiod likely was active in the early seventh century BC, at a time when the Homeric epics were reaching a relatively stable form. He mentions Mt. Etna (fig. 2), Ortygia, Latium, Etruria, and Cape Peloros, implying that in his day Greek ships had traveled to Syracuse and also had crossed the Strait of Messina.[22] Comparing Hesiod's grasp of geography with references in the *Odyssey* leaves the impression that Greek sea voyages to South Italy and Sicily were becoming increasingly frequent in the eighth and seventh centuries BC, an inference borne out by archaeological research.

PITHEKOUSSAI AND THE GREEK RENAISSANCE

Greek settlement in the western Mediterranean began in the eighth century BC, a time of rapid and dramatic change for Greek culture. The period saw the first inscriptions in the Greek alphabet (adopted from the Phoenician), the rise of Panhellenic sanctuaries such as Olympia and Delphi, and the evolution of the Homeric epics into monumental poems that reflected a set of collective values shared by much of the Greek world.[23] Archaeological and literary evidence supports the view that this was a time of great mobility, when enterprising Greeks from mainland Greece and Ionia established trading contacts, then settlements, traveling far in search of commercial opportunities, raw materials such as metals, and prime agricultural land.[24]

Fig. 3. Pithekoussai, looking northeast from the acropolis (Monte di Vico).

The first Greeks to settle in the West carried with them the momentum of a historical period aptly called a "renaissance."[25]

Ancient authors and current archaeology agree that the first Western Greeks were Euboeans.[26] While the Roman authors Strabo and Livy disagree on some details, each writes that Pithekoussai on Ischia, the small island just off the Bay of Naples, was settled by a contingent of Euboeans (fig. 3).[27] In view of the earliest pottery excavated there, this momentous event probably occurred in the first half of the eighth century BC on the northern shore of the island now occupied by the modern *comune* of Lacco Ameno. Depending on how the evidence is interpreted, Pithekoussai, the first Greek presence in the West, may be called an *emporion* (trading settlement) or an *apoikia* ("home away from home," or colony).[28] The population of Pithekoussai was certainly considerable, estimated at between 5,000 and 10,000.[29] It was established by Euboeans who lived and worked with Phoenicians who left evidence of their presence in the form of Semitic inscriptions.[30] Such a large settlement of Greeks and Levantines is reminiscent of Al Mina, the Euboean trading outpost in North Syria at the mouth of the Orontes River, set up slightly earlier, perhaps a little before the eighth century BC.[31] In both the East and the West, Euboean Greeks were seeking trade that probably involved metals and other commodities not apparent in the archaeological record. As

Fig. 4. Cup of Nestor. Greece, Rhodes, ca. 720 BC, excavated at Pithekoussai. From G. Buchner and D. Ridgway, *Pithekoussai I, La Necropoli: Tombe 1-723, Scavate dal 1952 al 1961* (Rome, 1993), tav. 72.

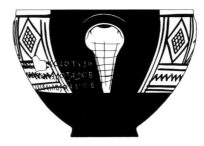

a center for trade, and with its mixed population of Greeks and Phoenicians, Pithekoussai was a dynamic, multinational crossroads of Western and Eastern cultures. It is important to remember this cultural collaboration when considering some of the remarkable artifacts excavated from the site.

The most famous discovery at Pithekoussai, a late eighth century BC Rhodian cup (*kotyle*) found in a cremation burial of a ten-year-old boy in the Valle di San Montano, bears the second earliest complete Greek inscription yet known (ca. 720 BC) (fig. 4).[32] Three lines of retrograde verse are scratched onto its surface, the last two of which are good epic hexameters (fig. 5). Not only does the meter of these verses relate to Homeric poetry, but the message seems in direct response to a specific passage in the *Iliad*. The inscription reads:

> Nestor had a fine drinking cup, but whoever drinks from this cup will soon be taken with desire for fair-crowned Aphrodite.

This jocular toast appears to be informed by an awareness of Nestor's golden cup, described in considerable detail in book 11 of the *Iliad:*

> . . . a beautifully wrought cup which the old man brought with him from home. It was set with golden nails, the eared handles upon it

Fig. 5. Inscription on the Cup of Nestor. From Buchner and Ridgway, *Pithekoussai I,* tav. 73.

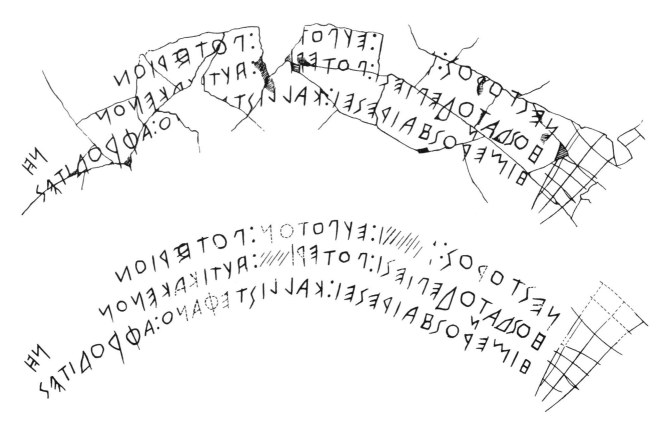

were four, and on either side there were fashioned two doves
of gold, feeding, and there were double bases beneath it.
Another man with great effort could lift it full from the table,
but Nestor, aged as he was, lifted it without strain.[33]

The person responsible for inscribing the Rhodian Cup of Nestor was familiar
enough with Homeric poetry to author a parody of it, presumably for equally
knowledgeable family members or friends, perhaps at a drinking party.[34]
Knowledge of epic poetry does not require written texts; its acquisition most
likely came from hearing multiple performances of the *Iliad* in a living oral
tradition.[35] The letters are in the Euboean script, so the author was surely
Euboean, and it is likely that the inscription was executed at Pithekoussai.[36]
Indeed, in light of the earliest preserved Greek inscriptions, it has been pro-
posed that the Euboeans were responsible for deriving the Greek alphabet
from a Semitic script, possibly Phoenician or Aramaic.[37] Where exactly this
happened, whether in the Levant or elsewhere where Greeks and Levantines
lived and worked together, is an open question. It seems certain, however,
that by scratching lines of epic verse onto a Rhodian cup at Pithekoussai, a
Euboean Greek was using a relatively new technology developed in a cul-
tural milieu much like the one in which he was living.

Also excavated at Pithekoussai was the earliest painted figural scene yet
found in Italy.[38] It is on a locally made krater, or deep mixing bowl, recon-
structed from several fragments and dating to the late eighth century BC (fig.
6).[39] The scene depicts a devastating shipwreck in which the capsized ves-
sel is surrounded by a confusion of six human bodies, all apparently male,
and fish of various sizes. It is unclear whether any of these unfortunate sailors
will survive, but one seems about to become a meal for the largest fish,
whose gaping jaws are closing on his head. This doomed individual may
already be dead, as both of his arms appear loose-jointed and lifeless. Above
the large fish a human figure is missing half of its body above the waist, prob-
ably an early victim of the largest fish,[40] perhaps a shark.[41] Some scholars
have suggested Homeric parallels for the scene.[42] The Cup of Nestor proves
that some of the Greek residents of Pithekoussai knew Homeric poetry. In

Fig. 6. Krater. Italy,
Pithekoussai, 725–700 BC.
From Buchner and Ridgway,
Pithekoussai I, tav. 231.

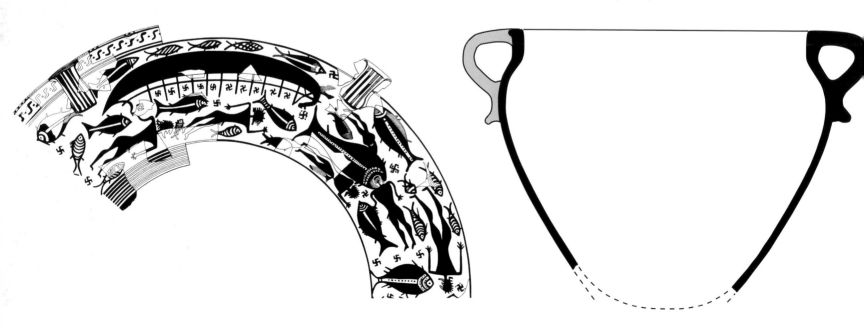

book 14 of the *Odyssey*, Odysseus relates a personal story to Eumaeus, a swineherd, of a shipwreck that occurred while he was sailing with a Phoenician—"well skilled in beguilements, a gnawer at other's goods"[43]— on a journey from Phoenicia to Libya. Suddenly, disaster struck by divine intervention:

> Zeus with thunder and lightning together crashed on our vessel,
> and, struck by the thunderbolt of Zeus, she spun in a circle,
> and all was full of brimstone. The men were thrown in the water,
> and bobbing like sea crows they were washed away on the running
> waves all around the black ship, and the god took away their
> homecoming.
> But Zeus himself, though I had pain in my heart, then put
> into my hands the giant mast of the ship with dark prows,
> so that I could escape the evil, and I embracing
> this was swept along before the destructive stormwinds.[44]

The painted scene compares with the *Odyssey* passage in its general atmosphere of mayhem and sudden death on the high seas, and also possibly in its context of a joint Greek and Phoenician venture.[45] The striking detail of the man-eating fish may also parallel the Homeric view of fish as denizens of an elemental sphere where death awaits.[46] Ironically, Odysseus's father, Laertes, speaks of fish in this way as he unknowingly addresses Odysseus, who is in the guise of Eperitus, after the return of his son to Ithaca. Laertes says to Odysseus/Eperitus:

> . . . an ill-starred
> man, one whom, far from his country and his own people,
> the fish have eaten in the great sea, or else on the dry land
> he has been spoil for wild beasts and for birds; and his mother
> and father, whose child he was, did not give him his rites nor mourn
> him.[47]

Hence, the painted scene of a shipwreck from Pithekoussai may refer to the dangers of Greek-Phoenician sea journeys with iconography that reflects the Homeric use of fish to characterize the sad aftermath of a death for which there is no mourning or proper burial. One imagines that this iconography would have been particularly meaningful for the Greek residents of Pithekoussai.

The Pithekoussai shipwreck is not the only painted scene of the period that has been identified with one of Odysseus's calamities at sea. An Attic oinochoe in Munich features a similar scene on its neck and is very near in date, around 720 BC (fig. 7). Here is another overturned ship with men overboard, most hanging onto some part of the vessel for dear life and the others clinging to these shipmates. The scene has been associated with another of Odysseus's harrowing, near-death experiences at sea. The episode, in book 12 of the *Odyssey*, contains much of the language of the passage in book 14 (305ff.) already cited. This time, however, Odysseus fashions a makeshift life raft from the keel and mast with a bit of oxhide and weathers the storm that takes the lives of his men.

Fig. 7. Oinochoe. Greece, Attica, ca. 720 BC. Staatliche Antikensammlungen und Glyptothek, Munich, inv. 8696.

But I went on my way through the vessel, to where the high seas
had worked the keel free out of the hull, and the bare keel floated
on the swell, which had broken the mast off at the keel; yet
still there was a backstay made out of oxhide fastened
to it. With this I lashed together both keel and mast, then
rode the two of them, while the deadly stormwinds carried me.[48]

Opinion varies as to whether the Attic eighth-century BC painted scene
faithfully illustrates this event.[49] In contrast to the ten other shipmates desper-
ately trying to save themselves, one sailor at the composition's center has
apparently straddled the keel of the upturned ship, where he sits upright.
Greek Geometric art generally avoids overlapping, yet here the figure's legs
clearly are shown superimposed over the ship's keel and are visible between
the struts. This unusual detail surely was executed in order to indicate that
he is seated astride the keel with his legs dangling.[50] To this should be added
the observation that the figure's head is above those of the other figures, and
therefore perhaps the only one above the level of the water. The other unfor-
tunate figures then would be underwater, clutching in vain at the ship or a
comrade, on the brink of drowning. Like Odysseus in the Homeric passage,
the central figure in the scene rides on the ship's keel with his head above
water. Text and image closely correspond, strongly suggesting a relationship
between poetic passage and painted scene.

The two contemporary shipwreck scenes—one from Attica, the other from
Ischia—together with the Cup of Nestor imply that the transmission of the
Ionian epic tradition from old Greece to South Italy can be dated to the
eighth century BC. These painted and incised fired clay vessels hint that
eighth-century BC performances of epic poetry were memorable enough to
inspire both written words and painted pictures in a Greek settlement on the
edge of the Western frontier.

Another remarkable artifact discovered during the construction of a pri-
vate home on the east slope of Monte di Vico, the acropolis of ancient
Pithekoussai, also depicts a scene from epic poetry. It is the neck of an Ionian
transport amphora displaying the impression from a square stone stamp,
made in the Argolis or the Cyclades (fig. 8).[51] Of late eighth century BC date
(ca. 720–700 BC), the amphora fragment is roughly contemporary with the
Cup of Nestor. The stamp shows two figures, the smaller of which wears a
crested helmet and carries the enormous unarmed body of the other across
his shoulders while raising two spears, one in each hand. Amazingly, the
very same stone stamp was used to make impressions on a terracotta votive
plaque found at the sanctuary of Hera on the island of Samos.

The image is familiar from later parallels and represents Ajax carrying the
dead body of Achilles from the plain of Troy. The event is known from the
Epic Cycle, the series of poems thought to have been composed after the
Iliad and *Odyssey* to round out and complete the story of the Trojan War.[52]
Most importantly, the stamp proves that the iconographic tradition deriving
from Ionian epic was understood on both the Ionian island of Samos and the
island of Ischia in the far West. In this connection, the traditional association
between Samos and Homeric poetry should be stressed. Samos was the
home of the rhapsodic guild known as the Kreophuleioi, named after their

founder, Kreophylos. According to tradition, Kreophylos had been visited by Homer himself, who taught him the *Oikhalias Halosis,* or "Capture of Oikhalia," a lost epic that features Herakles. The Kreophuleioi were said to have been responsible for transmitting knowledge of Homeric epic to Sparta.[53] The implications of the discovery of this stamped amphora at Pithekoussai also raise important questions concerning the relationships between the poems of the Epic Cycle and the *Iliad* and the *Odyssey.* Here it is enough to recognize that the Euboean Greeks of eighth-century BC Pithekoussai had a broad appreciation of the Ionian epic tradition: the *Iliad* (the Cup of Nestor), the *Odyssey* (the Pithekoussai shipwreck scene), and the Epic Cycle (the stamp depicting Ajax and Achilles).

In addition to one of the earliest inscriptions of Greek epic verse, and the earliest painted figural scene in Italy, the very earliest Greek potter's signature yet known was found at Pithekoussai (fig. 9). The retrograde inscription was painted on the rim of a local late eighth century BC (ca. 700 BC) krater discovered in the area called Mazzola, southeast of Monte di Vico. Within a horizontal register the inscription reads: ". . . inos made me."[54] The fragment preserves only part of the potter's name and the upper body of a winged mythical creature, perhaps a sphinx or siren. This strange composite being is Eastern in character. It resembles the kind of fantastic unions of human and animal forms that we begin to see in Greek art of the seventh century BC, the so-called Orientalizing period.

Fig. 9. Krater from Pithekoussai, ca. 700 BC, showing the earliest known signature of a Greek potter. From Ridgway, *The First Western Greeks,* fig. 26.

The extraordinary artifacts from Pithekoussai tell us much about the spirit, wit, and humor of the Euboean Greeks, who risked an uncertain future by setting sail for a tiny island in the distant West in the eighth century BC. These were Greeks who were able to read and write using the new technology of the alphabet recently adapted from the Phoenician script, which was still used by the Phoenicians living among them. Pithekoussai was a genuine multinational community. The Euboeans who settled there were also knowledgeable about the heroic personalities and themes of the epic tradition, making it possible for one of them to scratch lines of epic verse onto a drinking cup and cleverly compare his cup with one used by a famous hero of the *Iliad.* Dramatic pictorial episodes now recognized as from the *Odyssey* and the Epic Cycle were also familiar on Pithekoussai, suggesting that its residents possessed a degree of visual literacy as well. There is in these artifacts the powerful sense of an independent and confident group of people with the kind of self-awareness and pride that compelled one of them to sign a pot after having made it. Such character traits are distinctly Greek, clearly expressed in the moral code and societal values of epic poetry, and were present with the first Western Greeks. They allow us to render a profile of the people who would go on to found colonies in South Italy and Sicily.

POETRY AND HISTORY: THE PHAEACIANS AND THE EUBOEANS
When long-suffering Odysseus—naked, battered, and encrusted with sea salt—washes ashore on Scheria, the home of the Phaeacians, he finds himself in the company of people of great refinement and taste.[55] Led by Nausikaa to the home of her father, King Alkinoös, Odysseus admires the signs of an ordered and civilized way of life.[56] The ships are carefully sta-

tioned in the sheltered harbor. Nearby stands a temple of Poseidon, and deep-set stones mark the public gathering place, or agora. A high wall encircles the city. On the king's estate is a grove of poplar trees sacred to Athena, along with freshwater springs and abundant vineyards, fruit trees, and olives.[57] King Alkinoös's palace has golden doors flanked by silver pillars surmounted by a silver lintel, a bronze threshold, and guardian dogs crafted of gold and silver to keep watch over the entrance.[58] Once inside, Odysseus is treated with practiced hospitality. The Phaeacians have cultivated many aspects of the Greek ideal of civilized living: the pleasures of good food and wine, dancing,[59] athletic contests,[60] and songs of the Olympian gods and the heroes at Troy sung by a blind singer named Demodokos, accompanied by a lyre.[61] After dinner in the palace, Odysseus, perhaps in emulation of Demodokos, spins the astonishing tale of his many dangerous encounters with outlandish beings in strange lands—some malevolent like Polyphemos, some compassionate like Calypso. Much of this exotic world and its residents, probably a blend of old seafaring memories and folktales, came to be associated with the western Mediterranean. By telling of his heroic exploits in the first person, Odysseus acts as his own bard, thereby incorporating them into the epic tradition.

Although Scheria is clearly an idealized poetic portrait of an early Greek community, it offers a greater degree of reality than the otherworldly places described by Odysseus in King Alkinoös's palace and contained in books 9–12 of the *Odyssey*. These places were located in unknown waters, where navigation by the constellations was impossible and even the coordinates of the rising and setting sun were lost to view.[62] When on Aiaia, Circe's island, Odysseus plainly states the predicament in which he and his men find themselves, in a land beyond the sun:

> Dear friends, for we do not know where the darkness is nor the sunrise,
> nor where the Sun who shines upon people rises, nor where
> he sets, then let us hasten our minds and think, whether there is
> any course left open to us. But I think there is none.[63]

Odysseus and his men were traveling in an area outside the circuit of the sun, and therefore in a world outside of time, the cycles of the seasons, and generational continuity. After leaving Calypso and heading toward Scheria, Odysseus once again was able to locate familiar constellations, proving that the Phaeacians live within the mortal sphere governed by the sun's route, where heroic deeds are immortalized by being passed from one generation to the next in the epic tradition.[64] So in Alkinoös's palace, Odysseus again finds himself in a place where heroic deeds are remembered, and is moved to tears when Demodokos sings of the feud between Odysseus and Achilles at Troy. Among the Phaeacians, Odysseus tells of his many hardships in a timeless realm in order that they may not be forgotten.[65]

Scheria's aura of reality is made more tangible by an account of its foundation. At the opening of book 6 of the *Odyssey* we are told that the Phaeacians had originally lived in Hypereia, but were regularly harassed by their uncouth neighbors, the Cyclopes. Then a certain Nausithoös, one of the community's leading members, took the initiative to guide them to remote

Scheria, "far from men who eat bread." Once there, Nausithoös provided other important public services. He erected a wall to define and enclose the city, constructed houses, built temples for the gods, and divided the farmland among the colonists.[66] This colony, though far removed from the rest of humanity, is still situated within the world of mortality—as opposed to the never-never land of Odysseus's other travels, those far-flung places disconnected from the heavenly canopy and the sun, "who sees everything and hears everything,"[67] where time itself is dysfunctional.

What we have in Scheria is a poetic rendering of the establishment of an early Greek colony. Nausithoös is the city's founder, or *oikist,* responsible for leading his people to a promising place and then structuring the new community. To be sure, Scheria and the Phaeacians are idealizations created by poetry, but they are not entirely cut off from historical reality. This is made explicit by King Alkinoös to Odysseus after the king has offered Odysseus his daughter's hand in marriage. He would not keep Odysseus against his will, and offers to convey the travel-weary hero home. The wonderfully quick Phaeacian ships could set sail the following day.

> As for conveyance, so that you may be sure, I appoint it
> for tomorrow, until which time giving way to slumber
> you may rest, and they will sail in the calm, to bring you
> back to your country and house and whatever else is dear to you,
> even if this may be much further away than Euboea,
> which those of our people who have seen it say is the farthest
> away of all. . . .[68]

Of all the regions of the Greek world, King Alkinoös mentions only that his people have visited Euboea. This revelation connects Scheria, a utopian land retaining a tinge of the fantastic, to the historical Euboeans. The observation that Euboea is "farthest away of all" seems decidedly Euboean in its perspective. Apparently, King Alkinoös's worldview has been shaped by his people's direct knowledge of Euboea. In the same way that the Phaeacians will convey Odysseus away from the world beyond the sun to Ithaca, they represent the bridge between the worlds of poetry and history, between Calypso and the Euboeans. Scheria is therefore the ideal location for the creation of epic poetry. This is why Demodokos, the most developed portrait of an epic singer in all of Homeric poetry, is a Phaeacian. On Scheria, he lives at the nexus between folktale and history, between the timeless and the mortal spheres, the natural home of epic poetry.

The legend of Odysseus's return to Ithaca from Scheria may have inspired the dedications of thirteen bronze tripods in a cave sacred to the Nymphs on the western coast of the island, in Polis Bay.[69] Ithacans, Euboeans, and Corinthians familiar with the epic legend of Odysseus's return to Ithaca on a Phaeacian ship may have begun to treat the cave as a shrine to the hero as early as the ninth century BC.[70] These tripod dedications seem to be related to the account in book 13 of the *Odyssey,* which describes the Phaeacians gently laying the sleeping Odysseus on the sandy shore of Ithaca, laden with gifts, including thirteen tripods.[71]

> . . . they lifted and carried Odysseus out of the hollow
> hull, along with his bed linen and shining coverlet,
> and set him down on the sand. He was still bound fast asleep. Then
> they lifted and carried out his possessions, those which the haughty
> Phaeacians, urged by the great-hearted Athena, had given him, as he
> set out for home, and laid them next to the trunk of the olive,
> all in a pile and away from the road. . . .[72]

After waking and conversing with the goddess Athena, he then proceeds to conceal his gifts in a cave of the Nymphs near the shore.[73] Presumably, those Euboeans visiting the shrine would have reflected on their legendary relationship with the Phaeacians, whose assistance to Odysseus was so crucial for his return to Ithaca.

The Phaeacians and Euboeans draw nearer when we compare Scheria's foundation history with what we know of the Euboean Greek colonies of South Italy or Sicily. The poetic account of Scheria's settlement by Nausithoös has the ring of historical truth. The oikist, Nausithoös, facilitates the evacuation of the Phaeacians from Hypereia to Scheria, and there sets up the city's important social institutions—both religious (temples) and socio-economic (agora)—and apportions land to each settler for home construction and agriculture. Its general outline accords with a pattern recognized in the late eighth century BC Greek colonies of South Italy and Sicily, after the founding of Pithekoussai.[74]

The earliest of these were founded by Euboeans: Cumae in Campania (ca. 750–725 BC); Naxos (ca. 734 BC), Leontini (ca. 729 BC), and Catane (ca. 728 BC) in eastern Sicily; and Zancle (after ca. 734 BC), Rhegium (ca. 720 BC), and Mylae (ca. 716 BC) near the Strait of Messina.[75] According to tradition, as recounted by ancient authors, Cumae was founded after Pithekoussai by Euboeans, possibly in collaboration with other Greeks.[76] The legends of Cumae's foundation, similar to the poetic account of Scheria's foundation, provide the names of its oikists: Hippocles of Cumae and Megasthenes of Chalcis.[77] Similar stories are preserved for the other Euboean colonies. Theocles of Chalcis was said to have founded Naxos in eastern Sicily, a settlement of Euboeans and other Ionian Greeks.[78] The same Theocles is credited with the foundation of Leontini, and soon after a Naxian named Euarkhos would lead a group of his fellow citizens to found Catane.[79] On the Strait of Messina, Zancle was reportedly first occupied by pirates from Cumae and then properly settled by the oikists, Perieres of Cumae and Krataimenes of Chalcis, with settlers from Chalcis and other parts of Euboea.[80] Ancient sources also state that Rhegium, on the other side of the Strait of Messina, was settled by recruits from Chalcis under the guidance of the oikist Antimnestos, who was from Zancle.[81] Finally, Mylae was founded to protect Zancle from attack and to secure the fertile farmland of the plain between the sea and the mountains.[82]

The same emphasis on the individual that we have seen in the artifacts from Pithekoussai is reflected in these legendary accounts of great men who founded new colonies in a frontier on the western edge of the world. In the language of epic poetry, Scheria also represented this frontier, a cultured

outpost just within the scope of the sun's daily circuit, beyond which lived Calypso, Circe, and Polyphemos. On Scheria, as on Pithekoussai, the residents spoke of the heroes at Troy and of the gods on Olympus. The early Euboean settlers of the West would perhaps have identified with the words of King Alkinoös, that Euboea was "the farthest away of all," but also with the poet's portrait of a people who appreciated those things that set Greek culture apart. These elements of the Greek way of life would be replicated and disseminated throughout Magna Graecia and Sicily with the spread of the Greek colonies: a walled city, a public meeting place, temples for the gods, a home and a tract of land, good food, dancing, drinking, and the enjoyment of epic poetry.

NOTES

1. Translation by author.

2. Recent excavated evidence for Mycenaean contacts in the West continues to accumulate. For a current bibliography see J. K. Papadopoulos, "Magna Achaea: Akhaian Late Geometric and Archaic Pottery in South Italy and Sicily," *Hesperia* 70, no. 4 (2001), 434–44 n. 279. See also D. Ridgway, *The First Western Greeks* (Cambridge, U.K., 1992), 145 n. 1.

3. On the historical development of Homeric poetry see the work of G. Nagy, especially "An Evolutionary Model for the Making of Homeric Poetry: Comparative Perspectives," in *The Ages of Homer: A Tribute to Emily Townsend Vermeule*, ed. J. Carter and S. Morris (Austin, 1995), 163–79.

4. Homer, *Iliad* 18.592. On this, the first appearance of Daedalus in Greek literature, see S. Morris, *Daidalos and the Origins of Greek Art* (Princeton, 1992), 2ff.

5. See T. J. Dunbabin, "Minos and Daidalos in Sicily," *Papers of the British School at Rome* 3 (1948), 1–18.

6. Homer, *Odyssey* 9.80ff.

7. See M. J. Bennett, *Belted Heroes and Bound Women: The Myth of the Homeric Warrior-King* (Lanham, 1997), 150ff.

8. See E. D. Phillips, "Odysseus in Italy," *Journal of Hellenic Studies* 73 (1953), 53–67; also R. Cantarella, "Omero in Occidente e le Origini dell'Omerologia," in *Letteratura e Arte Figurata nella Magna Grecia, Atti del Sesto Convegno di Studi sulla Magna Grecia* (Naples, 1967), 38ff.; T. Severin, *The Ulysses Voyage: Sea Search for the Odyssey* (London, 1987).

9. *Odyssey* 9.106ff.

10. Ibid., 10.2ff.

11. Thucydides, *History of the Peloponnesian War* 6.2.1.

12. *Odyssey* 10.210ff.

13. Ibid., 11.1ff.

14. Ibid., 12.73ff.

15. Ibid., 12.39ff., 158ff.

16. For references in the *Odyssey*, see J. P. Crielaard, "Homer, History and Archaeology," in *Homeric Questions: Essays in Philology, Ancient History and Archaeology, Including the Papers of a Conference Organized by the Netherlands Institute at Athens (15 May 1993)*, ed. J. P. Crielaard (Amsterdam, 1995), 232–33.

17. *Odyssey* 24.303ff.

18. Ibid., 24.306–7.

19. Ibid., 24.307–14.

20. Ibid., 20.383; 24.210, 365, 388.

21. See E. S. Sherratt, "Reading the Texts: Archaeology and the Homeric Question," *Antiquity* 64 (1990), 807–24. The amalgam of historical periods is clear from the incompatible components of Homeric armor worn by Trojan War heroes; see Bennett, *Belted Heroes*, 61–123.

22. See T. J. Dunbabin, *The Western Greeks: The History of Sicily and South Italy from the Foundation of the Greek Colonies to 480 BC* (Oxford, 1948, reprinted 1999), 2 nn. 3–6.

23. For an authoritative overview of the Greek world in the eighth century BC, see J. N. Coldstream, *Geometric Greece* (New York, 1977); see also J. M. Hurwitt, "Art, Poetry, and the Polis in the Age of Homer," in *From Pasture to Polis: Art in the Age of Homer*, ed. S. Langdon (Columbia, 1993), 14–42. On the invention of the Greek alphabet and its uses, see L. H. Jeffery, *The Local Scripts of Archaic Greece*, rev. A. W. Johnston (Oxford, 1990); M. L. West, "The Rise of the Greek Epic," *Journal of Hellenic Studies* 108 (1988), 151–72; B. B. Powell, *Homer and the Invention of the Greek Alphabet* (Cambridge, U.K., 1991).

24. See J. Boardman, *The Greeks Overseas: Their Early Colonies and Trade* (London, 1980), esp. 161–216. For a recent general discussion of early Greek economic conditions, see A. Sherratt and S. Sherratt, "The Growth of the Mediterranean Economy in the Early First Millennium BC," *World Archaeology* 24 (1992–93), 361–78.

25. Coldstream, *Geometric Greece*, 107.

26. D. Ridgway, "The Foundation of Pithekoussai," in *Nouvelle Contribution à l'Étude de la Société et de la Colonisation Eubéennes, Cahiers du Centre Jean Bérard* (Naples, 1981), 6:45–60, figs. 1, 2, fragment nos. 1–9; Ridgway, *First Western Greeks* 31–42. See also G. Buchner and D. Ridgway, *Pithekoussai I, Accademia Nazionale dei Lincei, Monumenti Antichi*, 2 vols. (Rome, 1993).

27. Strabo, *Geographia* 5.4.9; Livy, *History of Rome* 8.22.5–6. Both Eretrians and Chalcidians are identified by Strabo, while Livy mentions only Chalcidians.

28. Ridgway, *First Western Greeks*, 107–9.

29. Ibid., 101–3.

30. See G. Buchner, "Testimonianze epigrafiche semitiche dell'VIII secolo a.C. a Pithekoussai," *Parola del Passato* 33 (1978), 135–47.

31. See J. Boardman, "Al Mina and History," *Oxford Journal of Archaeology* 9 (1990), 69–90; See also Boardman, *Greeks Overseas*, 38–54.

32. Ridgway, *First Western Greeks*, 55–57, 149–50 for notes and bibliography; Cantarella, "Omero in Occidente," 40ff., tav. 1; Powell, *Homer and the Invention of the Greek Alphabet*, 163 n. 110. The earliest is the Attic oinochoe known as the "Dipylon Jug," dated ca. 740–730 BC; see Powell, 158–63.

33. *Iliad* 11.631-6; *The Iliad of Homer*, trans. R. Lattimore (Chicago, 1951). For a possible Late Bronze Age parallel see H. L. Lorimer, *Homer and the Monuments* (London, 1950), 328–35; contra, A. Furumark, cited in *Homer and the Monuments*, 335 n. 1. In *Homer and the Invention of the Greek Alphabet*, Powell points out several unique characteristics of the inscription (p. 164): "The writing, in standard Euboian script is unique among early Greek inscriptions: first, it is written in continuous retrograde, not boustrophedon; second, the metrical lines are written separately, not continuously; third, the writer has used the 'colon,' two vertical dots in a row, a diacritic device, to indicate word-division in the first line, and to indicate phrase division in the second and third lines at the hexametric caesura and where there is diaeresis."

34. See O. Murray, "Nestor's Cup and the Origins of the Symposion," *Apoikia: scritti in onore de Giorgio Buchner, AION* 1 (1994), 47–54.

35. This would be true whether or not Nestor's cup was mentioned in the *Kypria*. See A. M. Snodgrass, *Homer and the Artists: Text and Picture in Early Greek Art* (Cambridge, U.K., 1998), 53ff. Powell, *Homer and the Invention of the Greek Alphabet*, 167 n. 124: "The only cup of Nestor we know anything about, *viz.* Homer's, is plausibly the same one known to the Pithekoussan symposiast."

36. Powell, ibid., 163–67.

37. Powell, ibid., 60; also C. J. Ruijgh, "D'Homère aux origines proto-mycéniennes de la tradition épique. Analyse dialectologique du lange homérique, avec un excursus sur la création de l'alphabet grec," in *Homeric Questions: Essays in Philology, Ancient History and Archaeology, Including the Papers of a Conference Organized by the Netherlands Institute at Athens (15 May 1993)*, ed. J. P. Crielaard (Amsterdam, 1995), esp. 43ff.

38. Ridgway, *First Western Greeks*, 57: "It is the oldest piece of figured painting ever found on Italian soil."

39. Ibid., 57–60, fig. 10.

40. G. Ahlberg-Cornell suggests that this is an octopus, not a human figure; see *Myth and Epos in Early Greek Art: Representation and Interpretation* (Jonsered, 1992), 28.

41. Boardman, *Greeks Overseas*, 166 n. 15.

42. See G. Buschor, "Figürliche bemalte spätgeometrische Vasen aus Pithekussai und Kyme," *Mitteilungen des Deutschen Archäologischen Instituts, Römische Abteilung* 60–61 (1953–54), 40–47, fig. 1, pls. 14–16; S. Brunnsåker, "The Pithecusan Shipwreck," *Opuscula Romana* (Lund, 1962), 4: 165–242; Ahlberg-Cornell, *Myth and Epos*, 28; Ridgway, *First Western Greeks*, 150.

43. *Odyssey* 14.288–89; *Odyssey of Homer*, trans. R. Lattimore (New York, 1965).

44. Ibid., 14.305–13.

45. For an overview of the treatment of Phoenicians in Homeric poetry, see I. J. Winter, "Homer's Phoenicians: History, Ethnography, or Literary Trope?" in *The Ages of Homer: A Tribute to Emily Townsend Vermeule*, ed. J. B. Carter and S. P. Morris (Austin, 1995), 247–71; (p. 249): "The story contains what seems to be a most realistic pattern of foreign movement related to the shipping ventures of the Phoenician shipmaster." See also Crielaard, "Homer, History and Archaeology," 227ff.

46. See Bennett, *Belted Heroes*, 13 n. 7. Fish symbolize the sphere of Okeanos, which must be navigated across to enter Hades (*Odyssey* 11.13–

19). See also *Iliad* 21.122–27; *Iliad* 21.316–23, cited by E. T. Vermeule, *Aspects of Death in Early Greek Art and Poetry* (Berkeley, 1979), 184–85; also *Odyssey* 24.291 and *Iliad* 21.203–4.

47. *Odyssey* 24.289–92 (trans. Lattimore).

48. *Odyssey* 12.420–25 (trans. Lattimore).

49. An association with the *Odyssey* was first made by R. Hampe, *Die Gleichnisse Homers und die Bildkunst seiner Zeit* (Tübingen, 1952), 27–30. Ahlberg-Cornell, *Myth and Epos,* 28 nn. 57, 62, gathers the bibliography for and against an epic interpretation. Snodgrass, *Homer and the Artists,* 35–36, follows Ahlberg-Cornell in doubting a reference to Homeric poetry.

50. I do not see how he can be "swimming in the sea around the ship," as suggested by Ahlberg-Cornell, *Myth and Epos,* 28. Snodgrass, *Homer and the Artists,* 36, while agreeing with Ahlberg-Cornell's opinion that the scene is not related to epic poetry, "personally cannot follow Ahlberg in this detail of her interpretation."

51. See G. Buchner, "Pithekoussai: Oldest Greek Colony in the West," *Expedition* 8 (1966), 11; Ridgway, *First Western Greeks,* 90, fig. 23; Snodgrass, *Homer and the Artists,* 36–38, fig. 15.

52. On the issue of what traditional subject matter may have been available to the epic oral tradition and used in the works attributed to "Homer" or in the poems of the Epic Cycle, see R. Scaife, "The Kypria and Its Early Reception," *Classical Antiquity* 14 (1995), 164–92, esp. n. 4; K. Dowden, "Homer's Sense of Text," *Journal of Hellenic Studies* 116 (1996), 47–61.

53. See Bennett, *Belted Heroes,* 46–47.

54. Ridgway, *First Western Greeks,* 96, fig. 26: ". . . the earliest occurrence of this well-known formula anywhere in the Greek world."

55. *Odyssey* 5.451ff.

56. Ibid., 6.262ff.

57. Ibid., 6.291ff.

58. Ibid., 7.81ff.

59. Ibid., 8.378ff.

60. Ibid., 8.100ff.

61. Ibid., 8.44ff.

62. See Bennett, *Belted Heroes,* 150ff.

63. *Odyssey* 10.190–93. Ibid., p. 151 (trans. Lattimore).

64. Crielaard, "Homer, History and Archaeology," 239: "Scheria is not some fairy-tale country which forms an exotic setting for just another of Odysseus' adventures. It is a fictitious, Greek city which is situated between two worlds, and it is in this respect that Scheria is essential to the plot, since it permits Odysseus' return to the 'real' world, the one to which the hero is seeking to return."

65. Bennett, *Belted Heroes,* 152: "The journey of Odysseus outside the mortal time zone is a poetic diagram for the heroic paradox. As deathless memory is mortal, death *must* define the hero. Hence, to win *kleos,* Odysseus must achieve *nostos.*"

66. See the translation of *Odyssey* 6.7–10 at the beginning of this essay.

67. *Iliad* 3.277.

68. *Odyssey* 7.317–23 (trans. Lattimore).

69. See S. Benton, "Excavations in Ithaca III," *Annual of the British School at Athens* (hereafter *BSA*) 35 (1934–35), 45–73; "The Evolution of the Tripod-lebes," ibid., 74–130; "Excavations in Ithaca III; The Cave at Polis II," *BSA* 39 (1938–39), 1–51.

70. See I. Malkin, "Ithaca, Odysseus and the Euboeans," in *Euboica: L'Eubea e la presenza euboica in Calcidica e in Occidente: Atti del Convegno Internazionale di Napoli 13–16 novembre 1996,* ed. M. Bats and B. d'Agostino (Naples, 1998), 1–10; (p. 10): "The cave at Polis seems to imply a local Ithaca-cult, but also what we may call a 'proto-pan-Hellenic' shrine, since the hero was shared by other Greeks and could connect with the personal experience of particular individuals sailing to—or by—Ithaca. The 'cult community,' therefore, included a wider spectrum of participants; both Ithacans and Greek visitors, Euboeans and Corinthians. The cult activity was closely identified with an epic hero, perhaps not precisely the Odysseus of the textual Homer, but all the same, that hero with that story of return to Ithaca, the landing at the bay and the placement of the gifts in the cave." Contra, C. M. Antonaccio, *An Archaeology of Ancestors: Tomb Cult and Hero Cult in Early Greece* (Lanham, 1995), 152–55.

71. See *Odyssey* 13.96ff. Thirteen tripods is a calculation from several passages: 13.13–14, 13.345–50, 13.362ff.

72. *Odyssey* 13.117–23 (trans. Lattimore).

73. *Odyssey* 13.187ff.

74. Crielaard, "Homer, History and Archaeology," 236–39.

75. These dates are approximate and are based on literary and archaeological evidence. See Boardman, *Greeks Overseas,* 165–72; R. Osborne, *Greece in the Making* (London, 1996), 121–25.

76. Dunbabin, *Western Greeks,* 5ff.

77. Strabo, *Geography* 243.

78. Dunbabin, *Western Greeks,* 8; Strabo, *Geography* 267.

79. Dunbabin, ibid., 10.

80. Ibid., 11.

81. Ibid., 12.

82. Ibid.

Photography credits

Figs. 1 and 2: Bruce M. White; fig. 3: Michael Bennett.

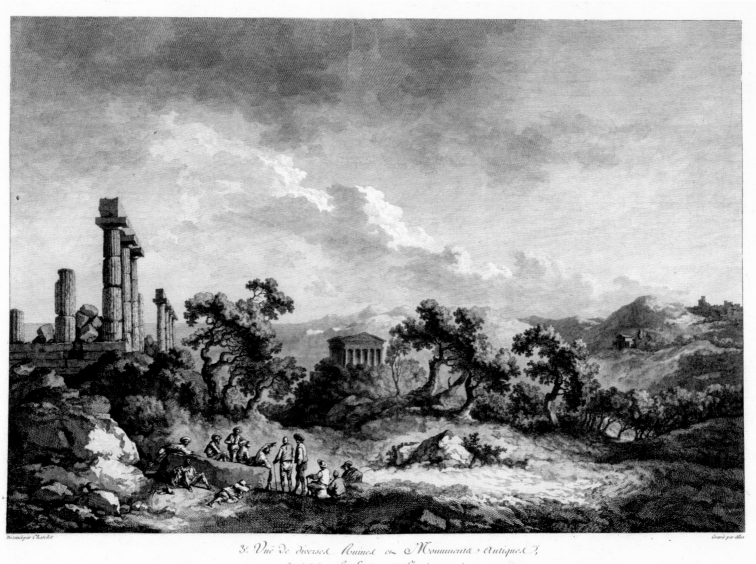

3.ͤ Vüe De diverses Ruines et Monuments Antiques,
dessinée dans les Environs de l'ancienne Agrigente.

Fig. 1. Valley of the Temples,
Agrigento. Engraving from
R. de Saint-Non, *Voyage
Pittoresque ou description des
Royaumes de Naples et de la
Sicile* (Paris, 1785), 4: pl. 96.

Agrigento: Profile of a Greek City

AARON J. PAUL

> At sunrise we did walk down, and at every step the surroundings grew
> more picturesque. Our little man, conscious of the fact that it was in
> our best interest, led us without stopping across the rich vegetation,
> past a thousand individual things, each of which offered a subject for
> idyllic pictures. The uneven ground contributes greatly to this, rolling in
> waves over hidden ruins.[1]
> —Goethe, *Italian Journey,* Agrigento, 25 April 1787

Thus the Valley of the Temples in the city of Agrigento, named Akragas by
the ancient Greeks, inspired Johann Wolfgang von Goethe to record his
impressions on a five-day stay there during his sojourn in Italy from Septem-
ber 1786 to April 1788 (fig. 1).[2] The poet and dramatist was one of many
European travelers who began to arrive at such destinations beginning in the
eighteenth century (fig. 2). At the time of Goethe's visit, Sicily, along with
Greece itself, would have been considered among the more remote reaches
of the Grand Tour, an educational travel regimen of sorts in which European
royalty, aristocrats, bourgeoisie, and artists traveled to see neighboring coun-
tries and the lands of the Mediterranean. For many eighteenth-century trav-
elers, a primary attraction was Italy, a land of ancient monuments and idyllic
landscapes that also would fuel passions for things Greek and lead to the
rediscovery of classical antiquity that continues even now. Spurred by such
visits from abroad, the ground covering Agrigento's verdant landscape, "roll-
ing in waves over hidden ruins," was in the process of being explored and
recorded by inquisitive scientific and artistic minds.

FAME AND FORTUNE IN ANCIENT LITERATURE
Though much of the ancient world remained undiscovered at the time of
Goethe's visit to Agrigento, like many other travelers on a Grand Tour of the
region he certainly would have had knowledge of ancient literary references
to the city's origins, layout, and wealth. The Greek historian Thucydides,
writing in the fifth century BC, a time contemporary with the height of
Agrigento's development, described the city's founding:

> Just about one hundred and eight years after their own foundation, the
> people of Gela colonized Akragas; and they named the city after the
> river Akragas, making Aristonous and Pystilos the founders, and giving
> it the constitution of the Geloans.[3]

Fig. 2. Johann Heinrich
Wilhelm Tischbein (German,
1751–1829). *Goethe in the
Roman Campagna,* 1786–87.
Oil on canvas. Städelsches
Kunstinstitut, Frankfurt am
Main.

Since Gela was founded circa 688 BC, we can calculate circa 580 BC as
the year that Agrigento was officially established by the Greeks. However,
few would believe that the city was founded without prior Greek contact in
the region. This was established long before the sixth century BC through
Greek overseas trade with the native population. The initial contact probably
would have taken place on the open beach, since the shores of Agrigento
provide one of the nearest approaches to a harbor on Sicily's south coast.
The area was visited in the Mycenaean period. Bronze Age vases from the
Aegean have been found there,[4] and Greek influence on native pottery of the
precolonization period demonstrates that contacts were resumed in the sev-
enth century BC.[5] Rapid growth in the amount of imported Greek pottery at
Agrigento, the last colony to be founded by the Greeks in the West, began in
the second quarter of the sixth century BC, very close to the foundation date
given by Thucydides.

Further testimony from ancient literary sources gives a description of
Agrigento that could have been written today. In the second century BC, the
Greek historian Polybius tells us:

> The city of Agrigentum is superior to most cities not only in the ways I
> have mentioned but in strength and especially in the beauty of its site
> and buildings. It stands at a great distance of eighteen stades from the
> sea, so that it enjoys all the advantage of a sea-coast town. It is en-
> circled by natural and artificial defences of unusual strength, the wall
> being built on a ridge of rock either naturally steep and precipitous or
> artificially rendered so. It is also surrounded by rivers, that which has
> the same name as the town running along the southern side and the
> Hypsas along the west and south-west sides. The citadel overlooking
> the town is due south-east from it, being surrounded on its outer side by
> an impassable ravine and having on its inner side but one approach

from the town. On its summit stand the temples of Athena and Zeus Atabyrius as in Rhodes. . . . The other temples and porticoes which adorn the city are of great magnificence, the temple of Olympian Zeus being unfinished but second it seems to none in Greece in design and dimensions.[6]

Ancient Agrigento's great agricultural wealth is attested to by Diodorus Siculus, a native of Sicily himself, writing in the first century BC:

> Their vineyards excelled in their great extent and beauty and the greater part of their territory was planted in olive trees from which they gathered an abundant harvest and sold to Carthage; for since Libya at that time was not yet planted in fruit trees, the inhabitants of Akragas took in exchange for their products the wealth of Libya and accumulated fortunes of unbelievable size. Of this wealth there remain among them many evidences.[7]

Illuminating the splendor of life in the city, Diodorus continues:

> Speaking generally, they led from youth onward a manner of life which was luxurious, wearing as they did exceedingly delicate clothing and gold ornaments and, besides, using strigils and oil flasks made of silver and even gold.[8]

Finally, he drives the point home in an amusing account of ancient comfort, describing what seems to be almost unheard of extravagance:

> Because of the immense prosperity prevailing in the city, the Akragantini came to live on such a scale of luxury that a little later, when the city was under siege, they passed a decree about the guards who spent the nights at their posts, that none of them should have more than one mattress, one cover, one sheepskin, and two pillows. When such was their most rigorous kind of bedding, one can get an idea of the luxury which prevailed in their living generally.[9]

The breeding and racing of horses, a prestigious sign of extraneous wealth, also was held in high regard in Agrigento. In fact, the city became known for its victories in the chariot races at the Panhellenic festivals, as celebrated by the lyric poet Pindar. Pindar probably left Greece for Sicily in the autumn of 476 BC, writing to celebrate the victories of the rulers of Akragas, where he lived for a time, and undoubtedly serving as an official poet to the ruling families. While in Akragas he must have written his second and third Olympian odes to honor the chariot race victory by Theron, ruler of Akragas from 488 to 471 BC:

> . . . Theron must be proclaimed by reason of his victorious chariot with its four horses, Theron who is just in his regard for guests, and who is the bulwark of Akragas, the choicest flower of an auspicious line of sires, whose city towers on high. . . .[10]

> . . . I honor the famous Akragas, by duly ordering my song in praise of Theron's victory at Olympia, as the choicest guerdon [i.e., reward] for those steeds with unwearied feet.[11]

Both odes celebrated the same victory in 476 BC; the first probably was sung in the palace of Theron, while the second was performed in the temple of the Dioscouroi at Agrigento on the occasion of the Theoxenia festival, when the gods were entertained by the twin heroes Castor and Polydeuces.[12]

Though the city's wealth and fame may have been exaggerated by ancient historians and poets, the great number of temples constructed at Agrigento in the fifth century BC supports their claims.[13] Agrigento's history as a Greek city is a relatively brief but glorious one.[14] After the city's official founding in 580 BC, the region's agricultural resources—grain, olives, and wine—were abundant enough to assure the city no small amount of extraneous wealth. Under the tyrant Phalaris (r. 570–555 BC) the city prospered, constructing public works and expanding its territory as a result of victorious wars with neighboring Carthaginian settlers and native Sican peoples. Theron continued this policy of territorial expansion. With his forces and those of his son-in-law, Gelon of Syracuse, he secured a great victory over the Carthaginians at the battle of Himera in 480 BC, and for a time expanded Agrigento's territory unbroken from the south to the north coast of Sicily.

At Theron's death he was succeeded by his son Thrasydeus (r. 470–471 BC), who soon was exiled with the accession of a democratic government. Almost a mirror image of the climactic heights achieved during the Classi-

Fig. 3. *The Phaedra Sarcophagus,* Roman, 100–200 AD. Hippolytos preparing for the hunt (left); Phaedra's grief at her rejection by Hippolytos (right). Cathedral Museum, Agrigento.

cal period of Athens in the fifth century BC, ancient Agrigento's own "golden age" extended from 470 to 409 BC. At the height of its prosperity and power, the city was splendidly embellished, with no less than nine temples constructed and its famous walls erected. It was during this time of flourishing art, literature, and science that Empedocles (493–433 BC) lived. Born of an aristocratic family in Agrigento, he became known as a philosopher, physician, scientist, poet, orator, and statesman, achieving almost legendary status in his own lifetime.[15]

Carthage renewed attempts to conquer Sicily beginning in 409 BC. It captured Himera and Syracuse and besieged Akragas in 406 BC, leaving the temples burnt, the city sacked, and the fortifications demolished. The people

of Akragas returned in 405 BC to rebuild what they could, but the city would never know its former fame or fortune, and its power continued to decline under the threat of Carthaginian rule. Between 344 and 338 BC, citizens from Syracuse refounded the city under the Corinthian Timoleon and once more joined forces with Syracuse against Carthage. Finally the Greek city of Akragas again fell under the dominion of the Carthaginians in the third century BC, eventually coming under Roman control in 210 BC. Afterward the city became known by its Latin name, Agrigentum.

THE REDISCOVERY OF AKRAGAS

In the eighteenth century, though most evidence of the rich material culture of ancient Agrigento still lay beneath the surface, it was hinted at by occasional finds that were displayed in the city's cathedral. At the time of Goethe's visit, two works of art from the necropolis of Agrigento were part of the standard tour given by every *cicerone,* or guide: a Roman marble sarcophagus depicting Phaedra and the death of Hippolytos (fig. 3), and a Greek red-figure column-krater with the departure of a warrior on the vase's front side and four draped youths on the reverse (fig. 4). The latter is the name-piece of the Duomo Painter, so-called after the cathedral in which the krater was displayed.[16]

Fig. 4. Attic red-figure column-krater attributed to the Duomo Painter, 440–430 BC. Cathedral Museum, Agrigento. Engraving from G. M. Pancrazi, *Antichità siciliane spiegate* (Naples, 1752), 1: 84.

Goethe, following his cicerone, visited the cathedral and reacted enthusiastically to the sarcophagus, which he noted as perfectly preserved and salvaged for use as an altar. Goethe recorded in his journal that he had never seen a more magnificent specimen of relief sculpture, and for the time being took it as an example of the "most charming period of Greek art."[17] He correctly interpreted the scene carved on the sarcophagus's sides as relating to Hippolytos and Phaedra but misattributed the sarcophagus as Greek, rather than Roman, which is understandable considering that it is a classicizing Roman work of the second century AD. The British traveler Richard Payne Knight, visiting Agrigento a decade before Goethe, recorded that the sarcophagus was being used as a baptismal font; he then described it in some detail, correctly noting it as Roman rather than Greek, without attempting to analyze the figural scene. To Knight the depiction was enigmatic, a quality he attributed to that which "the natural love of mystery and refinement, has construed into remote meanings of Allegory and Mythology."[18]

The Greek red-figure krater was mentioned at the same place in Goethe's journal as the sarcophagus, but at the time the poet remarked only that he and his fellow travelers were "transported back into earlier epochs by contemplating an exquisite vase of significant size."[19] Two days later, however, before leaving Agrigento, he returned to the subject, recording his interpretation of the vase's painted figural scene and speculating on the method of production: "The red is apparently the ground color of this vase, with the black being an overlay. Red seems to lie on black only in the woman's garment."[20] Johann Winckelmann, the famous eighteenth-century art historian, commented that "this vase is one of the grandest and . . . one of the most beautiful of antiquity. The vases I have seen in Sicily are generally fine and are a good witness to the taste of the inhabitants of Sicily and to the skillfulness of those who fabricated them."[21]

The fame of this particular Greek vase was due not only to the publicity afforded it by local guides, but also to the illustrations made by G. M. Pancrazi in his *Antichità siciliane spiegate,* published in Naples in 1752 (see fig. 4). Pancrazi gives information on the date, place, and condition of the vase's discovery in both his text and the engraved illustrations. He says that not far from the rocky ledges on the western side of the city, near via Dante, in one of the many usual graves that exist there in a necropolis, they found a wonderful vase in very good condition. Pancrazi did not publish a drawing of the tomb, perhaps because it was considered of the ordinary type that he already had illustrated generically. At the bottom of the page illustrating the vase, he tries to give more precise information about the conditions of its discovery: "Ancient vase found in the month of January of 1743 in a grave in one of those almost innumerable graves that you can see on the slope of Monte Camico. . . . The vase is held in Girgenti [Agrigento] by the very illustrious D. Gregorio Gamez." In the text, he provides additional information, relating that when the vase was found it was not functioning as a cinerary urn for ashes of the deceased but instead was filled with small ceramic vases of differing shapes.[22]

In 1827 the pursuit and study of Agrigento's Greek material culture was established on a systematic basis with the founding of the Committee for Antiquity and Fine Arts (Commissione Antichità e Belle Arti) in Palermo. Historical and topographical studies concerning Agrigento were begun during this time and by the end of the nineteenth century were firmly established. In the second half of the nineteenth century, the studies of Giuseppe Picone[23] and Giulio Schubring[24] addressed problems related to the localization, topography, and chronology of the necropoli and started to consider them as elements related to one another and the territory of the city.[25] Schubring recorded the locations and the extension of the necropoli in relationship to the city's perimeter.

Raffaello Politi, one of the earliest collector-scholars of the modern era, made his home in Agrigento during this time of systematic exploration. Born in Syracuse in 1783, Politi moved to Agrigento in 1809 and lived there until his death in 1870. The self-taught son of a painter, an excellent draftsman, and a versatile man of culture, he created a small private collection of vases (mainly lost over time, except for some given to the Agrigento Museum). He published many of these vases in small booklets illustrated with refined drawings that delineated the objects with subtle lines, in particular the Athenian vases found in Agrigento and later exported or lost.[26] Often an illustration was accompanied with important commentary, as well as information about when the vase was discovered, the findspot, and sometimes the composition of all the grave furnishings. Such documentation is significant since much of the information has been lost for vases found in the nineteenth century. Taking into account his comments published in *Descrizione di due vasi greco-sicolo agrigentini* (Agrigento, 1831), we might consider Politi an early archaeologist, a passionate and poetic man of his time:

> The classical soil of Agrigento undoubtedly can be defined as an inextinguishable source of clay vases, for after so many years, although people search to find and dig up vases in these large necropoli, in a land so many times marked with holes from the avid work of the excavators, never the less extraordinary vases still come to light today. One could say that an eternal workshop had worked there and their kilns, like an erupting volcano, made vases continuously, scattering them all around the territory. And so today, this land presents to antiquarians new objects always of interest for history and art; and I, an artist who lives in this place, would like to let cultured people know about the Greco-Siculi vases of Agrigento with drawings, made and engraved by myself.[27]

Sometimes, rather than being displayed as tourist curiosities in a local civic or religious building, a collection of vases would enter a bona fide museum. In April 1841, five vases were found at Agrigento in a grave and published by Politi in *Spiegazione di cinque vasi di premio,*[28] then subsequently given to the Palermo Museum.[29] One of these vases, a bell-krater by the Oreithyia Painter[30] that is included in this exhibition [80], is a masterwork of the Greek potter's and painter's art. The well-executed illustrations from Politi's 1841 publication reproduce the figural scenes painted on the

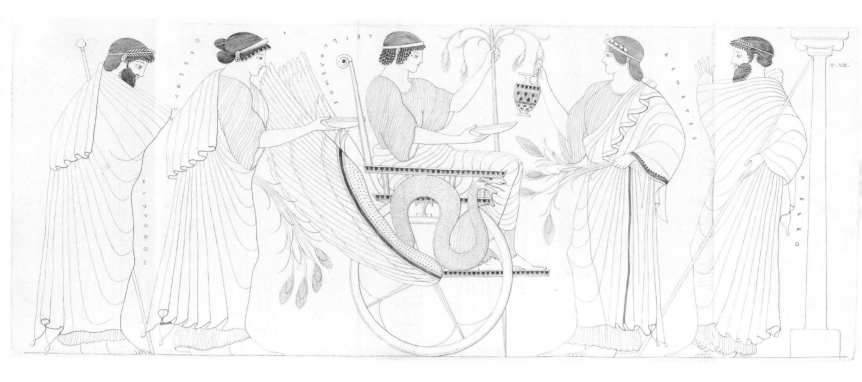

krater's sides and demonstrate his skills as an artist (fig. 5). Works of art in their own right, such fine quality, accurate illustrations of painted scenes were necessary to include in any serious publication of Greek vases.

Made in Athens but found in Agrigento, the krater by the Oreithyia Painter would have been a relatively expensive import in antiquity and demonstrates the surplus of wealth that Agrigento must have possessed. The centuries-long trade relationship established between the Greek cities of Sicily and those of mainland Greece, especially Athens, enabled thousands of similar red-figure pottery vessels to be transported from Athens to Magna Graecia and Sicily. The krater's painted scenes depict Greek social customs and myths that were shared and appreciated by mainland Greeks and those in the Western settlements. This krater was used as a wine-mixing bowl for the symposium[31] and eventually deposited in a tomb, probably as a reminder of life's joys and a harbinger of the continuation of those times in the afterlife. Protected by burial with the dead, many of these ceramic vessels survived to our own day intact.

The mythological scenes decorating this krater would have held a special meaning for Greek inhabitants of Sicily, known as it was for agricultural wealth and particularly for its prolific grain production. The scene on the front side depicts the departure of Triptolemos. First mentioned in the Homeric Hymn to Demeter,[32] it was Triptolemos, a prince of Eleusis, to whom the goddess taught the art of agriculture. In vase painting, Triptolemos is often represented receiving the gift of grain from Demeter as he is about to depart in his winged chariot, dispersing knowledge of agriculture to humankind.[33] The vase's opposite side illustrates a particularly poignant scene with Eos, goddess of the dawn, and Thetis, a Nereid, flanking Zeus. The two alarmed mothers appeal to Zeus, pleading frantically for the lives of their respective sons, Memnon and Achilles.[34]

A profile of ancient Agrigento would be incomplete without mention of at least one architectural monument in the Valley of the Temples: the temple of

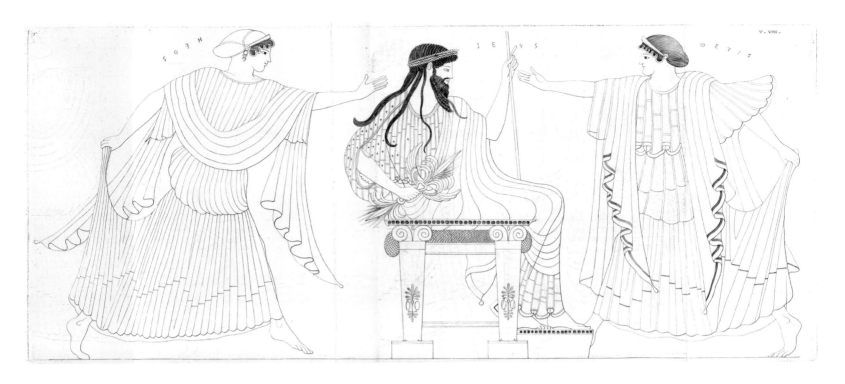

Concord (fig. 6). First seeing this temple in early morning light, Goethe describes a view in his journal that seems as clear today as it was in the eighteenth century (fig. 7):

> Surely never in our lives have we had such a magnificent springtime view as we had today at sunrise. . . . From our windows we saw the long, broad, gentle slope of the old city, completely covered with gardens and vineyards, under whose greenery hardly a trace of the former large urban districts can be imagined. At the very end of this green and blossoming area the Temple of Concordia can be seen to stand out. . . . The Temple of Concordia has withstood so many centuries; its slender architecture brings it quite close to our standards of beauty and grace.[35]

Built about 440 BC, the temple of Concord is one of the best preserved Doric Greek temples.[36] Its entablature of metopes, triglyphs, and overhanging cornice is completely intact on both the east and west sides. The metopes are uncarved, unlike some of the temples at Selinus [79], and may have been painted with mythological scenes relating to the deity to whom the temple was dedicated. The temple was erroneously named after a Latin inscription referring to the Roman goddess Concordia found nearby. Similar to the fate of two fifth-century BC temples in Athens—the Parthenon and the temple of Hephaistos—the temple of Concord owes its survival to the fact that it was converted into a Christian basilica, in this case by San Gregorio delle Rape, bishop of Agrigento, in the sixth century AD. The spaces between the columns were filled with walling, altering its Classical Greek form. The division between the *cella,* the main room where the cult statue would have stood in antiquity, and the *opisthodomos,* an adjoining room, was destroyed, and the walls of the cella were cut into a series of arches along the nave. In the eighteenth century, the temple was restored and the colonnade freed of its inner walling. The colonnade consists of thirteen columns along its north and

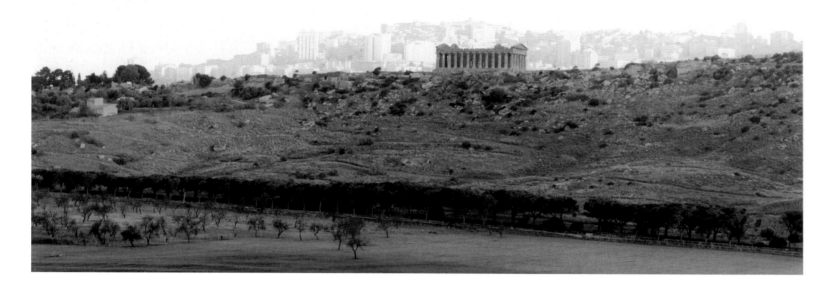

Fig. 6. Temple of Concord and the modern city of Agrigento, 2002.

south sides, and six each on the east and west. The columns are fluted and, following a Greek architectural innovation of the later fifth century BC, are set closer together at the corners, overcoming a design problem that would have been presented by the corner metopes. Incorporating another innovation of the time, the temple columns and stepped platform were planned to be slightly convex, swelling almost noticeably in the center (a technique called *entasis*), thus compensating for the optical illusion of concavity that would have resulted from perfectly straight-sided columns and platform.

Lacking the natural resources of marble enjoyed by some areas of mainland Greece, Agrigento's temples were built of local, easily eroded limestone that was covered with white stucco to imitate the Greek marble prototypes and to protect the stone from the elements. As in mainland Greece, columns were left white and architectural details were highlighted with bright colors. For the temple of Concord, the pediments and metopes likely were decorated with painted scenes. There is no surviving trace of the temple's altar, which would have been positioned outside and in front of the temple's east facade. Though little evidence remains, the sacred precincts surrounding the temples, and the processional ways leading to them, would have been embellished with dedicatory monuments celebrating military or athletic victories and decorated with stone, terracotta, and bronze sculpture.

A figure highlighted in this exhibition, the Youth of Agrigento, is likely to have graced such a temple precinct [72].[37] Discovered in Agrigento in 1897, this rare masterwork of marble sculpture dating to the early fifth century BC

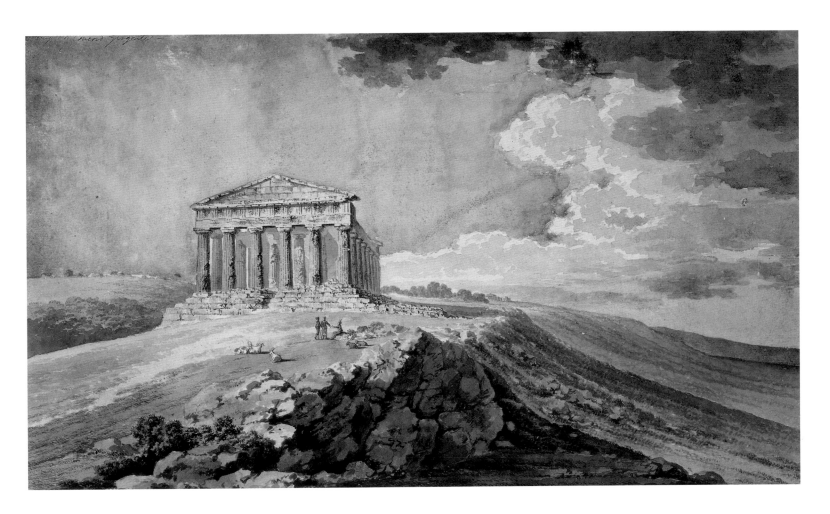

Fig. 7. Charles Gore (English, 1709–1827). *The Temple of Concord at Agrigentum,* 1777. Watercolor over pencil; inscribed in brown ink: "Temple of Concord Girgenti." British Museum, Oo. 4-26.

is the finest example of its type found outside mainland Greece and one of the most important early classical sculptures known. Perfectly poised, its commanding presence belies its under-life-size stature and would have suited its position in a sanctuary—perhaps as a dedication to a deity commemorating an athletic victory by a particular youth. The sculpture owes its extremely good state of preservation to the fact that it was found in a cistern near the river Akragas and the temple of Demeter, which is now partly incorporated into the medieval church of San Biagio. The marble's smooth surface retains much of its ancient luster. Rarer still is the well-preserved original red paint of the finely delineated hair.

The youth's pose and naturalistic modeling date it to a transitional period in the development of Greek art. During this time, the first quarter of the fifth century BC, sculptors abandoned the Archaic period's patterned anatomical conventions in pursuit of what we recognize as the Classical ideal: the embodiment of physical perfection in the depiction of the human figure. Spanning the Archaic and Classical styles, this sculpture joins the two in perfect unity. Evidence for transition between the two styles can be found in the youth's slightly lingering smile, which harks back to the "Archaic smile" of earlier sculptural tradition, in combination with aspects that look forward to the Classical period, such as a more natural representation of anatomy and an attempt to represent the figure as moving in three-dimensional space. Marble transfigured by hand and chisel into human form, it stands as one of the most notable monuments of Western Greek art.

Preserved for more than two and a half millennia, what remains today of the Greek city of Akragas is nothing short of miraculous: the architectural masterpieces occupying the ridges of Agrigento's Valley of the Temples, the ancient monuments of its pastoral countryside, and the fascinating and beautiful works of art in its Museo Archeologico Regionale (a number of which are included in this exhibition). With these in our view, the description of the city written by Pindar in the fifth century BC still resonates:

> Lover of splendor, fairest of mortal cities, home of Persephone thou that inhabits the hill of noble dwellings above the banks . . . beside the stream of Akragas.[38]

NOTES

1. J. W. von Goethe, *Italian Journey*, trans. R. R. Heitner (Princeton, 1989), 220.

2. Goethe's journal entry was likely inspired by a vantage point similar to that depicted by the artist Chatelet, published two years before Goethe's visit by R. de Saint-Non in *Voyage Pittoresque ou description des Royaumes de Naples et de la Sicile* (Paris, 1785), 4: pl. 96. Among the figures in the engraving's foreground, the one at the far right, wearing a large-brimmed hat and draped in the typical *mantello* (large traveler's cloak), is probably a visitor to the region in the company of his guide, or *cicerone*, and local inhabitants.

3. Thucydides, *History of the Peloponnesian War* 6.4.4–5, trans. C. F. Smith (Cambridge, Mass., 1921, reprinted 1992).

4. For a Mycenaean piriform jar, ca. 1400–1300 BC from the seacoast of Agrigento, see E. De Miro, *Le Valle dei Templi* (Palermo, 1994), pl. 23.

5. T. J. Dunbabin, *The Western Greeks: The History of Sicily and South Italy from the Foundation of the Greek Colonies to 480 BC* (Oxford, 1948, reprinted 1999), 305–10.

6. Polybius, *The Histories* 9.27.1–9, trans. W. R. Paton (Cambridge, Mass., 1925, reprinted 1993).

7. Diodorus Siculus, *The Library of History* 13.81.4–5, trans. C. H. Oldfather (Cambridge, Mass., 1950, reprinted 1994).

8. Ibid., 13.82.8.

9. Ibid., 13.84.5–6.

10. Pindar, *The Odes of Pindar*, Olympian 2.5–7, trans. J. E. Sandys (Cambridge, Mass., 1915, reprinted 1978). Born in Boeotia, Pindar (518–438 BC) wrote the *Odes* to celebrate victories by competitors at the Olympian, Pythian, Nemean, and Isthmian games.

11. Ibid., Olympian 3.5–9.

12. Ibid., Olympian 3.31. The identification of the reconstructed edifice popularly known as the Temple of Castor and Polydeuces is incorrect, as are those given to other temples at Agrigento; see Dunbabin, *Western Greeks*, 323 n. 4.

13. G. Gruben, *Die Tempel der Griechen* (Munich, 1966), 288–305.

14. For the history of the Greeks in Sicily, see Dunbabin, *Western Greeks;* R. R. Holloway, *The Archaeology of Ancient Sicily* (London, 1991); M. I. Finley, D. M. Smith, and C. Duggan, *A History of Sicily* (New York, 1987); M. Guido, *Sicily: An Archaeological Guide: The Prehistoric and Roman Remains and the Greek Cities* (London, 1977).

15. G. Zuntz, *Persephone: Three Essays on Religion and Thought in Magna Graecia* (Oxford, 1971), 181–85.

16. J. D. Beazley, *Attic Red-figure Vase Painters,* 2d ed. [hereafter ARV²] (Oxford, 1963), 1117, no. 2.

17. Goethe, *Italian Journey,* 219.

18. R. P. Knight, *Expedition into Sicily, 1777,* ed. C. Stumpf (London, 1986), 46.

19. Goethe, *Italian Journey,* 219.

20. Ibid., 224. Impressively, Goethe was correct in his analysis of the vase painter's technique. The red color of the clay acts as a ground for the application of clay slip that turns black upon firing in the kiln.

21. G. Fiorentini, "Le necropoli di Agrigento e i viaggiatori e antiquari del XVIII e XIX secolo," in *Veder Greco: Le necropoli di Agrigento,* exh. cat., Museo Archeologico Regionale, Agrigento (Rome, 1988), 56.

22. Ibid., 54–55.

23. G. Picone, *Memorie Storiche Agrigentine* (Girgenti [Agrigento], 1866); *Lettera al prof. R. Maugini sull'epoca dei sepolcri della nostra necropoli* (Girgenti [Agrigento], 1871).

24. G. Schubring, *Topografia storica di Agrigento* (Leipzig, 1870).

25. Fiorentini, "Le necropoli di Agrigento," 50.

26. For a list of thirteen of Politi's publications, see ARV², 1996.

27. Fiorentini, "Le necropoli di Agrigento," 60–61.

28. In the Agrigentine newspaper *La Concordia* dated 20 July 1841, Politi describes the discovery of the five vases and gives an exact and detailed description of them.

29. Fiorentini, "Le necropoli di Agrigento," 60.

30. Beazley, ARV², 496, no. 5; Palermo V779.

31. For the symposium, see F. Lissarrague, *The Aesthetics of the Greek Banquet: Images of Wine and Ritual* (Princeton, 1990).

32. Hesiod, *The Homeric Hymns,* Demeter 2.470–79, trans. H. Evelyn-White (Cambridge, Mass., 1982).

33. T. Gantz, *Early Greek Myth* (Baltimore, 1993), 69–70.

34. Ibid., 623–24.

35. Goethe, *Italian Journey,* 219–20; journal entries for 24–25 April 1787.

36. See E. De Miro, "Agrigento: Storia della ricerca archeologica" in *Bibliographia topographia della colonizzazione greca in Italia e nelle isola tirreniche,* ed. G. Nenci and G. Vallet (Pisa/Rome, 1984), 3: 75–85.

37. For the Youth of Agrigento, see G. M. A. Richter, *Kouroi: Archaic Greek Youths* (London, 1960, reprinted 1983), 145, figs. 547–49; E. Langlotz and M. Hirmer, *The Art of Magna Graecia: Greek Art in South Italy and Sicily* (London, 1965), 267, pls. 54–55; R. R. Holloway, *Influences and Styles in the Late Archaic and Early Classical Greek Sculptures of Sicily and Magna Grecia* (Louvain, 1975), 23, 27–28, figs. 156, 157. For a recent discussion of kouroi in Western Greece, see E. Lattanzi, "Il Kouros in Sicilia e Magna Grecia in età arcaica," in *Kouroi Milani: Ritorno ad Osimo* (Rome, 2000), 23–27.

38. Pindar, *Odes,* Pythian 12.1–3; written for Midas of Akragas, winner of a flute-playing contest in 490 BC.

Photography credits

Fig. 3: Fratelli Alinari; fig. 6: Bruce M. White.

Black-figure Pottery in Magna Graecia and Sicily

MARIO IOZZO

In the eighth century BC, Greeks from a number of poleis (city-states) began to leave their country and sail west, gradually colonizing the islands and coasts of South Italy and Sicily. The most vivid reflection of this widespread, complex cultural and economic phenomenon is undoubtedly expressed in the *Odyssey,* where Homer, as the historian Thucydides noted in the fifth century BC, "transfigured in order to glorify" real experiences.[1]

The Greek migration brought with it the great vase-making tradition of their homeland, based on centuries-old artisan and technical experience. There is strong archaeological evidence (for example, the recovery of several kilns) proving that since the first phases of settlement the colonists produced vases for daily, religious, and funerary functions. The vessels were painted according to the style of the city-states from which the settlers came, although the images often were influenced by the collective experience of the great phenomenon of migration. This applies both to the Greeks who settled in Sicily and to those who took up residence in South Italy, as made clear by ancient historians who considered the two areas inseparably joined.[2]

Indeed, the dangerous sea crossing of the new colonial enterprise echoes in one of the first and more dramatic expressions of the art of vase making in Magna Graecia: the krater of Lacco Ameno in Ischia (fig. 1). The scene de-

Fig. 1. Krater showing a shipwreck scene. Ischia, Lacco Ameno, 725–700 BC. Ceramic. Museo Archeologico di Pithecusa, 168813.

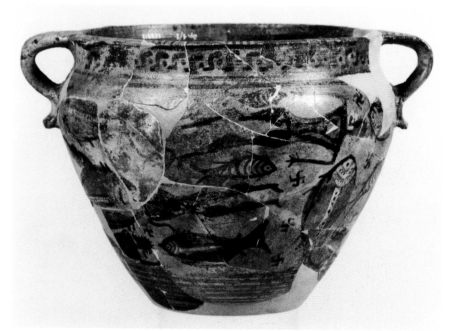

picts a shipwreck, with bodies floating on the waves next to the capsized vessel while large fish begin to devour them[3]—a symbolic image in which the perilous trip across the sea may have been interpreted as parallel to the ultimate voyage to the hereafter.

It is not accidental that the earliest evidence of a Greek presence in Italy comes from the island of Pithekoussai. Present-day Ischia was indeed the first settlement of the sailors and travelers who left the island of Euboea soon after the mid eighth century BC. Putting down roots in a paradise of luxuriant vegetation and thermal waters located at the southern border of the Etruscan world, they established strong trading contacts with their neighbors' rich mining centers.

The fragment of a krater depicting part of a frontally posed winged figure also comes from Ischia (fig. 2). It could be a sphinx or more likely a siren, since tradition places the mythical monsters with the bewitching voices in exactly the same geographical area. In any case, it is probably a celestial, funerary element, possibly set next to a dramatic scene similar to that of the shipwreck krater. Yet the small fragment is even more important because it records the oldest signature of a potter active in Magna Graecia. From right to left [inosmepoies] is clearly legible, obviously in the Euboean alphabet, and can most likely be interpreted as S[inos m'epoies]e: "Sinos made me."[4]

The proud statement on the vase, most likely its trademark, is therefore placed at an exact geographic location (at the border between the Etruscan and the Western Greek worlds) and at a precise time (725–700 BC). With objects inscribed like this one, the colonists coming from Euboea and settling in the area of Campania taught the Etruscans how to write in their language using the Greek alphabet, obviously in the Euboean version. This knowledge would be passed on with few changes from the Etruscans to the Romans, and subsequently to the entire Western world.

In addition to Pithekoussai, there is clear (though less abundant) archaeological evidence proving that ceramic production had already begun from the end of the eighth century BC in several other colonial poleis in Magna

Fig. 2. Krater fragment showing the potter's signature. Ischia, Lacco Ameno, 725–700 BC. Ceramic. Museo Archeologico di Pithecusa, 239083.

Graecia and Sicily. Moreover, though we focus here on figured pottery, it should be remembered that an extensive and diversified production of vases with simple linear or geometric decoration developed in all the main settlements. This production imitates examples imported from the Greek towns that at the time dominated the Mediterranean markets: Corinth, Chalcis and Eretria (cities in Euboea), and some centers of Eastern Greece such as Rhodes, Chios, and Phocaea.

The mix of peoples that formed the new colonies and the different places of origin of the products imported from the homeland were both instrumental in shaping one of the most essential characteristics of Western Greek art—a characteristic that remained constant over time. This was the assimilation and new elaboration of multiple cultural influences and the fusion of iconography, style, shapes, and patterns. In short, the art displayed a harmonic and balanced eclecticism.

The prologue to the first decades of Greek presence in Italy developed in a more decisive and easily recognizable fashion during the seventh century BC. The political situation was stabilized in the oldest cities, which contributed to increased migration and the rise of new settlements throughout South Italy. Although there were still a great variety of styles, the art of vase making among the Greeks of South Italy and Sicily reached a substantial unity in the seventh century BC. This unity was a result of several factors, including the constant attempt to revive the pictorial tradition of the homeland. Also influential were those artistic factors that dominate a period, a geographic area, a commercial situation, or a historic phase.

Fig. 3. Dinos picturing Bellerophon and the Chimera. Italy, Incoronata, ca. 650 BC. Ceramic. Museo Archeologico Nazionale di Metaponto, 298978.

From a style that was sparse but infused with a vital and intense dramatic force typical of the products of the late eighth century BC, we begin to see a considerable local production of vases in sub-Geometric and Orientalizing styles, made for both daily use and commercial exchange with the indigenous populations of the inland areas. Small Corinthian vases with linear decorations continued to influence the most current local production (for example, the Thapsos-like cups). At the same time, the figured vases produced in all the main settlements show a more lively and imaginative repertoire and style—clearly inspired, though perhaps not exclusively, by the production of the Cyclades.

At the beginning of the seventh century BC, on the Incoronata Hill near the colony of Siris, an *emporion* (trading settlement) was founded by Greeks who probably forced out the indigenous community. In turn, the colony was destroyed around 630 BC. The *oikoi* (houses) discovered on the site were more likely commercial depots full of products intended for trade with the inland indigenous populations. They have yielded some of the most important painted vases with Orientalizing characteristics in Magna Graecia. A dinos with its base—a vase that one could well imagine as the centerpiece of a drinking party, or symposium, of about 650 BC—depicts on one side Bellerophon and the Chimera, and on the other a fawn being attacked by two lions (fig. 3). While the shape and ring-like handles are inspired by more precious metal vases, the iconography and figural style combine elements derived from the repertoire of Corinthian vase painters, as well as those from the Cyclades and Crete. The dinos represents the earliest mythological figural

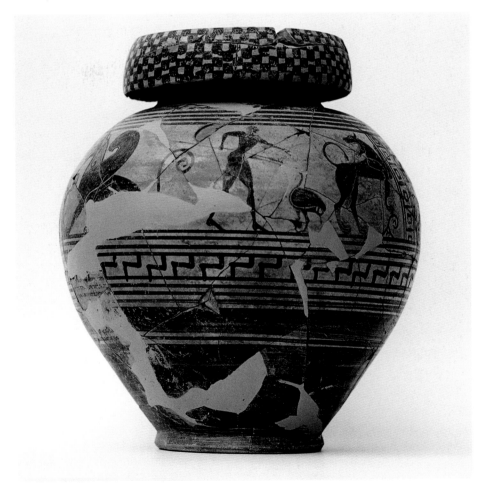

Fig. 4. Globular vase showing a lion hunt. Italy, Incoronata, ca. 650 BC. Ceramic. Museo Archeologico Nazionale di Metaponto, 298979.

Fig. 5. Krater of Aristonothos, depicting the blinding of Polyphemos (left) and a ship battle. Italy, Cerveteri, ca. 650 BC. Ceramic. Musei Capitolini, Rome, 172.

scene yet known from Magna Graecia. Its lively, naive, and spontaneous style is different from mainland models. It is free of the most solemn iconographic conventions of the homeland, particularly evident in the position of Pegasus's wings, separated in order to leave the hero's body completely visible.[5] A unique globular vase was discovered with the dinos (fig. 4). Looking almost like a Corinthian aryballos, but of exceptional size, it shows a hunter attacking a lion with a spear. Perhaps it is a local interpretation of the iconography of Herakles and the Nemean lion.[6]

If the dinos with Bellerophon and the Chimera is the earliest mythological scene produced and recovered in Magna Graecia, the well-known krater from Cerveteri, signed by the Greek Aristonothos, holds a more problematic place (fig. 5). Long considered a Cumaean product, it was more likely created by a painter, possibly from the Cyclades, who also worked among the Greeks of Italy—or at least whose style was not very distant from the contemporary Greek products from Sicily. Therefore, this is the earliest example of a vase depicting a mythological scene permeated by iconographic and stylistic influences of Magna Graecia found, if not produced, in Etruria. The scenes of the blinding of Polyphemos by Odysseus and his men on one side, and the clash between a warship and a cargo ship (possibly one Etruscan and one Greek) on the other, seem to follow a precise iconographic program that opposes Greeks to non-Greeks, both in the mythical and "realistic" worlds.[7]

The formal language recognizable in the products of Syracuse is more directly linked to the Peloponnesus. The oinochoe [47] is, in shape and ornamental syntax, a direct imitation of Corinthian models. But the menacing figure of Acheloos, the river god with the head of a bull, unfurls around the vase's body in a manner similar to the figures seen on contemporary proto-Attic vases. Acheloos was the father of the Sirens and the most important among the three thousand rivers, all sons of Oceanus. The large vases produced by a single workshop active in Syracuse at the beginning of the sev-

enth century BC are the work of Argive artisans who migrated to the new colony. For the most part, the products of this workshop were intended for funerary rituals conducted in the necropolis of Fusco. An example is the large krater with the figure of a horse, a clear symbol of social status (fig. 6).[8]

A very peculiar category of vases with polychrome decoration was likely produced in Megara Hyblaea and exported to nearby Syracuse, as well as to the Megarian subcolony of Selinus. Outstanding within this group are the large stamnoi decorated with ornamental motifs and figural scenes inspired by the repertoire of the Cyclades and Crete. The vase in Basel features outlined registers alternating with fully painted areas, showing on one side Herakles killing the Nemean lion and on the other Theseus slaying the Minotaur (fig. 7).[9] These two great mythological episodes, in which virtue opposes bestial force, are charged with multiple symbolic meanings. By

Fig. 8. Fragment of a polychrome dinos showing heroes pulling a rope. Sicily, Megara Hyblaea, 650–600 BC. Ceramic. Museo Archeologico Regionale "Paolo Orsi" di Siracusa, 84813.

contrast, a lively sense of color characterizes the scene of the male figures pulling a rope (perhaps connected to the Trojan Horse?) on the fragment of a dinos (fig. 8). It is an expression of the mature polychrome style, devoid of fillers, developed during the last decades of the seventh century BC.[10]

To the end of this century also belong some interesting examples of vases produced in Gela, which show Corinthian and Cretan influences in terms of ornamental motif and figural style. Among these are a stamnos with a pair of facing griffins (fig. 9),[11] the mythical birds with the head of an eagle and the body of a lion that protected the treasure of Apollo and the wine-filled krater of Dionysos (on the opposite side, a bird of prey and a possible crane face each other); and a dinos from the area of Agrigento, the subcolony of Gela, decorated with one of the earliest examples of the triskeles, the symbol of solar rotation expressed by three legs around a central face [66]. It may have been in the Rhodian-Cretan community of Gela that the triskeles became the emblem of Sicily, suggesting the island's triangular shape.[12]

Fig. 9. Stamnos with male and female griffins. Sicily, Gela, 650–600 BC. Ceramic. Museo Archeologico Regionale di Gela, 238.

Although the archaeological record is incomplete, other vase-making centers also flourished in the seventh century BC, often clearly influenced by the work of several poleis and their mother cities. Euboean and Laconian influences are apparent in vases from Reggio Calabria and Taranto, respectively. Croton appears to be clearly linked to the Peloponnesus, from whence its founders came. Corinthian and Euboean traditions, with East Greek elements, dominated the production of Locri and Sybaris. The vases produced in Metapontum and Siris can be compared to Euboean and Cycladic work. Two additional strong influences extended evenly to all colonies: Corinth, which for this entire period remained the unchallenged queen of Mediterranean trade, and the Ionian area, where the band-patterned pottery and the functional and easy-to-handle cups came from, reproduced in almost all the centers of Magna Graecia and Sicily.

At the beginning of the sixth century BC, the political contacts between the colonies and the homeland had increased so noticeably as to be visible in

Fig. 10. Kotyle fragments attributed to the Painter of Saturo. Italy, Taranto, ca. 600 BC. Ceramic. Museo Archeologico Nazionale di Taranto, 77063–66.

the area of trade. This is seen in the large numbers of vases imported from the mainland into the Western Greek colonies. These waves of imported vases were of all types, designed for a variety of functions: meals, personal care, banquets, and religious and funerary ritual. They were made in several centers, including Corinth, Athens, Sparta, Rhodes, Samos, Chios, the Cyclades, Phocaea, and Miletus. The increase in imported vases was very likely responsible for the noticeable decrease in figured-vase production in both Magna Graecia and Sicily. Not only is there no trace of the variety and diversity of products that characterized the previous century, but by comparison only a few specific categories of vases are found, produced primarily to fill the needs of sacred ritual or ceremony.

Many Corinthian vases were exported to Taranto for use in funerary ritual. Most likely, these vases were accompanied by one or more artisans from the city in the Peloponnesus to the Laconian colony, resulting in the establishment of one or more ceramic workshops that imitated Corinthian models and often produced vases of high quality. Such is the case of the Painter of Saturo, thought to be the artist responsible for a fragmentary kotyle depicting a lively scene of a boar hunt, probably the Calydonian boar (fig. 10).[13]

Some small vases recovered in Taranto, obviously not made locally, could be attributed tentatively to workshops in Metapontum.[14] A series of small

Fig. 11. Perirrhanterion with plastic flowers and painted zoomorphic friezes. Italy, San Biagio, 600–575 BC. Ceramic. Museo Archeologico Nazionale di Metaponto, 29961.

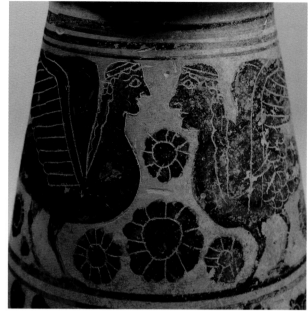

perirrhanteria of the first decades of the sixth century BC,[15] with plastic and figural decoration, are instead associated with the ceremonies of the sanctuary of San Biagio della Venella. Basins for lustral water were used to attain *agneia,* the temporary purity that allowed one to participate in certain cult practices and rites (probably fertility) in honor of the goddess to which that sanctuary was dedicated. Imitating Corinthian models, they are painted with typical zoomorphic friezes and small filling motifs that cover the entire surface as in an embroidered fabric (fig. 11).

During the first half of the sixth century BC, the large quantity of Corinthian vases exported to Sicily gave rise to local imitations of Corinthian ornamental schemes and decorative styles. These were applied, however, to forms

Fig. 12. Part of a stamnos with zoomorphic decoration. Sicily, 575–550 BC. Ceramic. Christie's catalogue, New York, 2000.

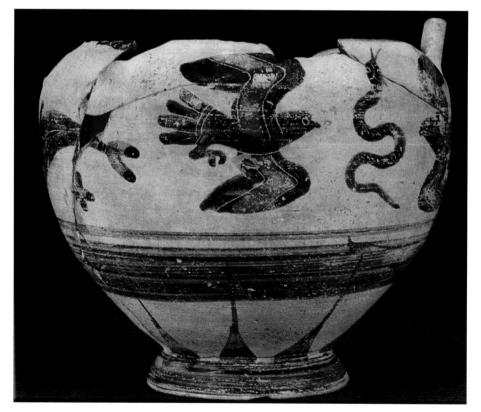

Fig. 13. Ovoid neck-amphora with galloping horsemen and running warriors. Italy, Taranto, ca. 550 BC. Ceramic. Museo Archeologico Nazionale di Taranto (ex Guarini Collection, no. 66).

more common to the island, like the stamnos in fig. 12 or a well-known phormiskos (a rattling vase) from Morgantina, with a figure of the Hydra of Lerna.[16]

The mosaic picture we have of Greek vase production in South Italy and Sicily is still incomplete. Only occasionally do some centers stand out clearly, like Sybaris, whose identified products appear to be strictly dependent on Ionian traditions, in agreement with the ancient sources that link the city to the Eastern Greeks of Miletus. In addition, we have only sketchy documentation for vase production in Siris and Posidonia. Vases from both colonies show affinities with Attic, Corinthian, and Ionian workshop traditions.[17]

Around the mid sixth century BC, the growing prosperity of the Western Greek poleis and the dominant political power of Athens resulted in a new impulse of artistic production of ceramic vases with figural decoration. Imported black-figure Attic vases initiated a radical change of direction in the Western workshops' productive output, almost exclusively toward the style perfected in the Athenian kerameikos. The ovoid neck-amphora once in the Guarini Collection in Pulsano was likely made in Taranto before the mid sixth century BC (fig. 13). It is decorated on one side with hoplite duels and on the other with the peculiar repetition of a scene showing a young nude

man mounting a galloping horse. Running at his side is an enormous warrior dressed in hoplite armor—possibly Achilles pursuing the prince Troilus, last son of Priam.[18]

Attic inspiration, together with a rare but detectable influence of Ionian style, becomes more evident in the ovoid neck-amphorae produced in Taranto between 560 and 520 BC. They have mostly black bodies and figural decoration on the neck, in which the choice of subject is clearly imitative. The neck-amphora in fig. 14 depicts a bird-hunting scene featuring a bird of prey. A hunter crouched behind a bush and accompanied by a bearded figure calls with a modulated whistle to the birds, probably larks, that are flocking to a tree, while a menacing owl perches nearby.[19] Another neck-amphora, though of the same shape and with a similar decorative scheme, was painted by a different hand (fig. 15). It shows a hoplite leaving for battle and saying good-bye to a child, probably his son, while on the opposite side a quadriga, whose horses are held back by the auriga, awaits him.[20]

The neck-amphora in Kiel with rams' heads on its neck may be attributed to the same Taranto workshop, judging by the similarity in shape, decorative syntax, and other technical characteristics (fig. 16). One side of the amphora features the earliest representation of the flight of Icarus and Daedalus, the latter shown with a saw and hammer, symbols of his technical ability and creative genius. On the other side is the earliest representation of Helle, daughter of Athamas, king of Thebes, shown in flight on the magic ram in an effort to escape the homicidal intentions of her stepmother. She fell from the ram to her death in the sea named for her, the Hellespont (the present-day

Fig. 14. Neck-amphora depicting a lark hunt. Italy, Taranto, ca. 530 BC. Ceramic. Museo Archeologico Nazionale di Taranto, 114326.

Fig. 15. Neck-amphora depicting a departing warrior (right) and the quadriga that awaits him. Italy, Taranto, 520–510 BC. Ceramic. Museo Archeologico Nazionale di Taranto, 52162.

Fig. 16. Neck-amphora showing Daedalus and Icarus (left), and Helle on a ram along with a panther. Italy, Taranto, ca. 530 BC. Ceramic. Kunsthalle, Kiel, B 700.

Marmara Sea). It was a tragic end, perhaps heralded by the nearby panther.[21] To a similar cultural context should be assigned the unique neck-amphora in the Museum of Agrigento, ex-Giudice Collection, showing a quadriga repeated with slight variations on both sides (fig. 17).[22]

The largest and most homogeneous production of vases by the Western Greeks was certainly the category conventionally designated "Chalcidian" pottery, which spans the entire second half of the sixth century BC and was produced in workshops very likely located in the Euboean colony of Rhegium, the present-day Reggio Calabria. The tremendous number and large variety of vases seasonally penetrating Western markets from Greece certainly must have passed, at least in its majority, through the strait between Rhegium and Messina. These vases were processed and temporarily stocked in their harbors in preparation for redistribution.

In this lively commercial climate, a prominent anonymous artisan, the Painter of the Inscriptions (or of the Inscribed Amphoras), capitalized on the various cultural influences fermenting in the region. He became the founder of a restricted number of workshops that produced a sizable and important group of vases of extremely high technical and aesthetic quality. At an early date these workshops exported in huge numbers not only to the Etruscan, South Italian, and Sicilian markets, but also to the Hispanic and Celtic markets. One might almost say that "Chalcidian" vases, so defined by the Euboean alphabet of their inscriptions, in which elements derived more from Chalcis than from Eretria prevail, were created expressly to exploit the substantial commercial trade that passed through Rhegium on its way to the

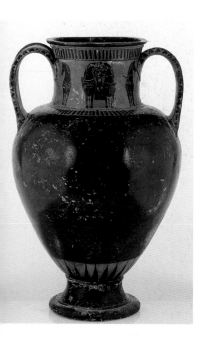

Fig. 17. Neck-amphora with quadriga (detail at right). South Italy or Sicily, ca. 530 BC. Ceramic. Museo Archeologico Regionale di Agrigento, R 140 (ex-Giudice Collection).

western Mediterranean. The workshops entrusted their products' success to the good quality of the vases, their marked coloration, and a decorative repertoire rich in rare and refined themes, executed with a peculiar, eclectic, and highly ornamental style by painters who were deeply knowledgeable of epic traditions. An outstanding example of this painter's work is the extraordinary neck-amphora in the J. Paul Getty Museum, with the earliest depiction of the legend of Rhesos, narrated in book 10 of the *Iliad* (fig. 18). The

Fig. 18. "Chalcidian" neck-amphora by the Painter of the Inscriptions. (From left) Odysseus slitting the throat of a Thracian hero; the frightened horses; the sleeping contingent; Diomedes killing the king, Rhesos. Italy, Rhegium, ca. 540 BC. Ceramic. J. Paul Getty Museum, Malibu, L.88.AE.56.

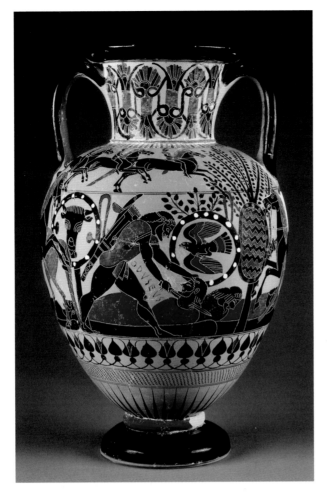

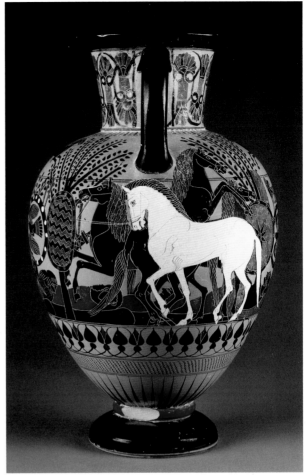

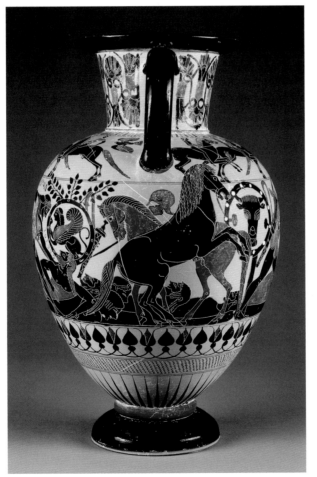

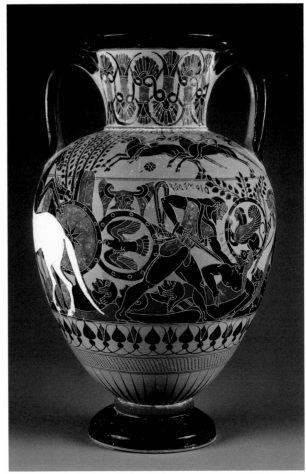

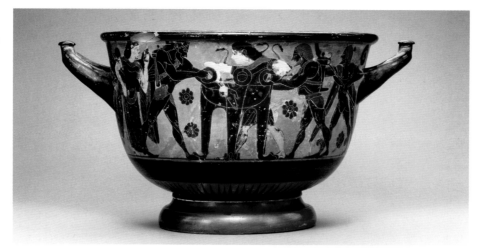

Thracian hero, allied with the Trojans and camped with his people outside the walls of Troy, is attacked while sleeping by Odysseus and Diomedes, who slaughter the entire contingent. The crime is committed in the silence of the night, while the horses, which Homer describes as "white as snow and as fast as the wind," stamp the ground and rear up.[23]

The production of the Inscriptions Painter influenced the artists who were his pupils, such as the anonymous painter whose only retrieved work is the skyphos formerly in the Santangelo Collection and now in Naples (fig. 19), depicting a unique struggle between Apollo and Herakles over the Delphic tripod. Standing in the center of the scene is a goddess surrounded by serpents, possibly either Athena protecting Herakles (her favorite hero), or Eris, or then again one of the Erinyes, embodiments of the spirits of discord. The

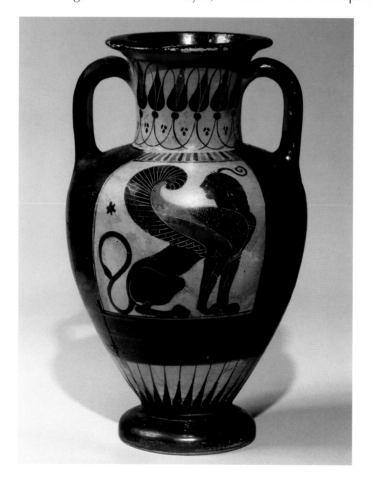

scene on the back portrays the duel between Achilles and Memnon, the Ethiopian king, on the battlefield of Troy in the presence of their mothers, Thetis and Eos. This is one of the themes dearest to the art of the Western Greeks.[24]

The last painter of the "Chalcidian" group, the Phineus Painter—a refined and elegant mannerist who authored many known works—executes simple but well-balanced and extremely accurate compositions. A fine example is his small neck-amphora now in Tampa, which shows a superb sphinx that looks back over its shoulder, possibly toward the young, nude horseman depicted on the other side (fig. 20).[25]

Around 500 BC the "Chalcidian" production ended for various reasons, including a changed political climate in the area of the Strait of Messina and the changing balance of power that once enabled the trade of artisan products from Rhegium. Another important factor was the change of taste induced by the spread of Attic red-figure vases. However, "Chalcidian" pottery production had spread extensively throughout not only Magna Graecia but also Sicily. It left strong and long-lasting traces in vase production from different areas of South Italy, an example being a well-known amphora of special shape found in Taranto, depicting on one side a centaur fighting against Kyknos and on the other two facing sphinxes (fig. 21). Initially attributed to a Greek-Oriental production and more recently interpreted as Western Greek but under a strong Ionic influence, the sphinxes clearly reveal an inspiration deriving from "Chalcidian" pottery.[26]

By contrast, in other centers the black-figure Attic vases imported for decades in more than considerable numbers dominated the formal language of

Fig. 21. Amphora with sphinxes. Italy, Taranto, ca. 530 BC. Ceramic. Museo Archeologico Nazionale di Taranto, 52158.

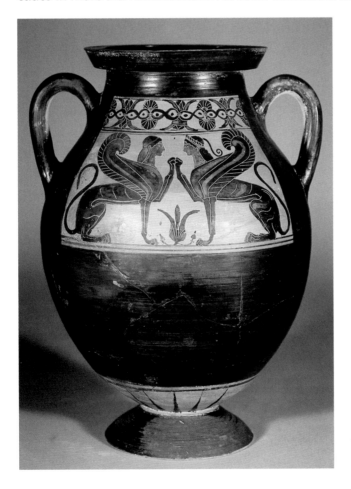

Fig. 22. Fragment of a cup-skyphos with a Dionysiac scene. Italy, Metapontum, 525–500 BC. Ceramic. Museo Archeologico Nazionale di Metaponto.

local production, and for the most part adapted to the stylistic innovations introduced by the Attic red-figure vases. An example of this is the fragment of a cup-skyphos from the urban sanctuary of Metapontum (fig. 22), dated to the end of the sixth century BC. Another is the unique kalathos found in a tomb of the first decades of the following century. Both vases have Dionysiac scenes dominated by a wine-filled vessel.[27]

The Attic style definitely exerted a stronger influence on various other painted vases produced between the late sixth century and the beginning of the fifth century BC. The most important group of such vases was undoubtedly a series of small neck-amphorae that J. D. Beazley grouped in the Hyblaea class, probably of western Mediterranean origin, possibly Sicily. A good example from this group is in the Tampa Museum of Art, showing Herakles freeing Deianira from the violent attentions of the centaur Nessos (fig. 23).[28] The class of Etruscan-Campanian vases and that of the column-kraters produced in Apulia (fig. 24) are also in the Attic style, even if very simplified and adapted to the taste of the Italic populations. These vases were created in environments that were not fully Greek but strongly hellenized.[29] Decades later, the great legacy of South Italian black-figure vase production would bear fruit, from Campania to Sicily, in the form of the small lekythoi like the Pagenstecher type, employed for specific ritual uses.[30]

The long, lively, and eclectic history of the black-figure vases produced by the Western Greeks was born of a cultural and commercial phenomenon associated, for the most part, with the pottery's contents, functions, and uses. In addition, the often symbolic meanings of the iconographies they represented formed the technical, stylistic, and conceptual background for the production of that other great class of South Italian vases: namely, the red-figure vases of the late fifth and fourth centuries BC. In these vases the Western Greeks will reach new expressions of form and content.

Fig. 23. Neck-amphora of the Hyblaea class, showing Herakles attacking Nessos. Sicily?, ca. 520 BC. Ceramic. Tampa Museum of Art, 1986.125.

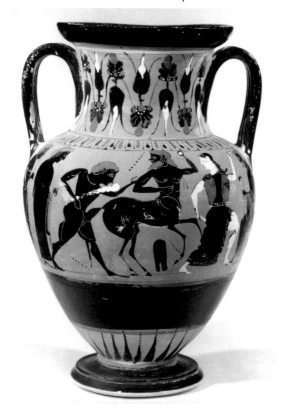

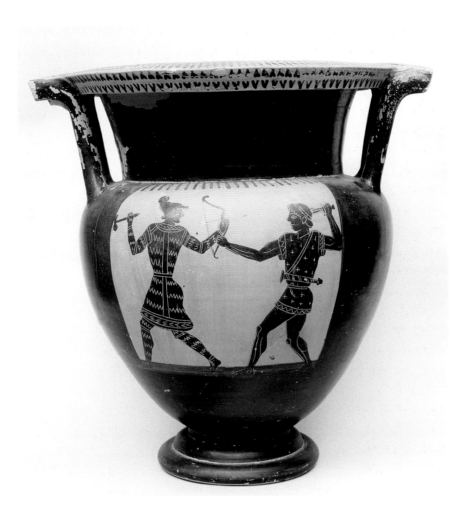

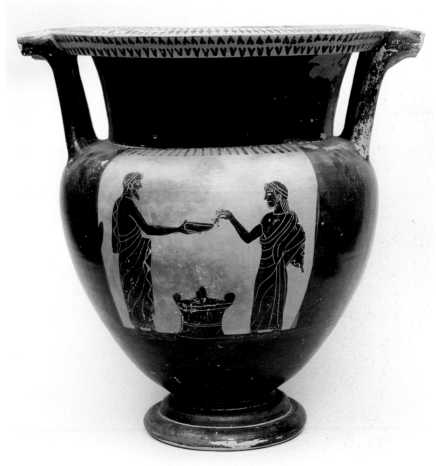

Fig. 24. Column-krater, showing an Amazonomachy (top) and a scene of sacrifice (bottom). Italy, Apulia, Rutigliano, ca. 490 BC. Ceramic. Museo Archeologico Nazionale di Taranto, 170202.

1. Thucydides, *History of the Peloponnesian War* 1.21; G. Pugliese Carratelli, "Storia civile," in G. Pugliese Carratelli et al., *Megale Hellas: Storia e civiltà della Magna Grecia* (Milan, 1983), 11–13.

On black-figure vase production from Magna Graecia and Siciliy, see the following recent essays, with references to previous bibliographies: P. Orlandini, "Le arti figurative," in Pugliese Carratelli, *Megale Hellas*, 331–554; G. Rizza and E. de Miro, "Le arti figurative dalle origini al V secolo a.C.," in G. Pugliese Carratelli et al., *Sikanie: Storia e civiltà della Sicilia greca* (Milan, 1985), 125–242; the following essays in E. Lippolis, ed., *I Greci in Occidenti: Arte e Artigianato in Magna Grecia*, exh. cat., Convento di San Domenico, Taranto (Naples, 1996): G. A. Maruggi, "Le produzioni ceramiche arcaiche," 247–67; G. Semeraro, "Ceramica geometrica ed orientalizzante," 269–79; C. W. Neeft, "Ceramica di imitazione cornizia," 281–91; A. Alessio, "Ceramica di imitazione corinzia dal santuario di Saturo," 293–97; A. M. Esposito, "Ceramica arcaica figurata," 307–12; M. Iozzo, "Ceramica 'calcidese,'" 313–21. See also P. Orlandini, "L'arte in Magna Grecia e in Sicilia: Aspetti e problemi," in *Les Grecs et l'Occident: Actes du Coloque de la Villa "Kérylos" (1991)* (Rome, 1995), 137–39; C. L. Lyons, *Morgantina Studies V: The Archaic Cemeteries* (Princeton, 1996); M. Schmidt, "Southern Italian and Sicilian Vases," in G. Pugliese Carratelli, ed., *The Western Greeks*, exh. cat., Palazzo Grassi, Venice (Milan, 1996), 444–45; A. Rouvert, "Tradizioni pittoriche magno-greche," in G. Pugliese Carratelli, ed., *Magna Grecia: Arte e artigianato* (Milan, 1990), 317–26; E. M. De Juliis, *Mille anni di ceramica in Puglia* (Bari, 1997); and B. d'Agostino, "Il leone sogna la preda," *Annali dell'Istituto Orientale di Napoli*, n.s. 6 (1999), 25–33.

2. F. Jacoby, *Fragmente der griechischen Historiker, IIIb, Kommentar, Text* (Leiden, 1955), 479ff.

3. Orlandini, "Le arti figurative," 332, figs. 279, 280; P. Pomey, "Navigazione e navi all'epoca della colonizzazione greca," 135, and C. Gualanella, "Late Geometric Krater," 662, no. 5, in

Pugliese Carratelli, *Western Greeks.*

4. R. Arena, "The Greek Colonization of the West: Dialects," 191, 193, 666, no. 22, and C. Gualanella, "Fragments of Late Geometric Krater," 666, no. 22, in Pugliese Carratelli, *Western Greeks.*

5. P. Orlandini, "Due nuovi vasi figurati di stile orientalizzante dagli scavi dell'Incoronata di Metaponto," *Bollettino d'Arte* 49 (1988), 6–16; A. De Siena, "Figured Dinos with Bellerophon," in Pugliese Carratelli, *Western Greeks*, 666, no. 26.

6. Orlandini, "Due nuovi vasi figurati di stile orientalizzante," 1–6.

7. B. Schweitzer, "Zum Krater des Aristonothos," *Sonderdruck aus Mitteilungen des Deutschen Archäologischen Instituts Römische Abteilung* 62 (1955), 78–106; M. Martelli, "Prima di Aristonothos," *Prospettiva* 33 (1984), 2ff.; G. L'Arab, "Cratere di Aristonothos," in Pugliese Carratelli, *Western Greeks*, 662, no. 6; L. Minarini, "Krater of Aristonothos," in *Principi etruschi tra Mediterraneo ed Europa*, exh. cat., Museo Civico Archeologico, Bologna (Venice, 2000), 230, no. 255.

8. Rizza and de Miro, "Le arti figurative," 141–42, figs. 113–14.

9. P. Blome, "Theseus und Herakles auf einem polychromen Stamnos aus Sizilien," *Antike Kunst* 34 (1991), 156–68; P. Pelagatti, "Sulla dispersione del patrimonio archeologico: le ragioni di un secondo incontro e il caso Sicilia," *Bollettino d'Arte Supplemento* 101–2 (1997), 14–16, figs. 6–8.

10. Rizza and De Miro, "Le arti figurative," 151–52, fig. 129.

11. Ibid., 154, fig. 136; R. Oliveri, in R. Panvini, ed., *Gela: Il Museo Archeologico, Catalogo* (Gela, 1998), 358; E. C. Portale, "Stamnos," in Pugliese Carratelli, *Western Greeks*, 666, no. 24.

12. G. Caputo, "Il triskele arcaico di Bitalemi di Gela e di Castellazzo di Palma," *RendLincei* 26 (1971), 3ff.; G. Castellana, "Figured Dinos," in Pugliese Carratelli, *Western Greeks*, 666, no. 25; P. Griffo, *Il Museo Archeologico Regionale di Agrigento* (Palermo, 2000), 39–40, fig. 23.

13. Neeft, "Ceramica di imitazione cornizia," 284–85, Painter of Saturo no. 4 (color pl., p. 252).

14. Ibid., 284, 291, nos. 269–70.

15. D. Ugolini, "Tra Perirrhanteria, Louteria e Thymiateria," *Mélanges de l'école française de Rome, Antiquité* 95 (1983), 449ff.; Orlandini, "Le arti figurative," 356, fig. 328; Maruggi, "Le produzioni ceramiche arcaiche," 251, 255; M. L. Viola, "Perirrhanterion with Black Figures," in Pugliese Carratelli, *Western Greeks*, 690, no. 133.

16. For another figured phormiskos produced in Metapontum, see J. Neils, "The Morgantina Phormikos," *American Journal of Archaeology* 96 (1992), 225–35; figs. 10–11.

17. For an overview, see Esposito, "Ceramica arcaica figurata," 307–8.

18. L. Todisco, "Ceramica attica a figure nere: Anfora," in *Antichità della Collezione Guarini* (Galatina, 1984), 39, no. 1, pl. 29.

19. The attribution, made by D. von Bothmer, is quoted by K. Schauenburg, "Zu griechischen Mythen in der etruskischen Kunst," *Jahrbuch des Deutschen Archäologischen Instituts* 85 (1970), 57, n. 117; L. Masiello, "Taranto, Rione Italia, tra le vie Umbria e Calabria: Tomba 66; 9.VI.1959," in A. D'Amicis et al., *Atleti e guerrieri: Tradizioni aristocratiche a Taranto tra VI e V sec. a.C.*, vol. 1, part 3 of *Catalogo del Museo Nazionale Archeologica di Taranto* (Taranto, 1994), 197–98, no. 30.1. For the Attic "model," see the neck-amphora attributed to the Bucci Painter currently in the Shelby White and Leon Levy collection: D. von Bothmer, *Glories of the Past: Ancient Art from the Collection of Shelby White and Leon Levy Collection* (New York, 1990), 139–40, no. 106. A skyphos with a Gorgon mask also is attributed to Taranto; see B. Freyer-Schauenburg, "Ein Gorgoneion-Skyphos aus Tarent," *Archäologischer Anzeiger* 86 (1971), 538–42.

20. G. Giboni, "Taranto, contraa Carceri Vecchie, prop. Acclavio, fra via Duca degli Abruzzi e via Duca di Genova: Tomba; 3.XII.1936," in D'Amicis, *Atleti e guerrieri*, 253–54, no. 60.1; K. Schauenburg, "Parisurteil und

Nessosabenteuer auf attischen vasen hocharchaischer Zeit," *Aachener Kunstblätter* 44 (1973), 42, no. 90 (same workshop of the neck-amphora with fowling scene).

21. K. Schauenburg, "Zwei seltene mythologische Bilder auf einer Amphora in Privat-besitz," in G. Schwartz and E. Pochmarski, ed., *Classica et Provincialia: Festschrift E. Dietz* (Graz, 1978), 169ff.; M. Prange, in *Corpus Vasorum Antiquorum: Germany, Kiel,* fasc. 1 (Munich, 1993), 82, pl. 52; Esposito, "Ceramica arcaica figurata," 309; E. Simon, "Early Images of Daidalos in Flight," in J. B. Carter and S. P. Morris, *ed., The Ages of Homer: A Tribute to Emily Townsend Vermeule* (Austin, 1995), 409, fig. 24.2.

22. Already attributed by Schauenburg, "Zwei seltene mythologische Bilder auf einer Amphora," 170, pl. 60.3; believed to be Attic by A. Calderone, *Corpus Vasorum Antiquorum: Italy, Agrigento,* fasc. 1 (Rome, 1985), 11–12, pl. 17, and by Griffo, *Il Museo Archeologico Regionale di Agrigento,* 48–49, fig. 33.

23. M. True, "The Murder of Rhesos on a Chalcidian Neck-Amphora by the Inscription Painter," in *Ages of Homer,* 415ff.

24. Recently, see C. Calabria, "Le fatiche di Eracle nella ceramica 'calcidese,'" *Rendiconti dell'Accademia di Archeologia, Lettere e Belle Arti di Napoli* 69 (2000), 65–71, fig. 10.

25. S. P. Murray, *The J. Veach Noble Collection* (Tampa, 1986), 18, no. 14; M. Iozzo, *Ceramica "calcidese": Nuovi documenti e problemi riproposti,* in *Atti e Memorie della Società Magna Grecia* 2, ser. 3 (1993) (Rome, 1994), 67, 80.

26. E. Lippolis, "Taranto, tra le vie Dante e T. Minniti: Tomba 1; 28.VIII.1951," in D'Amicis, *Atleti e guerrieri,* 257–59, no. 63.1; Esposito, "Ceramica arcaica figurata," 312, no. 302.2. Also problematic and very close to Magno-Greek products is the amphora at the San Antonio Museum of Art, 86.134.39; see H. A. Shapiro, "Italic Black-figure Amphora," in Shapiro et al., *Greek Vases in the San Antonio Museum of Art* (San Antonio, 1995), 61–62, no. 21, because doubt still exists that it might be of Etruscan production.

27. De Siena, "Black-Figure Kalathos," in Pugliese Carratelli, *Western Greeks,* 645–46, no. 135; the kalathos was found in tomb 260 in the necropolis of Crucinia, laid in accordance to a unique ritual—that is, half inside and half outside the burial.

28. D. von Bothmer, "Review of *Der Affecter* by Heide Mommsen," *American Journal of Archaeology* 80 (1976), 435; the Tampa specimen is in Murray, *J. Veach Noble Collection,* 48, no. 99; recently F. Dìez de Velasco, under "Nessos," in *Lexicon Iconographicum Mythologiae Classicae* (Zurich/Munich, 1992), 6: 841, no. 55, (corresponding to J. D. Beazley, *Paralipomena* [Oxford, 1971], 108, 4). Probably not of Siciliote or Magno-Greek production is the problematic amphora in the Palermo museum (Schauenburg, "Parisurteil und Nessosabenteuer," 17–18, figs. 7–8), which could possibly be related to Euboean workshops.

29. F. D'Andria, "Messapi e Peuceti," in G. Pugliese Carratelli, ed., *Italia omnium terrarum alumna* (Milan, 1988), 668; A. Ciancio, "Un gruppo di vasi apuli a figure nere del secolo V a.C.," *Bollettino d'Arte* 93–94 (1995), 71–86.

30. R. Hurschman, "Die Pagenstecher-Lekythen," *Jahrbuch des Deutschen Archäologischen Instituts* 103 (1988), 39–66.

Sculptural Styles of Magna Graecia

CARLOS A. PICÓN

For Brunilde Sismondo Ridgway on her 73rd birthday (14 November 2002), with deep affection and gratitude.

Any discussion of Archaic and Classical sculpture in Magna Graecia must consider the raw materials available in these regions. The lack of suitable supplies of white marble meant that limestone and sandstone, readily accessible in large quantities throughout South Italy and Sicily, were the materials for most of the pieces we know today; at the same time, the abundance of fine clay encouraged a particularly strong tradition of terracotta sculpture.[1] Marble, then, did not play a leading role in the sculptural or architectural tradition of Magna Graecia. There are no marble temples in South Italy or Sicily from this time, and the freestanding marble sculptures that survive are few—in contrast to the rest of the Greek world. On the other hand, we must remember that many of the Western sites—from the Campanian settlements in the north to Taranto and Syracuse farther south—have experienced continuous occupation since Classical times. The opposite happened in places like Miletos and Didyma in western Asia Minor or the sanctuary of Hera on the island of Samos, which were virtually abandoned in late antiquity and in modern times have yielded such quantities of Archaic sculpture.[2] Given all these considerations, it is remarkable that any amount of marble sculpture has come down to us from the West, and that significant additions continue to be unearthed to this day.

Following the establishment of the first Greek colonies in the West from around the middle of the eighth century BC onward, the earliest sculptural remains are works in the so-called Daedalic style of the seventh century BC. This modern term refers to the legendary Cretan sculptor Daedalus, but works of art in the Daedalic style are attested in every part of the Greek world.[3] They also come in every medium: marble, limestone, bronze, terracotta, wood, precious metals (especially gold jewelry), and even bone; witness the little plaque from Megara Hyblaea carved with a frontal draped woman, one of the earliest objects included in this exhibition [46]. Even more elaborately attired than the figure in Syracuse is a fragmentary terracotta female figure in Naples (fig. 1). She wears a skirt embellished with three rows of figured scenes, including one of Ajax carrying the body of Achilles. The decoration of the marble oil lamp from a sanctuary near Selinus [1] repeats the most distinctive stylistic traits of these Daedalic renditions. Characteristic are the heads with a relatively flat top and low forehead, and triangular faces flanked by locks of hair rendered as inverse triangles.

Fig. 1. Fragmentary terracotta female figure. Italy, findspot unknown, ca. 650 BC. Museo Archeologico Nazionale, Naples, Santangelo Collection, inv. CS 106.

One would think that the lamp in Palermo, made of Cycladic Greek marble, was imported into Sicily in antiquity. The lamp belongs to a type thought to have originated in the Cyclades and to have been widely exported throughout the Mediterranean.[4] In the case of many other marble finds from Magna Graecia, however, it is truly difficult to tell whether the sculptures are local products or imports from the marble-rich motherland. This question has occupied specialists of Greek sculpture for many years, but perhaps it should not be considered an issue of paramount importance.[5] Many art historical surveys start with the premise that sculpture from Western Greece is initially (if not essentially) provincial or backward, and that it lags behind or is overly dependent on the artistic traditions of the mother country. The relative scarcity of ancient literary sources relating to the sculptors of South Italy and Sicily encourages this point of view.[6] As Boardman has recently remarked, "We have more names of homeland sculptors working in the west than of home-born western sculptors."[7] One could argue, however, that this paucity tells us more about the nature (or bias) of the surviving ancient sources than it does about the overall achievements of Western artists. We should not judge Magna Graecian art only by mainland standards, nor should we expect stylistic developments to be concurrent throughout the Greek world. There is little that seems parochial about the Youth of Agrigento

[72] when compared, for instance, to the bulk of the mainland kouroi unearthed at the Boiotian Sanctuary of Ptoan Apollo in mainland Greece.[8]

The bulk of the extant, large-scale sculpture in stone from Magna Graecia is architectural. While not the primary focus of the present exhibition, the architectural material has received ample coverage in the standard art historical surveys.[9] The favored architectural decoration in the West is metopal, rather than pedimental. There are substantial sculptural remains from Selinus (three major Archaic groups of metopes and the early Classical reliefs of the so-called temple E), as well as from a series of small buildings in a sanctuary of the Archaic period located north of Paestum.[10] Dedicated to Hera, the sanctuary lies near the mouth of the river Sele. These sandstone reliefs from Foce del Sele [2], numbering approximately seventy metopes, offer a wealth of mythological scenes treated in a naive, vigorous style that betrays close links to the period's colorful terracotta production. Several of the reliefs look like flat cutouts, their details not articulated in stone but most likely originally rendered in paint. The majority of the sculptures have been assigned to two buildings referred to in the literature as Treasury I and II.[11]

Two technical peculiarities among the various metopal groups from Selinus deserve mention here. The extant metopes attributed to the late Archaic temple F are made of two blocks joined horizontally at the middle, an unusual practice that betrays direct Eastern Greek influence.[12] The metopes from temple E (fig. 2), on the other hand, introduce us to the akrolithic technique in Greek sculpture, evident also in the head in Paestum discussed in this catalogue [5].[13] Literally, the term means that the extremities of a sculp-

Fig. 2. Metope showing Zeus and Hera. Sicily, Selinus, temple E, ca. 470–460 BC. Limestone, marble. Museo Archeologico Regionale "A. Salinas" di Palermo, inv. 3921B.

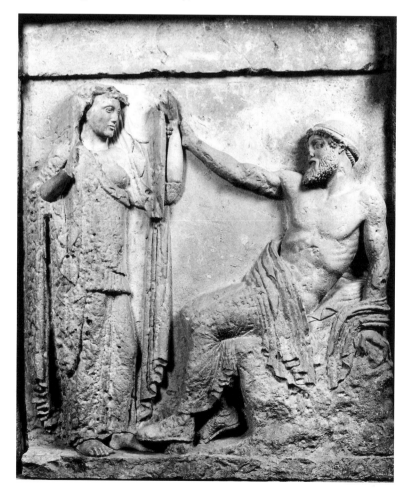

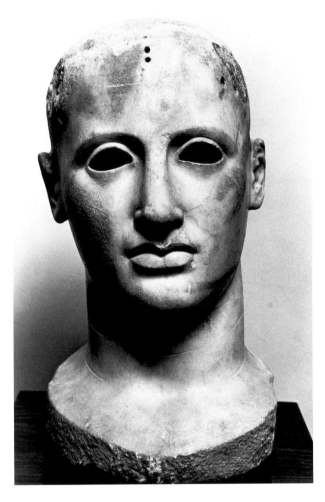

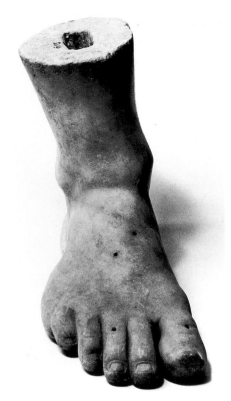

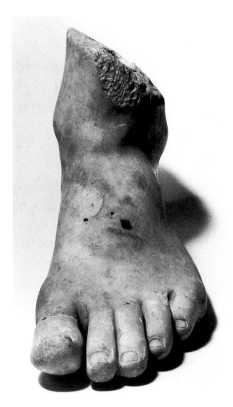

Figs. 3a–c. Akrolithic statue of Apollo. Italy, Cirò, ca. 450–400 BC. Marble. Museo Archeologico Nazionale di Reggio Calabria.

ture are of stone, and the rest of another material such as wood or metal. In the case of the limestone metopes from temple E, only the exposed flesh parts of the women (but not the men) are carved in white marble. Akrolithic sculpture was not restricted to the West, but the practice was popular there, obviously because good marble was scarce. Among the better known Western akroliths are the marble remains of a Classical statue of Apollo (head, feet, and part of a hand) from the temple of Apollo Alaios at Krimisa (Cirò) in southern Italy (figs. 3a–c). Apollo's hair was surely rendered in metal, but the fragmentary bronze wig (figs. 3d–e) recovered in the vicinity does not fit his head and must have belonged to a second akrolith.[14]

Figs. 3d–e. Fragmentary bronze wig. Italy, Cirò, ca. 450–400 BC. Bronze. Museo Archeologico Nazionale di Reggio Calabria.

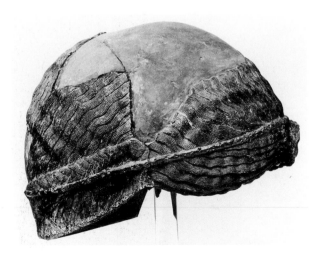

Among the terracotta sculptures in this exhibition, the head of a young woman from Agrigento [68], with its delicate, pointed features and unarticulated eyes, exemplifies the presence of Ionic traits in the art of Archaic Magna Graecia.

The evidence of both sculpture and architecture clearly points to direct artistic connections between East Greece (that is, the Ionian coast of Asia Minor and the Aegean Islands) and the West.[15] Syracuse can claim a fully Ionic temple,[16] and numerous other manifestations of Ionic forms and hybrids are attested, such as an unusual Doric capital with Ionic volutes from Selinus.[17] As for sculpture, one need look no further than the draped marble figure from Syracuse[18] or the nude kouros from Megara Hyblaea dedicated to the doctor Sombrotidas (fig. 4).[19] The kouros bears an inscription along the figure's right thigh, which is an Eastern Greek fashion, distinct from the mainland practice of carving the inscription on the statue's base. Were these sculptures imported (unfinished?)[20] from East Greece, or did Eastern artists

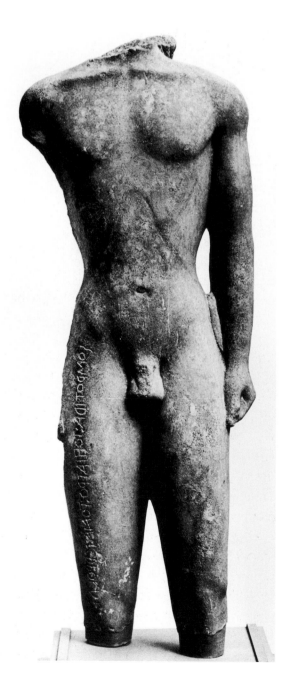

Fig. 4. Kouros dedicated to the doctor Sombrotidas. Sicily, Megara Hyblaea, ca. 550–540 BC. Marble. Museo Archeologico Regionale "Paolo Orsi" di Siracusa, inv. 49401.

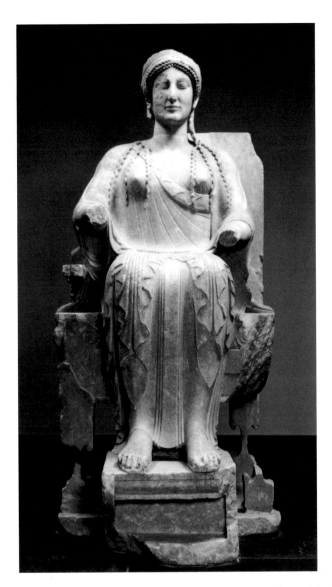

settle in the West? Both possibilities are equally likely. Be that as it may, one should note here that kouroi (and korai) in general are rare in Magna Graecia, as are carved grave reliefs, in both the Archaic and the Classical periods.[21]

Another sculpture displaying Ionic influence is the terracotta seated draped male found in a votive pit at Paestum [4]. The statue is surely the product of a local workshop, and, because they could easily be damaged in transit, so are the vast majority of monumental terracottas. This brightly painted statue, whether a votive figure or a small cult-image of a god (presumably Zeus), approaches the quiet grandeur of the famous Enthroned Goddess in Berlin (fig. 5).[22] The marble goddess, discovered in Taranto in 1913, is one of the most accomplished fifth-century BC sculptures from Magna Graecia, as are the famous nude warrior from Agrigento (perhaps a pedimental figure) (fig. 6),[23] which is purely Severe in style, and the striking Charioteer from the Phoenician city of Motya in western Sicily.[24]

Somewhat earlier in date than the seated draped man from Paestum, the terracotta plaque from Syracuse depicting the Gorgon Medusa [50] likewise preserves much of its original polychromy. The numerous colorful clay revetments from the West, often of superb workmanship, constitute one of the most alluring groups of architectural decoration anywhere in the Greek

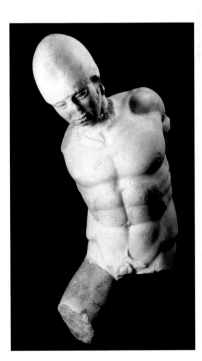

world, especially in the Archaic and early Classical periods.[25] They are a constant reminder of the ornate sense of color prevalent in Greek sculpture and architecture. The three terracotta altars excavated recently in Gela [56–58] stem from this brilliant coroplastic tradition. The one decorated with a kneeling Gorgon invites comparison with the revetment from Syracuse [50], which has been dated to about half a century earlier. Pride of place, however, goes to the altar featuring three frontal korai surmounted by a scene of animal combat. The late Archaic forms are soft and sensuous, yet the rendering is firm and the figures seem almost monumental; this is late Archaic terracotta sculpture at its best.

As is the case with painted pottery of the Archaic and Classical periods, small terracottas produced in great numbers are easier to group stylistically and to assign to individual regional schools than are most monumental works of art in any medium. Among the most distinctive and charming of these mass-produced terracottas are the so-called Locri reliefs [36–39], which offer a restricted repertoire of cultic scenes (many relating to Aphrodite and Persephone) in a crisp and calligraphic style.[26] They are for the most part Early Classical in date and have been found in other Western sanctuaries as well, where in theory they could also have been manufactured. Many additional regional studios producing quantities of mold-made terracottas are readily identifiable and have been the subject of scholarly surveys, among them Taranto, Metapontum, Medma, Rhegium, Syracuse, Gela, Selinus, and most recently Hipponion (modern Vibo Valentia) in Calabria.[27]

In sharp contrast to the terracotta production in Magna Graecia, the corpus of Archaic and Classical bronzes found in the West presents more challenging questions in terms of regional groupings and attributions. One can expect portable luxury items such as costly small bronzes and gold jewelry to travel farther afield from their place of manufacture than objects made of humbler materials. Whereas a provincial Classical bronze like the so-called Castelvetrano Youth[28] (after the place where it was formerly housed) from Selinus may be safely assigned to a Sicilian workshop, a masterful bronze like the late Archaic Zeus from Ugento south of Taranto is difficult to attribute (fig. 7).[29] Doubtless impressed by the superb style and technique of the Zeus, some scholars have assumed that the statue was an import from mainland Greece, yet other authorities have rightly stressed its affinities to the terracotta sculptural production from Taranto.[30] The bronze stands on a Doric stone capital decorated with rosettes that originally surmounted a column. For a Doric capital, this kind of ornamentation is more at home in the West or the East than in mainland Greece. In terms of quality, the fine bronze nude athlete from Adrano near Catania in Sicily [52] falls somewhere between the provincial Castelvetrano Youth and the exceptional Ugento Zeus; in fact, the Adrano statuette has been called quintessentially Western,[31] but quality alone is not an indication of origin.

Significant bronze sculptures and vessels must have been imported from mainland Greece throughout the Archaic and Classical periods, yet it is difficult to believe that local Western workshops were unable to manufacture first-rate statuary like the Ugento Zeus, which I take to be Tarantine work.

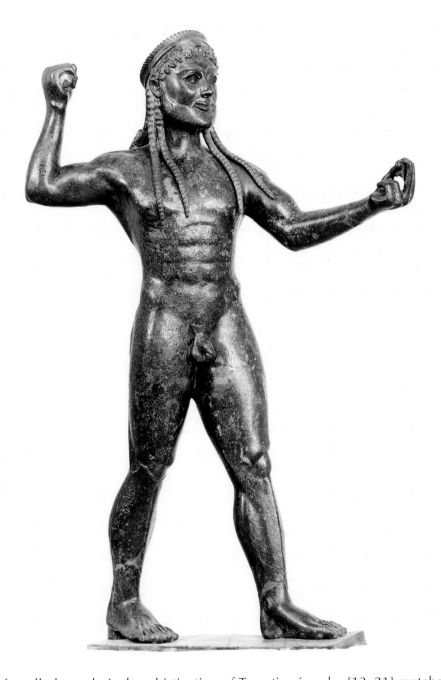

Fig. 7. Zeus. Italy, Ugento, ca. 500 BC. Bronze. Museo Archeologico Nazionale di Taranto, inv. 121327.

After all, the technical sophistication of Tarantine jewelry [13–21] matches the best bronze castings found in Magna Graecia. And a class of exquisite, late Archaic miniature head-pendants, both silver-gilt and gold, seem typically South Italian in terms of style and manufacture.[32] The recent finds of Archaic bronzes and jewelry from the sanctuary of Hera Lacinia at Capo Colonna south of Croton should receive mention here.[33] There is no reason to doubt that these votives were made in Western Greece, especially since this was a relatively modest place rather than an international sanctuary. The three most accomplished and attractive figured bronzes from Capo Colonna are a seated sphinx, a running Gorgon, and a siren.[34]

Colonial workshops also produced elaborate and costly bronze armor, not only for warriors but also for their horses. Among the most striking examples of horse armor are a pectoral in Naples decorated with a gorgoneion and a face guard featuring the head of a helmeted warrior.[35] The composition of a pair of face guards in Metapontum consists of a Potnia Theron holding two

large waterfowls.[36] This Orientalizing image is the so-called Mistress of the Animals, an ancient Near Eastern deity that became absorbed into Greek mythology.[37] The repoussé technique of these bronzes is quite delicate and accomplished. Note how the pectoral in Naples was further embellished with inlays (ivory or bone), some of which remain. Luxurious bone or ivory inlays occur only rarely in Archaic Greek bronzes; they also are found in early Etruscan metalwork, as are additions in amber.[38]

The Mistress of the Animals calls to mind the unusual iconography of an Archaic bronze mirror in New York said to come from Taranto (fig. 8).[39] A nude girl standing on a recumbent lion forms the mirror's support. The traditional Near Eastern motif of two animals flanking the figure of Potnia Theron has been transformed into a purely Greek subject—namely, a pair of symmetrical griffins rising from the girl's shoulders to help support the mirror disk. Called Spartan (after the mother city of Taranto), Corinthian, and South Italian by different authorities, this object reminds us how difficult it is to attribute such masterworks.[40] The same could be said of several bronzes from the Reggio Calabria Archaeological Museum in this exhibition, such as the mirror from Locri Epizephirii with a handle in the form of a siren [43] or the Classical mirror from Medma with a handle showing a satyr and a youth [44].

The excavation in 1954 of a small underground gabled building in the agora at Paestum, presumably intended as a shrine or a symbolic tomb, yielded one of the most significant and interesting groups of Archaic bronze

Fig. 8. Archaic mirror. Italy, said to be from Taranto, ca. 550–500 BC. Bronze. Metropolitan Museum of Art, New York, 38.11.3.

Fig. 9. Head of a Goddess. Italy, said to be from Taranto, ca. 350–300 BC. Marble. Metropolitan Museum of Art, New York, 10.142.1.

vases from Magna Graecia. Eight exceptionally well-preserved bronze vessels were recovered, including six hydriae of outstanding quality.[41] The one hydria included in this exhibition [3] stands apart from the rest for its cast vertical handle in the shape of a rearing lion, which has been compared to the lions at either side of the handles of the famous bronze volute-krater from a tomb at Vix (Côte-d'Or) in France.[42] The group of bronze vessels from Paestum has rightly been considered purely Western in terms of style and technique,[43] and it may well be that the Vix krater belongs here as the foremost bronze to have survived from this accomplished South Italian workshop.

There is no real shortage of important sculpture—in all media—from the later fifth century BC onward, but thereafter the production seems more homogeneous, its style more international, and the volume of the material decidedly less plentiful than in earlier years. To be sure, many museums in Italy and farther afield can point to Classical and early Hellenistic masterpieces from Magna Graecia among their holdings. Illustrated here is only one superb marble head said to come from Taranto and now in New York (fig. 9).[44] Well over life-size and worked for insertion in a draped statue, the head dates to the end of the fourth century BC and stylistically shows nothing particularly Western. In all likelihood, this is a cult-statue of a youthful goddess such as Persephone. An unusual technical detail is that the woman's hair knot at the top of the head (now missing) was carved separately and attached with dowels, for which three large drillings remain. The ears are pierced as well, to receive metal earrings.

The last truly regional school of stone sculpture in Magna Graecia that can be readily identified started at a time when regional trends in Greek sculpture had already begun to disappear. Tarantine sculptures, carved in a soft, fine-grained local *pietra tenera* (white limestone), constitute a distinctive group dating from the late fourth to the first half of the third century BC.[45] The bulk of the extant material can be assigned to relatively small funerary structures (*naiskoi,* or shrines) that were often lavishly embellished with architectural sculpture, including figured friezes, metopes, pediments, akroteria, and even caryatids. Most Tarantine reliefs are quite small in scale. The occasional carving, however, attests to more ambitious compositions, such as the well-known relief in New York preserving two mournful figures standing by an altar,[46] or an intriguing panel in Princeton showing an old priestess with a large temple key approaching two younger women seated at an altar (fig. 10).[47] The quality and style of these Tarantine reliefs tend to vary, but the best ones can match the mainstream sculptural developments in other regions of the Greek world, and some even anticipate baroque trends usually associated with later Hellenistic works. The nature of the soft limestone used for the sculpture and the architecture of these funerary monuments encouraged (if not dictated) the very sharp, precise style developed by the Tarantine ate-

Fig. 10. Relief showing three women at an altar. Italy, Taranto, third century BC. Limestone. The Art Museum, Princeton University, Princeton, New Jersey, y1983–34.

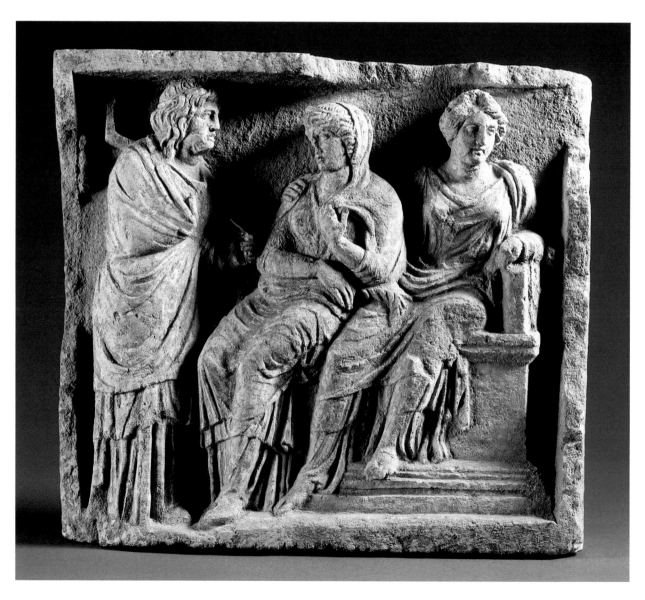

liers. Some of the naiskoi must have stood aboveground for only a relatively short period of time, judging from the crispness and unweathered surfaces of numerous extant fragments.

It seems appropriate to conclude this brief account of aspects of Magna Graecian sculpture with Taranto, for this truly local school continued the tradition of strength and vitality evident in the outstanding Western sculptures of earlier periods. The present exhibition makes clear that sculpture in South Italy and Sicily reached a pinnacle in the late Archaic and early Classical periods. This remarkable gathering from Italian museums is also a testimony to the diversity of ancient Greek art and the enthusiasm and cleverness with which the artists from each region of the Greek world manifested their creativity.

NOTES

1. On this topic, see B. Ashmole, "Late Archaic and Early Classical Greek Sculpture in Sicily and South Italy," reprinted from *Proceedings of the British Academy* 20 (1934), 5–6; E. Langlotz and M. Hirmer, *The Art of Magna Graecia: Greek Art in South Italy and Sicily* (London, 1965), 38, 40, 42, 58.

2. For Miletos and the sanctuary of Apollo at Didyma, see K. F. Tuchelt, *Die archaischen Skulpturen von Didyma* (Berlin, 1970); J. G. Pedley, *Greek Sculpture of the Archaic Period: The Island Workshops* (Mainz, 1976), 57–59, pls. 40–47; K. Tuchelt, *Revue Archéologique* (1976), 55, with reference to new finds. For Samos see B. Freyer-Schauenburg, *Samos XI: Bildwerke der archaischen Zeit und des strengen Stils* (Bonn, 1974); H. Kyrieleis, "Eine neue Kore des Cheramyes," *Antike Plastik* 24 (1995), 7–36, pls. 1–8; Pedley, *Greek Sculpture of the Archaic Period*, 46–57.

3. B. S. Ridgway, *The Archaic Style in Greek Sculpture*, 2nd ed. (Chicago, 1993), 22–32, 48 n. 2.21, with refs. For the history of Greek colonization in the West, see G. Pugliese Carratelli, *The Western Greeks*, exh. cat., Palazzo Grassi, Venice (Milan, 1996), 141–200; J. Boardman, *The Greeks Overseas*, rev. ed. (London, 1980), 161–92.

4. J. D. Beazley, "A Marble Lamp," *Journal of Hellenic Studies* 60 (1940), 22–49; Langlotz and Hirmer, *Art of Magna Graecia*, 250–51, pl. 2; G. M. A. Richter, *Catalogue of Greek Sculptures in the Metropolitan Museum of Art* (Cambridge, Mass., 1954), 6, no. 8, pl. 11.

5. See in general, Ashmole, "Late Archaic and Early Classical Greek Sculpture," passim; R. R. Holloway, *Influences and Styles in the Late Archaic and Early Classical Greek Sculpture of Sicily and Magna Graecia* (Louvain, 1975), ix–xii, with refs.; J. Boardman, *Greek Sculpture: The Late Classical Period* (London, 1995), 163.

6. See Ashmole, "Late Archaic and Early Classical Greek Sculpture," 4.

7. Boardman, *Greek Sculpture*, 144.

8. Ridgway, *Archaic Style*, 65–66, who also comments on the imported kouroi, especially from the Cyclades. For all the kouroi from the Ptoan sanctuary, see J. Ducat, *Les Kouroi du Ptoion* (Paris, 1971).

9. See, for instance, Holloway, *Influences and Styles*; Ridgway, *Archaic Style*; Boardman, *Greek Sculpture*.

10. For Selinus and Foce del Sele, see Boardman, *Greek Sculpture*, 146–49, figs. 155–63, with refs.

11. For a thorough summary of the sculptures from Foce del Sele, see also Ridgway, *Archaic Style*, 347–50, with refs., to which add: B. A. Barletta, "Reconstructing the 'Treasury,' or Temple of Hera I, at Foce del Sele," in *Stephanos: Studies in Honor of Brunilde Sismondo Ridgway*, ed. K. J. Hartswick and M. C. Sturgeon (Philadelphia, 1998), 21–37.

12. Ridgway, *Archaic Style*, 348, 354, 390–91.

13. For the temple E metopes, see Langlotz and Hirmer, *Art of Magna Graecia*, 280–83, pls. 100–13; Holloway, *Influences and Styles*, 16–26, figs. 125–31, 136–43; C. Marconi, *Selinunte: Le metope dell' Heraion* (Modena, 1994). For the akrolithic technique in the West, see Boardman, *Greek Sculpture*, 147–48, with refs.; see also E. Langlotz, *Studien zur nordostgriechischen Kunst* (Mainz, 1975), 147, pl. 47.

14. For the Cirò Apollo, see Langlotz and Hirmer, *Art of Magna Graecia*, 284–85, pls. 118–19; B. S. Ridgway, *The Severe Style in Greek Sculpture* (Princeton, 1970), 122–23, 125, no. 7; Boardman, *Greek Sculpture*, 165, figs. 190 (marble parts), 191 (bronze wig).

15. On this topic, see esp. Langlotz and Hirmer, *Art of Magna Graecia,* 50; B. A. Barletta, *Ionic Influence in Archaic Sicily: The Monumental Art* (Gothenburg, 1983); Boardman, *Greek Sculpture,* 144–45.

16. Barletta, *Ionic Influence,* 86–91.

17. W. Fuchs, "Archäologische Forschungen und Funde in Sizilien von 1955 bis 1964," *Archäologischer Anzeiger* 79 (1964), 693, fig. 13; K. Schefold, "Neue Entdeckungen in Sizilien," *Antike Kunst* 15 (1972), 81, pl. 21:1; Barletta, *Ionic Influence,* frontispiece.

18. Syracuse Museum, no. 705: Holloway, *Influences and Styles,* 32, 50, figs. 182–84; Barletta, *Ionic Influence,* 91–92, figs. 17–19, with refs.; Ridgway, *Archaic Style,* 91, 118 n. 3.74, figs. 36a–b; B. A. Barletta, "The Draped Kouros Type and the Workshop of the Syracuse Youth," *American Journal of Archaeology* 91 (1987), 233–46.

19. G. M. A. Richter, *Kouroi: Archaic Greek Youths,* 3rd ed. (London, 1970), 112, no. 134, figs. 388–90; Barletta, *Ionic Influence,* 141–44, figs. 27, 28; Ridgway, *Archaic Style,* 87, 115 n. 3.63; Boardman, *Greek Sculpture,* 164, fig. 180.

20. See the unfinished kore from Punta del Tonno, near Taranto, Taranto Museum no. 20923: Langlotz and Hirmer, *Art of Magna Graecia,* 263–64, pl. 42; G. M. A. Richter, *Korai: Archaic Greek Maidens* (London, 1968), 95, no. 171, figs. 541–44; Boardman, *Greek Sculpture,* 164, fig. 183.

21. Ridgway, *Archaic Style,* 64, 129, 243. For kouroi in the West, see most recently M. Landolfi and G. de Marinis, eds., *Kouroi Milani: Ritorno ad Osimo,* exh. cat., Palazzo Campana (Rome, 2000), esp. the chapter by E. Lattanzi, "Il Kouros in Sicilia e Magna Grecia in età arcaica," 23–27; see p. 26 for an illustration of the newly discovered kouros in Reggio Calabria.

22. Langlotz and Hirmer, *Art of Magna Graecia,* 266, pls. 50, 51; H. Herdejurgen, *Untersuchungen zur Thronenden Göttin aus Tarent in Berlin und zur archaischen und archaistischen Schrägmanteltracht* (Waldsassen and Bayern, 1968); Boardman, *Greek Sculpture,* 164, fig. 185.

23. Holloway, *Influences and Styles,* 28–29, figs. 158–62; Boardman, *Greek Sculpture,* 164, fig. 186; M. Barbanera, *Il Guerriero di Agrigento: Una probabile scultura frontonale del Museo di Agrigento e alcune questioni di Archeologia "siceliota"* (Rome, 1995).

24. Museo Giuseppe Whitaker, Motya, no. I.G. 4310: Boardman, *Greek Sculpture,* 164–65, fig. 187; Pugliese Carratelli, *Western Greeks,* 418–19 (illus.), 697, no. 147; N. Bonacasa and A. Buttitta, eds., *La Statua Marmora di Mozia e la scultura di stile severo in Sicilia* (Rome, 1988); N. Bonacasa, *Lo Stile Severo in Grecia e in Occidente: Aspetti e Problemi* (Rome, 1995).

25. For a bibliography of architectural terracottas, see Holloway, *Influences and Styles,* 51–52; see also Pugliese Carratelli, *Western Greeks,* passim.

26. H. Pruckner, *Die lokrischen Tonreliefs* (Mainz, 1968); B. S. Ridgway, *The Severe Style in Greek Sculpture* (Princeton, 1970), 96, 108 (refs.), figs. 129, 130; Boardman, *Greek Sculpture,* 167, fig. 202; Pugliese Carratelli, *Western Greeks,* 701–2, nos. 166, 167; U. Spigo, "I pinakes di Francavilla di Sicilia (Parte I)," *Bolletino d' Arte,* serie 6, fasc. 111 (2000), 1–60; U. Spigo, "I pinakes di Francavilla di Sicilia (Parte II)," *Bolletino d' Arte,* serie 6, fasc. 113 (2000), 1–78.

27. In general see Ashmole, "Late Archaic and Early Classical Greek Sculpture," passim; Langlotz and Hirmer, *Art of Magna Graecia,* 32–33; Holloway, *Influences and Styles,* passim; Pugliese Carratelli, *Western Greeks,* passim. For individual sites see, for example, C. Letta, *Piccola Coroplastica Metapontina nel Museo Archeologico Provinciale di Potenza* (Naples, 1971); M. B. Bagnasco, *Protomi in Terracotta da Locri Epizefiri* (Turin, 1986); M. T. Ianelli and V. Ammendolia, *I volti di Hipponion* (Catanzaro, 2000); J. P. Uhlenbrock, *The Terracotta Protomai from Gela: A Discussion of Local Style in Archaic Sicily* (Rome, 1988).

28. Palermo Museum: Langlotz and Hirmer, *Art of Magna Graecia,* 273, pl. 81; Holloway, *Influences and Styles,* 25, 49, no. 20, figs. 147, 148; Boardman, *Greek Sculpture,* 166, fig. 196.

29. Holloway, *Influences and Styles,* 10, 51, no. 1, figs. 67, 68; N. Degrassi, *Lo Zeus stilita di Ugento* (Rome, 1981), who calls it Tarentine; Boardman, *Greek Sculpture,* 166, fig. 193, who calls it Spartan. See most recently C. M. Stibbe, *The Sons of Hephaistos: Aspects of the Archaic Greek Bronze Industry* (Rome, 2000), 173–79, figs. 115–18 and fig. G (reconstruction drawing), who reviews previous attributions and argues in favor of Sparta.

30. Holloway, *Influences and Styles,* 10; see also Degrassi, *Lo Zeus stilita di Ugento.*

31. Langlotz and Hirmer, *Art of Magna Graecia,* 246.

32. Langlotz and Hirmer, *Art of Magna Graecia,* 245, pl. VII; Pugliese Carratelli, *Western Greeks,* 686, no. 105; M. True and K. Hamma, eds., *A Passion for Antiquities: Ancient Art from the Collection of Barbara and Lawrence Fleischman.* exh. cat., J. Paul Getty Museum (Malibu, 1994), 120–23, no. 54, with refs. (A. Herrmann).

33. R. Spadea, *Il Tesoro di Hera: Scoperte nel Santuario di Hera Lacinia a Capo Colonna di Crotone* (Milan, 1996), 54–55, 60–69.

34. R. Spadea, *The Treasures of Hera: Magna Graecian Antiquities from Southern Italy,* exh. cat., European Academy for the Arts and Accaedmia Italiana, London (Milan, 1998), 38, nos. 10–12. The original, fuller Italian version of the catalogue appeared in 1996 (see note 33 above).

35. For the pectoral, see S. Cassani, ed., *I Greci in Occidente: La Magna Grecia nelle collezioni del Museo Archeologico di Napoli* (Naples, 1996), 124, no. 10.43; for the face guard, see ibid., 243.

36. Pugliese Carratelli, *Western Greeks,* 644–45, no. 117 II.

37. B. Johnson, *Lady of the Beasts: Ancient Images of the Goddess and Her Sacred Animals* (San Francisco, 1988); *Lexicon Iconographicum Mythologiae Classicae,* (Zurich/Düsseldorf 1997), 8, part 1: 1021–27, under "Potnia" (N. Icard-Gianolio).

38. For inlays in Greek bronzes, see D. Haynes, *The Technique of Greek Bronze Statuary* (Mainz, 1992), 106–12; P. C. Bol, *Antike Bronzetechnik* (Munich, 1985), 55 (fig. 31), 107 (fig. 63). The Monteleone Etruscan bronze chariot in New York had numerous ivory inlays, a number of which survive (unpublished, in Florence and New York): F. Roncalli and L. Bonfante, eds., *Gens antiquissima Italae: Antichità dell' Umbria a New York* (Perugia, 1991), 113, 115–16, 120 (A. Emiliozzi). For a Greek ivory sphinx with amber face in Stuttgart, see Boardman, *Greeks Overseas*, 223, fig. 264; Pugliese Carratelli, *Western Greeks*, 389 (illus.). For a Greek bronze greave decorated with a gorgoneion that has eyes inlaid in amber, see D. von Bothmer, ed., *Glories of the Past: Ancient Art from the Shelby White and Leon Levy Collection* (New York, 1990), 110–11, no. 91, with references to Greek bronze armor with ivory inlays as well.

39. G. M. A. Richter, "An Archaic Greek Mirror," *American Journal of Archaeology* 42 (1938), 337–44, figs. 1–7; A. P. Kozloff and D. G. Mitten, eds., *The Gods Delight: The Human Figure in Classical Bronze,* exh. cat., Cleveland Museum of Art (1988), 69–74, no. 6 (M. True).

40. G. M. A. Richter, "An Archaic Greek Mirror," 344, favors Corinth over Sparta. Boardman, *Greeks Overseas,* 146, fig. 178, describes the mirror as Spartan.

41. P. C. Sestieri, "Il sacello—heroon posodoniate," *Bolletino d'Arte* 40 (1955), 53–64; B. Neutsch, *Tas nymphas emi hiaron: Zum unterirdischen Heiligtum von Paestum* (Heidelberg, 1957); C. Rolley, *Greek Bronzes* (London, 1986), 144–46, pls. 126, 127; Pugliese Carratelli, *Western Greeks,* 696–97, no. 145.

42. Rolley, *Greek Bronzes,* 146, pl. 129. For the Vix krater, see also R. Joffroy, *Vix at ses trésors* (Paris, 1979); R. Förtsch, *Kunstverwendung und Kunstlegitimation im archaischen und frühklassischen Sparta* (Mainz, 2001), 100 n. 879, no. 6 in second list, figs. 38, 232, 262, 263.

43. Rolley, *Greek Bronzes,* 146, 150; C. Rolley, *Les vases de bronze de l'archaïsme récent en Grande Grèce* (Naples, 1982), passim.

44. G. M. A. Richter, *Catalogue of Greek Sculptures,* 79, no. 141, pl. 103; G. M. A. Richter, *Handbook of the Greek Collection, The Metropolitan Museum of Art* (New York, 1953), 106 and n. 3, pl. 85b.

45. J. C. Carter, *The Sculpture of Taras* (Philadelphia, 1975); B. S. Ridgway, *Hellenistic Sculpture I: The Styles of ca. 331–200 BC* (Bristol, 1990), 180–85, with refs; Pugliese Carratelli, *Western Greeks,* 378; E. Lippolis, "La tipologia dei *semata,"* in *Taranto, La Necropoli: Aspetti e problemi della documentazione archeologica tra VII e I sec. a. C.,* vol. 3, part 1 of *Catalogo del Museo Nazionale Archeologico di Taranto* (Taranto, 1994), 109–28.

46. Metropolitan Museum of Art, New York, 29.54: G. M. A. Richter, *Catalogue of Greek Sculptures,* 72–3, no. 119, pl. 92; B. S. Ridgway, *Hellenistic Sculpture I,* 184–85; A. Stewart, *Greek Sculpture: An Exploration* (New Haven/London, 1990), 196, pl. 601; Pugliese Carratelli, *Western Greeks,* 378 (illus.).

47. B. S. Ridgway, ed., *Greek Sculpture in The Art Museum, Princeton University* (Princeton, 1994), 28–31, no. 7 (J .B. Connelly). For the iconography, see esp. C. Aellen et al., *Le Peintre de Darius et son milieu,* exh. cat., Musée d'art et d'histoire, Geneva (1986), 74–75 (amphora in St. Petersburg), 283.

Photography credits

Fig. 1: Bruce M. White.

Demeter and Persephone in Western Greece: Migrations of Myth and Cult

H. A. SHAPIRO

> Let her radiance stream upon this island now,
> Persephone's gift from Zeus, lord of Olympos,
> Who bent his brow and promised to exalt her
> Over the fruitful earth,
> Sicily, teeming with cities supreme in wealth.[1]
> —*Odes of Pindar,* Nemean 1.13–15

In the year 70 BC, Gaius Verres, Roman governor of Sicily, went on trial in Rome for extortion and misgovernment. In his detailed and meticulous prosecution of Verres, Cicero proves to be one of our most informative sources on ancient Sicily, especially the island's religious life—including the many temples, sanctuaries, and cult statues that Verres was accused of pillaging. One of these statues was said to be the oldest bronze image of Demeter, at Enna, the small inland site that was famous in Roman times as the spot where Hades carried off Persephone to the underworld.[2] Two other statues at Enna, of Demeter and Triptolemos, were so large and difficult to transport that they withstood the rapaciousness of Verres, who had to content himself with the Nike held in Demeter's hand.[3] Cicero famously remarks that the whole island of Sicily was sacred to Demeter and Persephone: "insulam Siciliam totam esse Cereri et Liberae consecratam."[4]

Modern archaeological investigation of sanctuaries throughout the island has tended to confirm Cicero's impression, and the situation was not dissimilar in the Greek colonies of South Italy (Magna Graecia).[5] Consider, says Cicero, how devoted the Athenians are to Demeter, because the goddess taught them the cultivation of grain and her oldest sanctuary, at Eleusis, the home of her Mysteries, is located in their territory. Then think how much more passionate was the devotion of the Sicilians, who believed it was in *their* territory that Demeter was born and invented the gift of corn in the first place.[6]

Cicero no doubt hit upon one of the principal reasons for the extraordinary popularity of Demeter's cult in Sicily and anticipated the more mundane explanation of modern scholarship: that in a land colonized by the Greeks primarily for the rich fertility of the soil, the goddess who insured that fertility would naturally be honored above all others. But who was the Demeter of Sicily and Magna Graecia? Was she identical with the Demeter worshiped in Athens and Eleusis; how were her myths, cults, and rituals

brought from mainland Greece to the Western colonies; and how were they transformed once they had taken root in this exceptionally fertile religious soil? The question is even more complex in the case of Demeter's daughter, known variously in our sources as Persephone or Kore, or even, at Locri, as simply the Great Goddess. And what of Triptolemos, the hero who, in some versions, is the son of Demeter, who dispatches him from Eleusis to spread the knowledge of agriculture throughout the civilized world? His image must have been known in the West from exported Athenian vases like the magnificent bell-krater in the exhibition [80], found at Agrigento, and from statues like the one that Verres failed to steal. But was he worshiped in the same fashion as in his native Attica? This essay explores some of the mechanisms involved in the transfer of cult and religious imagery from the cities of old Greece to the new colonies in South Italy and Sicily.

There is perhaps no better example of the complex nature of adaptation and transformation than the worship of Persephone at Locri. Diodorus, the Augustan-age historian and native of Sicily, called her sanctuary there the most brilliant of any in Italy: ἐπιφανέστατον τῶν κατὰ τὴν Ἰταλίαν ἱερῶν.[7] We do not get much sense of that splendor today, for the best preserved dedications from the sanctuary are what would once have been among the most humble: the mold-made painted terracotta pinakes [36–39]. These make it clear that Persephone was indeed the main deity worshiped at Locri, while her mother Demeter played no role whatever.[8] But just what was the nature and function of Persephone at Locri?[9]

Greek sources, most notably the Homeric *Hymn to Demeter* (perhaps the closest thing we have to a sacred text describing a major Greek cult), as well as many Athenian vases, seem to draw a sharp distinction between two aspects of this goddess. One is the young, innocent daughter of Demeter, who is violently abducted by the underworld god Hades (her own uncle), with the tacit approval of Zeus (also her uncle). This is the key episode of the Homeric hymn, and everything else—Demeter's extravagant grief, the devastation of the earth as she searches inconsolably for her daughter, and her kind reception at Eleusis, where she will found her cult after the joyous reunion with Persephone—follows from this. But as part of the deal brokered by Zeus, Persephone will spend only part of the year on earth with her mother, the rest as Hades' queen in the underworld. This stern and regal figure, whom we often see observing Herakles as he fetches Cerberus in his final labor,[10] seems so far removed from the shy girl picking flowers with her playmates when she was suddenly carried off. Some scholars have wanted to keep the two manifestations of a single deity separate by designating one Kore ("daughter, maiden," as the Greek word may be translated), the other Persephone, the queen of the dead in Hades. G. Zuntz, whose book *Persephone* did much to clarify the goddess's nature, believed this distinction was obvious to the ancient worshiper: "No farmer prayed for corn to Persephone; no mourner thought of the dead as being with Kore."[11] Greek writers, unfortunately, are not as consistent as Zuntz's hypothetical mourners and worshipers.[12]

The worshipers at Locri combined elements of both personalities, while at the same time creating a version of Persephone as a goddess of marriage that

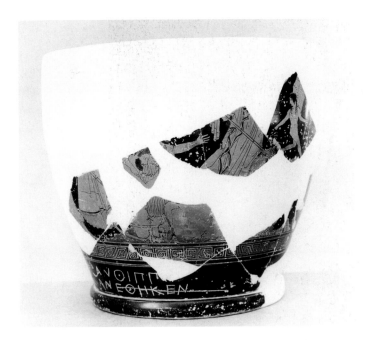

Fig. 1. Red-figure skyphos depicting Hades abducting Persephone. Ceramic. Greece, Attica, ca. 440 BC. Eleusis Museum, 1804.

is different from any manifestation of her in mainland Greece.[13] Some of the pinakes do show the abduction of Kore by the bearded god Hades, not unlike the description in the *Hymn to Demeter* or the very rare depictions in Athenian art (fig. 1).[14] Yet others [37, for example] show a young woman abducted by a beardless youth who cannot be Hades (especially since the bearded god is also present in one of the examples).[15] The couple in this much-discussed series of pinakes is probably neither Hades nor Kore, but a mortal couple whose marriage-by-abduction is imagined as an idealized version of the divine prototype.[16]

In recent years we have come to realize that this type of votive pinax, and the form of cult worship it represents, are not unique to Locri. Similar pinakes were manufactured at other sites in Magna Graecia, notably Medma and Hipponion, and examples originating in Locri have been found at such sites as Caulonia and Croton, as well as at Syracuse and Selinus in Sicily.[17] In recent years, the small town of Francavilla, near Sicilian Naxos, yielded a large number of locally made pinakes that share the style and many of the same themes as the more famous ones from Locri.[18] Among the more popular subjects at both Locri and Francavilla are the mature Persephone, either as Queen of Hades, along with her consort (fig. 2),[19] or more often alone, receiving the homage of mortal worshipers and other gods.[20] The female worshipers are surely brides-to-be seeking the blessings of the goddess for a happy and fruitful marriage [38]. Yet another motif omits the goddess entirely and focuses on the young bride as she prepares her trousseau [39]. How appropriate that one of the panels decorating the hope chest shows the kind of romantic abduction (though without the chariot) that is such a central element in the Locri cult.

In rare instances the prospective bride may be accompanied by a small child, perhaps a proleptic reference to the hoped-for offspring of the marriage (fig. 3). The role of Persephone as *kourotrophos* (nurturer of children) is probably expressed in the great Leukothea relief, whose style makes it look like a translation of a small terracotta pinax into a large-scale marble relief (fig. 4).[21] Based on the stylistic affinity, Erika Simon has speculated that this

Fig. 2. Pinax with Hades and Persephone. Sicily, Francavilla, ca. 450 BC. Terracotta. Museo Archeologico Regionale "Paolo Orsi" di Siracusa.

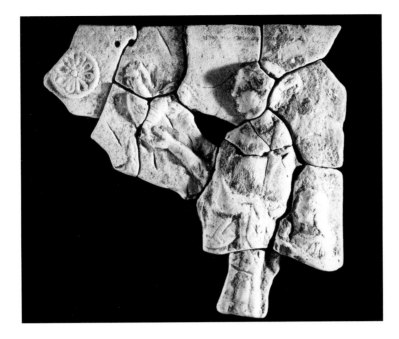

Fig. 3. Pinax depicting a woman offering a cock, with a small child. Sicily, Francavilla, ca. 450 BC. Terracotta. Museo Archeologico Regionale "Paolo Orsi" di Siracusa.

relief could have been a dedication in the temple of Persephone at Locri.[22] The enthroned goddess holds a small child on her lap, as two older children and a grown woman (the mother of the children?) reverently approach the goddess.

Unlike the famous pinakes, not all the dedications in the Locri sanctuary were made in local workshops. Quantities of imported Attic pottery also were found, and in at least a few instances the choice of subject cannot be accidental.[23] Most notable is the large fragment of an impressive black-

Fig. 4. Leukothea relief, with Persephone(?) receiving worshipers. Italy, Locri?, ca. 470 BC. Marble. Villa Albani, Rome.

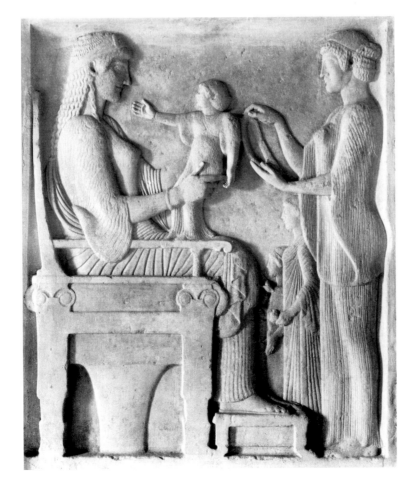

Fig. 5. Black-figure amphora from Locri, showing Herakles bringing Cerberus from the underworld (above), and the departure of Demeter in the presence of Herakles and divinities. Greece, Attica, 540–530 BC. Ceramic. Museo Archeologico Nazionale di Reggio Calabria, 4001.

figure amphora that may be the work of the greatest master of this technique, Exekias (fig. 5).[24] Two distinct, though thematically related scenes appeared on this unusual masterpiece.[25] The subsidiary one, above the ornament, shows Herakles, at the left, leading Cerberus out of the underworld, accompanied by his protectress, the goddess Athena, and his cousin and frequent sidekick, Iolaos. Iolaos holds the hero's club and bow, as Herakles has his hands full dealing with the recalcitrant dog. Whether Persephone was depicted in the missing part of the scene we cannot tell, but there is certainly plenty of room for her, and parallels from contemporary vases suggest that she probably was.[26]

Even more unusual is the main scene on the amphora's belly. It features Triptolemos, a dignified, bearded figure near the left edge, holding a sheaf of grain and looking toward a goddess who must be Demeter, for she, too, holds the grain. She also holds the reins of a chariot in which she is evidently about to depart. We are here two generations earlier than the creation of the canonical Triptolemos seen on so many red-figure vases like the krater from Agrigento [80], the beautiful youth departing Eleusis in a magical winged and snake-adorned chariot as both Demeter and Persephone see him off.[27] Here it seems to be Demeter who is departing, but for where? A hint is provided by the pair in the middle of the scene, Athena and her protégé Herakles. Around the time this vase was made (540–530 BC), the Athenians established a kind of branch cult for the goddess of Eleusis and instituted an annual rite known as the Lesser Mysteries, to distinguish it from the Greater Mysteries at Eleusis.[28] Herakles was the first initiate in these Lesser Mysteries and thereby became an honorary Athenian.[29] The scene on our vase seems to celebrate the founding of this cult. But why would this peculiarly Athenian ritual have seemed an appropriate subject for a dedication to Persephone at Locri?

One possibility is the presence of Herakles, who was thought to be instrumental in the spread of the cult of Demeter and Persephone to the West. Diodorus reports that when Herakles came to Syracuse and learned of the rape of Persephone, he made a sacrifice and instituted yearly rites in honor of the goddess among the natives.[30] Another clue may be offered by the enigmatic, kingly figure who observes the scene from the far right. An inscription identifies him as Ploutodotas, literally "Giver of Wealth." This unique occurrence has been variously interpreted as another name for Ploutos (Hades) or as a personification of the prosperity distributed by Demeter and Triptolemos. In an earlier study, I argued that the word is an epithet designating Zeus in his chthonic form, better known as Zeus Meilichios (the "kindly" or "well-disposed" one).[31] On some votive reliefs this chthonic deity is depicted as a snake, or a god accompanied by a snake,[32] but on others (fig. 6)[33] he is simply a bearded king holding a long scepter like the figure on the Exekias amphora (see fig. 5). While, on the one hand, epigraphical evidence from Attica helps connect Zeus Meilichios with the Lesser Mysteries that are commemorated here,[34] other inscriptions from Western Greece now confirm that Zeus Meilichios was an equally important divinity in the colonies.[35] Among the earliest attestations is a stone inscrip-

Fig. 6. Votive relief to Zeus Meilichios. Greece, Attica, 325–300 BC. Marble. National Museum, Athens, 1431.

tion from Syracuse that is close in date to our amphora.[36] A recently discovered inscribed lead tablet from Selinus contains a *lex sacra* prescribing sacrifices to Zeus Meilichios.[37] The tablet was found in the sanctuary of Demeter Malophoros, which has become well known as one of her major Sicilian sanctuaries thanks to intensive recent excavation.[38] The association of Zeus Meilichios with Demeter at Selinus suggests that he could also have been recognized by the worshipers of Persephone at Locri.[39]

Just as there is no direct evidence for the presence of Zeus Meilichios at Locri, so, too, neither the literary and epigraphical sources nor the abundant pinakes would lead us to suspect much of a role for Triptolemos there.[40] Yet not only is he present on the Exekian amphora, but a much later red-figure krater of the mid fifth century BC (fig. 7),[41] also dedicated in the sanctuary,

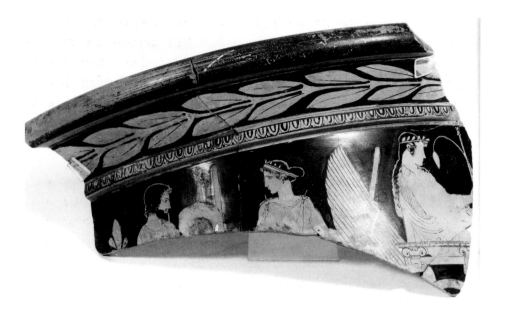

Fig. 7. Fragment of a red-figure bell-krater from Locri, depicting the departure of Triptolemos. Greece, Attica, ca. 450 BC. Ceramic. Museo Archeologico Nazionale di Reggio Calabria.

depicts Triptolemos on his winged cart, much in the manner of the slightly earlier krater from Agrigento [80]. A goddess, probably Demeter, stands beside the car, but turns away from Triptolemos to exchange glances with a bearded man. The scene on the Agrigento krater is framed by two such bearded figures, filled with modesty and awe as they witness the miraculous event unfolding before them. They are labeled as Hippothoon and Keleos, the former a hero from Eleusis, the latter the Eleusinian king in whose home Demeter found refuge in her wandering. In the *Hymn to Demeter*,[42] Keleos is one of the Eleusinian kings to whom Demeter teaches her Mysteries, and we can imagine her doing just that in the intimate encounter portrayed on the fragment from Locri.

We have already seen some possible links between cults of Demeter and Persephone in Magna Graecia and in Sicily. One of this exhibition's great virtues is to demonstrate the cultural and artistic unity of these two regions, instead of treating them as separate and distinct, as is often done in the scholarship. The widespread worship of Demeter was one of the powerful bonds among the many cities and sanctuaries on both sides of the Strait of Messina. Archaeologically, there is a kind of koine throughout the region in the form of such dedications as the terracotta bust of a goddess wearing a polos [54], the seated statue of a goddess [9], and the standing female worshiper holding a piglet [73].

The origins of Demeter's cult in Sicily are much debated. On one hand, we are not likely to find any secure archaeological evidence for Demeter and Kore in Sicily before the sixth century BC. The earliest depiction of the two goddesses from the island is often thought to be the early sixth-century BC limestone metope from temple Y at Selinus (fig. 8), on which they are joined by a third, identified by Vincenzo Tusa as Hekate, on account of her prominent role in the *Hymn to Demeter*.[43] On the other hand, with Greek colonies being planted on Sicily from soon after the middle of the eighth century BC, there is no reason to exclude the possibility that Demeter's cult arrived much earlier than we find it in the visual record. An excellent case

in point is Syracuse (founded traditionally in 733 BC), the pre-eminent city of the island in Early Classical times, when Demeter's cult was most actively promoted by none other than the glittering tyrants Gelon and his brother Hieron.[44] Yet, for the original Corinthian colony on the island of Ortygia, monumental and literary evidence agree in naming as the chief gods Artemis, whose epithet Ortygia ("quail") was given to the city itself, as well as Apollo and Athena, whose temples are still the city's archaeological landmarks.

And what of Demeter? Until recently, there was a curious discrepancy between the abundance of ancient literary testimony to the importance of Demeter's cult in Syracuse and the paucity of archaeological evidence. Systematic excavation has now begun to right the balance, with the discovery of more than one previously unattested sanctuary.[45] The conventional wisdom, that sanctuaries of Demeter tend to be "extra-urban," that is, outside the city center, seems to be borne out in Syracuse.[46] The temples to the two

Fig. 8. Metope from temple Y at Selinus, showing Demeter, Persephone, and Hekate(?). Sicily, Selinus, 600–575 BC. Limestone. Museo Archeologico Regionale "A. Salinas" di Palermo.

goddesses built by Hieron after the victory over the Carthaginians at Himera in 480 BC are located by Diodorus in the district known as Akradina,[47] and Cicero speaks of major temples of Demeter and Kore in the new city, Neapolis (both some distance from Ortygia). Luigi Polacco has argued that the original home of Demeter's cult in Syracuse, the "casa-madre," should have been at the Cyane Spring, where Persephone disappeared beneath the earth in Hades' chariot and where Herakles stopped on his tour of Sicily and, as we have seen, established a festival in honor of the goddess.[48]

In 1911 the Sicilian historian Emanuele Ciaceri published his *Culti e miti nella storia dell' antica Sicilia,* a modest book whose influence has been enormous. Ciaceri argued that the cult of Demeter and Kore first came to Sicily with the founding of Gela in the early seventh century BC; that it was brought to Syracuse by the Geloan tyrant Gelon when he moved his power base there in 485 BC; and that the cult was thence diffused to the native inhabitants of eastern Sicily as an instrument of Gelon's political ambitions.[49]

The implication of this ingenious theory is that Syracuse did not have a cult of Demeter before the early fifth century BC, and it is true that no ancient writer attests one before that time. The earliest evidence is Pindar's sixth Olympian ode, composed in the 470s BC, praising the then-tyrant Hieron who "tends the worship of Demeter of the purple feet and the festival of her daughter, she of the white horses."[50]

When Ciaceri was writing, at the beginning of the twentieth century, Sicily was in the midst of its most intense and fruitful era of excavation, under the leadership of Paolo Orsi. Has a century of investigation changed the picture of Demeter's worship in Archaic Syracuse? The most impressive find is a colossal limestone head found near the Cyane Spring, dated around 600 BC or soon after, which some have suggested comes from a cult statue of Kore.[51] At a recently discovered sanctuary at Piazza della Vittoria in Syracuse, Giuseppe Voza found an inscription, dating probably to the second half of the sixth century BC, which can be restored as a dedication "Megalas Theas" (of the great goddess), that is, Demeter.[52] Yet the sum total of the evidence for Demeter and Kore in Archaic Syracuse is not overwhelming. Given the widespread popularity of the two goddesses throughout Sicily, we might have expected more. But if the influence from Gela did not pre-date the dynasty of the Deinomenid tyrants, then whence did the cult come?

That the Greek colonists in the West transplanted major cults from their hometowns in Greece to the new foundations has never been doubted.[53] Thus, for example, Telines, the Rhodian founder of Gela, is assumed to have brought with him the cult of Demeter, whose priesthood his descendants would later control.[54] But the extent of religious influence from mother city to daughter colony once the latter was established as an autonomous polis has not been much studied. Certainly Syracuse would seem a likely candidate, for historical and archaeological evidence suggests that relations with the mother city of Corinth remained very close throughout the Archaic period. The great temple of Apollo in Syracuse, for example, was built not long after its counterpart in Corinth, well over a century after the founding of the colony.

Until recently, little was known of the worship of Demeter and Kore in Corinth, apart from a few scattered references in ancient writers.[55] One anecdote, set in the fourth century BC, does seem to indicate close ties between the cult in Corinth and in the West. On the eve of the Corinthian general Timoleon's departure for Sicily in 344 BC, the priestess of Persephone had a vision. This prompted the Corinthians to send a sacred trireme named for Demeter and Kore with Timoleon's fleet.[56]

In the mid 1960s, the American School of Classical Studies at Athens excavated a large sanctuary on the slopes of Acrocorinth that turned out to be that of Demeter and Kore, one of several sanctuaries noted by Pausanias in his ascent of the hill.[57] The sanctuary was active by the seventh century BC, reached its mature form by the end of the sixth century BC, and continued in use at least into the Hellenistic period. The identity of the sanctuary was put beyond doubt by inscribed dedications, terracottas of the familiar type of a woman in a headdress carrying a torch and a pig [73], and evidence for the holocaust of young pigs and ritual dining.[58] In other words, the sanctuary has

the hallmarks of a Thesmophoreion, a type of Demeter sanctuary now best known in Sicily from the recently excavated one at Bitalemi near Gela.[59] Other characteristics shared by the two sanctuaries are the presence of large quantities of simple, undecorated pottery, with certain so-called "female" shapes (especially hydriae) predominating.[60]

Among the relatively rare examples of decorated pottery from the sanctuary on Acrocorinth, two are of particular interest in our context. One is a

Fig. 9. Fragment of a kotyle from the sanctuary of Demeter and Kore on Acrocorinth, showing the upper part of Persephone's head and the beginning of her inscribed name. Greece, Corinth, 480–470 BC. Ceramic. Corinth Museum, 69-82-32.

small fragment of a kotyle preserving the upper part of a female head and the beginning of the inscription Phers[ephatta] (fig. 9).[61] This is the same form of Persephone's name that is found on the krater from Agrigento, as well as on the skyphos by Makron that is one of the greatest depictions of the Triptolemos theme (fig. 10).[62] Even the small spikes on her crown on the Corinth fragment resemble those of Makron's and other Attic vases (see fig. 7). While the iconography of Persephone was probably established earliest at Athens, it had clearly influenced Corinth on its way to the West.

The second fragment is even more suggestive (fig. 11).[63] It belongs to a bottle-shaped vessel and carries part of a scene familiar from a group of almost a dozen previously known Corinthian vases, many of them of this distinctive shape. The subject is a gathering of women at a festival for a female divinity, hence the nickname Frauenfest vases, coined by Ines Jucker, who first collected and studied them in 1963.[64] She tentatively associated these vases with the cult of Artemis, but in 1970, after the discovery of the sanc-

Fig. 11. Bottle from the sanctuary of Demeter and Kore on Acrocorinth, showing a women's ritual (at top). Greece, Corinth, 600–575 BC. Ceramic. Corinth Museum, 66-139-22.

Fig. 10. Red-figure skyphos by Makron, depicting the departure of Triptolemos from Demeter and Persephone. Greece, Attica, 490–480 BC. Ceramic. The British Museum, London, E 140.

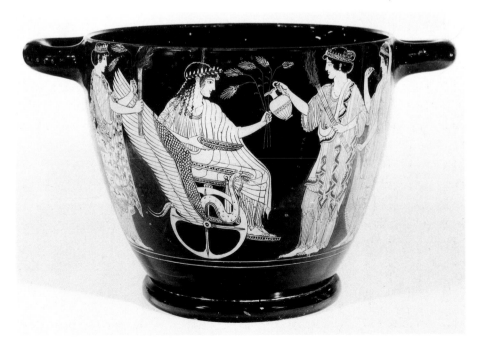

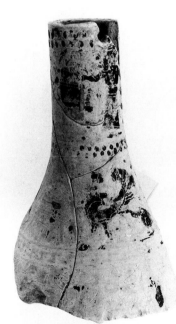

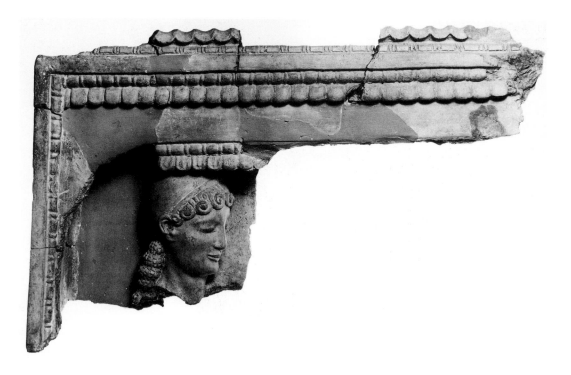

Fig. 12a. Fragment of a votive plaque showing Demeter and Persephone. Sicily, Syracuse, 500–475 BC. Terracotta. Museo Archeologico Regionale "Paolo Orsi" di Siracusa.

tuary on Acrocorinth, Denise Callipolitis-Feytmans more plausibly connected them with Demeter and Kore.[65] One of Demeter's epithets at Syracuse, *Epilusamene,* characterizes her as a protectress of children, who are often present along with the women on these vases. One example was found in the Fusco Necropolis in Syracuse, and another, now in the Syracuse Museum, comes from Gela.[66] Thus we have evidence for a festival of Demeter and Kore not described in the literary sources but nevertheless traceable through the medium of painted pottery from Corinth to Sicily.

This is also an important reminder of the tremendous variety of cults and rites of Demeter and Kore throughout the Greek world and in Sicily and Magna Graecia in particular. Whereas at Locri, Persephone was the principal divinity in a cult closely associated with marriage, the sanctuaries of Demeter where the Thesmophoria were performed, whether in Attica,

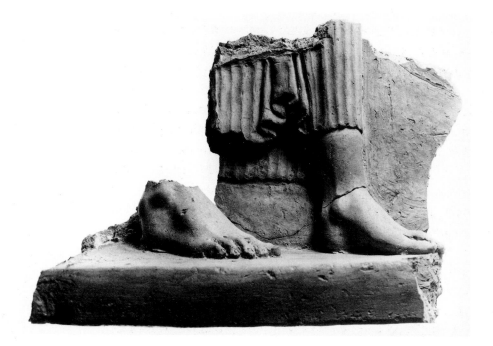

Fig. 12b. Fragment of a votive plaque showing Demeter and Persephone. Sicily, Syracuse, 500–475 BC. Terracotta. Museo Archeologico Regionale "Paolo Orsi" di Siracusa.

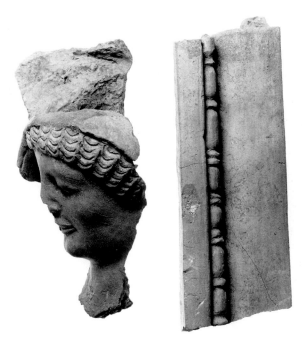

Corinth, or Sicily, were probably frequented mainly by mature women and focused much less on Persephone. Yet another variant was the chthonic sanctuary, such as that of Demeter Malophoros referred to earlier. Here Persephone was called by the epithet Pasikrateia, the "all-powerful," and the chthonic nature of the cult brought out her underworld associations.[67]

The one model of Demeter worship in mainland Greece that we hear the least about in Sicily and Magna Graecia is what we may call the Eleusinian model, the Mystery cult featuring secret initiation and re-enacting the motifs of Kore's abduction and her return from Hades. There is some evidence that individual elements of the Eleusinian version, as recorded in the *Hymn to Demeter*, were echoed in Sicily. So, for example, the practice of *aischrologia*, or ritual obscenity, inspired by a girl called Baubo (or Iambe) who was said to have distracted Demeter in her grief by telling dirty jokes,[68] is attested by Diodorus for Sicily,[69] and Hekate, who plays a key role in the hymn,[70] was associated with Demeter at the Malophoros sanctuary.[71] Yet we never hear of Mysteries of Demeter, on the Eleusinian model, in the West.[72]

I end with a relatively recent and unexpected find from Syracuse that is a promising piece of new evidence for understanding an aspect of the cult of Demeter in Sicily, as well as another kind of link back to the cult in its Greek homeland. This terracotta relief, originally about one meter in height, was found in 1960 in Piazza Archimede on Ortygia, not far below the summit of the ancient city.[73] The form of the monument is most unusual, especially the architectural frame with its rows of moldings, and its original purpose and setting are enigmatic. We have parts of two female figures. The woman at left is firmly anchored to the frame (fig. 12a), and the fragment of drapery, lower legs, feet, and plinth belong to her (fig. 12b), while the second woman's head is "floating," that is, not attached to the frame at any point (fig. 12c). I need hardly point out that this is a work of extraordinary quality and sophistication, and it is particularly astonishing to find this combination of monumental grandeur, sharp detail, and sensitive modeling in terracotta. The excavator

has dated it to about the last decade of the sixth century BC, though, as we shall see, a somewhat later date is also possible. But let us focus first on the iconography.

No one has doubted the identification of the figures as Demeter and Kore, and yet depictions of the two goddesses together in the art of Western Greece are quite rare, even more so at this early date. The only parallels that come to mind are two metopes from the early Archaic temple Y at Selinus: the one with three goddesses, discussed above (see fig. 8), and a second one with a pair in a chariot.[74] The latter has been called Demeter and Kore, but this is uncertain, as indeed is the gender of the figures.[75] How different is the situation on our Syracuse relief, with its exquisitely clear differentiation of the two figures, especially by hairstyle, but also facial features, pose, expression, and probably—if we had more of it—dress. Persephone, at the left, has a row of large, loose snail-curls across the forehead and long, gently waving hair down the back. Demeter wears both a veil and a tall polos, her wavy hair as crisp as fine metalwork. Her centrally parted, wavy hair recalls that of the contemporary terracotta head from Agrigento in the exhibition [68].

When we look for iconographical parallels in mainland Greek art, especially in Athens, we are led once again back to scenes of the Departure of

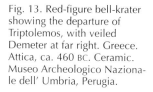

Fig. 13. Red-figure bell-krater showing the departure of Triptolemos, with veiled Demeter at far right. Greece. Attica, ca. 460 BC. Ceramic. Museo Archeologico Naziona-le dell' Umbria, Perugia.

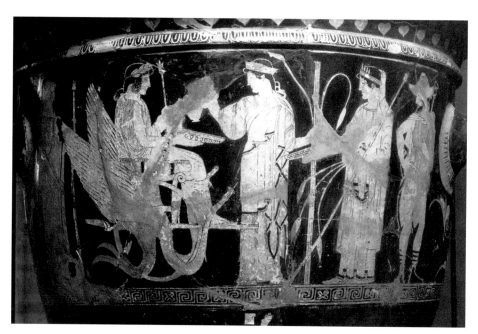

Triptolemos (see fig. 7) [80]. When one of the two goddesses is veiled, it is always Demeter (fig. 13),[76] and when one wears a polos, it is again always the mother.[77] In vase paintings and votive reliefs of just the two goddesses, Demeter is sometimes seated,[78] and the slight tilt of her head and upward gaze on the Syracuse relief suggest that this may have been the case here as well.[79] In the second half of the fifth century BC, such two-figure votive reliefs in stone are not uncommon at Eleusis and elsewhere, including one found at Catania.[80] Another, in Munich, has an unusual motif—Persephone placing her hand on Demeter's shoulder—that suggests a narrative element, an allusion to her return from the underworld.[81] Looking again at the expressiveness of the faces and evident intensity of eye contact on our relief, one is tempted

to think that it too refers to the same moment. The Syracusan festival of "Kore of the white horses," of which Pindar sings (see the discussion earlier in this essay), celebrated the return of Kore from the underworld; thus, the subject of our relief would have made it an appropriate dedication.

The stylistic dating of a work such as this is done mainly through comparisons with mainland Greek sculpture, such as the korai from the Athenian Acropolis.[82] Yet the use of such parallels is triply handicapped, in comparing marble with terracotta, freestanding sculpture with high relief, and Athens with Sicily. If I am correct that our relief should be downdated to the 480s BC, then we may see reflected in it the historical context of Syracuse under the Deinomindai, the period when Gelon, hereditary priest of Demeter and Kore, sought to promote the cult of the two goddesses.[83] A few years later his younger brother Hieron thanked Demeter and Kore for his victory over Carthage, on the very same day (as the ancients believed) that Greece routed the Persians at Salamis.[84] That battle had in turn been preceded by a strange portent.[85] It was September, the time of year of the great procession from Athens to Eleusis for initiation into the Mysteries of Demeter. Even though the city of Athens had been evacuated and the procession canceled, the sound of thirty thousand voices was heard coming from Eleusis, raising the joyous cry "Iakche!" which drifted toward Salamis, signaling Xerxes' doom. A year later, Demeter once again lent her support to the Greeks when the last two decisive victories over the Persians, at Plataea and Mykale, were both fought in and around sanctuaries of Eleusinian Demeter.[86] At a single stroke, Demeter saved the Greek world from barbarian threats from both East and West. Seventy years later, Athens and Syracuse would be mortal enemies, but for now, for this brief shining moment, there was panhellenic joy and harmony, when mother cities and daughter colonies were united in the worship of the divine paradigm of mother and daughter.

NOTES

1. Pindar, *The Odes of Pindar,* Nemean 1.13–15; trans. F. J. Nisetich, in *Pindar's Victory Songs* (Baltimore, 1980).

2. Diodorus Siculus, *The Library of History* 5.32; Cicero, *In Verrem* 4.107.

3. Cicero, *In Verrem* 4.109–10.

4. Ibid., 4.106.

5. For the fullest and most up-to-date survey see V. Hinz, *Der Kult von Demeter und Kore auf Sizilien und in der Magna Graecia* (Wiesbaden, 1998).

6. Cicero, *In Verrem* 4.108; see Diodorus Siculus, *Library of History* 5.2.4, who claims that Demeter and Kore first taught the art of agriculture in Sicily.

7. Diodorus Siculus, *Library of History* 27.4.3.

8. E. Simon, "Criteri per l'esegesi dei pinakes locresi," *Prospettiva* 10 (1977), 18. Some scholars do, however, argue that the *Hymn to Demeter* was known at Locri; see, for example, H. Prückner, *Die Lokrischen Tonreliefs* (Mainz, 1968), 82. Even Triptolemos has been recognized on a few of the pinakes: Prückner *Die Lokrischen Tonreliefs,* 122; and M. Torelli, "I culti di Locri," in *Atti Magna Grecia* 16 (1976), 170. For a good recent survey of the themes depicted on the Locri pinakes, with earlier references, see L. Vlad Borelli and C. Sabbione, in E. Lattanzi et al., *Santuari della Magna Grecia in Calabria,* exh. cat., Museo Archeologico di Vibo Valentia and tour (Naples, 1996), 40–42.

9. See C. Sourvinou-Inwood, "Persephone and Aphrodite at Locri: A Model for Personality Definitions in Greek Religion," *Journal of Hellenic Studies* (hereafter *JHS*) 98 (1978), 101–21.

10. See note 26.

11. G. Zuntz, *Persephone* (Oxford, 1971), 77.

12. As Zuntz, ibid., acknowledges, there are places where the poets do not observe this distinction, for example, Euripides, *Herakles* 608: Herakles invokes the underworld divinities as Hades and Kore.

13. On Persephone as goddess of marriage at Locri, see Simon, "Criteri per l'esegesi dei pinakes locresi."

14. J. D. Beazley, *Attic Red-figure Vase Painters,* 2d ed. [hereafter *ARV²*] (Oxford, 1963), 647, 21; R. Lindner, *Der Raub der Persephone in der antiken Kunst* (Würzburg, 1984), 14–15, pls. 2–3; R. Lindner, "Hades im Wagen, umfaßt Persephone mit beiden Armen," in *Lexicon Iconographicum Mythologiae Classicae* [hereafter *LIMC*] (Zurich/Munich, 1988), 4: 384, under "Hades," no. 110.

15. P. E. Arias, "L'arte locrese nelle sue principali manifestazioni artigianali: Terracotte, bronzi, vasi, arti minori," *Atti Magna Grecia* 16 (1976), 521, pl. 66.2.

16. C. Sourvinou-Inwood, "The Young Abductor of the Locri Pinakes," *Bulletin of the Institute of Classical Studies of the University of London* 20 (1973), 12–21; C. Giuffrè Scibona, "Lo sposo di Persephone a Locri: tipologia e ideologia della coppia nella religiosità demetriaca," *Quaderni dell' Istituto di Archeologia della Facoltà di Lettere e Filosofia della Università di Messina* 2 (1986–87), 73–90. For a different interpretation, as Eubouleus bringing Persephone back from Hades, see K. Clinton, *Myth and Cult: The Iconography of the Eleusinian Mysteries* (Stockholm, 1992), 72–73.

17. See Vlad Borelli and Sabbione, in Lattanzi, *Santuari della Magna Grecia in Calabria,* 40.

18. U. Spigo, "Nuovi contributi allo studio di forma e tipologia della coroplastica delle città greche della Sicilia ionica e della Calabria medidionale," *Atti Magna Grecia* 26 (1986), 275–335; U. Spigo, "I *pinakes* di Francavilla di Sicilia: Nuova classificazione e brevi note sugli aspetti cultuali," in *Damarato: Festschrift P. Pelagatti* (Naples, 2000), 208–20.

19. Simon, "Criteri per l'esegesi dei pinakes locresi," 18, suggests that the Hades/Plouton figure here is also a chthonic version of Zeus. See the discussion of Zeus Meilichios at Locri later in this essay.

20. These gods include Apollo, Hermes, Dionysos, Ares, Artemis, and Athena. See Vlad Borelli and Sabbione, in Lattanzi, *Santuari della Magna Grecia in Calabria,* 40.

21. B. S. Ridgway, *The Severe Style in Greek Sculpture* (Princeton, 1970), 94–95, fig. 126. See Sourvinou-Inwood, "Persephone and Aphrodite at Locri," 116. C. Rolley, *La Sculpture grècque* (Paris, 1994), 1: 386, points out the close parallel for this relief now provided by a relief recently discovered on the Island of Icaria (359–60, fig. 377), with a kourotrophos goddess receiving three children of different ages and two adult male worshipers.

22. E. Simon, "La scultura di Locri Epizefirii," *Atti Magna Grecia* 16 (1976), 476. Simon believes the two women are both goddesses: Demeter (seated) and Hekate. Ridgway, *Severe Style,* argues it is a funerary relief of a "heroized" matron.

23. See F. Giudice, *Vasi e frammenti "Beazley" da Locri Epizefiri* (Catania, 1989); F. Guidice, "La ceramica attica da Locri Epizefiri," in Lattanzi, *Santuari della Magna Grecia in Calabria,* 46–48; F. Brommer, "Themenwahl aus örtlichen Gründen," in *Ancient Greek and Related Pottery,* ed. H. A. G. Brijder (Amsterdam, 1984), 180.

24. J. D. Beazley, *Attic Black-figure Vase-painters* (Oxford, 1956) 146, 7; first published by G. Procopio, "Vasi a figure nere del Museo Nazionale di Reggio Calabria," *Archeologia Classica* 4 (1952), 153–58.

25. The connections between the two scenes are explored by J. Boardman, "Heracles, Peisistratos and Eleusis," *JHS* 95 (1975), 7.

26. See ibid., 7–8, pls. 1–3; *LIMC,* 8: 971–72, under "Persephone."

27. T. Hayashi, *Bedeutung und Wandel des Triptolemosbildes vom 6.–4. Jh. V. Chr.* (Würzburg, 1992).

28. E. Simon, "Neue Deutung zweier eleusinischer Denkmäler des 4. Jahrhunderts v. Chr.," *Antike Kunst* 9 (1966), 84.

29. Boardman, "Heracles, Peisistratos and Eleusis," 6.

30. Diodorus Siculus, *Library of History* 4.23.4; M. Giangiulio, "Greci e non-Greci in Sicilia alla luce dei culti e delle leggende di Eracle," in *Modes de contacts et processus de transformation dans les sociétés anciennes* (Rome, 1983), 785–846, esp. 826–27 on Herakles as *archegetes* of the cult of Kore.

31. H. A. Shapiro, *Art and Cult under the Tyrants in Athens* (Mainz am Rhein, 1989), 77–78.

32. *LIMC,* 8: 340–41, under "Zeus."

33. Votive relief, inscribed as a dedication of Aristarche to Zeus Meilichios from Piraeus, National Museum, Athens, 1431: *LIMC,* 8: 340, under "Zeus," no. 200 (325–300 BC).

34. M. H. Jameson, "Notes on the Sacrificial Calendar from Erchia," *Bulletin de correspondance hellénique* [hereafter *BCH*] 89 (1965), 159–62.

35. M. T. Manni Piraino, "Epigrafia Selinuntina," *Kokalos* 16 (1970), 268–85.

36. G. Manganaro, in *Cronache di Archeologia* 16 (1977), 149, pl. 43.2; M. T. Manni Piraino, "Su alcuni documenti epigrafici della religiosità siciliota," in *Religione e città nel mondo antico* (Rome, 1980), 167–70.

37. M. H. Jameson, D. R. Jordan, and R. D. Kotansky, *A "Lex Sacra" from Selinous* (Durham, 1993); see pp. 81–107 for a full survey of the sources for Zeus Meilichios throughout the Greek world.

38. See Hinz, *Der Kult von Demeter,* 144–52.

39. A limestone relief found in the Malophoros sanctuary showing the Rape of Persephone is another link with Locri: G. Pugliese Caratelli, ed., *Sikanie: Storia e civiltà della Sicilia greca* (Milan, 1985), fig. 203 (dated 530–525 BC).

40. A youthful male figure on a few of the pinakes has been identified as Triptolemos: see Vlad Borelli and Sabbione, in Lattanzi, *Santuari della Magna Grecia in Calabria,* 40.

41. Beazley, *ARV²* 603, 40; Hayashi, *Bedeutung und Wandel des Triptolemosbildes,* 145, no. 70.

42. *Hymn to Demeter* 475.

43. Ibid., 438–40; V. Tusa, "Due nuove metope archaiche da Selinunte," *Archeologia Classica* 21 (1969), 153–71; V. Tusa, *La scultura in pietra di Selinunte* (Palermo, 1983), 109. See also L. Giuliani, *Die archaischen Metopen von Selinunt* (Mainz, 1979), 63–66, who considers other possibilities, such as that all three figures are the Moirai holding spindles. See also L. Beschi, "Demetra e il Ritorno di Kore," *LIMC*, 4: 872, no. 330.

44. See R. van Campernolle, "Les Deinoménides et le culte de Déméter et Kore à Gela," in *Mélanges W. Déonna* (Brussels, 1957), 474–79; D. White, "Demeter's Sicilian Cult as a Political Instrument," *Greek, Roman and Byzantine Studies* 5 (1964), 261–79.

45. See Hinz, *Der Kult von Demeter*, 95–111.

46. S. G. Cole, "Demeter in the Ancient Greek City and Its Countryside," in *Placing the Gods: Sanctuaries and Sacred Space in Ancient Greece*, ed. S. E. Alcock and R. Osborne (Oxford, 1994), 199–216.

47. Diodorus Siculus, *Library of History* 14.63.1.

48. L. Polacco, "I culti di Demetra e Kore a Siracusa," *Numismatica e Antichità Classiche* 15 (1986), 32–33.

49. E. Ciaceri, *Culti e miti nella storia della Sicilia antica* (Catania, 1912), esp. 190–205. See T. J. Dunbabin, *The Western Greeks* (Oxford, 1948), 180. This view was opposed, for example, by Zuntz, *Persephone*, 72–74.

50. Pindar, *Odes*, Olympian 6.93–95; on this passage see G. Sfameni Gasparro, *Misteri e culti mistici di Demetra* (Rome, 1986), 144–45. A scholiast on the passage explains the "white horses" as an allusion to the chariot that brought Kore to Olympos after her return from Hades.

51. The Laganello head: see G. Voza, "Cultura artistica fino al V secolo a.C.," in E. Gabba and G. Vallet, eds., *La Sicilia antica* (Naples, 1980), 2, part 1: 114.

52. E. Manni, "La Sicilia e il mondo greco arcaico fino alla fine del VI secolo a.C.: l'apporto della ierologia," *Kokalos* 30–31 (1984–85), 183.

53. I. Malkin, *Religion and Colonization in Ancient Greece* (Leiden, 1987), esp. 185.

54. Herodotos 7.153.

55. R. Lisle, "The Cults of Corinth" (Ph.D. diss., Johns Hopkins University, Baltimore, 1955), 110–16; P. Reichert-Südbeck, *Kulte von Korinth und Syrakus* (Dettelbach, 2000), 219–58.

56. Plutarch, *Life of Timoleon* 8.

57. Pausanias 2.4.7; N. Bookidis and R. S. Stroud, *Demeter and Persephone in Ancient Corinth* (Princeton, 1987).

58. N. Bookidis, "Dining in the Sanctuary of Demeter and Kore at Corinth," *Hesperia* 68 (1999), 1–54.

59. Hinz, *Der Kult von Demeter*, 56–64; U. Kron, "Frauenfeste in Demeterheiligtümern: das Thesmophrion von Bitalemi, eine archäologische Fallstudie," *Archäologischer Anzeiger* 107 (1992), 611–50. Celebration of the Thesmophoria at Syracuse is attested by Athenaeus 14.647; Plutarch, *Life of Dion* 56.

60. E. G. Pemberton, *Corinth* 18, Part 1: *The Sanctuary of Demeter and Kore: The Greek Pottery* (Princeton, 1989), 5.

61. Pemberton, *Sanctuary of Demeter and Kore*, 133–34, no. 292 (dated ca. 480–470 BC).

62. Beazley, *ARV*2 459, 3; N. Kunisch, *Makron* (Mainz, 1997), 194, no. 319, pl. 107.

63. Pemberton, *Sanctuary of Demeter and Kore*, 144, no. 215 (Middle Corinthian, early sixth century BC).

64. I. Jucker, "Frauenfest in Korinth," *Antike Kunst* 6 (1963), 47–61.

65. D. Callipolitis-Feytmans, "Déméter, Coré et les Moires sur des vases corinthiens," *BCH* 94 (1970), 45–65; see also D. A. Amyx, *Corinthian Vase-Painting of the Archaic Period* (Berkeley, 1988), 228–30, 653–57; and, most recently, E. G. Pemberton, "Wine, Women and Song: Gender Roles in Corinthian Cult," *Kernos* 13 (2000), 85–106.

66. Jucker, "Frauenfest in Korinth," 50–52, nos. 5, 22.

67. *Inscriptiones Graecae* 14.268, lines 5–6.

68. *Hymn to Demeter* 202–5.

69. Diodorus Siculus, *Library of History* 5.4.7; see G. Martorana, "Il riso di Demetra in Sicilia," *Kokalos* 28–29 (1982–83), 105–12; A. Brumfield, "Aporreta: Verbal and Ritual Obscenity in the Cults of Ancient Women," in *The Role of Religion in the Early Greek Polis*, ed. R. Hägg (Stockholm, 1996), 67–74.

70. *Hymn to Demeter* 438–40.

71. M.-T. Le Dinahet, "Sanctuaires chthoniens de Sicile de l'époque archaïque à l'époque classique," in *Temples et sanctuaires*, ed. G. Roux (Paris, 1984), 142.

72. Only from the Late Classical period is there evidence for Demeter cults in Sicily taking on an Eleusinian character: see A. Brelich, "La religione greca in Sicilia," *Kokalos* 10–11 (1964–65), 50.

73. G. V. Gentili, "Incunaboli coroplastici di stile ionico dalla *nésos* siracusana e loro inquadrimento nella scuola plastica arcaica di Syrakosai," *Bollettino d'Arte* 58 (1973), 3–8.

74. Tusa, *La scultura in pietra di Selinunte*, 110. Giuliani, *Die archaischen Metopen von Selinunt*, 37–40, accepts this identification.

75. R. R. Holloway, *Influences and Styles in the Late Archaic and Early Classical Sculpture of Sicily and Magna Graecia* (Louvain, 1975).

76. Beazley, *ARV*2 603, 34; Hayashi, *Bedeutung und Wandel des Triptolemosbildes*, 145, no. 69.

77. For example, the relief from Eleusis, *LIMC*, 4: 867, under "Demeter," no. 269; or the white-ground lekythos, National Museum, Athens, 1754, *LIMC*, 4: 864, under "Demeter," no. 222.

78. For example, *LIMC*, 4:867–68, under "Demeter."

79. Gentili, "Incunaboli coroplastici," 5, fig. 1, restores the composition as two standing figures. So also Voza, in *La Sicilia antica*, 116.

80. E. Mitropoulou, *Corpus I: Attic Votive Reliefs of the 6th and 5th Centuries* (Athens, 1977), 108–10, listing 15 examples between 460 and 400 BC. For the Catania relief see *LIMC*, 4: 865, under "Demeter," no. 229.

81. Glyptothek, Munich, 198: *LIMC*, 4: 865, under "Demeter," no. 232.

82. Gentili, "Incunaboli coroplastici," compares the kouros from Anavysos (Kroisos), Antiope from the Eretria pediment, and the Kore Acr. 616; G. M. A. Richter, *Korai: Archaic Greek Maidens* (London, 1968), figs. 420–22. But this kore is dated by E. Langlotz, in H. Schrader, *Die archaischen Marmorbildwerke der Akropolis* (Frankfurt am Main, 1939), 136, no. 106, to ca. 490. See also B. A. Barletta, *Ionic Influence in Archaic Sicily* (Gothenburg, 1983), 83, who characterizes Syracusan sculpture as "a fusion of East Greek style and Western form."

83. G. A. Privitera, "Politica religiosa dei Dinomenidi e ideologia dell' optimus rex," in *Festschrift Angelo Brelich* (Rome, 1980), 393–411; see also the references above, n. 44.

84. The coincidence of the dates is noted by Herodotos 7.166; Aristotle, *Poetics* 1459 a 25. In 470 BC, Pindar had already noted that the victory at Himera was on a par with those at Salamis and Plataea: *Odes*, Pythian 1.75–80.

85. Herodotos 8.65.

86. Ibid., 9.101.

Sanctuaries of Magna Graecia and Sicily

EMANUELE GRECO

The concept of the sacred that the Greek settlers carried with them when they founded new cities in the West was maturing during the eighth century BC, the crucial period for the development of the city-state, or polis. Establishment of Western Greek colonies during this special historical period coincided with (and sometimes preceded) the creation of mainland Greece's first cities. Consequently, the settlers did not have "models" for their settlements, and the colonial experience was a fundamental moment of experimentation. Similarly, the colonies, with their new layouts and ways of organizing the surrounding territory and urban centers, represent valuable ways of viewing and understanding the dynamics of settlement procedures.

The traditional division of space into public, sacred, and private areas is well known from literary and epigraphic evidence as early as the Archaic period, and particularly from the lively philosophical debates of the fifth and fourth centuries BC. It is by now certain that the colonial communities originally divided the surrounding territory and urban space, reserving tracts of land for sanctuaries in both the countryside and the city. In addition to the land where the *temenos* (precinct), the setting of the cult, was located, the colonies assigned land to the sanctuaries to provide for their economic support.

The sphere of the sacred certainly played a fundamental role in the political organization of the homeland, at least as a unifying element for vast and fragmented territories.[1] Therefore, in mainland Greece the sanctuary became an integrative element in terms of territorial, and then political, identity. Its function in the West was equally fundamental.

The deity to whom a sanctuary was dedicated and the sanctuary's location within the territorial, or urban, setting of the colony indicate its intended functions. Depending on function and location, sanctuaries can be subdivided into two large categories: urban sanctuaries (that is, those located within a city's boundaries), and sanctuaries of the surrounding territory (that is, outside the walls, but near the urban center). Structural elements that characterize a sanctuary include the surrounding enclosure that delimits its total area, known as the *peribolos*, inside which are located the sacred building and the altar to the named deity, and where other cults may be practiced, expressed in forms more or less monumental.

In general, the polis sanctuary, located inside the urban setting where the cult of the city's guardian deity is celebrated, is a privileged observation

point for understanding the city's history and structure. This is the case not only in terms of the city's spatial organization—its internal divisions and topographical location—but also in determining the ritual functions related to the cults, and their political and social roles from the time of the colony's founding. A clear example of this is given by the two best known Achaean colonies: Metapontum and Posidonia. From the arrival of these cities' first settlers, a wide area was reserved for public cult and political activities in separate but adjacent areas located near the city walls, close to important access ways. Some cults were strictly religious, while others encompassed important civic functions, such as Zeus as guardian of agorai (public, political, and economic areas) and warrantor of *parrhesia,* or freedom of speech. They were located in the colonies not only at the sacella, the small altars dedicated to the cult of the founding hero, but also at dedicated areas on the roads and in the countryside.

The functions of the extra-urban sanctuaries were very complex. Besides defining the city's space of influence and property, and marking and defending boundaries of its *chora* (agricultural territory), the sanctuaries facilitated integration with the local, or Greek, neighboring populations through cult practices. At times it appears that some assimilation of pre-existing indigenous rites had occurred, particularly where those rites could easily be accommodated with cults based on natural elements or phenomena. Possibly this is what happened in Sicily, in Selinus, in the sanctuary of the Demeter Malophoros, as well as with the cult of Zeus Meilichios. In Agrigento the two deities had sanctuaries located on the western tip of the southern sacred area, where there also is evidence of certain indigenous cults. Similarly, in the same city the goddess Demeter supplanted a cult devoted to the waters, formerly established in San Biagio (Metapontum). Studies have pointed to the "mixed" characteristics of some extra-urban cults in Gela, derived from the assimilation of local elements. The role played by relationships with local populations in Magna Graecia is made very clear by the extra-urban sanctuary of Metapontum, dedicated to Artemis, on the hill of San Biagio. For Posidonia, Artemis also protected the colony's sovereignty over its territory on the wooded slopes of the eastern hills that delimit the chora.

In the Achaean colonies of Sybaris, Croton, Metapontum, Posidonia, and Caulonia, the polis goddess Hera was entrusted with governing the complex network of relationships with the local neighboring Greek populations,

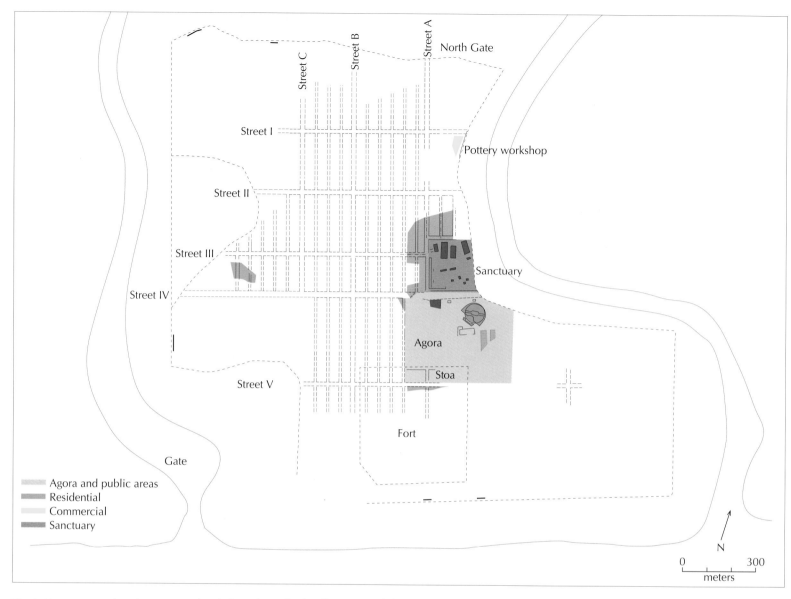

Fig. 1. Metapontum: plan of the city. After G. Pugliese Carratelli, ed., *The Western Greeks,* exh. cat., Palazzo Grassi, Venice (Milan, 1996), 248 (De Siena and Mertens).

emphasizing the ethnic diversity of the community to which the sanctuary belonged.[2] Here I am referring to the Etruscan speakers to the north of the Sele River and those inland whose life revolved around the river, and to the boundaries of the chorai of Taranto and Metapontum, near the Bradano River, and the sanctuary of Capo Lacinio in Croton.

SANCTUARIES OF METAPONTUM

Due to extensive archaeological research, the Achaean city of Metapontum is among the best known colonies. In Metapontum, occupation of the agricultural and urban territories occurred simultaneously. This is precisely expressed by the extra-urban sanctuaries, "located always in sites privileged either for the presence of natural resources (springs) or for the easy access to a road network."[3] Different explanations have been given for the reasons behind the choice of sanctuary locations, but their important political functions—to mark the physical boundaries of the Greek occupation and to favor relations with local populations—are very clear. Although dangerous generalizations should be avoided, it is evident that within the area of the colonies a unified picture begins to emerge at least in the Archaic period. It shows that cult behavior served to enhance the cultural identity of the set-

tlers, to preserve the historical memory, and to restate the city's socioeconomic and political structure through the determining role of land ownership and hereditary rule, or oligarchy.

The single deities, aspects of their guardianship, virginal and military, still poorly differentiated, receive particular attention in the sanctuaries outside of the city walls (*extra moenia*). These sanctuaries become important points of reference and political convergence, especially for large families (*gene*) that in reality control all the means of production, and derive their wealth from property ownership. On the other hand, the religious synthesis is made in the urban sanctuary. Here, under the protection of the goddess Hera, who serves to confirm and guarantee the institutions for the citizens of all the Achaean *poleis:* Sybaris, Croton, Caulonia, and Posidonia. In addition, the cults of other deities imported from the homeland are expressed and duplicated.[4]

The division of space was characteristic of the city plan, from the arrival of the first contingent of settlers (fig. 1). The wide area between the Bradano and Basento rivers and the sea was chosen as the space to build the city; consequently, it was enclosed by a wall of mudbricks, completed in the century following the city's founding. Later, the inner area was subdivided following rational criteria in order to allocate land for specific purposes: for the deities, for the city administration, and for the citizens. This land division resulted in the creation of a sacred space for the sanctuaries, a civic space (which coincides with the agora), and a space assigned to individual properties, all within the urban walls. In Metapontum, sacred and civic spaces were adjacent, located in an area northeast of the city near the walls (fig. 2).

Fig. 2. Metapontum: plan showing the urban sanctuary and agora. After Pugliese Carratelli, *Western Greeks,* 253 (above right) (De Siena, Mertens, and Schötzenberger).

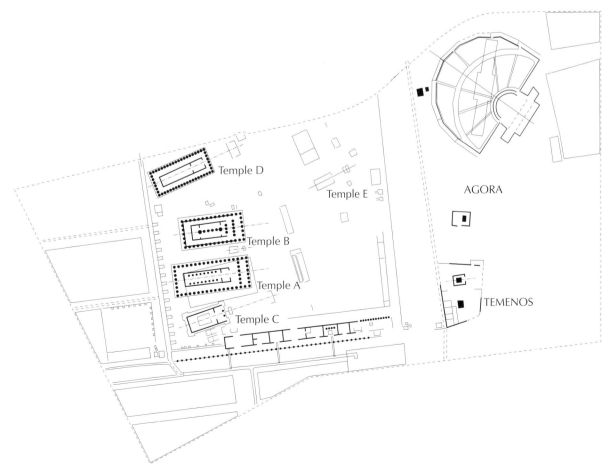

The area occupied by the sanctuary was approximately 180 x 150 meters, while the agora, or public square, covered an area of approximately 290 x 300 meters. The boundaries were defined on the ground by a portico that marked the transition from the eastern rim of the sanctuary to the western side of the agora. Sacella and sacred areas of limited size also were identified in the agora and linked to civic activities. The agora was under the protection of Zeus Agoraios, as recorded by an archaic inscribed pillar discovered near the *ekklesiasterion* (assembly hall), and belonging to a small sacred enclosure. Occupation of the space devoted to the sanctuary appears to be contemporaneous with both the arrival of the settlers, as shown by data collected during the excavation, and the first major subdivision of the urban space. The small areas of cult, recognizable by the concentration of votive objects and sacrificial remains, are placed in a sequence that more recent buildings will respect.

The cult of Apollo Lykaios at Metapontum was located in the large urban sanctuary. Aniconic forms (the so-called *argoi lithoi*) were found around temple B and attest to cult-related activities. It appears that this cult was also practiced outside the walls in the locality of Pizzarieddo, north of the city. The cult of Artemis was identified in the urban sanctuary associated with temple D; she appears to be among the earliest deities of the Metapontine pantheon according to the antiquity of her cult's site, which underwent several building phases. The first, dated around the first half of the sixth century BC, was identified in the urban sanctuary. The cult of this goddess also extended to the extra-urban territory and was particularly important in San Biagio della Venella, where the famous sanctuary erected around a natural spring has been much studied.

One of the oldest cults identified in the city was that of Athena, to whom temple C, built between the first and second quarters of the sixth century BC, was dedicated. The famous terracotta metopes sculpted in relief are part of her decorative display, showing a procession of female figures with a carriage pulled by she-mules. This cult compares iconographically with the contemporary cults of Francavilla Marittima and Policoro, although no similarities are known from the territory around Metapontum itself.

During the mid sixth century BC a grand construction project that included the erection of two large Doric peripteral temples—temple A dedicated to Hera, and temple B dedicated to Apollo—was initiated in the sanctuary. These temples are outstanding for their important architectural features, such as the repetition of columns on the eastern front, and the dimensions and parallelism that enhance their monumentality. They are also extraordinary for their orientation, which diverges from that of previous buildings of the beginning of the century and conforms perfectly to the arrangement of the urban plan. The orientation of temple A was even modified during construction.

Occupation of the surrounding territory was carried out at the same time, adhering to a precise program and implemented through the creation of points that facilitated contact with, and control by, the urban area. The most famous extra-urban sanctuary of the Metapontine territory is the one dedicated to Hera, the polis deity of the Achaeans. Located about five kilometers to the northwest of the present-day village, it was actually close to the

colony's city walls. Archaeological documents show that the sanctuary was visited from the very beginning of colonization. Its role was particularly significant because of its location in the outlying agricultural territory, or chora, on the border with the territory of Taranto, the Laconian colony that was limited in its expansion precisely because of the new Achaean colony of Metapontum. Besides controlling and defending the borders, the sanctuary asserted the settlers' ethnic origins, and the deity's presence sanctioned their right to occupy the vast plain.

Those sanctuaries located at a greater distance from the city, in the chora, represented the polis and must have played important roles in the mediation and control of the territory (fig. 3). The sanctuary of Artemis in San Biagio, within the territory of Metapontum, is well known. Archaeological finds show that it was frequented from the time of the settlers' arrival. At the beginning, the deity did not show characteristic attributes, and certainly other deities were worshiped in the sanctuary as well. Lousoi in Arcadia has been suggested as a possible place of origin for the main cult; this suggestion was made after comparing the archaeological remains of Metapontum with a verse from the eleventh epinician ode of Bacchylides, composed to celebrate the Delphic victory of Alexidamos of Metapontum.[5] Epigraphic records recall the presence of Zeus Aglaios. The supplemental name (*epiclesis*), Aglaios, suggests a Peloponnesian/Achaean origin. The central presence of a spring was an important reason for the sanctuary's location, as can be seen in other sacred localities of the territory.

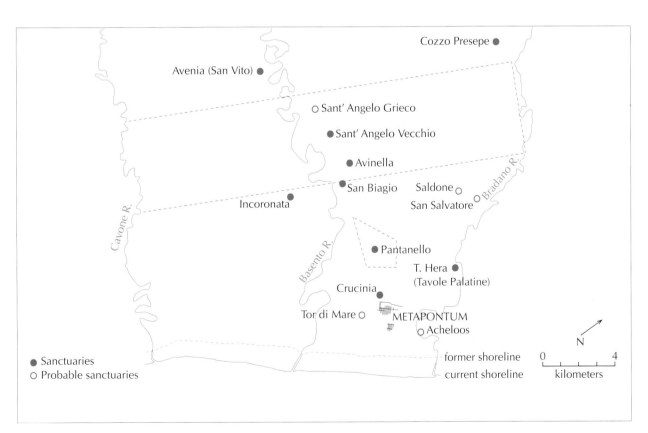

Fig. 3. Metapontum: map of the chora between the Cavone and Bradano rivers, showing the sanctuaries. After Pugliese Carratelli, *Western Greeks*, 363.

SANCTUARIES OF POSIDONIA

Equally well known, thanks to recent excavations, is Posidonia, the other large Achaean colony of the beginning of the sixth century BC, located on the Tyrrhenian Sea. According to ancient sources, the colony was founded around 600 BC by the Sybarites. It is located at the center of a rich plain crossed by several rivers that ensure its year-round fertility.[6] Its origins are still a subject of lively debate. One theme of discussion considers the possibility that the colony was founded in two phases. Among the many hypotheses is the suggestion, not supported by archaeological evidence, that the first settlement may have been near the promontory of Agropoli, the best landing site. However, the recovery of Archaic architectural terracottas[7] does seem to support the hypothesis of Zancani Montuoro, who located here the sanctuary of Poseidon Enipeus, mentioned by Lycophron.[8] In light of present evidence, one should probably imagine a synchronous occupation of the territory from the mouth of the Sele River to the promontory of Agropoli. This seems to be indicated by the other extra-urban sanctuaries—for example, the Heraion at the mouth of the Sele and the sanctuary of Fonte di Roccadaspide.

In the urban center, ceramics and a small sacred building in the northern sanctuary, likely the oldest temple of Athena, document the first phases of life (fig. 4). Based on the recovery of terracottas in situ, the temple is dated to 580 BC. A few decades later, temple buildings in the southern sanctuary became monumental, as seen in the temple of Hera.

Archaeological finds have shown that the wide area dedicated to the community's sanctuaries and agora was reserved for these public activities

Fig. 4. Posidonia: plan of the city. After Pugliese Carratelli, *Western Greeks,* 249 (Greco and Theodorescu).

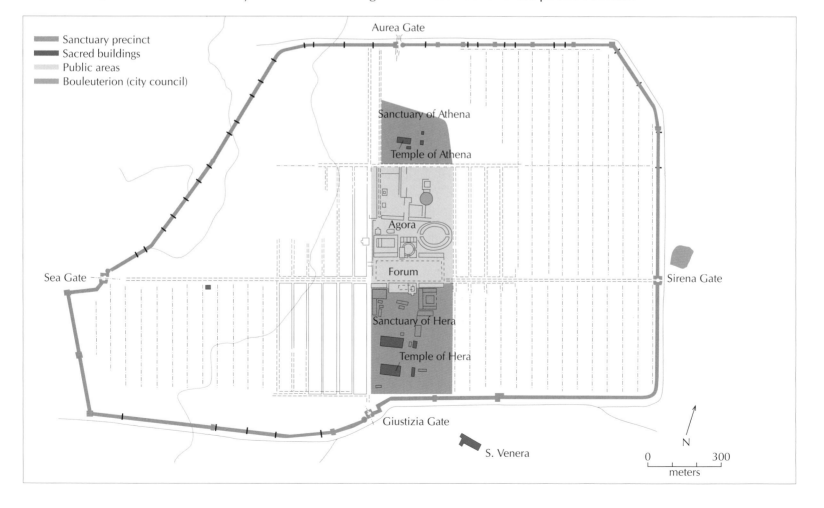

- Sanctuary precinct
- Sacred buildings
- Public areas
- Bouleuterion (city council)

Aurea Gate

Sanctuary of Athena

Temple of Athena

Agora

Forum

Sea Gate

Sirena Gate

Sanctuary of Hera

Temple of Hera

Giustizia Gate

S. Venera

N

0 300
meters

from the very beginning,[9] something also seen in the layout of Metapontum. This was done without erecting monuments to mark its boundaries, as will happen a few generations later. In fact, construction of the first roads dates to the last decades of the sixth century BC.[10]

The period between the last decades of the sixth century BC and the middle of the fifth century BC was a time of economic growth and great building activity, the most evident testimonies of which are preserved. The first roads were built to physically define the division of space as conceived two generations earlier. One of the city's best known areas, the rectangular public space extends north to south approximately one kilometer and is delimited by the major thoroughfares, or *plateiai*. The layout of the thorough-fare that defined the area to the west is clear, while the eastern and northern boundaries are not well delineated. Two additional plateiai, perpendicular to those just mentioned, subdivide the wide space into three sectors: to the north the precinct, or temenos, of Athena; at the center the square of the agora; to the south the southern sanctuary with the temples of Hera and the so-called temple of Neptune, actually identified as a shrine of Zeus (or Apollo).[11] The first monumental temple was built to Hera, the polis deity, followed later by the small prostyle temple at the border of the east-to-west plateia in the southern sanctuary, then the temple of Athena, and finally the temple of Neptune, slightly before the mid fifth century BC.

Until a few decades ago, the agora was thought to coincide with the more recent Roman Forum. Its actual area was discerned thanks to the discovery and identification of two peculiar monuments: the ekklesiasterion, where meetings of the assembly took place, and the *heroon,* site of the exclusively political cult of the founding hero. This monument is similar to others in other cities. Its location reveals its importance as a marker (*sema*) of a kind of refounding of the city, constructed at the moment of the definition of the urban space as it was organized on the ground. Recent excavations also have located the eastern edge of the agora[12] and have shown that the regular urbanization of the area did not begin before the third century BC.

During the Lucanian phase, Posidonia retained the urban layout created by the Greek settlers. However, many additional building projects were carried out in the sanctuaries. Several buildings and altars were added, especially in the southern sanctuary, both as a result of new cults introduced by the conquerors and as an expression of renewed interest in the old cults (fig. 5). A stone wall, or peribolos, that retraced the previous, possibly wooden one, enclosed the temenos. In addition to the large roofed porch (*stoa*) that delimited the middle plateia and acted as the backdrop and monumental entrance to the temenos, a new sacred complex was built during the second half of the fourth century BC on the pre-existing one from the previous century and was dedicated to a health-bestowing deity. The identification of this complex is based on a comparison with building E in Epidaurus.[13]

The agora continued to be used for civic activities that likely took different forms. There is interesting evidence of cults (clearly included in the Sannite pantheon), of which we have a few important archaeological finds. The stele with a dedication to Jupiter, written in Oscan language with Greek characters, is perhaps a recollection of the cult of Zeus Agoraios. Objects

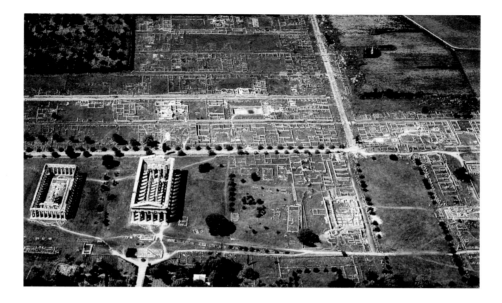

Fig. 5. Posidonia: aerial view of the southern sanctuary, looking west. From Pugliese Carratelli, *Western Greeks*, 153.

from a votive deposit (yet to be discovered) are related to the cult of Demeter and possibly to a recently discovered building (a *tesmophorion?*).

Posidonia's extra-urban sanctuaries were essential to the organization of the surrounding territory. Their function was not limited to the definition of agricultural space. From the second half of the sixth century BC, the sanctuary of Hera, near the mouth of the Sele, marked the northern boundary of Posidonia's chora (fig. 6). The southern border was marked by the sanctuary of Poseidon, and the eastern, toward the wooded slopes of the interior, by the sanctuary of Artemis.[14] Entrusted with institutional and political roles, these sanctuaries acted as a filter for contacts with other communities and the outside world.

Several additional clues document a network of small countryside sanctuaries that played an important role in the organization of the urban terri-

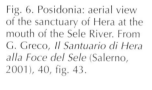

Fig. 6. Posidonia: aerial view of the sanctuary of Hera at the mouth of the Sele River. From G. Greco, *Il Santuario di Hera alla Foce del Sele* (Salerno, 2001), 40, fig. 43.

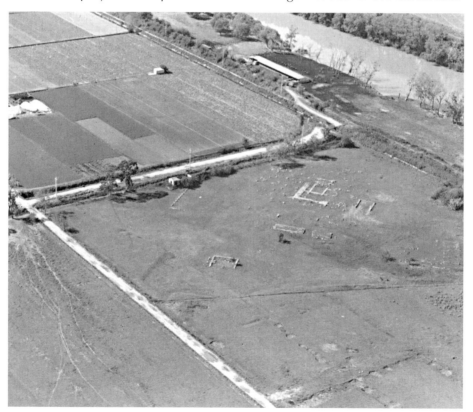

tory in this colonial world.[15] Other sanctuaries were identified near the city—for example, the sanctuary of Santa Venera and the sanctuary at the modern railway station near the Archaic and Classical city. From the fifth century BC on, there are no signs of the creation of new sanctuaries, although numerous archaeological finds indicate the comprehensive organization of the territory through a dependent distribution of scattered rural settlements.[16]

In the fifth century BC, the large sanctuary of the Sele shows signs of the same building activity already noticed in the city. The sanctuary continued to retain its role as a mediator not only with the populations north of the river, but also with those inland who used the river for trading purposes. In addition to the main temple, roughly contemporary with the Athenaion in the city, the sanctuary was enriched by new structures, porticos, and a banquet hall.

As already seen, the rural sanctuaries had different functions and characteristics. A good example is the sanctuary of Albanella to the northeast of the chora, probably dedicated to Demeter. Additional small cult sites existed around the city, next to the entryways to the urban center. These were associated as well with the sacred significance of city walls in ancient times. A small sanctuary was recognized in the locality of Linora, but it is a cult site linked to the settlement next to the road that connected the town to the port of Agropoli. These sanctuaries exerted their organizing and controlling functions on the surrounding territory, which in the Archaic period was not settled as fully as in the following centuries. The large Heraion on the Sele River now entered a new phase of lively cult and building activity. In addition to the porticos, the peculiar "square building" was created, an element of discontinuity both for the massive use of architectural elements borrowed from Archaic buildings, and for the strictly feminine and matrimonial characteristics that have been connected with its cult.

The fourth century BC was a time of noticeable population growth and strong assimilation of Greek cults by the Lucanians who now ruled the city. This development was most apparent in the countryside, where small rural sanctuaries and settlements proliferated.

SANCTUARIES OF ELEA
By contrast, a very different situation existed in Elea,[17] the Phocaean colony founded in 540 BC on a promontory very close to the sea (fig. 7). The city developed to the north and south at the foot of the promontory, with sanctuaries apparently distributed on the hill of the acropolis toward the interior. The acropolis, on which most of the original settlement was located, included clusters of dwellings built in the typical polygonal shape as well as the polis sanctuary on its western rim.

Changes during the fifth century BC led to a more urban environment. Buildings erected on the acropolis between 480 and 450 BC were obliterated in the wake of a vast construction program that redefined the urban topography. From this moment on, the acropolis ceased to have a residential function and became instead a monumental center of urban cult. This change resulted in the construction of a massive terraced wall that may be considered the first peribolos of the Classical period. The sanctuary spread out to

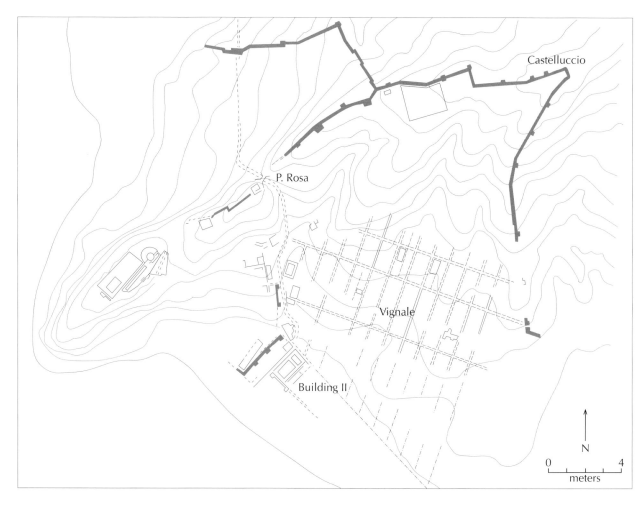

Fig. 7. Elea (Velia): plan of the city. After Pugliese Carratelli, *Western Greeks,* 250 (below) (Krinzinger).

occupy the entire acropolis. At the top was the temple dedicated to the polis deity, possibly Athena; unfortunately, it was devastated by plundering during medieval times. In the fourth century BC the entrance was transformed by construction of a theater on the east side of the temple's terrace, and by the creation of a road that, following construction of the theater's *cavea* (auditorium), reached the new *propylon* (entrance gate). Two stoai in front of the terraced wall and to the west of the temple formed a kind of enclosure around the temple. There was a continuation of the earlier temenos with the expansion of the sanctuary toward the eastern ridge of the acropolis. Several cults have been partially identified in this temenos, both by their archaeological remains and by abundant epigraphic evidence: Poseidon Asphaleios, Zeus Ourios, Leucothea, and the Kairòs. At the extreme eastern edge of this series of sacred precincts was a large square paved with sandstone blocks. On its west side was a large altar identifying the area as an *agora theon* (sacred place of assembly).

SANCTUARIES OF LOCRI

The concept of a "sacred belt," a term coined by Roland Martin to describe the topographic distribution of sanctuaries around an urban settlement, certainly applies to Locri (fig. 8). Locri was founded at the end of the eighth or the beginning of the seventh century BC by people from the Greek Locris on the mainland. However, the sources are not precise concerning the foundation date or the specific origin of the founders (Locris Ozolis or Locris Opuntia).

Fig. 8. Locri: plan of the city. After Pugliese Carratelli, *Western Greeks,* 251 (Barra and Bagnasco).

The settlement developed in two phases. After the short-lived occupation of Capo Zefirio, the city was moved to a more favorable location in the Esopis valley. The distribution of Locrian cult sites, urban and peri-urban, is well known. The sanctuary of Zeus, centrally positioned within the city and its circuit of walls, is famous for the bronze tablets found in a stone container at the site. These tablets describe aspects of the sanctuary's administration, particularly during the Hellenistic period. From this temple, located near the theater, only the *acroterion* and the unusual pentaglyph of the frieze are preserved. The sanctuary of Marasà, dedicated to the Dioscuri, tutelary polis gods and expressions of the aristocratic equestrian class, was constructed at the city's eastern edge near the fortifications built in a later period (fig. 9). The sanctuary of Aphrodite, located next to the southern walls of the city facing

the sea near the city gate, was probably connected as well to the city's port. The sanctuary is well known for its U-shaped stoa (porch), in whose *oikoi* (small rooms) sacred prostitution was probably practiced, and for the numerous *bothroi* (pits) with offerings to the goddess. On the fringes of the city was the sanctuary of Kore, located outside the walls in a small valley close to the Mannella hill. The small shrine dedicated to Athena was set nearby on the same hill.

With regard to the Locrian sanctuaries in the surrounding territory, it is important to note the lack of archaeological evidence that would confirm the identification of cult sites. Reports of altars near the Sagra River, possibly erected in gratitude to the Dioscuri for their help in the military success against Croton, may have some merit but are not yet confirmed by archaeological finds. It is definitely possible that the natural border between the two territories was in fact outlined, almost "marked," by a sacred sign—a sanctuary whose traces, however, are lost. At present, the southern border with Rhegium, which sources locate on the river Halex, is still uncertain. A small votive deposit recovered near the inner border with Medma represents evidence of a cult, though with no visible monuments.

Fig. 9. Locri: sanctuary of Marasà. From G. Pugliese Carratelli et al., *Megale Hellas: Storia e civiltà della Magna Grecia* (Milan, 1983), fig. 248.

From the time of the earliest settlements, Sicily presents an important picture of the religious life of the Greek colonists, with rich and imposing urban sanctuaries as well as small but highly frequented cult sites spread out in the surrounding territory.

SANCTUARIES OF GELA

Gela, founded at the beginning of the seventh century BC by Rhodian and Cretan colonists, was built on a narrow ridge parallel to the sea. The Archaic city's acropolis was located at the hill's eastern edge (fig. 10). Also on the acropolis is a shrine, temple A, identified as dedicated to Athena by the objects found in the votive deposits and dated to the sixth century BC. In the following century, temple B, dedicated to the same goddess, was built on the same site. A large temple foundation, located to the northwest, can possibly be interpreted as the shrine of Zeus Atabyrios, belonging to the sixth century BC. Temple C was erected around 480 BC, a grand Doric structure southeast of temple B that provides evidence of the tyrannical regime's building pro-

gram. Other poorly preserved archaeological remains of the sixth century BC belong to a temenos dedicated to an unknown deity; the imposing architectural elements suggest that it may well be the sanctuary of Zeus Atabyrios. The cult of Hera, located to the west of the acropolis, was established in the seventh century BC. A votive deposit and architectural terracottas are related to this cult.

The sacred extra-urban areas that surround the city are better known. Judging by the objects consecrated there, a large sacred complex was dedicated to the cult of Demeter, which was practiced in the open air during the seventh century BC. Subsequently, a shrine was built in the sixth century BC on the hill's western sides. On the opposite side of the hill, several small cult sites were apparently all dedicated to Demeter and Kore, although a possible identification with Aphrodite and Dionysos has been proposed.[18] A sanctuary on the northwestern side of the hill was perhaps dedicated to Hera Argiva.

The main extra-urban sanctuary dedicated to Demeter Thesmophoros and possibly related to the family of the Deinomenid dynasty was located on the Bitalemi hill facing the city. This cult is extremely ancient, dating to the first phase of the settlement. Traces in the archaeological record indicate that

Fig. 10. Gela: map of settlements and sanctuaries. After Pugliese Carratelli, *Western Greeks*, 277 (right).

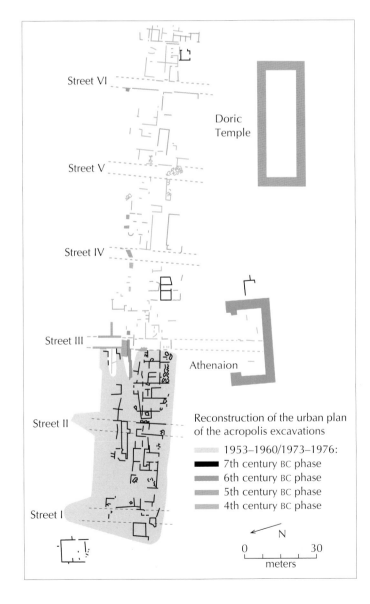

Street VI

Doric Temple

Street V

Street IV

Street III

Athenaion

Street II

Reconstruction of the urban plan of the acropolis excavations

1953–1960/1973–1976:
7th century BC phase
6th century BC phase
5th century BC phase
4th century BC phase

Street I

N

0 30
meters

local people frequented the site before construction of the sanctuary, attesting to the sporadic presence in the area of older local groups. However, this cannot be considered decisive proof of a pre-existing indigenous cult. Archaeological research has identified the first phase, dating to the seventh century BC, during which the rites were performed mostly outdoors. Scanty remains of mudbricks indicate the presence of small structures of uncertain function in the temenos. From the first phases the sanctuary is characterized by the richness of its votive deposits, placed in pits and covered with inverted vases.

Later, around the middle of the sixth century BC, a terrace was constructed. It was made of mudbricks and must have supported a number of sacella with walls of unbaked clay standing on a stone base. Destruction of these edifices during a fire around the mid fifth century BC caused them to be rebuilt in stone, preserving their original arrangement. The destruction inflicted by the Carthaginians in 405 BC seems to have obliterated life in the city, until its new founding by Timoleon in 339 BC.

SANCTUARIES OF AGRIGENTO

Agrigento (Akragas), founded by Gela in 580 BC, represents an even better example of what Martin called a "sacred belt," as seen in the arrangement of the sanctuaries that surrounded this city. The urban settlement was located atop two long and narrow hills, the Hill of Girgenti and the Rupe Atenea, and on the southern plateau (fig. 11). The extension of the city was impressive. It encompassed a sequence of hills as far as the Hill of the Temples, at whose base the so-called Valley of the Temples offered excellent possibilities for a regular urban settlement and for the installation of harbor structures along the nearby coast. The urban settlement was organized along a system of perpendicular road crossings, with the juxtaposition of two blocks with different orientations. The reason behind this difference is not well understood, but was possibly due to factors related to the local geomorphology. The agora, or public square, whose presence is clearly indicated by the ekklesiasterion, probably served as a kind of "hinge" between these two different orientations. The imposing ring of walls, praised by the ancient sources for its grand construction, is known for its expansive, preserved sections, generally dated to the sixth century BC. However, substantial restorations may be attributed to later periods.

The city's modern fame is due mainly to the series of sanctuaries erected along a semicircular arch on the rocky ridge that dominates the urban site. Sanctuaries of Athena and Zeus dominate the highest point of the acropolis, known as Rupe Atenea. The characteristics of these two deities relate more to the corresponding deities of Rhodes than to those of Gela. The epiclesis of Atabyrios given to Zeus is not known in Gela. The same is true of the college of priests, which refers instead to the Hierothyes known in Rhodes. Athena, although she was not called Lindia, wears all the same ornaments that adorn the goddess in both Gela and Lindos on the island of Rhodes. A particular rite known as *apura hiera* recalls one practiced on Rhodes.

The independent position of the sacred areas is shown by their crown-like distribution. On the acropolis are the temple of Zeus Atabyrios and the sanc-

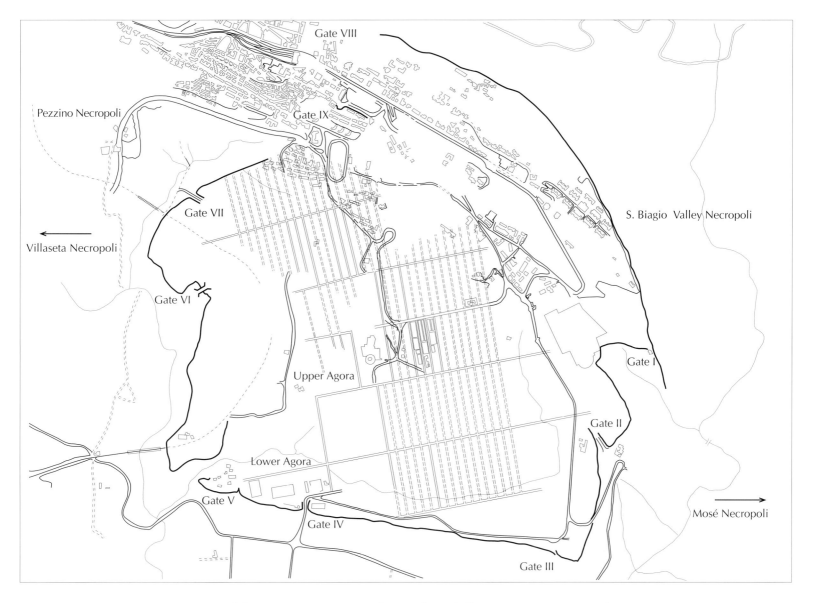

Fig. 11. Agrigento: plan of the city. After L. Franchi dell'Orto and R. Franchi, *Veder Greco: Le necropoli di Agrigento*, exh. cat., Museo Archeologico Regionale di Agrigento (Rome, 1988), 237, fig. 1.

tuaries of the Rupe Atenea. On the northern hill are the sanctuaries of San Biagio. Lastly, the southern hill is completely dedicated to cult practice, from the chthonic deity of the western rim to the temple of Hera Lacinia on the opposite side. In fact, precisely on this hill, almost a century after the city's founding, there developed the "most extraordinary group of temples in western Greece."[19]

On the so-called Hill of the Temples, the architectural monuments seem to be placed in order to achieve a certain juxtaposition, in what has been defined as a "'processional kind' of composition."[20] From the point of the temple of Hera Lacinia to the western edge of the hill where the chthonic deities are located, the temples are arranged in alignment with the road that connects them, keeping a roughly east-west orientation. This arrangement does not attempt to give a particular organization to the buildings' spaces and volumes. The first evidence of cult practice, dating to the sixth century BC, is found here, near the so-called temple of Vulcan on the hill's western slope. The temple of Herakles is the oldest among the monumental temples, dated to the end of the sixth century BC. The nearby temple of Zeus (Olympieion) was probably planned at this time as well. After the victory against the Carthaginians in the battle of Himera (480 BC), the resulting in-

Fig. 12. Agrigento: temple of Concordia, looking northwest. From G. Pugliese Carratelli et al., *Sikanie: Storia e civiltà della Sicilia greca* (Milan, 1985), fig. 545.

Fig. 13. Agrigento: plan of the area of the sanctuary of Zeus at the Colimbetra. After E. De Miro, *Agrigento I. I santuari urbani. L'area sacra tra il tempio di Zeus e Porta V* (Rome, 2000), 2: fig. 1.

flux of slave labor enabled the tyrant Terone to begin an ambitious program of monumental public building. This program included, in particular, the temples and the *kolymbetra* (grand fishery) populated with fish and birds, and equipped with a complex hydraulic system. Attesting to this plan are the grand temples that surround the city like a crown: the temple on the Hill of Girgenti, the temple of San Biagio, temple L (480–460 BC), the temple of Hera Lacinia, the temple of the Dioscuri (450 BC), the temple of Concordia (fig. 12), the so-called temple of Vulcan (440–430 BC), the temple of Asclepius (410 BC), and especially the imposing temple of Zeus (Olympieion), started in 480 BC and still unfinished at the time of the great defeat of 406 BC.

This last temple, together with its sanctuary (fig. 13), is topographically separated from the others. It was surrounded by a large plateia with three *stenopoi* (narrow streets) and flanked by residential districts.[21] To the west is another sanctuary enclosed by an L-shaped stoa, where a stone-paved square, a shrine, and a *tholos* (circular building) were identified. Beyond these, near a city gate, are in succession: the sanctuary of the chthonic deities, an Archaic temenos, the kolymbetra, and finally the temple of Vulcan. The temple of Zeus is an impressive building, measuring 112.7 x 56.3 meters. Its structure is peculiar, with a colonnade closed by a high wall. At a certain height several large *telamones* (standing nude male figures)

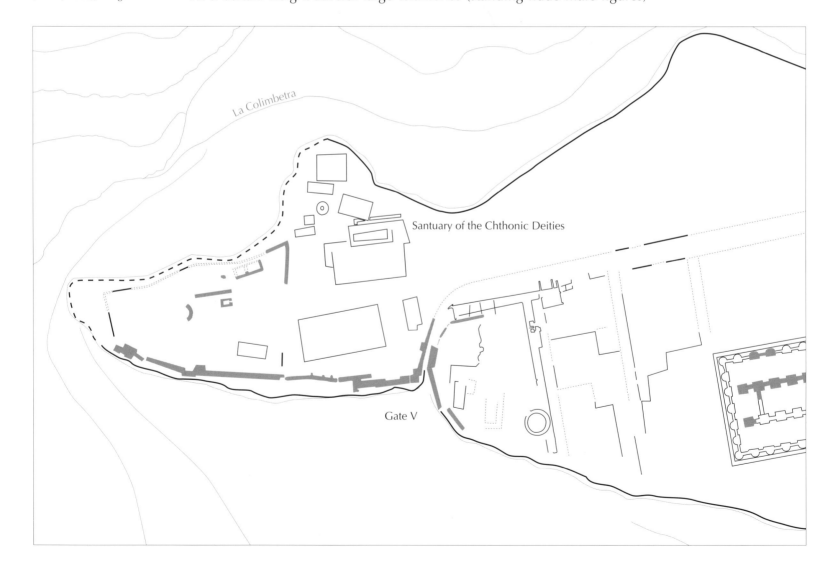

La Colimbetra

Santuary of the Chthonic Deities

Gate V

were placed on a ledge among the semi-columns to better distribute the architrave's weight. In addition, the temple's cella, or central room, was constructed with a wall enlivened visually by several pillars. The entire building was made of small stone blocks with refined sculpted marble decoration.

The sanctuary of the chthonic deities that Martin defined as of "open" type is located on the western edge of the city's southern hill. At this site, elements pertaining to the cults practiced there are found juxtaposed with one another: circular and rectangular altars, along with very simple small shrines. This is one of the few sanctuaries where archaeological research has been able to verify that the Greek sanctuary was superimposed on a previous site of an indigenous cult whose sacrificial remains and votive deposits also were found. However, one should not be tempted to recognize in this type of sanctuary elements of continuity with local cults.

SANCTUARIES OF SELINUS

Selinus, the colony founded by the citizens of Megara Hyblea around 630 BC, enjoyed a favorable location on a promontory facing the sea, with the choice of two ports, flanking streams, and two hilly ridges that provided protection to the east and west (fig. 14). The magnificence of the sanctuaries, located in designated sectors inside and outside the urban walls, is evidence of how rich and powerful the city had become.

Distribution of the sanctuaries of Selinus presents some peculiarities. The sacred areas are located primarily in three large sectors. In addition to the area on the acropolis, inside the walls are two others that stand out. One is the complex at the base of the hilly ridges to the east (temples E, F, and G), and the other is in the west (sanctuary of the Malophoros). The latter was almost certainly related to harbor activities that likely took place in the two bays.

From the sixth century BC, when the urban spaces were planned, the grand scale of the public building program characterized the city. Such projects are often connected with tyrannical regimes, even though brought to completion later.[22] Bearing this fundamental point in mind, it is possible to place the colony's grand architectural monuments in a chronological context. The main temples of the acropolis date to 560 BC, and temple F on the eastern hill is roughly contemporary. Several buildings were erected during a second phase: the grand terracing of the acropolis, the beginning of the construction of temple G (which was unfinished), the first rebuilding of temple E, and the construction of the so-called temple M on the western hill. Some scholars believe that this last structure was a monumental fountain like those constructed under the direction of other tyrants.[23] At this time in Olympia, the sanctuary of the games, the city of Selinus was building its *thesauros* (treasury). The expulsion of tyrannical regimes by the fifth century BC does not seem to alter the trajectory of the grand building program that they had begun. The reconstruction of temple E dates to 460 BC, while on the acropolis, temple A, temple O, and a large stoa were built. The stoa circumscribes the views of the older temples C and D. After the mid fifth century BC the building fervor seems to end temporarily. Only in the sanctuary of the Malophoros do gates reach monumental proportions. This was in the

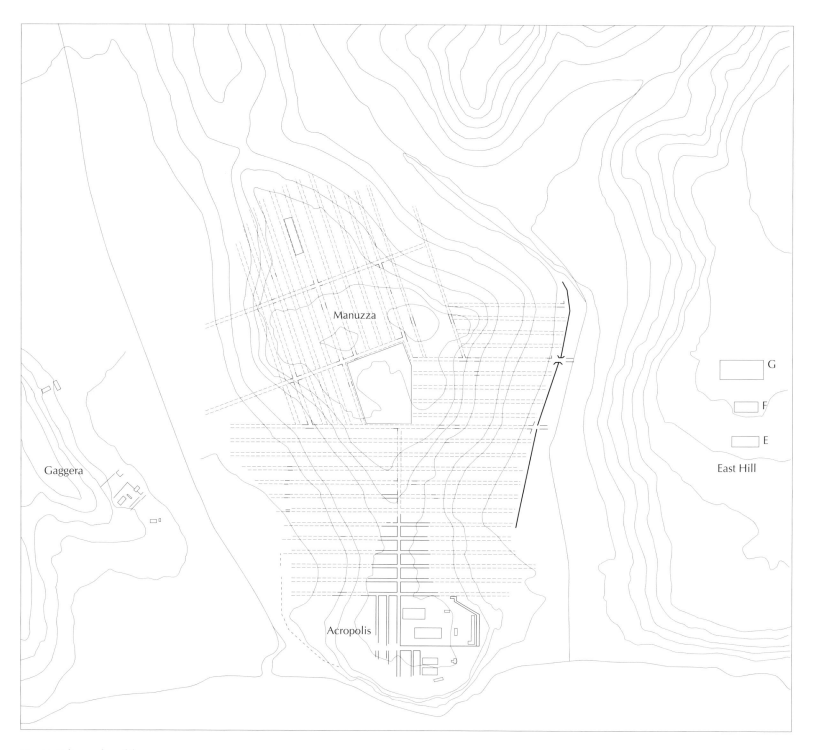

Fig. 14. Selinus: plan of the city. After Pugilese Carratelli, *Western Greeks,* 281 (De Siena and Mertens).

Manuzza

Gaggera

Acropolis

East Hill

G

F

E

temenos where cult activity apparently did not end until the city's tragic destruction by the Carthaginians in 409 BC.

The complex of sanctuaries associated with temples C and D, located on the acropolis, is a large area that included almost half of the acropolis itself (fig. 15). The first expressions of cult here—small shrines, altars, and sacred enclosures—date to the late seventh century BC. The slightly later monumental building activity took place from the sixth to the fifth centuries BC. Initially the temenos had an orientation fixed by walls dating to 560 BC and was completely independent from the urban settlement. Later, toward the beginning of the fifth century BC, this situation was rectified. The two grand temples were dedicated to the city's most prestigious and important cults. Recovery of a dedication to Apollo and Athena clarified the nature of the

cults. An interesting parallel between colony and mother city emerges when one compares sanctuary dedications. In addition to the cults already mentioned, the deities that complete the pantheon of Selinus are present on two bordering hills, with obvious similarities to the pantheon of gods known from the mother city, Megara Nisea.

Outside the urban circuit, on the eastern hill, the sacred area devoted to temple E appears to have been laid out at the same time as the sanctuaries on the acropolis, at the end of the seventh to the beginning of the sixth century BC. Subsequent rebuilding in this area took place in successive phases, the last of which dates to the mid fifth century BC. This temple has been identified with the temple of the great goddess Hera. Often the sanctuaries consecrated to Hera were built outside the urban area—as documented, for example, in Argos, Samos, and Posidonia. Hera protected the city and sanctioned the act of taking possession of a territory. This would explain the original location of the sanctuary of Selinus. Other previously venerated deities in the urban sanctuaries coalesced here at a later time. This was probably the

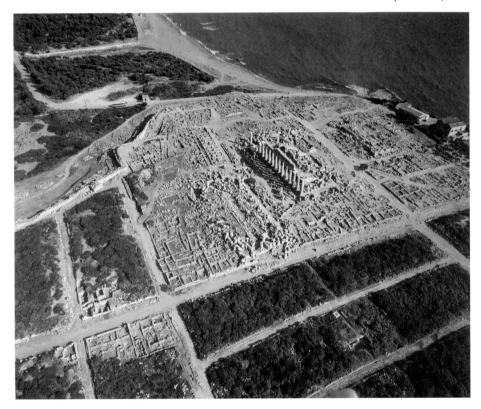

Fig. 15. Selinus: acropolis, view of the sanctuaries, looking east. From Pugliese Carratelli, *Sikanie*, 496.

case of the temple apparently dedicated to Apollo Pythian, while Apollo Archegetes ruled over the acropolis. Given these observations, the Heraion and the adjacent temples represented the most authentic symbol of the possession of the territory at the edge of the hellenized world.[24]

Temple F, separated from the previous one by a temenos wall dating to the first building phase, was built around 550–540 BC. It includes a peculiar double colonnade on its front, and a 4.7-meter-high wall that closes off the columns of the surrounding colonnade, or peristyle. This structural element played an important role in defining the cult practices, and may have been of functional importance for the performance of mystical rites. Among the deities recalled from the "great tablet of Selinus," only Demeter, to whom the sanctuary of the Malophoros was dedicated, was the object of mystery cults.

It has therefore been proposed that this temple should be associated with a cult of Dionysos Nyktelios, whose existence has been documented at Megara Nisea. In the same way, the identification of temple E with the temple of Aphrodite has also been proposed. This hypothesis would repeat the succession of cults from the homeland.

Another great temple is the so-called temple G, begun around 530 BC but never completed. Identification of the cult for this temple is again uncertain. Both Zeus and Apollo have been proposed as the resident deity. The debate revolves around the interpretation of the "great tablet of Selinus," which lists the city's guardian deities. The tablet's location in the proximity of temple G and the repeated mention of Zeus seem to support the attribution of the temple to this god, assigning the function of thesauros to the temple of Apollo.

Located on the western hill was the sanctuary of Demeter Malophoros and Kore, a vast, irregularly shaped complex that contained the shrine of the goddess and a small Hekateion, in addition to several altars and the foundations of large dedications. The sanctuary of Demeter at Selinus has a peribolos made of blocks, providing access to the lower part of the sanctuary through a propylon with two distyle facades *in antis,* made monumental in the mid fifth century BC. Within the enclosed sacred area were the sacellum to the deity and the corresponding sacrificial altar. The cult, as documented by material evidence found there, dates to the end of the seventh century BC—the time when the colonists occupied the area around the harbor. The sanctuaries of Demeter and Kore often were located outside the city walls, as in Syracuse, Camarina, Gela, and Eloro, where their cults tended to provide intermediary functions with the indigenous populations.[25]

Aspects of the cult of the underworld are also present in the cult of Zeus Meilichios, whose small temenos—a square with 17-meter sides—was built next to the enclosure of the Malophoros sanctuary, on its northeast side. The enclosure has a colonnade with columns of different styles. At the back is the small shrine of the god. Next to the altar in the sanctuary of Zeus are several peculiar, but characteristic, votive deposits made in the sand. These are marked by two- or four-sided stelai, sometimes called aniconic (argoi lithoi). Zeus Meilichios represented an important intermediary with local populations, through rituals connected to funerary rites.

Like the Heraion on the eastern hill, the sanctuary of the Malophoros also represented an important center of coalescence for other cults. Hence, other small temples were built in the vicinity over time. The so-called temple M was also built on this hill. Its functions have been debated, and it has even been identified as a monumental fountain[26]—an identification that would be in keeping with the panorama of grand public buildings promoted by the tyrannical regimes of the sixth century BC.

The recent publication of an epigraphic text of extraordinary importance, the so-called *Lex Sacra Selinuntina,* shed new light on the rites practiced in the sanctuary of the Malophoros to which the inscription surely refers.[27] Regrettably, the scarcity of epigraphic documents in the West prevents us from providing the large amount of archaeological evidence with more precise historical and religious context.

NOTES

1. F. De Polignac, *La naissance de la cité grecque* (Paris, 1992).

2. E. Greco, "I santuari," in G. Pugliese Carratelli, ed., *Magna Grecia: Arte e Artigianato* (Milan, 1990), 4: 187.

3. L. Giardino and A. De Siena, "Metaponto," in E. Greco, ed., *La città greca antica* (Rome, 1999), 346.

4. Ibid., 346–47.

5. C. Montepaone, "L'apologia di Alexidamos: L'avventura del Cavaliere," *Metis I* 1 (1986), 219–35; G. Camassa, "I culti delle poleis italiote," in *Storia del Mezzogiorno,* vol. 1, *Il Mezzogiorno antico* (Naples, 1991).

6. For an updated and complete bibliographic record see F. Longo, "Poseidonia," in Greco, *La città greca antica,* 365–84.

7. C. A. Fiammenghi, "Agropoli: primi saggi di scavi nell'area del castello," *AIONAArchStAnt* 6 (1986), 69–74.

8. Lycophron 722–25.

9. E. Greco, "Poseidonia-Paestum," in A. Vauchez, ed., *Lieux sacrés, lieux de culte, sanctuaries* (Rome, 2000), 88.

10. Ibid., 85–86.

11. M. Torelli, "Paestum romana," in *Poseidonia-Paestum* (Naples, 1992), 60.

12. Greco, "Poseidonia-Paestum," 89.

13. E. Greco, "L'Asklepieion di Paestum," in *I culti della Campania antica* (Naples, 1998), 71–79.

14. E. Greco, "La città e il territorio: Problemi di storia topografica," in *Poseidonia-Paestum* (Naples, 1992), 471–99.

15. Ibid., 482.

16. Ibid., 489–90.

17. G. Greco and F. Krinziger, eds., *Velia: Studi e ricerche* (Modena, 1994); Greco, "I santuari," 4: 171.

18. F. Coarelli and M. Torelli, *Sicilia* (Bari, 1984), 122.

19. R. Martin et al., "Le strutture urbane e il loro rapporto con la storia," in E. Gabba and G. Vallet, eds., *La Sicilia antica* (Naples, 1980), 1, part 2: 251.

20. R. Martin and G. Vallet, "L'architettura monumentale religiosa e civile," in Gabba and Vallet, *La Sicilia antica,* 1, part 2: 291.

21. E. De Miro, *Agrigento I: I santuari urbani. L'area sacra tra il tempio di Zeus e Porta V* (Rome, 2000).

22. Coarelli and Torelli, *Sicilia,* 75–76.

23. Ibid., 102.

24. Martin and Vallet, "L'architettura monumentale," 285.

25. Ibid., 286.

26. C. Masseria, "Ipotesi sul 'Tempio M,'" *Annali Perugia* 16, ser. 2 (1978–79), 61–88; Coarelli and Torelli, *Sicilia,* 102; for a different opinion see L. Pompeo, *Il complesso architettonico del tempio M di Selinunte: Analisi tecnica e storia del monumento* (Florence, 1999).

27. M. H. Jameson et al., *A lex sacra from Selinous* (Durham, 1993).

Illustration credits

Figs. 1–4, 7, 8, 10, 11, 13, and 14 were redrawn by Carolyn K. Lewis from publications cited in the captions.

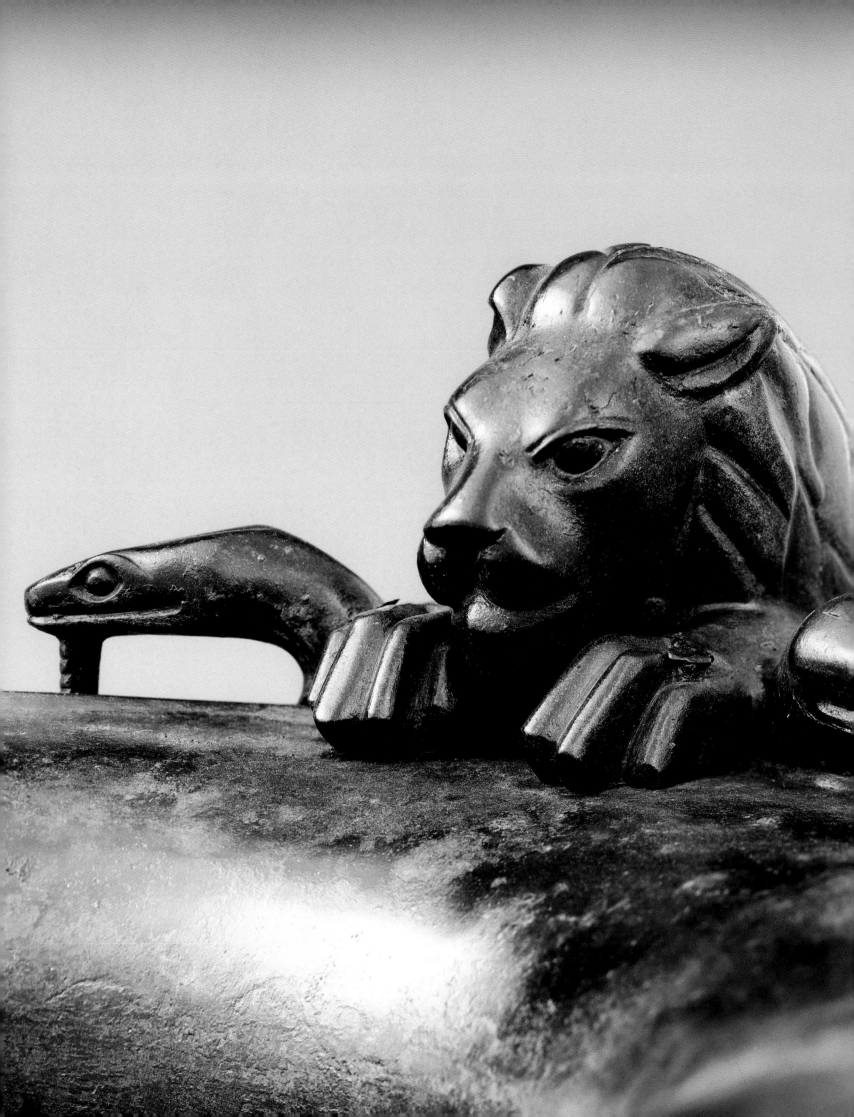

PAESTUM

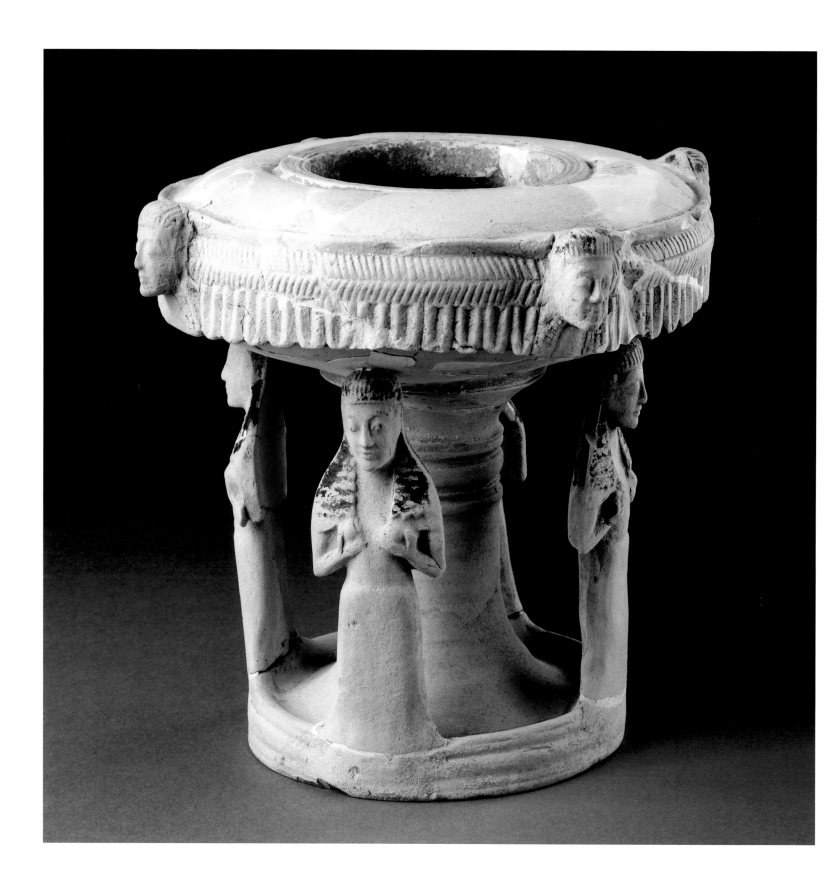

1. CARYATID LAMP

580–570 BC
Terracotta, wheel and mold-made, painted
H. 17, Diam. 17.5; caryatids: H. 10.5
Museo Archeologico Nazionale di Paestum,
inv. 48496
Paestum, Heraion of Foce del Sele

Flared at the base, the bowl of this vessel is supported by a hollow cylindrical stem set on a high foot. The base has a raised rim with four female caryatid figures. Their hair is rendered with horizontal incisions and falls on their shoulders, and their hands are raised to their breasts. Four small female heads, similar to those of the caryatids, are applied to the edge of the lamp's bowl.

This unusual type of oil-lamp (or censer), with female figures as caryatids whose hands are raised to their breasts, was found at the sanctuary of Hera on the Sele River. It is the best preserved specimen of a class of similar objects known as Lampade del Sele. On the basis of the stylistic analogies of the caryatid figures here to Laconian products,

Zancani Montuoro believes that Taranto was the original site of production. This is still an open question. Even though more examples of this type of lamp have been found in recent years, especially in the area of Croton, clear diagnostic stylistic features are missing that would identify Croton as the center of production. Sabbione considers these lamps to be part of a homogeneous figurative tradition developed in the Achaean cities on the Ionian coast. This hypothesis is attractive, but the characteristics of these handmade objects point more to a specific workshop tradition. Unfortunately, its location remains unknown. The eclectic character of this production, as cleverly emphasized by Croissant, and the difficulty in isolating specific stylistic elements raise again the more general problem of defining colonial styles. These lamps also call for a new and different approach in the classification and understanding of the workshops active in Magna Graecia during the Archaic period. MC

LITERATURE

H. Hellenkemper, *Die neue Welt der Griechen*, exh. cat., Römisch-Germanisches Museum (Cologne/Mainz, 1998), 97, no. 19.

G. Pugliese Carratelli, ed., *The Western Greeks*, exh. cat., Palazzo Grassi, Venice (Milan, 1996), 375, 668, no. 35.

R. Spadea, *Il Tesoro di Hera: Scoperte nel Santnario di Hera Lacina a Capo Colonna di Crotone* (Milan, 1996), 70.

C. Rolley, *La Sculpture Grecque* (Paris, 1994), 1: fig. 136.

F. Croissant, "Sybaris: La production artistique," in A. Stazio and S. Ceccoli, eds., *Sibari e la sibaritide: Atti del trentaduesimo Convegno di studi sulla Magna Grecia* (Taranto, 1993), 548.

J. G. Pedley, *Paestum: Greeks and Romans in Southern Italy* (London, 1990), 73, fig. 43.

C. Sabbione, "L'artigianato artistico a Crotone," in A. Stazio and S. Ceccoli, eds., *Crotone: Atti del ventitreesimo Convegno di studi sulla Magna Grecia* (Taranto, 1983), 272.

G. Pugliese Carratelli et al., *Megale Hellas: Storia e civiltà della Magna Grecia* (Milan, 1983), 354, 361, no. 327.

M. Napoli, *Il Museo di Paestum* (Naples, 1969), pl. 15.

L. von Matt, *Grossgriechenland* (Zurich, 1961), 48, pl. 27.

P. Zancani Montuoro, "Lampada arcaica dall' Heraion alla foce del Sele," *Atti e Memorie della Società Magna Grecia* 3 (1960), 60, pls. 16–18.

2. HERAKLES AND ALKYONEUS METOPE

ca. 560–550 BC
Sandstone
H. 83, L. 152, W. 31
Museo Archeologico Nazionale di Paestum,
inv. 133155
Paestum, Heraion of Foce del Sele, 1958

This block of sandstone is a complete metope and
triglyph. On the metope Herakles traps a giant by
the hair and leg, thrusting a sword into his
adversary's back. The hero wears a *chitoniskos*
(short-skirted garment) and a quiver is suspended
from his shoulders.

Found in 1958 during the excavation of the so-
called Edificio Quadrato (square building), this
metope had been reused as construction material.
It is part of the most famous group of Archaic ar-
chitectural sculptures from the sanctuary of Hera
at the Sele River. Zancani Montuoro and later van
Keuren identified Herakles' opponent as the giant
Alkyoneus. Croissant identified another giant,
Thourios. According to the traveler Pausanias
(3.18.11), who was the only one to write about
this mythical episode, it also appeared on the
throne of Amyklai, a town near Sparta. Whoever
the opponent, the metope shows that the theme of
Herakles struggling with a giant was part of a
frieze found at the sanctuary of Hera near the Sele
River. MC

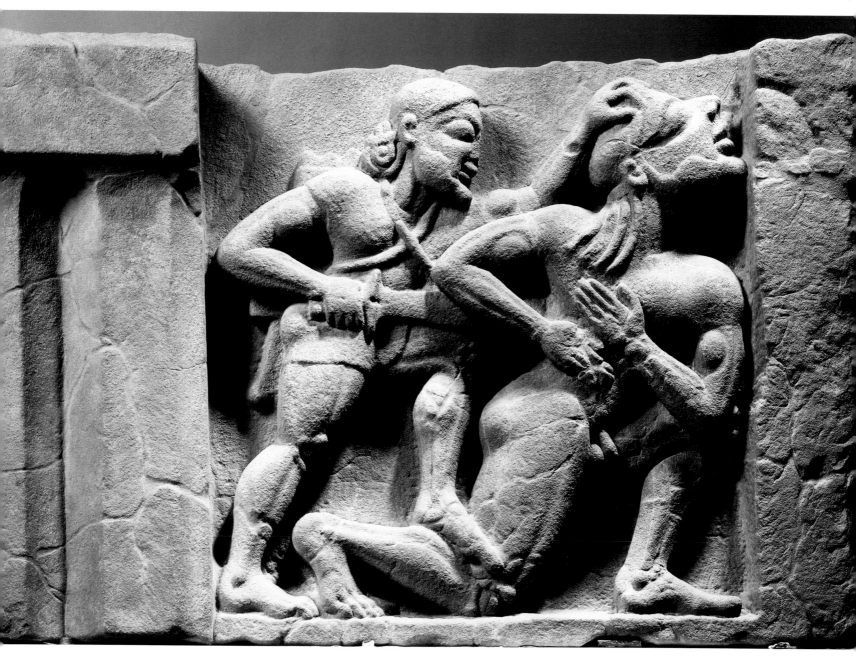

LITERATURE

G. Greco, *Il Santuario di Hera alla Foce del Sele* (Salerno, 2001), 58, 86, figs. 63, 112.

E. Greco, *Paestum, Past and Present* (Rome, 1999), 55.

C. Masseria and M. Torelli, "Il mito all'alba di una colonia greca," in F. H. Massa-Pairault, *Le mythe grec dans l'Italie antique: fonction et image* (Rome, 1999), 211–15.

G. Pugliese Carratelli, ed., *The Western Greeks*, exh. cat., Palazzo Grassi, Venice (Milan, 1996), 674, no. 68.

The Western Greeks, Guide to the Exhibitions in Southern Italy (Naples, 1996), 58.

E. Greco et al., *Archaeological and Historical Guide to the Excavations: The Museum and Antiquities of Poseidonia and Paestum* (Taranto, 1996), 119.

P. G. Guzzo et al., *Antiche Genti d'Italia,* exh. cat, Sala dell'Arengo and Palazzo del Podestà, Rimini (Rome, 1994), 84, fig. 3.

G. Rolley, *La Sculpture Grecque* (Paris, 1994) 1: 213–215, fig. 205.

J. G. Pedley, *Paestum: Greeks and Romans in Southern Italy* (London, 1990), 65, fig. 37.

F. van Keuren, *The Frieze from the Hera I Temple at Foce del Sele* (Rome, 1989), 72–77, pls. 7b, 8–9, 11a.

C. Rolley, "La sculpture de Poseidonia," in A. Stazio and S. Ceccoli, eds., *Poseidonia-Paestum: Atti del ventisettesimo Convegno di studi sulla Magna Grecia* (Taranto, 1988), 195–96, pl. 26.

R. Bianchi Bandinelli and E. Paribeni, *L'arte dell'antichità classica: Grecia* (Turin, 1986), 1: no. 349.

G. Pugliese Carratelli et al., *Magna Grecia* (Milan, 1985), 1: 77, fig. 83.

G. Pugliese Carratelli et al., *Megale Hellas: Storia e civiltà della Magna Grecia* (Milan, 1983), 356, 373, fig. 334.

N. Degrassi, *Lo Zeus stilita di Ugento* (Rome, 1981), 88, pl. 50b.

W. Fuchs, *Die Skulptur der Griechen*, 2d ed. (Munich, 1979), figs. 205, 213, 215.

R. R. Holloway, *Influences and Styles in the Late Archaic and Early Classical Greek Sculpture of Sicily and Magna Graecia* (Louvain, 1975), 4, fig. 22.

M. Napoli, *Il Museo di Paestum* (Naples, 1969), pl. 13.

F. Croissant, "Remarques sur la metope de 'la mort d'Alkyoneus' à l'Heraion du Silaris," *Bulletin de Correspondence Héllenique* 89 (1965), 390–99, fig. 1.

P. Zancani Montuoro, "Heraion alla foce del Sele I, altre metope del primo thesauros," *Atti e Memorie della Società Magna Grecia* 5 (1964), 76–83, pls. 18.b–d, 19–20.

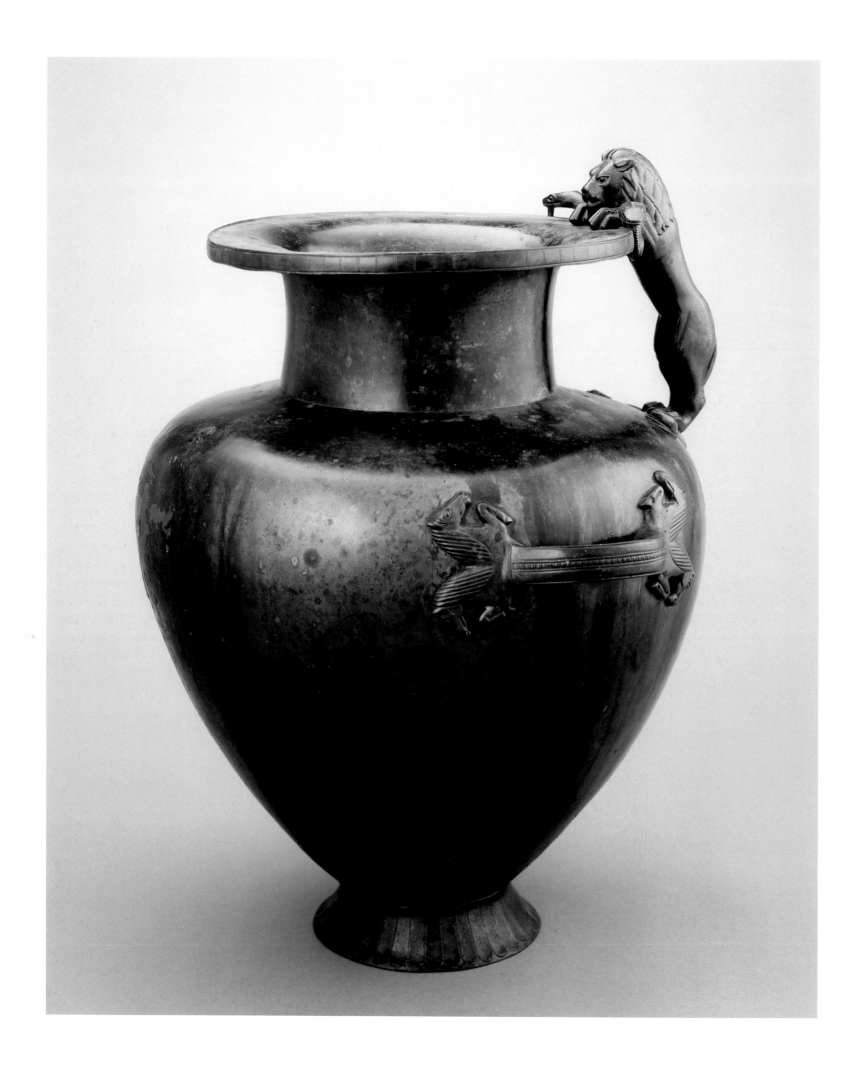

3. HYDRIA

ca. 530–520 BC
Bronze, cast, hammered, repoussé, incised
H. 49
Museo Archeologico Nazionale di Paestum,
inv. 49801
Paestum, Heroon of the agora, 1954

This water vessel or hydria has an ovoid body, rounded shoulder, neck with a slightly concave profile, and ring-like foot decorated with small tongues. A furrow separates the foot from the body. Deep incised furrows connected by regularly spaced vertical incisions decorate the rim of the lip. A lion, fully sculpted in the round, forms the vertical handle. Standing on its back legs, which are set on a palmette with rounded leaves and spirals from which snake heads arise, the lion leans over the rim of the vase, flanked by two additional snake heads. The horizontal handles are ribbon shaped, decorated by a string of small raised beads. The attachments for the handles are in the form of the foreparts (*protomes*) of horses, opposed as mirror-images with one foreleg folded.

The vessel belongs to an assemblage of six bronze hydriae and two bronze amphorae (large two-handled storage vessels) found in the Heroon of Posidonia (Paestum). Scholars do not agree on the location of the workshop that produced this hydria and four of the others, which Rolley designated as "of Greek style." Taranto, Laconia, and Cumae have been suggested as possible sites of production. In his most recent study, Rolley proposed that they were likely produced in the same workshop that produced the Vix krater (an enormous bronze vessel found in France), which was probably active in Sybaris during the last decades of the city's history. The other bronze vases in the assemblage, defined as "non Greek" by Rolley, display production techniques and have formal characteristics not found in Greece. Instead, they are similar to several vases found in Illyrian cemeteries in southeastern Macedonia, in the former Yugoslavia.

THE HEROON OF POSIDONIA

Now located among imperial Roman houses and other structures, this monument was originally set near the western edge of the agora of Posidonia, as demonstrated by the archaeological research of Greco and Theodorescu. Since its discovery by Sestieri in 1954, it has been the source of a lively debate regarding its possible function.

The complex is composed of an enclosure made of stone blocks, within which is a small and slightly off center rectangular building without windows or doors. Three walls are set in bedrock, and the eastern wall is built completely of blocks. The pitched roof is made of limestone slabs upon which a layer of terracotta tiles was superimposed later. The interior sides of three walls are coated with fine white plaster, but the east wall is unplastered. Six hydriae and two bronze amphorae were found inside; some of these vessels still contained solidified remains of honey. In addition, there was an Attic black-figure amphora by the Chiusi Painter (active ca. 520–510 BC) depicting, on one panel, the ascent of Herakles to Mt. Olympus and, on the other, Dionysos with satyrs and maenads. At the center of this wall was a table formed by two blocks of limestone supporting a bundle of five iron spits, originally wrapped in a woolen fabric, of which only a few mineralized fibers remained.

When discovered, the building was completely buried within the enclosure. Abundant terracotta shards were found in the soil covering the building, and are interpreted to be the remains of votive offerings associated with the consecration of the building. Among them was the famous fragment of a black-figure *olpe* (pitcher) with the inscription "I am sacred to Nympha." These objects led the building's excavators to interpret it as a subterranean chamber consecrated to the cult of Hera Nympha.

Zancani Montuoro's interpretation is completely different. She noticed that the soil covering the building contained ceramic fragments spanning a period from the beginning of the sixth century to the middle of the third century BC and correctly excluded a direct link between the fragments and the function of the building. An analysis of the complex mixture of material contained in the soil persuaded her to identify the building as a Heroon that she proposed was dedicated to Is of Helike, the founder of Sybaris, one of the exiled Sybarites who escaped to Posidonia after the fall of the city in 510 BC.

Greco and Theodorescu began a new study of the building during archaeological research that led to the identification of the agora of Posidonia.

Having demonstrated how the building belonged to the plan of the agora, they also made clear that the surviving design of the complex, with the enclosure that surrounds the building asymmetrically, was due to a later intervention. These changes were part of the urban transformations implemented after 273 BC. Before then the complex must have looked very different. Further study of the site and comparisons with similar archaeological sites in the Greek world persuaded Greco and Theodorescu to suggest that the building was covered by soil in the form of a tumulus. Its base must have been adjacent to an altar of which only a few blocks remain, and those blocks are incorporated into the Roman enclosure. The reconstruction of the original setting of the complex, its

position in the agora, and the re-evaluation of the vessels deposited inside made it possible to reaffirm its function as a Heroon, as already proposed by Zancani Montuoro. These burial conditions were thought to enhance greatly the symbolic value of the structure. However, addressing the question of to whom the monument was dedicated, Greco excluded the reference to the founder of Sybaris. Instead, he proposed that the Heroon was possibly the cenotaph of the founder of Posidonia, who was worshiped as a hero after his death. He then became the object of cult for the city, that "through the glorification of its hero, acknowledges and exalts itself."

In this light, the supposition that the building was constructed at the end of the sixth century BC becomes even more meaningful because that was the most significant period during a thirty-year process when the city erected the buildings of its urban plan. Such construction included a network of roads and the monumental display of its structures. The urban plan demonstrated a renewed understanding of the collective identity of the polis (city-state) that was confirmed and glorified in the years during the fall of Sybaris.

For a bibliography on the Heroon, see C. Rolley, *Les vases de bronze de l'archaïsme récent en Grande Grèce*, 15–16; for Greco and Theodorescu's interpretation, see E. Greco and D. Theodorescu, *Poseidonia-Paestum, L'Agora* (Rome, 1983), 2: 25–33. MC

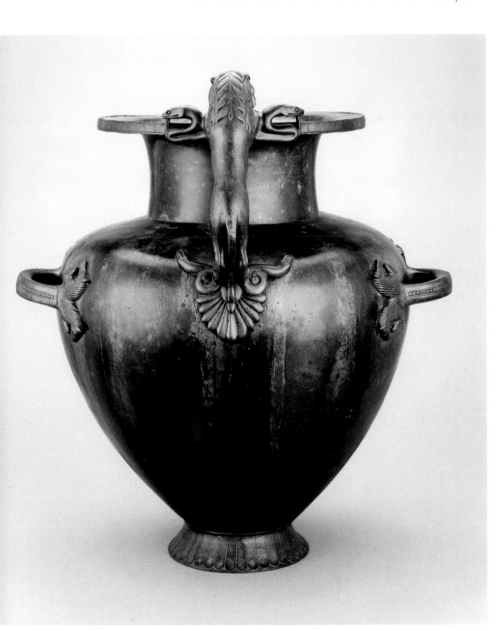

LITERATURE

A. Carandini and R. Cappelli, eds., *Roma, Romolo, Remo e la fondazione della città* (Rome, 2000), 352.

H. Hellenkemper, *Die neue Welt der Griechen*, exh. cat., Römisch-Germanisches Museum (Cologne/Mainz, 1998), 135, no. 67.

G. Pugliese Carratelli, ed., *The Western Greeks*, exh. cat., Palazzo Grassi, Venice (Milan, 1996), 371, 696, no. 145 V.

E. M. De Juliis, *Magna Grecia: L'Italia meridionale dalle origini leggendarie alla conquista romana* (Bari, 1996), 149, fig. 135.

The Western Greeks, Guide to the Exhibitions in Southern Italy (Naples, 1996), 60.

E. Lippolis, ed., *Arte e artigianato in Magna Grecia*, exh. cat., Convento di San Domenico, Taranto (Naples, 1996), 104.

E. Greco et al., *Archaeological and Historical Guide to the Excavations: The Museum and Antiquities of Poseidonia and Paestum* (Taranto, 1996), 40.

C. M. Stibbe, "Archaic Bronze Hydriai," *Bulletin antieke beschaving, Annual Papers on Classical Archaeology* 67 (1992), 29–20, 56, no. G11, fig. 39.

W. Gauer, *Die Bronzegefässe von Olympia* (Berlin/New York, 1991), 108.

J. G. Pedley, *Paestum: Greeks and Romans in Southern Italy* (London, 1990), 37, fig. 12.

G. Pugliese Carratelli et al., *Megale Hellas: Storia e civiltà della Magna Grecia* (Milan, 1983), 90–91, 371–72, pls. 375–77.

C. Rolley, *Les vases de bronze de l'archaïsme récent en Grande Grèce* (Naples, 1982), 19, 49–52, no. 5, figs. 5, 14, 59–61, 65, 67, 70, 154.

E. Langlotz and M. Hirmer, *The Art of Magna Graecia: Greek Art in South Italy and Sicily* (London, 1965), 50, 258–59, pl. 25.

B. Neutsch, *Zum unterirdischen Heiligtum von Paestum* (Heidelberg, 1957), 2: 1.

B. Neutsch, "Archäologische Grabungen und Funde in Unteritalien 1949–1955," *Archäologischer Anzeiger* 71 (1956), 390–96, figs. 120–25.

P. C. Sestieri, "Cronaca d'Arte, Il sacello—heroon posidoniate," *Bollettino d'Arte* 40 (1955), 53, 58–61.

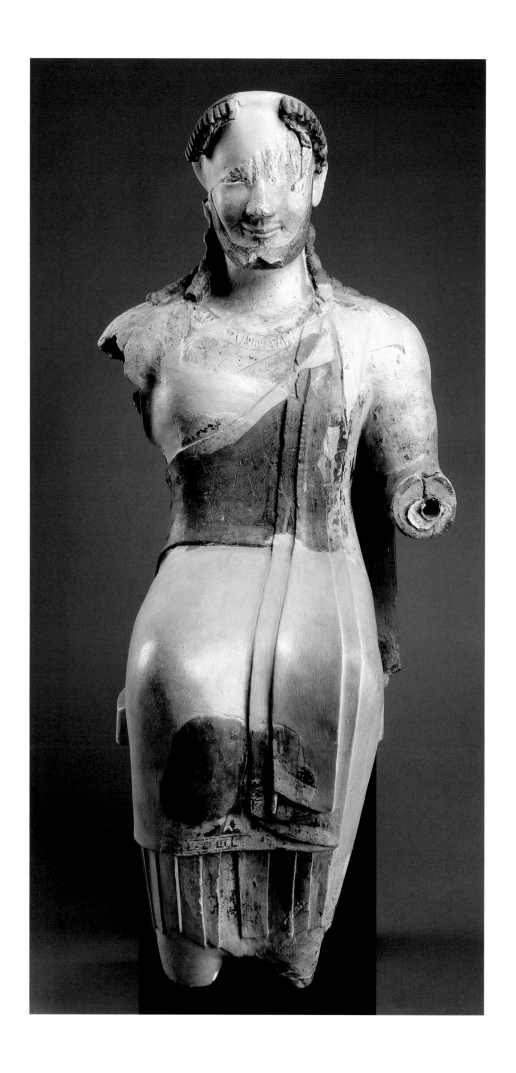

4. ENTHRONED ZEUS

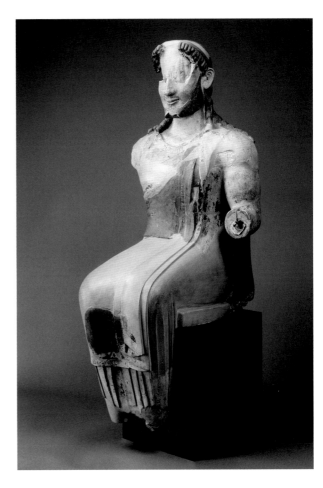

ca. 530–520 BC
Terracotta, painted
H. 90
Museo Archeologico Nazionale di Paestum, inv. 133149
Paestum, southern urban sanctuary

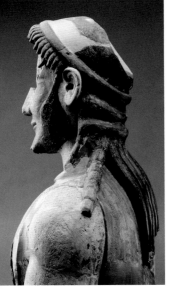

This terracotta statue probably represents Zeus sitting on a backless throne. The god wears a yellow chiton (garment) that clings to his stocky body. A red himation (cloak) drapes from the left shoulder, its edges embellished with black geometric motifs. Zeus's face is a ruddy color, with a contrasting pointed black beard and painted moustache. His hair, also painted black, falls on his forehead in two rows of thick locks and onto his shoulders and back in heavy braids. He wore a bronze *stephane* (headband), now lost, that was attached through a series of small holes pierced at the top of the head, where traces of metal are still evident.

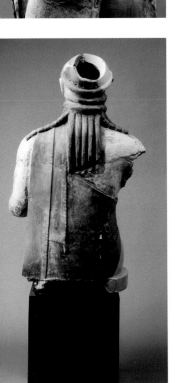

Likely a cult image, this statue must originally have been placed in one of the Archaic sacella (shrines) in the sacred area in the southern part of the city. Even though extensively restored and reconstructed, the sculpture is possibly the most significant example of terracotta sculpture from Posidonia of this period. It is the elaborate work of a craftsman who knew and combined the elements of different artistic traditions.

The Paestum Zeus has been compared to contemporary Etruscan terracotta sculptures, such as the famous sarcophagus of the Caere bride and groom. Such a comparison reiterates the intensity of the contacts and cultural exchanges between Posidonia and the Etruscan world during the second half of the sixth century BC. MC

LITERATURE

A. Pontrandolfo, "Poseidonia e le comunità miste del golfo di Salerno," in M. Cipriani and F. Longo, *Poseidonia e i Lucani*, exh. cat., Museo Archeologico Nazionale, Paestum (Naples, 1996), 37–39.

G. Pugliese Carratelli, ed., *The Western Greeks*, exh. cat., Palazzo Grassi, Venice (Milan, 1996), 675, no. 65.

The Western Greeks, Guide to the Exhibitions in Southern Italy (Naples, 1996), 61.

E. Greco et al., *Archaeological and Historical Guide to the Excavations: The Museum and Antiquities of Poseidonia and Paestum* (Taranto, 1996), 136.

C. Rolley, "La sculpture de Poseidonia," in A. Stazio and S. Ceccoli, eds., *Poseidonia-Paestum: Atti del ventisettesimo Convegno di studi sulla Magna Grecia* (Taranto, 1988), 205–6.

P. Orlandini, "Le arti figurative," in G. Pugliese Carratelli et al., *Megale Hellas: Storia e civiltà della Magna Grecia* (Milan, 1983), 379–80, 405, figs. 392–93.

N. Degrassi, *Lo Zeus stilita di Ugento* (Rome, 1981), 88, pl. 49.

W. Fuchs, *Die Skulptur der Griechen*, 2d ed. (Munich, 1979), 251, figs. 275–76.

R. R. Holloway, *Influences and Styles in the Late Archaic and Early Classical Greek Sculpture of Sicily and Magna Graecia* (Louvain, 1975), 4, figs. 19–21.

M. Napoli, *Il Museo di Paestum* (Naples, 1969), pls. 9–10.

E. Langlotz and M. Hirmer, *The Art of Magna Graecia: Greek Art in South Italy and Sicily* (London, 1965), 50, 244, pls. 3–4.

L. von Matt, *Grossgriechenland* (Zurich, 1961), 71, pl. 56.

P. C. Sestieri, *Das neue Museum in Paestum, Führer durch die Museen und Kunstdenkmäler Italiens* (Rome, 1956), 7–8, fig. 35. English ed., *The New Museum of Paestum* (Rome, 1956), 6–8, 31.

B. Neutsch, "Archäologische Grabungen und Funde in Unteritalien 1949–1955," *Archäologischer Anzeiger* 71 (1956), 411–14, figs. 135, 136.

P. C. Sestieri, "Statua Fittile di Posidonia," *Bollettino d'Arte* 40 (1955), 193–202, figs. 1–6, pl. 2.

P. C. Sestieri, "From Calabria to Campania," in A. V. Giardini, ed., *Vita Italiana* (Rome, 1953), 99.

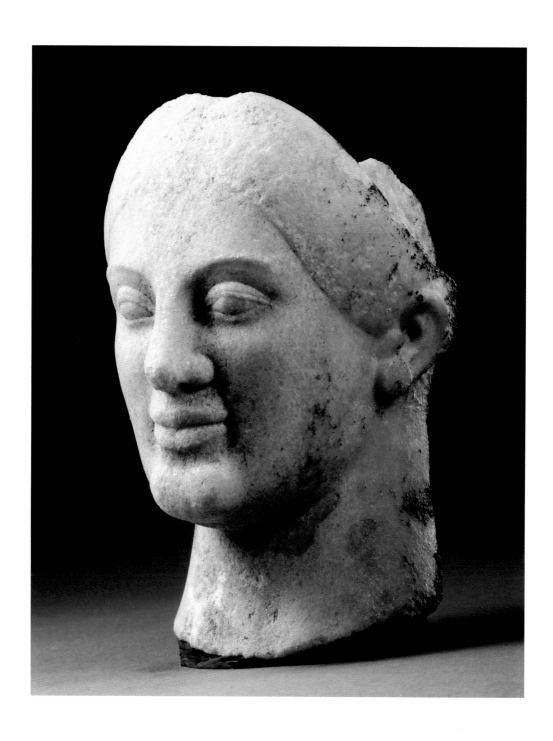

5. STONE HEAD

ca. 500 BC
Marble
H. 17, W. 10.5
Museo Archeologico Nazionale di Paestum,
inv. 133150
Paestum, southern urban sanctuary, to the north of
the fourth group of votive offerings

This stone head is a rare example of marble sculpture from Greek Posidonia. Two other incomplete heads have been associated with it, from different stratigraphic levels. The three pieces are acroliths (portions of sculptures made to be inserted into statues composed of materials different than marble, sometimes wood). Possibly imported from Ionia, the heads have been considered the work of different sculptors. This head, the only complete one, is executed in the round, wears a headband, and is cut from top to bottom at the back. Above the headband is a semi-circular cavity on which a veil of different material must have been attached. The second head, only half-preserved, has a dotted area on the cheek and lacks an ear, leading to the supposition that a helmet had originally covered the head, and that it represented the goddess Athena. MC

LITERATURE

H. Hellenkemper, *Die neue Welt der Griechen*, exh. cat., Römisch-Germanisches Museum (Cologne/Mainz, 1998), 114, no. 38.

G. Pugliese Carratelli, ed., *The Western Greeks*, exh. cat., Palazzo Grassi, Venice (Milan, 1996), 676, no. 79.

C. Rolley, "Têtes de marbre de Paestum," in N. Bonacasa, ed., *Lo Stile Severo in Grecia e in Occidente* (Rome, 1995), 107–13, pls. 22, 25.1.

J. G. Pedley, *Paestum: Greeks and Romans in Southern Italy* (London, 1990), 84, fig. 53.

C. Rolley, "La sculpture de Poseidonia," in A. Stazio and S. Ceccoli, eds., *Poseidonia-Paestum: Atti del ventisettesimo Convegno di studi sulla Magna Grecia* (Taranto, 1988), 107, 209, pl. 32.1.

R. Bianchi Bandinelli and E. Paribeni, *L'arte dell'antichità classica: Grecia* (Turin, 1986), 1: no. 433.

P. Orlandini, "Le arti figurative," in G. Pugliese Carratelli et al., *Megale Hellas: Storia e civiltà della Magna Grecia* (Milan, 1983), 369, 382, fig. 365.

R. R. Holloway, *Influences and Styles in the Late Archaic and Early Classical Greek Sculpture of Sicily and Magna Graecia* (Louvain, 1975), 1–2, figs. 1–4.

M. Napoli, *Il Museo di Paestum* (Naples, 1969), pl. 24.

E. Langlotz and M. Hirmer, *The Art of Magna Graecia: Greek Art in South Italy and Sicily* (London, 1965), 264, pl. 45.

L. von Matt, *Grossgriechenland* (Zurich, 1961), 72, pl. 63.

B. Neutsch, "Archäologische Grabungen und Funde in Unteritalien 1949–1955," *Archäologischer Anzeiger* 71 (1956), 423–26, pl. 141.

P. C. Sestieri, "Statua Fittile di Posidonia," *Bollettino d'Arte* 40 (1955), 201, n. 9.

P. Zancani Montuoro and U. Zanotti-Bianco, *Heraion alla Foce del Sele* (Rome, 1951), 1: 178.

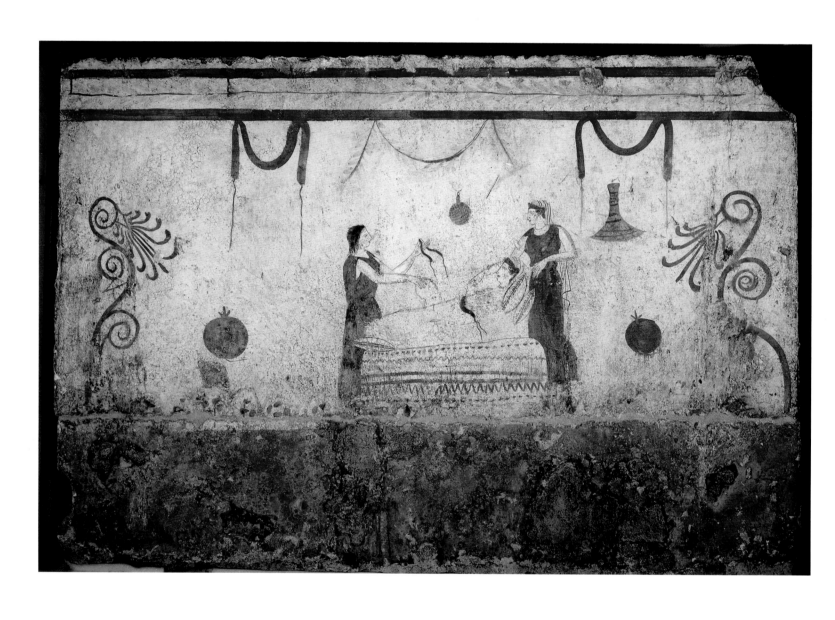

6. TOMB PAINTING

ca. 350 BC
Limestone and plaster, painted
H. 136, W. 200
Museo Archeologico Nazionale di Paestum,
inv. 133460
Paestum, Spina-Gaudo necropolis, tomb 87

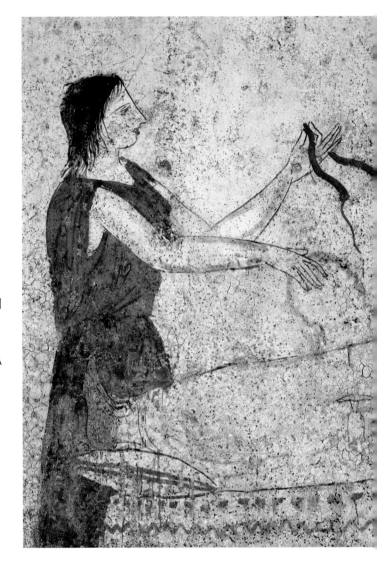

From the northern side of a box-shaped tomb with
a pitched roof, this rectangular wall painting has a
white background and is decorated with a scene
of prothesis (laying-out), in which two women are
preparing a deceased woman for ritual presenta-
tion. The funerary bed at the center of the scene is
covered with a white fabric hemmed and embroi-
dered with painted red and yellow motifs: straight
horizontal lines, a wolf's-tooth pattern, waves, and
small dots. The deceased woman is wrapped in a
sudarium (shroud), wears yellow shoes, and holds
an alabastron (small oblong vessel) in her hands. A
red ribbon has been placed on the shroud. Her
head, which is adorned with a tall diadem that
secures a veil, rests on two white pillows trimmed
in red. The two women who prepare the body
wear red dresses. The woman at the foot of the
bier, possibly a servant, has short dark hair and no
veil. She extends her arms and holds a red ribbon
in her left hand. The other woman, who wears a
red necklace and a diadem that secures a veil,
appears to be giving instructions. A small yellow
spherical cage and an upturned yellow kalathos
(flared basket) with black linear motifs hang from
the wall, suspended by small nails painted black.
The subsidiary decoration above includes a
central festoon—a pale red branch with yellow
leaves—flanked by two red ribbons. The branch
hangs from a red band above which is an elon-
gated branch, similar to the festoon, above which
is another red band. These bands create the upper
border of the figural scene, which is framed on
each side by a pomegranate and volute with
palmettes and closed at the bottom by a tall red
plinth. The other walls of the tomb show a

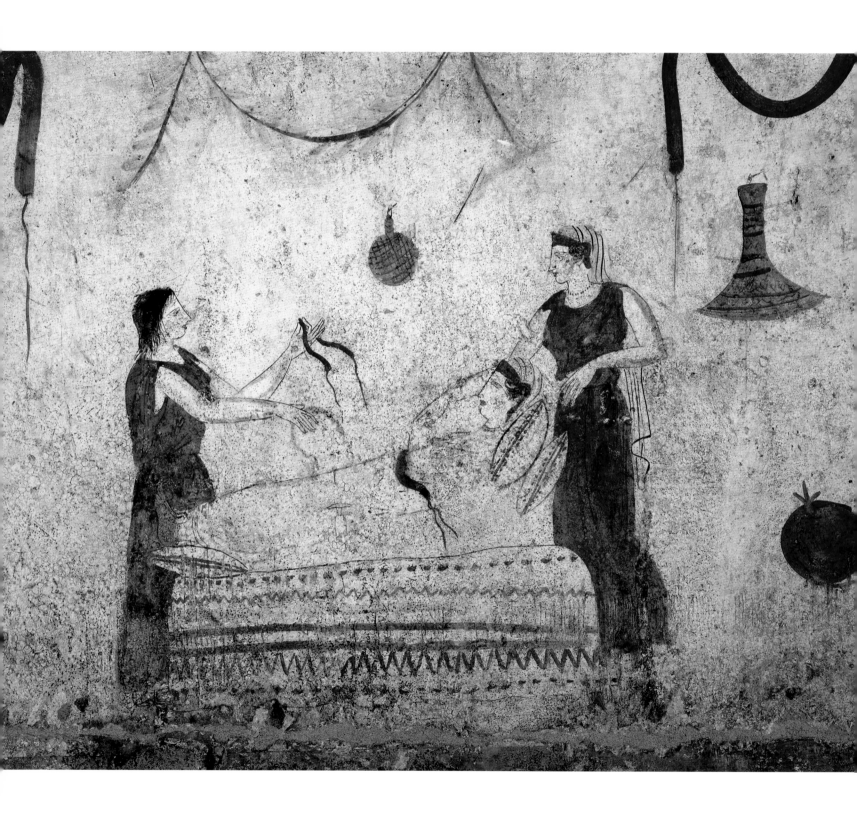

funerary procession on the south side, a Nereid (sea nymph) riding on a sea creature on the east side, and a rooster on the west side.

Unfortunately, the accompanying funerary assemblage that must have made up the tomb's contents was completely looted by tomb robbers. This is not atypical in the rich necropolis to which this tomb belongs. Illicit excavation of this kind makes interpreting the funerary context difficult because the objects that formed the funerary arrangement—patrimony of the Italian state—are unavailable for study. Tomb robbing frustrates historical interpretation and tends to relegate the objects to the role of mere "beautiful things." Such objects have been obtained at the cost of the destruction of their original context, and their final recipients, collectors or even foreign museums, are participating in the illegal market. MC

LITERATURE

H. Hellenkemper, *Die neue Welt der Griechen,* exh. cat., Römisch-Germanisches Museum (Cologne/Mainz, 1998), 204, no. 143.

A. Pontrandolfo et al., *Le tombe dipinte di Paestum* (Paestum, 1998), 52–53, fig. 51.

G. Pugliese Carratelli, ed., *The Western Greeks,* exh. cat., Palazzo Grassi, Venice (Milan, 1996), 648, no. 262 III.

C. Rolley, *La Sculpture grecque* (Paris, 1994), 1: 213, 215, fig. 205.

A. Pontrandolfo and A. Rouveret, *Le tombe dipinte di Paestum* (Modena, 1992), 33.

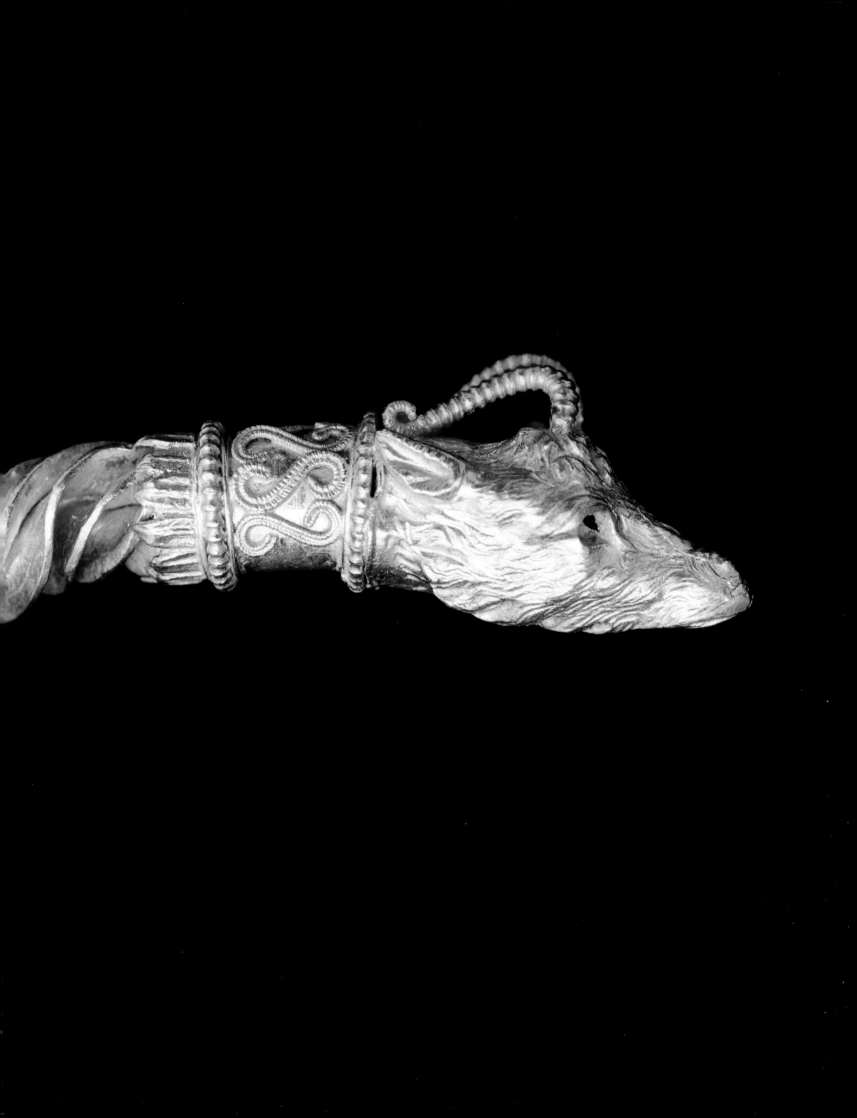

TARANTO

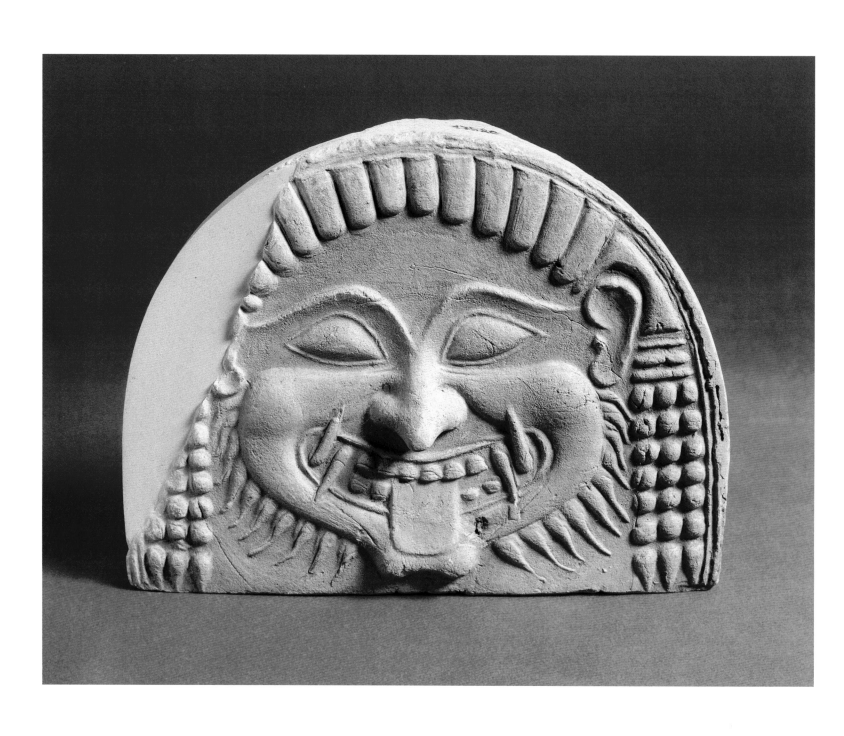

7. GORGON ANTEFIX

ca. 525–500 BC
Terracotta, mold-made, finished with a stick
H. 18, W. 24
Museo Archeologico Nazionale di Taranto,
inv. 17580
Taranto, Vecchio Museo

Antefixes are ornamental plaques that cover the ends of roof tiles. One common feature of the entire series of Tarantine antefixes is the protome, which could be the Gorgon (Medusa), a woman, a deity, or a silen (aged satyr). Less numerous are antefixes with a palmette, a motif common in other parts of the Greek world. Tarantine antefixes tend not to have pronounced frames around the images represented.

This Gorgon antefix is among the earliest produced in Taranto between the mid sixth and the third century BC. The face, of the "horrid" type, is contained within the arched top and flat bottom of the antefix. The mouth is fixed in a terrifying smile, the tongue hanging down between two sets of fangs. Other frightening features include dilated nostrils, raised eyebrows, a beard of pointed locks, and a jutting chin. Bright paint, only traces of which remain today, would have enhanced the monstrous effect of the antefix. Red, black, and sky-blue were predominant colors, and contributed to the strong visual impact.

Ancient authors emphasize the mysterious, dreadful power of Medusa's voice and gaze, and her decapitation by Perseus. The earliest description of her features with hanging tongue and animal-like fangs appears in Hesiod (*Shield of Herakles* 230–36). Homer states that the Gorgon head was used as shield decoration (*Odyssey* 11.634).

The schematic physical traits represented here stress the Gorgon's apotropaic function. During the Archaic period, the gorgoneion (image of the Gorgon) was a decorative motif used for antefixes, metopes, acroteria (statues or other architectural ornaments), coins, and vases. To protect against bad luck and the negative effects of wine, the Gorgon was also used to decorate the inside of kylikes (drinking cups).

Gorgon antefixes warded off evil for the buildings they decorated. The Archaic sacellum (shrine) in the vicinity of the necropolis of Taranto, which was possibly dedicated to the deities of the underworld, incorporated such antefixes. Sections of the rim and hair are restored. LT

LITERATURE

G. Pugliese Carratelli, ed., *The Western Greeks*, exh. cat., Palazzo Grassi, Venice (Milan, 1996), 672, no. 53 l.

P. Orlandini, "Le arti figurative," in G. Pugliese Carratelli et al., *Megale Hellas: Storia e civiltà della Magna Grecia* (Milan, 1983), 402, 418, fig. 420.

C. Laviosa, "Le antefisse fittili di Taranto," *Archeologia Classica* 4 (1954), 232, no. 4, pl. 68.4.

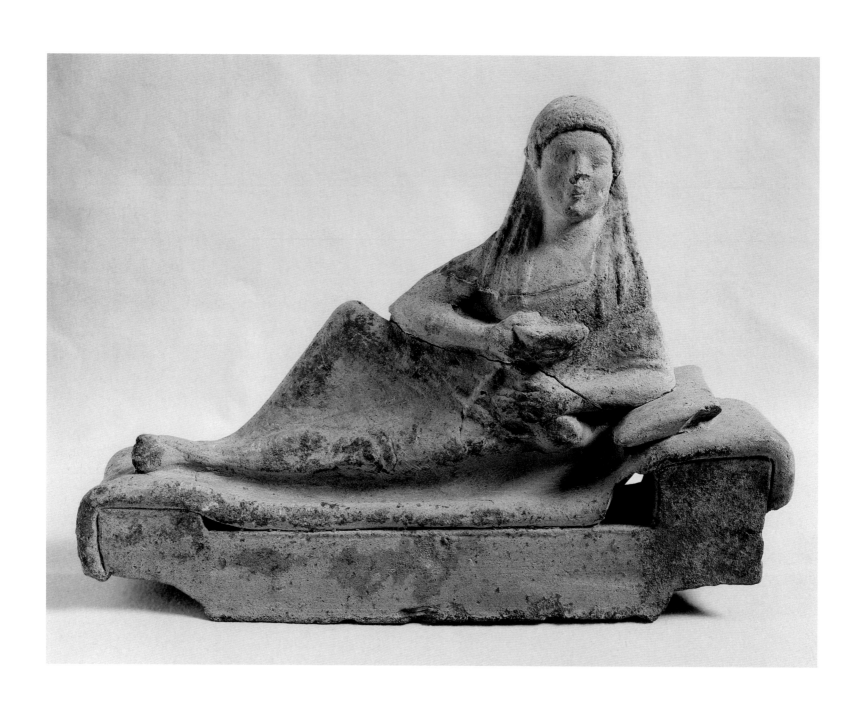

8. RECLINING YOUTH

ca. 525–500 BC
Terracotta, beige clay with micaceous inclusions, mold-made, hand-finished
H. 21.5, L. 31
Museo Archeologico Nazionale di Taranto, inv. 20047
Taranto, Cortivecchie district, Via Regina Elena, 15 July 1919

This terracotta figure of a young man reclining on a *kline* (couch) has an oval face, almond-shaped eyes, and "Archaic smile." On each side of his head, three braids fall over his shoulders. He holds a phiale (shallow bowl) up to his chest in his right hand and a lyre underneath in the left. A himation draped from his left shoulder clings to his lower body.

Produced from a single mold in high relief, this figure has traces of a slip on its surface over which red, black, and sky-blue paint were applied but are now missing. The face and himation certainly would have been painted. Under the figure at each end, wood or clay shims would have helped stabilize the relief.

Defined as "recumbent," this type of figure is widely documented in Taranto by numerous examples produced in series from the end of the sixth century BC through the Classical period. The iconography evolved stylistically over time. The type disappears almost completely during the last quarter of the fourth century BC when other cult objects become more popular. Reclining figures like this one have been found in votive deposits related to the cult practices of the necropolis. In the Laconian colony of Taranto, in contrast to other Greek cities, cult rituals were performed within the necropolis.

Interpreting the recumbent figure as a type is difficult. It can be traced to Assyrian antecedents; it then passed into the Greek world through Corinthian painted ceramics. Some scholars have identified it with the deities Dionysos Hades or Pluton. Others have considered it to be the deceased, elevated to the status of a hero. It has also been associated with the heroic cults of Orpheus, Zeus Kataibates, and Taras, the eponymous hero-founder of the city.

Finally, the type does not lend itself to a specific divine or heroic subject. The typology varies both in the treatment of the figure and in its attributes. The phiale and the lyre, present in most of the Archaic examples, refer to the aristocratic symposium. Later, other attributes such as an egg belong to the chthonic sphere (the underworld). Fantastic animals allude to the heroic journey of the dead to the hereafter. LT

LITERATURE

L. Todisco, "Coroplastica," in L. Todisco, *Introduzione all'artigianato della Puglia antica dall'età coloniale all'età romana* (Bari, 1992), 73, no. 146.

C. Iacobone, *Le Stipi votive di Taranto* (Rome, 1988), 54, pl. 42b.

D. Loiacono, "Le terrecotte figurate," in E. M. De Juliis and D. Loiacono, *Taranto: Il Museo Archeologico* (Taranto, 1985), 342, no. 409.

P. Orlandini, "Le arti figurative," in G. Pugliese Carratelli et al., *Megale Hellas: Storia e civiltà della Magna Grecia* (Milan, 1983), 420, fig. 428.

D. Adamesteanu, "La colonizzazione greca in Puglia," in D. Adamesteanu, ed., *La Puglia dal Paleolitico al Tardoromano* (Milan, 1979), 204, fig. 427.

E. Langlotz and M. Hirmer, *The Art of Magna Graecia: Greek Art in South Italy and Sicily* (London, 1965), 258, no. 23.

B. Neutsch, "Der Heros auf der Kline," *Mitteilungen des Deutschen Archäologischen Instituts Römische Abteilung* 68 (1961), 156, pl. 66.2.

C. W. Lunsingh Scheurleer, *Beiträge zur tarentinische Kunstgeschichte: La Critica d'Arte* 2 (1937), pl. 146, fig. 3.

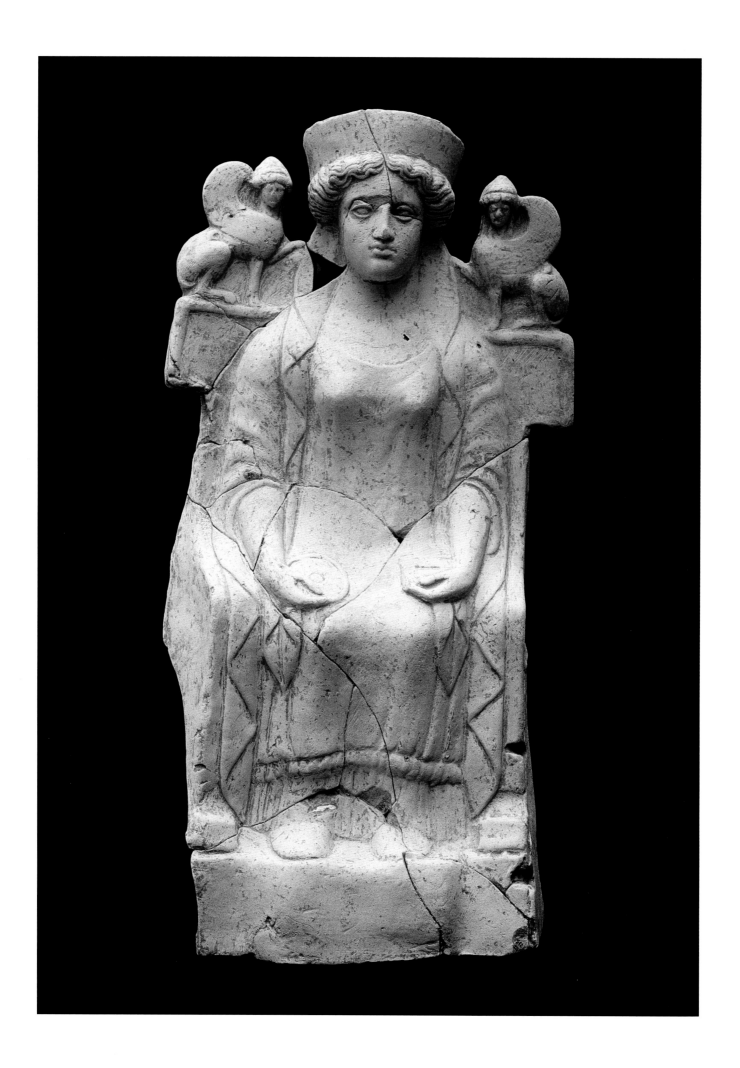

9. ENTHRONED FEMALE DIVINITY

ca. 450–400 BC
Terracotta, orange clay, beige slip, mold-made, hand-finished
H. 51.5, W. 28.2
Museo Archeologico Nazionale di Taranto, inv. 51709
Taranto, Ospedale Civile "SS. Annunziata" deposit, lot no. 12, 21 December 1989

Seated on a throne, this votive figure wears a chiton with a wide neckline. Over the chiton, a himation falls from each side of her head, rests on her shoulders, covers her arms, and then drapes in regular wide folds to her knees and over the front of the throne. She wears a low-flared polos (cylindrical headdress or crown) on her head. Her hair is parted, arranged in soft wavy locks on her forehead and drawn up away from her face at the sides. The features of the face are very regular. She holds a phiale in her right hand and a small cista (box) in her left. The throne has sculpted feet, and the back has an upper horizontal crossbar with a border in relief. It is surmounted at its ends by two sphinxes wearing pointed headdresses, mirror images of one another. Each raises a front leg to touch the edge of the himation. There has been some restoration to the figure, and small gaps are visible.

This type of enthroned female figure was produced from three molds, one for the central part and one for each side. The back is hollow and poorly finished. Traces of color on several Tarantine examples demonstrate that it was used to emphasize facial features, garments, and attributes. These colored pigments were mostly applied after firing.

Enthroned figures produced in the Classical period follow those of the Archaic period, which are characterized by a very rigid posture. The Classical examples have more elaborate thrones with protruding crossbars at the back, sometimes adorned with additional decorative elements. In these figures, the presence of phialae, cistae, and other attributes indicate a date in the second half of the fifth century BC.

In the Classical period, new production techniques involving the integration of components obtained from different molds resulted in a more vigorous sculptural quality and greater variety of detail. Until the discovery of this particular terracotta and one other, the iconography of such figures was known only from a few smaller and more fragmented specimens, mostly from the Villa Beaumont (at the present-day Villa Peripato), an important part of the old city that faces the Mar Piccolo. This one was found in a votive deposit at a site now occupied by the Ospedale Civile "SS. Annunziata." The chronology of the site is somewhat unclear. It had a number of functions related to cult and funerary practices involving the production of terracottas. In fact, by-products of the process of manufacturing terracottas may be interpreted as *bothroi* (refuse pits). The votive figurines are linked to cult practices connected with a sacellum, the remains of which were found nearby.

On the find, see A. Dell'Aglio, "L'argilla, Taranto," in E. Lippolis, ed., *Arte e artigianato in Magna Grecia,* exh. cat., Convento di San Domenico, Taranto (Naples, 1996), 52–53. On the type, see C. Iacobone, *Le stipi votive di Taranto, Excavations 1885–1934* (Rome, 1988), 44–45, B1 Xib. AD

LITERATURE

G. A. Calabrese, "La coroplastica votiva: Taranto," in E. Lippolis, ed., *Arte e artigianato in Magna Grecia,* exh. cat., Convento di San Domenico, Taranto (Naples, 1996), 188, 191, no. 64.

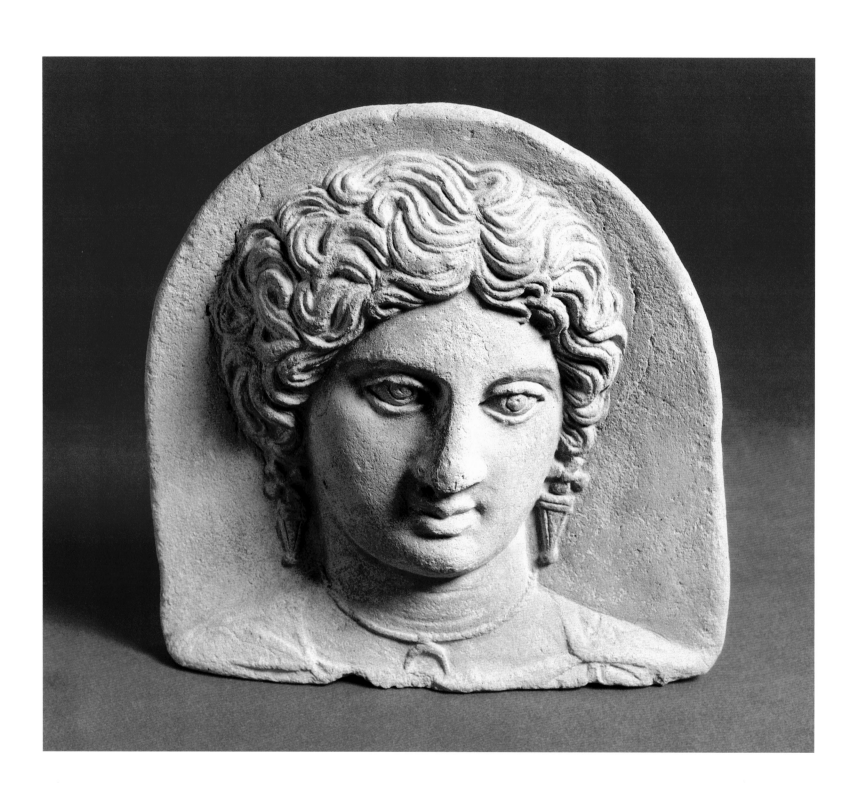

10. FEMALE HEAD ANTEFIX

ca. 400–350 BC
Terracotta, pale yellow clay, mold-made, finished with a stick
H. 19.8, W. 20.5
Museo Archeologico Nazionale di Taranto, inv. 17554
Taranto, Vecchio Museo

Between the late fifth century and first half of the fourth century BC, Tarantine antefixes decorated with Gorgon protomes lost their monstrous quality and began to take on more naturalistic female features, leading to the depiction of female divinities. This antefix is an example of the new type and represents a female protome in three-quarter view. The head is bent slightly forward and has soft but well-delineated contours within a plaque with an arched top and flat bottom. The eyes are large with incised pupils and irises. The nose is straight and the lips fleshy. The short hair is shown in wavy locks. She wears earrings with a small cross supporting an inverted pyramid and a necklace with small beads and a lunar crescent. The neck and part of the shoulders are visible.

The head's dignified features and empathetic gaze have been recognized as belonging to the goddess Aphrodite. In fact, other Tarantine antefixes with similar female heads are accompanied by a small Eros, clearly the companion of the goddess. The necklace she wears strengthens this identification. Its lunar crescent pendant may be connected both with Artemis and Aphrodite Urania. The symbol, associated with the sphere of women and likely of Syrian origin, is invested with the power to ward off evil. The pyramid earrings are of a recognizable type, widespread in the ancient world and especially popular in Taranto during the fourth century BC.

The antefix was produced in Taranto from a mold and finished with a stick. The creativity of Tarantine artisans is evident in this architectural element, as it is in other works of art produced in the city, from ceramics to gold jewelry, from funerary monuments to terracotta sculpture. The small size of this antefix, which is characteristic of the Tarantine series, suggests that they were used on private buildings or for funerary or cult purposes. They are documented from various locations throughout the city.

For an almost identical antefix in Basel, see H. Herdejürgen, *Götter, Menschen und Dämonen, Terrakotten aus Unteritalien* (Basel, 1978), 96, no. C 15. LT

LITERATURE

H. Hellenkemper, *Die neue Welt der Griechen*, exh. cat., Römisch-Germanisches Museum (Cologne/Mainz, 1998), 219, no. 164.

G. Pugliese Carratelli, ed., *The Western Greeks*, exh. cat., Palazzo Grassi, Venice (Milan, 1996), 727, no. 292 I.

L. Todisco, "Coroplastica," in L. Todisco, *Introduzione all'artigianato della Puglia antica dall'età coloniale all'età romana* (Bari, 1992), 83, no. 188.

E. M. De Juliis and D. Loiacono, *Taranto: Il Museo Archeologico* (Taranto, 1985), 122–23, no. 106.

P. Orlandini, "Le arti figurative," in G. Pugliese Carratelli et al., *Megale Hellas: Storia e civiltà della Magna Grecia* (Milan, 1983), 498, 504–5, fig. 560.

C. Laviosa, "Le antefisse fittili di Taranto," *Archeologia Classica* 4 (1954), 238–39, no. 26, pl. 73.3.

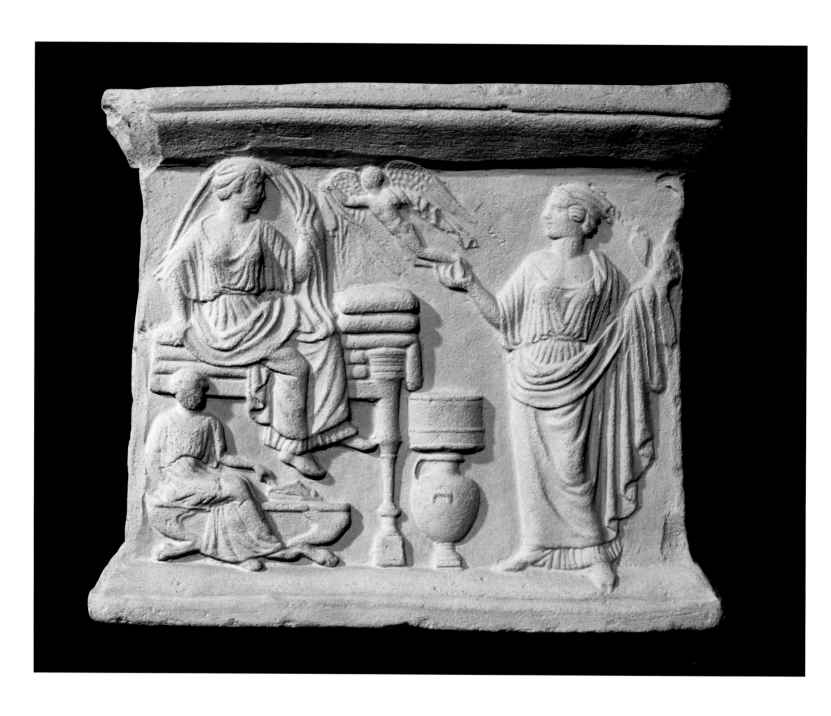

11. MARRIAGE ALTAR

ca. 400–350 BC
Terracotta, mold-made, hand-finished
H. 22.5; lower base: 18.5 x 27.5; upper base:
19 x 27.8
Museo Archeologico Nazionale di Taranto,
inv. 208343
Taranto, Masseria Vaccarella, accidental find,
27 April 1914

The front of this altar depicts a marriage initiation ceremony. On the right is a female figure, identified as Aphrodite, wearing a chiton and himation, her hair held in a *sakkos* (hair wrap). With her right hand she directs Eros toward the bride, seated at the left. Eros offers the bride a *tainia* (ribbon). She sits on a kline and lifts her veil. A handmaiden sitting under her has removed the bride's shoes. To the right of the kline is a hydria, a vessel used for ritual washing associated with the *gamos* (wedding). On top of the hydria is a cista. The sides of the altar are decorated with an elaborate vegetal pattern.

During the fourth century BC, Taranto became a major center of production of terracotta altars, a class of objects typical of the Western Greeks. Recent excavations have resulted in catalogues and interpretative studies on the production, iconography, manufacturing techniques, and markets for the terracotta altars produced in such cities as Gela, Medma, Himera, and Locri. Unfortunately, the terracotta altars of Taranto have not been as well published. Although not numerous, they are of high quality. Many were excavated between the end of the nineteenth and the beginning of the twentieth century. At this time some entered private and museum collections with only basic prov-

enance information. Wuilleumier was the first to assemble a corpus of Tarantine altars. A more recent study spans the period from the sixth to the third century BC and attempts to catalogue and provide an art historical analysis of Tarantine altars as part of a more general examination of Western Greek terracotta altars. This study dated the altar under consideration, a well-documented type, to the fourth century BC. The scene of a wedding initiation may be compared with the iconography of South Italian red-figure vases, which provide numerous variations of similar scenes.

According to a recent theory, these altars were used in sacred rites conducted within the home. Small offerings of fruits, sweets, or beans may have been placed on them. These altars may have been the sites of symbolic sacrifices accompanied by libations. Alternatively, they may have been used to make specific votive offerings within sacred precincts. Because this altar comes from the Tarantine necropolis, it may have been used for libations or funerary offerings such as crowns, ribbons, or perfumed oil. GR

LITERATURE
G. Pugliese Carratelli, ed., *The Western Greeks,* exh. cat., Palazzo Grassi, Venice (Milan, 1996), 727, no. 293 I.

E. Lippolis et al., *Taranto: Culti greci in Occidente* (Taranto, 1995), pl. 22.1.

H. Van der Meijden, *Terrakotta-arulae aus Sizilien und Unteritalien* (Amsterdam, 1993), 330, no. NM 46.

P. Wuilleumier, *Taranto: Dalle origini alla conquista romana* (Taranto, 1987), 433, pl. 61.6.

E. M. De Juliis and D. Loiacono, *Taranto: Il Museo Archeologico* (Taranto, 1985), 391, no. 483.

12. FEMALE HALF-FIGURE MOLD

ca. 350–300 BC
Terracotta
H. 25.8, W. 22
Museo Archeologico Nazionale di Taranto,
inv. 151778
Taranto, courtyard of the Caserma "C. Mezza-capo," Via Principe Amedeo, cistern no. 8,
8–15 March 1989

This mold depicts the bust of a female offering bearer. Her hair, parted in the center, is encircled by a stephane with a central rosette. She wears a chiton and a himation. Her hands are pressed to her body as she holds a skyphos (deep cup) and a basket brimming with pieces of fruit, each of a similar spherical shape. The mold has been reassembled from five fragments; there is a missing section corresponding to the figure's left temple.

The subject has few parallels among the votive terracottas from Taranto. This detailed and well-executed mold may be related to the cult of Demeter. It is the product of the prolific and varied output of local artisans who sought to meet the diverse needs of cult activities and satisfy customers with different levels of sophistication.

The mold was found in a cistern that contained layers of fill with numerous other terracotta molds. These finds indicate that the cistern was abandoned between the end of the fourth and the beginning of the third century BC. The subjects of the molds belong to the figurative repertoire typical of Tarantine votive terracottas. They include the sisters Polyboea and Hyacinthus (goddesses associated with Artemis and Kore), a recumbent woman and child, and offering bearers, all casually executed. Many pieces are of special interest because of the Greek inscriptions that are visible on their backs, impressed into the wet clay. The interpretation of these inscriptions is still an open question, but they may refer to particular workshops within the vast artisan districts. Over the past twenty years, research at Taranto has been systematically identifying the topography of these districts and their levels of production.

On the findspot, see A. Dell'Aglio, "L'argilla, Taranto" in E. Lippolis, ed., *Arte e artigianato in Magna Grecia*, exh. cat., Convento di San Domenico, Taranto (Naples, 1996), 57. AD

LITERATURE

The Western Greeks, Guide to the Exhibitions in Southern Italy (Naples, 1996), 94.

G. A. Calabrese, "Taranto, Cortile della Caserma 'C. Mezzacapo,' via Principe Amedeo, 8–15 Marzo 1989," in E. Lippolis, ed., *Arte e artigianato in Magna Grecia*, exh. cat., Convento di San Domenico, Taranto (Naples, 1996), 71–79, no. 67.

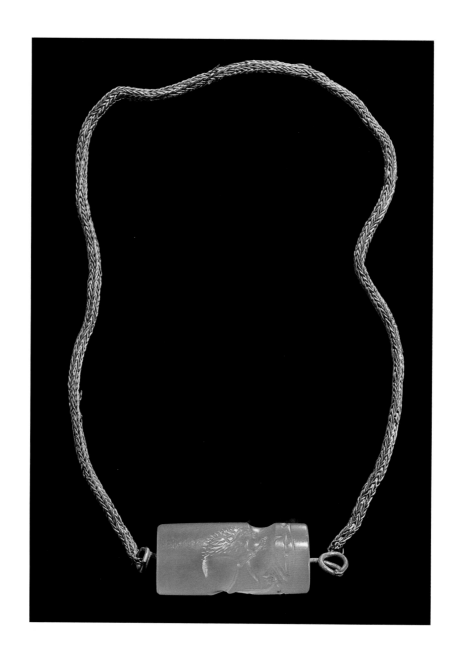

13. CYLINDER SEAL NECKLACE

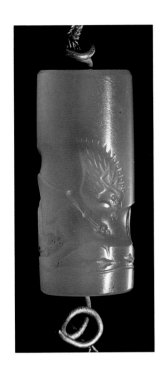

ca. 500–400 BC
Gold, chalcedony, incised
L. 23; seal: H. 2.7
Museo Archeologico Nazionale di Taranto,
inv. 12023
Monteiasi, Amoroso district, purchased 30 June
1912

A lion attacks a deer on this cylindrical chalcedony seal, which is perforated lengthwise to accommodate a gold wire with eyelet terminals. Attached at each terminal is a length of herringbone chain, frayed in places and missing a part near one of the ends. The chalcedony surface is chipped in places.

Seals of Eastern or, more specifically, Mesopotamian origin have a widespread distribution in the Mediterranean area. Their use in Taranto by the fifth century BC is amply documented, proving that this cultural environment had a practical need for such personal seals. Ring seals are abundant and their function easy to identify. Seals without ring supports, less numerous and generally smaller in size, have been wrongly interpreted in the past as decorative elements for necklaces or pendants.

The gold chain here is short and lacks a hook for closure, making its interpretation as something to be worn around the neck only a conjecture. Also, because the piece was purchased, we cannot be certain that the chain and seal were originally paired; they may have been put together later. In any case, recent excavations clearly show that such objects were not worn exclusively as pendants or necklaces. They were often suspended from the wrist, or from a belt, by a gold or leather tie or one made from some perishable material that was then connected to the cylindrical seal, ready to be used to place an impression on some other object. That such objects were found in women's burials shows that they were not reserved for men only and suggests that women held power over the domestic sphere—a precursor to a custom that would become typical in the Roman world.

The motif of fighting animals repeats one of the most widespread images of Greek glyptic art. Such images have been documented from the Archaic to Hellenistic periods, and the subject was adopted into the figural repertoires of Roman art. Here we see a lion with a full bristly mane, sunken belly, and pronounced ribs attacking a deer. It has pounced on the deer, knocking it to the ground. The deer looks back, lifting its head as the lion bites and claws its back. Vividly interpreted by the engraver, this representation reveals the high quality reached by fifth-century BC workshops. AD'A

LITERATURE

G. Pugliese Carratelli, ed., *The Western Greeks*, exh. cat., Palazzo Grassi, Venice (Milan, 1996), 735, no. 307.

P. G. Guzzo, *Oreficerie della Magna Grecia: Ornamenti in oro e argento dall'Italia meridionale tra l'VIII ed il I secolo* (Taranto, 1993), 56–57, 207, fig. 34.

A. D'Amicis, "Sigilli," in E. M. De Juliis et al., *Gli ori di Taranto in età ellenistica* (Milan, 1989), 310–11, 314, no. 7.

J. Boardman, "Greek Cylinder Seal and Necklace in London," *Antike Kunst* 13 (1970), 50.

G. Becatti, *Oreficerie antiche dalle minoiche alle barbariche* (Rome, 1955), 202, no. 432.

14. BOAT-SHAPED EARRINGS

ca. 350–325 BC
Gold, tooled
H. 2.7, W. 1.8 each
Museo Archeologico Nazionale di Taranto,
inv. 196946
Taranto, Via Marche, tomb 62, 18 October 1994

Each of the boat-shaped sections of these earrings is made of two sheets of gold soldered together. A hook of gold wire, thinning toward one end, suspends the earring from the earlobe. A vertical beaded wire between two smaller plain wires decorates the central part of each boat-shaped section; three small beads of decreasing size are soldered to the bottom of that wire. Beaded wires within two smaller plain wires mark the ends of the boat-shaped sections. The hooks are slightly distorted and each earring has small dents.

Earrings of similar half-moon shape are known from Cyprus as early as the Mycenaean period and were in use at various sites in the Mediterranean basin through the Archaic and Classical periods. In fact, during the fifth and fourth centuries BC, the type is widespread, not only in mainland Greece but also in Magna Graecia, Sicily, southern Russia, Thrace, Macedonia, and Croatia.

A study of Tarantine gold jewelry conducted in 1984 concluded that the largest number of boat-shaped earrings had come from Taranto, with several varieties represented. The most refined and elaborate examples of Tarantine goldwork were crafted during the Hellenistic period. During the fourth century BC, the boat-shaped earring was replaced by other styles, such as the lion protome, the pendant, and the loop. These types characterize Tarantine earring production from the third to the first centuries BC.

Recently, archaeological research at Taranto has added to the known examples of this earring type, both in gold and silver, found in funerary contexts in the city as well as the *chora* (surrounding agricultural territory). Excavations carried out in successive campaigns since 1994 in Via Marche have uncovered a large part of the Tarantine necropolis, providing important topographical information. It was found that sections of the necropolis had been laid out systematically from the Archaic period. Chamber tombs were built at the intersections of roads in the Hellenistic period.

This pair of gold earrings are part of a grave deposit found in a woman's tomb in the vicinity of the Via Marche necropolis. The tomb, which probably dates to the fourth century BC, is lined with stone slabs. From the fourth century BC, this type of tomb was placed beside tombs cut directly into the rock and progressively came to replace sarcophagi.

An analysis of the skeletal remains indicates that the burial was of a girl, approximately nine years of age. This objective data confirms earlier inferences based on the typological and functional characteristics of objects making up the funerary deposit. Suggesting the social status and age of the deceased, these objects include figural terracottas suitable for a young girl; a bronze mirror and Apulian red-figure pyxis with traces of white pigment are grooming aids, part of the *mundus muliebris* (the feminine realm).

An uncommon deposit of two *litra* (silver fractional coins of Taranto) enclosed within a small wooden container was also found in the tomb. Only a few iron nails and a bronze ring remained of the container. The monetary value of the coins was perhaps secondary to their symbolic value and ritual function. Their significance as grave deposits may be associated in some way with the social status of the deceased. According to the archaeological context, the burial may date to the third quarter of the fourth century BC.

For comparanda, see T. Schojer, "Orecchini," in E. M. De Juliis et al., *Gli ori di Taranto in età ellenistica* (Milan, 1989), 131–32, 150–54, no. 56. On the necropolis at Via Marche, see A. Dell'Aglio and E. Lippolis, "Taranto, via Marche," *Taras* 15 (1995), 105–7. AD

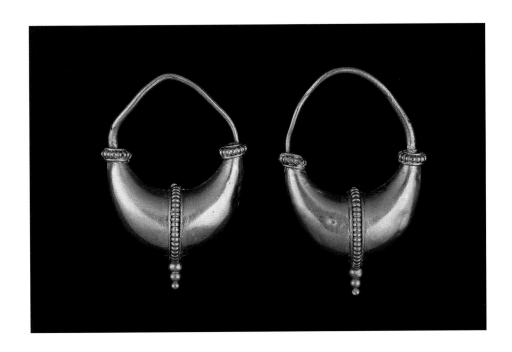

LITERATURE

A. Dell'Aglio, "Taranto, via Marche," *Taras* 20 (2000), 88.

A. Dell'Aglio, "Taranto, via Marche," *Taras* 18 (1998), 79.

V. Scattarella et al., "Le necropoli di età classica (VI–IV sec. a.C.) di via Marche a Taranto: L'analisi antropologica," *Antropologia Contemporanea* 20, nos. 1–3 (1977).

G. Andreassi, "L'attività archeologica in Puglia nel 1994," in *Corinto e l'Occidente: Atti del trentaquattresimo Convegno di studi sulla Magna Grecia* (Taranto, 1994), 805–8.

N. Degrassi, "Oreficerie greche ed ellenistiche," in *Ori e argenti dell'Italia antica* (Turin, 1961), 77–127, no. 307.

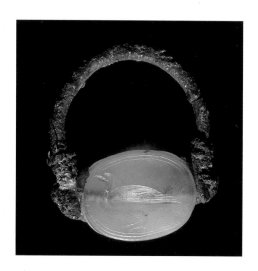 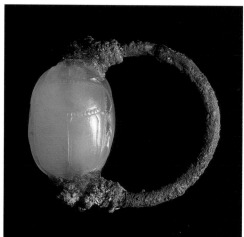

15. BIRD SCARAB RING

340–330 BC
Silver, pale violet chalcedony, drilled, incised
Band: Diam. 1.8; scarab: H. 1.2, L. 1.6
Museo Archeologico Nazionale di Taranto,
inv. 106516
Taranto, Via Bellini, tomb 2, 15 November 1956

The band of the ring is flat on the inside and round on the outside, becoming narrower toward the conical ends. A silver thread passes through the scarab and is repeatedly twisted around the band. The head and the clypeus (shield-shaped body) of the scarab are outlined, and a broken incised line separates the protothorax from the elytron (pair of anterior wings), which are divided by an incised line ending in an acute angle. The insect's four legs rest on a baseline.

On the flat side of the scarab a web-footed bird is represented inside a frame composed of a broken line. The bird is shown in profile facing left. Its legs are rendered in the "round-tipped incision" technique.

Rings set with swiveling stones of chalcedony, carnelian, or more rarely gold, and carved into scarabs or scaraboids were produced in Taranto from the first half of the fourth century BC well into the third century BC. At that time they were replaced by rings set with stones in fixed mounts. Gold, silver, bronze, and iron were used for the bands. Iron and bronze are rare, probably because they are more subject to corrosion. Some gems without bands, which have been found with some frequency in Hellenistic contexts in Taranto, may have been mounted using those metals.

The scarab ring seems to be connected particularly with women's tomb deposits, and the size of the ring here would seem to support this observation. The hypothesis that the seal rings had an exclusively decorative use, at a time far removed from their introduction, contrasts with the presence of cylinder seals in Taranto. Undoubtedly, such rings belong to women's tomb deposits. Like the cylinder seals, rings with scarabs that swivel were mainly used in household settings, where the woman was in charge of domestic life within the *oikos* (home).

Semi-precious stones such as carnelian and chalcedony, in the varieties present in Taranto, probably came from India, the Arabian Peninsula, or the Egyptian deserts. Their introduction coincides with an enrichment of the decorative repertory, in which complex scenes are often shown as well as isolated representations of animals or birds.

The web-footed bird here is carefully executed in intaglio and skillfully adapted to the oval shape of the stone. The effect is harmonious. The engraver's fine technique and naturalistic style renders the bird's plumage as a compact mass on the body trailing into delicate, thin incisions on the tail, which continue to the border of broken lines. The prominent beak overlaps the border on the opposite side. The use of a rounded-point drill is visible in the execution of the eyes and the joints of the legs. The ring was found with a pair of boat-shaped terracotta earrings with gold gilt in a woman's burial, dated between 340 and 325 BC.

LM

LITERATURE

G. Pugliese Carratelli, ed., *The Western Greeks*, exh. cat., Palazzo Grassi, Venice (Milan, 1996), 737, no. 322.

P. G. Guzzo, *Oreficerie della Magna Grecia: Ornamenti in oro e argento dall'Italia meridionale tra l'VIII ed il I secolo* (Taranto, 1993), 172, no. A8.

A. Alessio, "Anelli," in E. M. De Juliis et al., *Gli ori di Taranto in età ellenistica* (Milan, 1989), 276, no. 175.

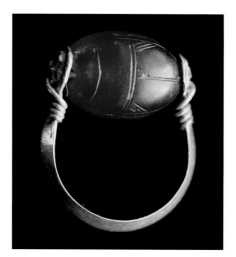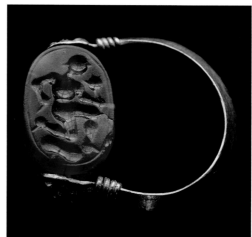

16. WARRIOR SCARAB RING

ca. 325–300 BC
Gold, dark amber chalcedony, drilled, incised
Band: Diam. 1.8; scarab: H. 1, L. 1.5
Museo Archeologico Nazionale di Taranto,
inv. 54752
Taranto, Via Iapigia, from a tomb, 5 December
1934

The band of this ring is triangular in cross section. The terminals are in the form of lion protomes, pierced to allow a gold thread to pass inside the scarab and wrap repeatedly around the band. Incisions define the head and clypeus of the scarab; a double incision marks the division between the protothorax and the covers of the elytron. Three diagonal incisions appear on the wings; the legs are rendered with quickly executed incisions on a baseline.

A warrior facing to the right in a three-quarter view is represented on the flat surface of the scarab. His right knee leans against a rise in the ground, framed within a simple incised line. He appears to wear some kind of head gear and is armed with a dagger held in his lowered right hand. In the other hand he holds another object, possibly a club.

On this kind of ring, fitted with a stone that swivels, terminals in the form of lion protomes are common. Their use in other categories of jewelry, such as the terminals of necklaces and bracelets, is widespread during this period. The motif of the wild animal protome appears repeatedly on a remarkable, well-defined group of earrings produced between the last quarter of the fourth century BC and the middle of the third century BC.

In the classification of rings, lion protomes appear on a few pieces with gold bands on which the lion heads are executed from molds and have finely detailed manes, pronounced muzzles, and outlined eye sockets. In other pieces of jewelry the eye sockets are inlaid with decorative stones. The chalcedony scarab displays evidence of the round-tipped incision technique, which became common from the second half of the fourth century BC. Based on the use of a round-pointed drill and no additional finishing with emery, this technique results in figures that appear sketchy and ill-shapen. The lack of sharp detail is caused by the overlapping of the rounded grooves—a characteristic of the technique.

On scarabs the figural repertory is limited to generic themes with little interest in content or complex figural scenes. Mythological scenes are absent. Instead, isolated subjects or single figures are preferred, especially warriors, deities, animals, centaurs, and heroes—especially Herakles.

The meaning of the representation incised on the scarab from Taranto is difficult to interpret. The motif of a warrior leaning on a rising ground line is present on another unpublished chalcedony scarab found in the vicinity of the Santuario della Sorgente di Saturo in Taranto. The study of the tomb deposit suggests a date for that scarab of the third quarter of the fourth century BC. Thus it should be considered part of the production of artisans expert in the round-tipped incision technique whose workshops were probably located in Taranto, a center of the goldsmith's art. LM

LITERATURE

G. Pugliese Carratelli, ed., *The Western Greeks*, exh. cat., Palazzo Grassi, Venice (Milan, 1996), 737, no. 320.

P. G. Guzzo, *Oreficerie della Magna Grecia: Ornamenti in oro e argento dall'Italia meridionale tra l'VIII ed il I secolo* (Taranto, 1993), 174–75, no. E1.

A. Alessio, "Anelli," in E. M. De Juliis et al., *Gli ori di Taranto in età ellenistica* (Milan, 1989), 280–81, no. 185.

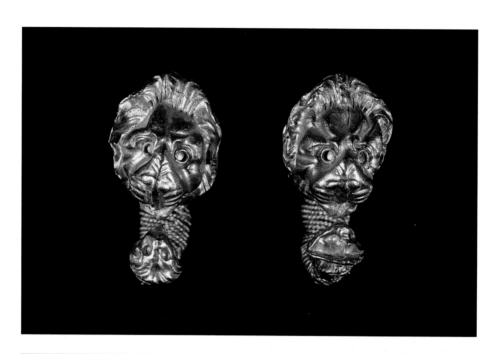

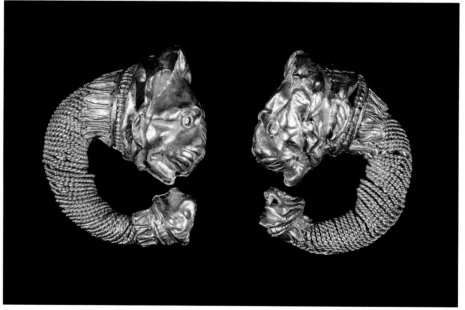

17. LION PROTOME EARRINGS

ca. 325–300 BC
Gold, incised, filigree, mold-made protomes
H. 2.1 each
Museo Archeologico Nazionale di Taranto,
inv. 126231 A–B
Taranto, Via Molise, tomb 1, 11 March 1966

The curved part of each earring is made of twisted gold threads, wound in a spiral around a tube of sheet gold that becomes wider at the end where it connects to the lion protome. Each lion has a mane of thick wavy locks and eyes underlined by a smooth gold thread. The well-shaped muzzle has incisions on the nose and around the parted mouth, and others that define the bone structure of the brow. The protome is connected to the earring arch by a small collar of sheet gold decorated with a series of petals in filigree, bordered at the top by a smooth thread and a beaded thread. The opposite end of the earring terminates in another, smaller protome with less defined features. It has a small sheet gold collar with petals applied in filigree, set off by a beaded thread. Each arch is slightly damaged. The sheet gold is dented and the solder has become detached near the collar of one of the larger protomes.

Lion protomes, executed in sheet gold from a mold, were widely used for the finials of necklaces, bracelets, and especially earrings. Tarantine goldsmiths were particularly fond of this motif from the last quarter of the fourth century BC to almost the middle of the following century. Among the vast figurative repertoire of jewelry produced in the Mediterranean basin, the lion protome was a particular favorite in Tarantine workshops, which used it in a considerable number of pieces, especially in sets of necklaces and earrings. These pieces share specific formal characteristics, such as the refined chiseling and the sculptural vigor of the lion heads. This work may be distinguished from similar pieces produced by other workshops. Further characteristics of Tarantine work included pairs of protomes of different sizes, ivy branches, leaves, or volutes in

filigree applied to the smaller collar, as well as other details not found on earrings produced elsewhere.

Such technical similarities, together with the chronological data provided by the Taranto necropolis, seem to justify the hypothesis that the city specialized in the production of such gold jewelry. Perhaps this jewelry was exported to other areas, such as Campania and Etruria. In any case, the distribution was widespread, as documented by the large number of pieces that have recently appeared on the art market.

Similar earrings have holes corresponding to the eyes, obviously for insertion of vitreous pastes or colored stones that generally do not survive. These inlays added an accent of color to the monochromatic gold, as seen in some rare intact examples. The earrings exhibited here may be dated to the last quarter of the fourth century BC, as suggested by the study of the funerary deposit, which included a spiral ring with similar lion protomes. Earrings produced in the first half of the third century BC are simpler, having only one protome. This production was gradually replaced by other styles reflecting Hellenistic taste.

For comparanda, see E. M. De Juliis, *Archeologia in Puglia: Il Museo Nazionale di Taranto* (Bari, 1983), 52–53, fig. 112; M. Cipriani et al., *The Lucanians in Paestum* (Paestum, 1996), 25. AD'A

LITERATURE

P. G. Guzzo, *Oreficerie della Magna Grecia: Ornamenti in oro e argento dall'Italia meridionale tra l'VIII ed il I secolo* (Taranto, 1993), 256, no. 2.

T. Schojer, "Orecchini" in E. M. De Juliis et al., *Gli ori di Taranto in età ellenistica* (Milan, 1989), 140–41, 182–83, no. 110.

P. Orlandini, "Le arti figurative," in G. Pugliese Carratelli et al., *Megale Hellas: Storia e civiltà della Magna Grecia* (Milan, 1983), 508, 515, fig. 604.

A. Stazio, "L' attività archeologica in Puglia," in *Letteratura e arte figurata nella Magna Grecia: Atti del sesto Convegno di studi sulla Magna Grecia* (Taranto, 1966), 291, pl. 14.3.

N. Degrassi, "Oreficerie greche ed ellenistiche," in *Ori e argenti dell'Italia antica* (Turin, 1961), 107, no. 312, pl. 36.

18. ODYSSEUS AND ARGO RING

ca. 320–300 BC
Gold, incised
Band: Diam. 1.6; bezel: H. 1.1, L. 1.7
Museo Archeologico Nazionale di Taranto,
inv. 12019
Taranto, Via Regina Elena, from a tomb, 9 January
1915

This ring has an oval bezel with a flat upper sur-
face. The band is rounded on the outside and has
edges that slant inward. The figure finely cut into
the bezel of the ring and finished with a burin has
been identified as Odysseus with his faithful dog,
Argo. The Homeric hero is represented bent with
age, with long hair and a thick beard, barefoot,
and stepping forward while leaning on a stick. He
wears a pilos (conical hat with a narrow rim); the
mantle that has slid from his extended left arm
drapes in front in closely spaced arcs. Argo, partly
hidden by his master, stands on the same baseline.
The dog is schematically rendered in the round-
tipped incision technique frequently used in the
same period for the decoration of scarabs.

An exceptional example of the goldsmith's art,
this ring is part of a series of metal rings with in-
cised figural decoration that were produced in
Taranto beginning in the first half of the fourth
century BC. Tarantine burials of the Hellenistic pe-
riod have yielded a number of rings of this kind as
well as those with scarabs that swivel. This rich

series of rings makes it possible to follow the
evolving shape of the bezel, in oval and circular
variations. The profile may be flat or convex, and
the engraved figure may completely fill the space,
or in the case of a circular bezel, leave most of the
field free. The latter style was widespread toward
the end of the fourth century BC. Because of its
elliptical bezel, the ring with Odysseus and Argo
may be dated between 320 and 300 BC. Oval
bezels with rounded ends are documented until
about 350 BC, when the elliptical shape came into
usage. The thinning noticeable in the band was
caused by the hammering of the bezel before the
figural scene was incised.

As executed by the Tarantine goldsmith, the
representation of Odysseus with Argo departs from
the typical rendition of the scene on engraved
gems. Usually the king of Ithaca is shown youth-
ful, or armed, and in front of the dog in a moment
of recognition. Here the Homeric episode is given
a more intimate narration. Odysseus appears
less heroic, with a greater emphasis on the strong
emotional bond between dog and aged master.
Odysseus looks tired, his footsteps slow, as his dog
shows the way.

This ring is the only piece of jewelry from a
woman's burial dated to the last decades of the
fourth century BC. The burial deposit also included
an oinochoe (pitcher), a two-handled cup, and a
loom weight. LM

LITERATURE

P. G. Guzzo, *Oreficerie della
Magna Grecia: Ornamenti in
oro e argento dall'Italia
meridionale tra l'VIII ed il I
secolo* (Taranto, 1993), 31,
180, fig. 10.

*Catalogo del Museo Naziona-
le Archeologico di Taranto*
(Rome, 1990), 1: pt. 2, 71, fig.
69.

A. Alessio, "Anelli," in E. M.
de Juliis et al., *Gli ori di
Taranto in età ellenistica*
(Milan, 1989), 285, no. 197.

E. M. De Juliis and D.
Loiacono, *Taranto: Il Museo
Archeologico* (Taranto, 1985),
309, no. 359.

E. M. De Juliis, *Archeologia in
Puglia: Il Museo Nazionale di
Taranto* (Bari, 1983), 57, fig.
123.

G. M. A. Richter, *Engraved
Gems of the Greeks and the
Etruscans* (London, 1968), 79,
no. 228.

N. Degrassi, "Oreficerie
greche ed ellenistiche," in *Ori
e argenti dell'Italia antica*
(Turin, 1961), 110, no. 327, pl.
42.

J. Boardman, *Greek Gems and
Finger Rings* (London, 1970),
300, pl. 757.

G. Becatti, *Oreficerie antiche
dalle minoiche alle barbariche*
(Rome, 1955), 83, 187, no.
329, pl. 81.

L. Breglia, "Le oreficerie del
Museo di Taranto," *Iapigia* 10
(1939), 27–29, no. 31, fig. 16.

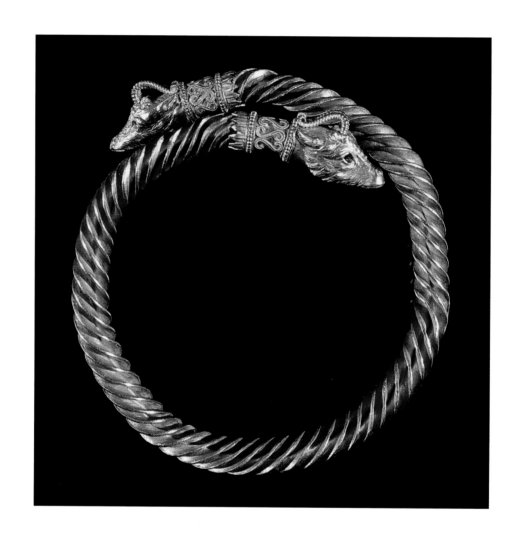

19. ANTELOPE ARMBAND

ca. 300–280 BC
Gold, incised, filigree, mold-made protomes
L. 28 (end to end), Diam. 7.7
Museo Archeologico Nazionale di Taranto,
inv. 54118
Mottola, from a tomb, purchased 21 December
1936

The stylistically homogeneous gold jewelry presumed to be from Mottola [19–21], in the vicinity of the northern Tarantine chora, was acquired only in part by the Taranto museum. The rich ensemble became known during an investigation of the unclear circumstances surrounding its discovery and subsequent appearance on the art market.

The deeply grooved band of this bracelet is twisted into a helix and becomes slightly thinner toward the ends. The finials, set off by elaborately finished collars, take the form of antelope heads, mold-made, finely chiseled, and with precise anatomical details. The fur is rendered in a naturalistic style; the horns are thick serrated wires bent into volutes and soldered down at the ends; the hollow eyes were once inlaid with stones. The collar connecting the heads to the band is sheet gold decorated in filigree with opposing S-shaped volutes between two borders, each of which is composed of a beaded wire between two smaller plain wires. At the juncture between the finials and the band are cylinders of sheet gold worked into a series of pointed leaves with central veins of cut sheet gold. The twisted band has several dents.

The bracelet is probably not the product of a Tarantine workshop that was inspired by examples from northern Greece or Asia Minor, as suggested in a study conducted in 1984. It seems more likely that it is an Eastern import. Its presence in South Italy may be related to the movement of mercenary soldiers during the period of Alexander the Great's successors (the Diadochi). The antelope or ram protomes suggest an Eastern origin for the piece. This motif has been connected with an erotic meaning, leading to its widespread and varied appearance in the Hellenistic age in the decoration of bracelet terminals, earrings, and necklaces. Also, the twisted shape of the bracelet is different from comparable pieces, which show the protomes facing each other. Perhaps the diameter was reduced, either because of certain burial rites, or to fit a smaller wrist. AD

LITERATURE

G. Pugliese Carratelli, ed., *The Western Greeks*, exh. cat., Palazzo Grassi, Venice (Milan, 1996), 733, no. 302 I.

L. Masiello, "La necropoli ellenistica: le oreficerie," in E. Lippolis, ed., *Taranto La necropoli: Aspetti e problemi della documentazione archeologica dal VII al I sec. a.C. Catalogo del Museo Nazionale Archeologico di Taranto* (Taranto, 1994), 3, part 1: 319, no. 86, pl. 21.2.

P. G. Guzzo, *Oreficerie della Magna Grecia: Ornamenti in oro e argento dall'Italia Meridionale tra l'VIII ed il I secolo* (Taranto, 1993), 78–79, 238, 314–15, fig. 37.

A. Dell'Aglio, "Bracciali," in E. M. De Juliis et al., *Gli ori di Taranto in età ellenistica* (Milan, 1989), 239–40, 243–45, 434–35, no. 167.

F. Coarelli, *Greek and Roman Jewellery* (London, 1988), 145, no. 35.

P. G. Guzzo, "Gioie clandestine," *Mitteilungen des Deutschen Archäologischen Instituts Römische Abteilung* 84 (1987), 169–76.

E. M. De Juliis, *Archeologia in Puglia: Il Museo Nazionale di Taranto* (Bari, 1983), 54, figs. 113–14.

A. Bevilacqua et al., *Gli ori di Taranto* (Genoa, 1975), 35.

U. Zanotti Bianco, *La Magna Grecia* (Genoa, 1973), 187, fig. 202, pl. 48.

F. Coarelli, *L'oreficeria nell'arte classica* (Milan, 1966), 87–88, no. 37.

H. Hoffman and P. F. Davidson, *Greek Gold, Jewelry from the Age of Alexander*, exh. cat., Museum of Fine Arts, Boston and tour (Mainz am Rhein, 1965), 162, fig. 57b.

N. Degrassi, "Oreficerie greche ed ellenistiche," in *Ori e argenti dell'Italia antica* (Turin, 1961), 105, no. 302, pl. 37.

L. von Matt, *Grossgriechenland* (Zurich, 1961), 187, fig. 202.

C. Drago, *Il Museo Nazionale di Taranto* (Rome, 1956), 45, 89.

G. Becatti, *Oreficerie antiche dalle minoiche alle barbariche* (Rome, 1955), 194, no. 373a–b, pl. 96.

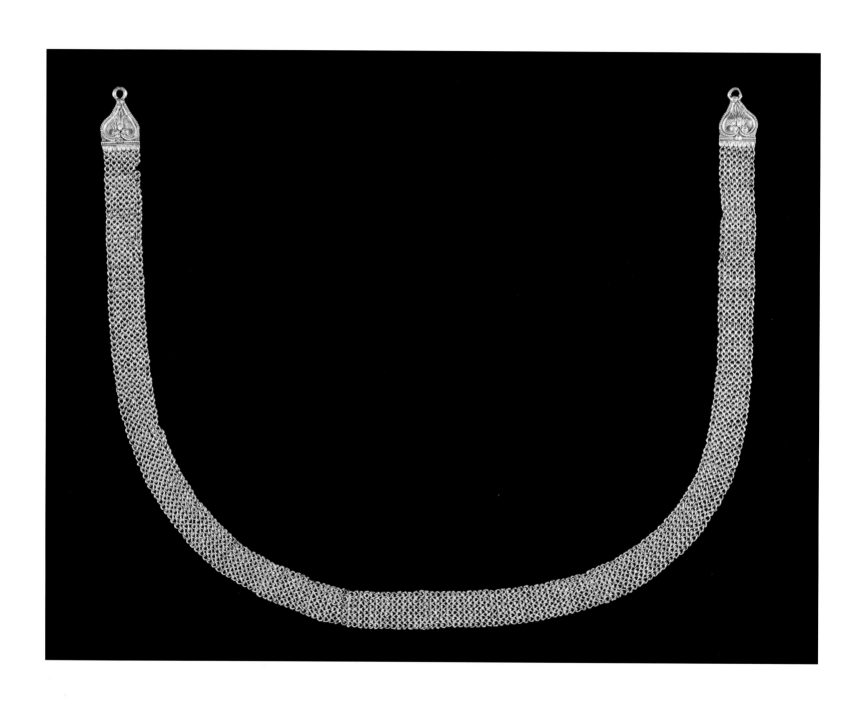

20. NECKLACE

ca. 300–280 BC
Gold, tooled
L. 42.5
Museo Archeologico Nazionale di Taranto,
inv. 54116
Mottola, from a tomb, purchased 21 December
1936

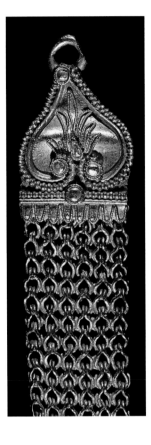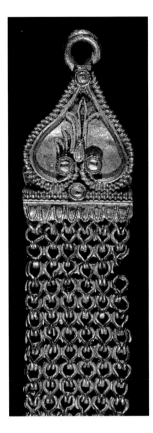

A flat ribbon comprising six double-linked chains soldered together lengthwise to form a dense mesh, this necklace ends in heart-shaped palmettes with eyelets. These forms are decorated at their edges with a beaded outer wire and a plain inner wire. This border closes at the bottom in two volutes; a filigree palmette set within a field of sheet gold sprouts from each volute. Small raised discs punctuate the ends of the volutes. A beaded wire, interrupted at its center by another raised disc, marks the base of the palmette. Next to this section runs a plain wire to which is attached a plate of sheet gold ornamented with a series of leaves defined by a fine beaded wire. The necklace is attached by means of two rectangular plates soldered to the backs of the heart-shaped ends. There are small losses in the mesh ribbon. The sheet gold of the terminals is dented.

This necklace cannot be compared with contemporaneous pieces point by point. The numerous flat ribbons of gold mesh crafted during the Hellenistic period are made of extremely fine braided gold threads, in most cases suspending a series of pendants. This type of mesh is usually found in gold pieces of different functions, often associated with exuberant decorative elements.

This Mottola *hormos* (necklace) is of a distinctive type, not intended to be worn around the neck, but fastened to clothing, probably with fibulae, from shoulder to shoulder by means of the palmette terminals with eyelets at their ends. Its function as a *periskelis* (bangle) has been proposed as well. AD

LITERATURE

P. G. Guzzo, *Oreficerie dalla Magna Grecia: Ornamenti in oro e argento dall'Italia Meridionale tra l'VIII ed il I secolo* (Taranto, 1993), 56–57, 59, 78–79, 205, 314–15, fig. 30.

E. M. De Juliis et al., *Gli ori di Taranto in età ellenistica* (Milan, 1989), 217–19, 434–35, no. 151.

P. G. Guzzo, "Gioie clandestine," *Mitteilungen des Deutschen Archäologischen Instituts Römische Abteilung* 84 (1987), 169–76.

E. M. De Juliis, *Archeologia in Puglia: Il Museo Nazionale di Taranto* (Bari, 1983), 55, 61, fig. 117.

G. Gregorietti, *Il gioiello nei secoli* (Milan, 1969), 30.

G. Gregorietti, *Jewelry through the Ages* (New York, 1969), 30.

N. Degrassi, "Oreficerie greche ed ellenistiche," in *Ori e argenti dell'Italia antica* (Turin, 1961), 105, no. 301, pl. 35.

C. Drago, *Il Museo Nazionale di Taranto* (Rome, 1956), 45, 89.

G. Becatti, *Oreficerie antiche dalle minoiche alle barbariche* (Rome, 1955), 202, no. 429, pl. 116.

21. LADY'S PORTRAIT RING

ca. 300–280 BC
Gold, incised
Band: Diam. 2.3; bezel: H. 2.9, L. 2.4
Museo Archeologico Nazionale di Taranto,
inv. 54117
Mottola, from a tomb, purchased 21 December
1936

Rounded on the outside, the band of this ring widens gradually as it merges into the almost circular bezel, which features a female head in profile, worked by incision. She has a "melon"' hairstyle, gathered at the back of her head in a chignon. She wears pendant earrings with erotes and a *lonchia* (necklace with lance-shaped elements). There are small dents on the band and several scratches on the mount.

The image worked into the top of the ring has been identified as a mature Berenice I or perhaps Berenice II (Hellenistic queens of Egypt), a suggestion that has initiated much scholarly discussion. The portrait seems to reflect the likeness of a young woman of the Ptolemaic dynasty. Hence, the ring was probably made for a woman in Egypt rather than South Italy. Its date at the beginning of the third century BC is confirmed by the way that the band widens to join the semi-circular bezel.
AD

LITERATURE

H. Hellenkemper, *Die neue Welt der Griechen,* exh. cat., Römisch-Germanisches Museum (Cologne/Mainz, 1998), 206, no. 146.

G. Pugliese Carratelli, ed., *The Western Greeks,* exh. cat., Palazzo Grassi, Venice (Milan, 1996), 733, no. 302 II.

P. G. Guzzo, *Oreficerie della Magna Grecia: Ornamenti in oro e argento dall'Italia Meridionale tra l'VIII ed il I secolo* (Taranto, 1993), 32–33, 78–79, 165, 314–15, no. 3.

A. Alessio, "Anelli," in E. M. De Juliis et al., *Gli ori di Taranto in età ellenistica* (Milan, 1989), 260, 289–90, no. 210.

F. Coarelli, *Greek and Roman Jewellery* (London, 1988), 144, no. 33.

P. G. Guzzo, "Gioie clandestine," *Mitteilungen des Deutschen Archäologischen Instituts Römische Abteilung* 84 (1987), 169–76.

E. M. De Juliis, *Archeologia in Puglia: Il Museo Nazionale di Taranto* (Bari, 1983), 58–59, fig. 125.

J. Boardman and M. L. Vollenweider, *Ashmolean Museum Oxford: Catalogue of the Engraved Gems and Finger Rings* (Oxford, 1978), 1: 113, 282.

J. Boardman, *Greek Gems and Finger Rings* (London, 1970), 362, 371, pl. 1008.

G. M. A. Richter, *Engraved Gems of the Greeks and Etruscans* (London, 1968), 161, no. 643.

F. Coarelli, *L'oreficeria nell'arte classica* (Milan, 1966), 88, no. 35.

N. Degrassi, "Oreficerie greche ed ellenistiche," in *Ori e argenti dell'Italia antica* (Turin, 1961), 104, no. 300, pl. 37.

M. L. Vollenweider, "Das Bildnis des Scipio Africanus," *Museum Helveticum* 15 (1958), 29, no. 1.

C. Drago, *Il Museo Nazionale di Taranto* (Rome, 1956), 45, 89.

G. Becatti, *Oreficerie antiche dalle minoiche alle barbariche* (Rome, 1955), 84, 188, no. 334, pl. 83.

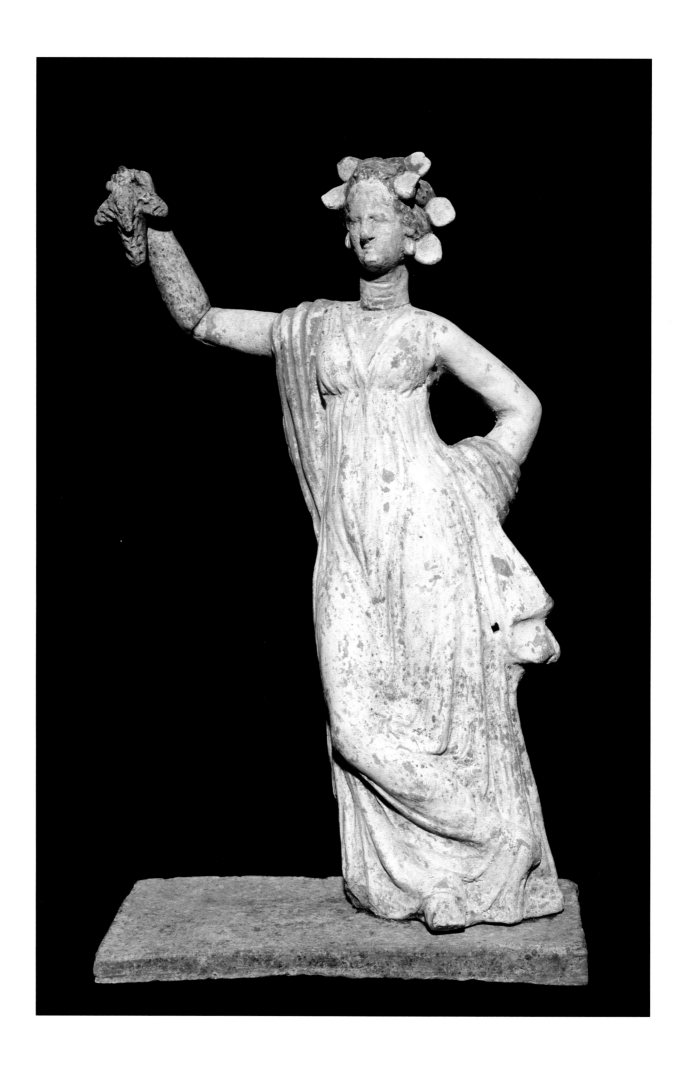

22. PAINTED FIGURINE

ca. 250–200 BC
Terracotta, white slip, mold-made, finished with
a stick, painted
H. 24.8; base: 15.2 x 6.5
Museo Archeologico Nazionale di Taranto,
inv. 51675
Taranto, Via Tito Livio, tomb 1, 27–29 May 1996

The refined and vividly painted figural terracottas
from Taranto [22–26] are part of the funerary
assemblage from the tomb of a young girl dated
to the second half of the third century BC, based
on a study of the human remains and other grave
deposits.

Terracottas found in Tarantine tombs that are in
some way related to the world of infants often
have been identified as toys, although not all may
have served this function. Indeed, similar terracot-
tas found in cult contexts permit us to associate
such votive gifts with protective cults. These cults
provided divine protection in the raising of young
boys, especially during the first few months of life.
Others were rites of passage from early childhood
to adulthood. For girls, such rites were directed
toward their future roles as wives and mothers.
Therefore, the meanings of the sculptural terracot-
tas found in funerary contexts may be compared
to similar terracottas found in votive contexts. In
each, the terracotta figurines suggest social status.

Several of the objects found in this tomb
have a distinctly feminine character: the bronze
mirror and the lead pyxis containing an over-
painted miniature lekythos (oil vessel), and a mus-
sel shell designed to hold ointments and colored
pigments useful for a woman's toilette. The *guttus*
(baby bottle) is consistent with the young age of
the deceased and may be associated with the
overpainted lekythos and a double-handled cup
with black glaze. This type of cup is commonly
found in Hellenistic tombs of the Tarantine
necropolis.

This terracotta figurine raises a bunch of grapes
high in her right hand. Her white chiton, clasped
at the breast, has a red edge. A blue himation is
slung around her right shoulder and wrapped
around her left forearm. She stands on her left leg.
Her right leg is crossed at the knee, the toes resting
on the low rectangular base. Her brown hair is
gathered in the "melon" style with a low chignon
at the nape of her neck. She wears a gold diadem
with large ivy leaves and earrings. Yellow paint
survives on the grapes. Reassembled from frag-
ments, this figurine has small surface abrasions
and superficial gaps. There is a circular vent hole
at the back. AD

LITERATURE

A. Dell'Aglio, *Ricordo di una
fanciulla del III secolo a.C.*
(Taranto, 1999), 14, no. 1.

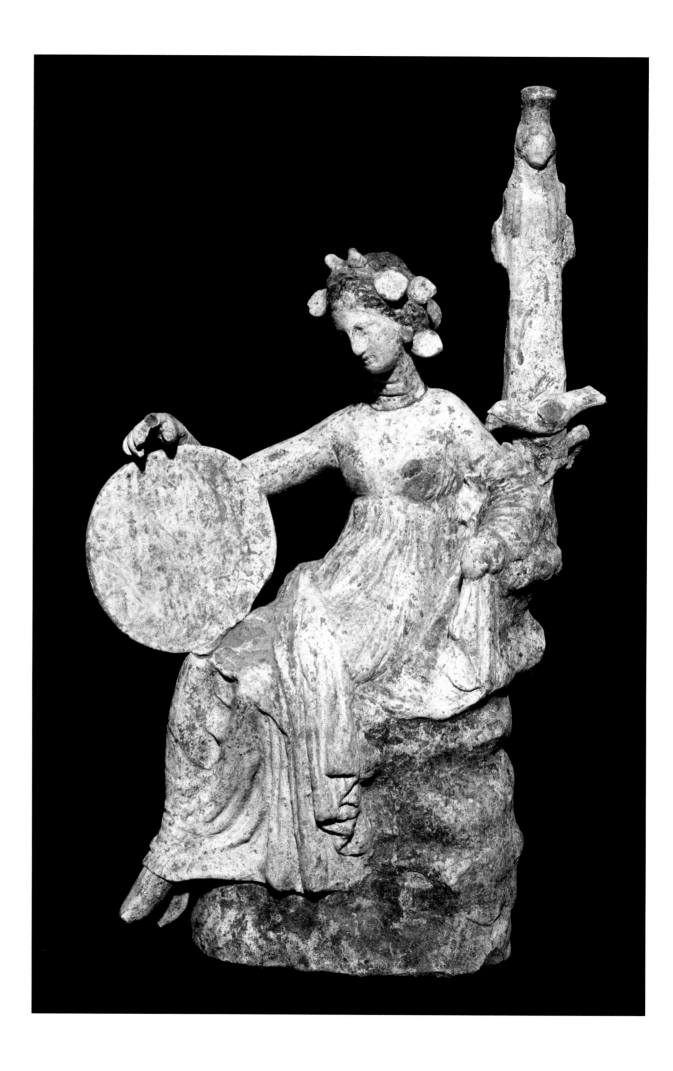

23. PAINTED FIGURINE

ca. 250–200 BC
Terracotta, white slip, mold-made, finished with a stick, painted
H. 26.3, W. 15
Museo Archeologico Nazionale di Taranto, inv. 51676
Taranto, Via Tito Livio, tomb 1, 27–29 May 1996

The draped female figures in the funerary ensemble are characterized by attributes such as the ivy crown [22, 23] (also worn by the deceased), the bunch of grapes [22], the *tympanon* (large round drum) [23], and the phiale with a raised central knob [24, 26]. These attributes belong to the world of Dionysos, which supports identifying these figures as Maenads, possibly associated with cults of female divinities and the institution of marriage.

Perched on a large rock, this terracotta figurine balances a tympanon between her right knee and forearm. Her legs are crossed at the ankles. She wears a chiton; a blue himation is wrapped around her waist and left forearm. Her diadem is decorated with ivy leaves and berries. Her hair is brown. Behind her left shoulder is a *xoanon* (statue) of a female deity with a high polos and long yellow braids. A dove sits at the base. The xoanon indicates the cult of Nymphai or Aphrodite. In this case, however, the cult of Aphrodite is suggested by the presence of the dove. The figurine was reassembled from many fragments, has small gaps, and much of the paint has worn off or faded. There is a vent hole at the back. AD

LITERATURE

K. Slej and K. Goransson, *Taranto, en grekisk koloni I Sydinalien* (Stockholm, 2001), 80.

A. Dell'Aglio, *Ricordo di una fanciulla del III secolo a.C.* (Taranto, 1999), 15, no. 2.

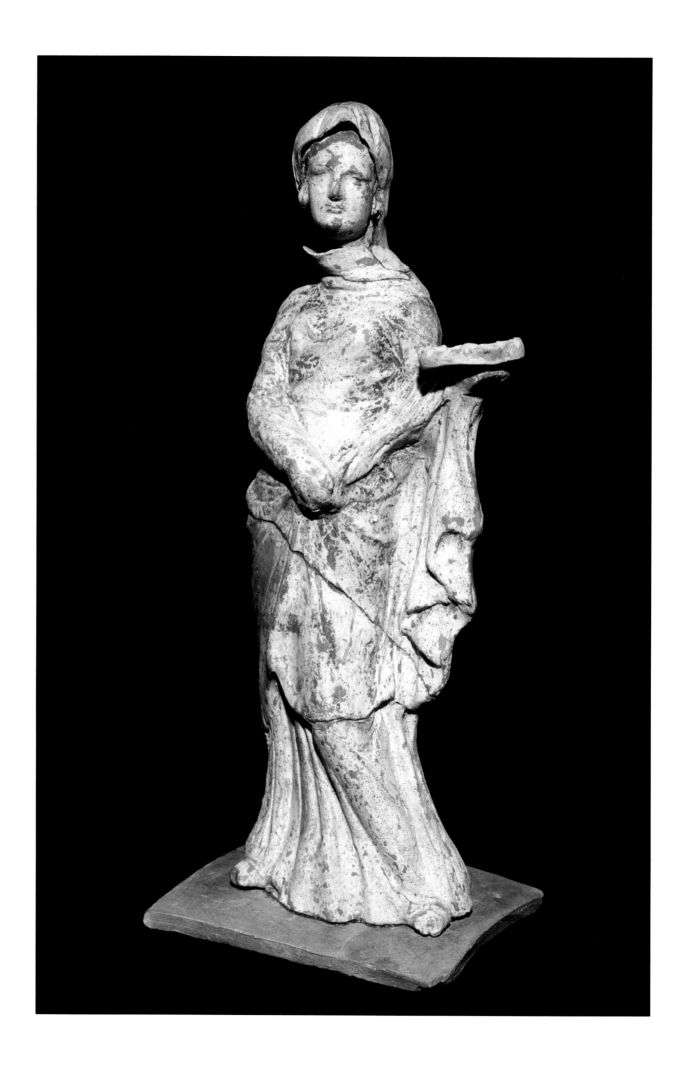

24. PAINTED FIGURINE

ca. 250–200 BC
Terracotta, brown and beige clay, white slip, mold-made, finished with a stick, painted
H. 29.3; base: 12 x 9.5
Museo Archeologico Nazionale di Taranto,
inv. 51677
Taranto, Via Tito Livio, tomb 1, 27–29 May 1996

Generally, Tarantine terracotta statuettes relate to the age, sex, and social status of the deceased. They are found in funerary assemblages of children and adolescents. In burials of young girls, statuettes are almost exclusively female, while male burials have statuettes of erotes and children.

A sacrificial offerant, this draped terracotta figurine holds a phiale with a scalloped rim and radial incisions in her left hand. She leans on her right leg with the left leg slightly flexed. She wears a red chiton under a himation that covers her head, which is turned slightly to the left. Holding her himation with her right hand, she stands on a rectangular base that has traces of pink paint. This figurine is chipped, has superficial gaps, and has been restored. Traces of paint remain on the surface. There is a squarish vent hole at the back.
AD

LITERATURE

A. Dell'Aglio, *Ricordo di una fanciulla del III secolo a.C.* (Taranto, 1999), 16, no. 3.

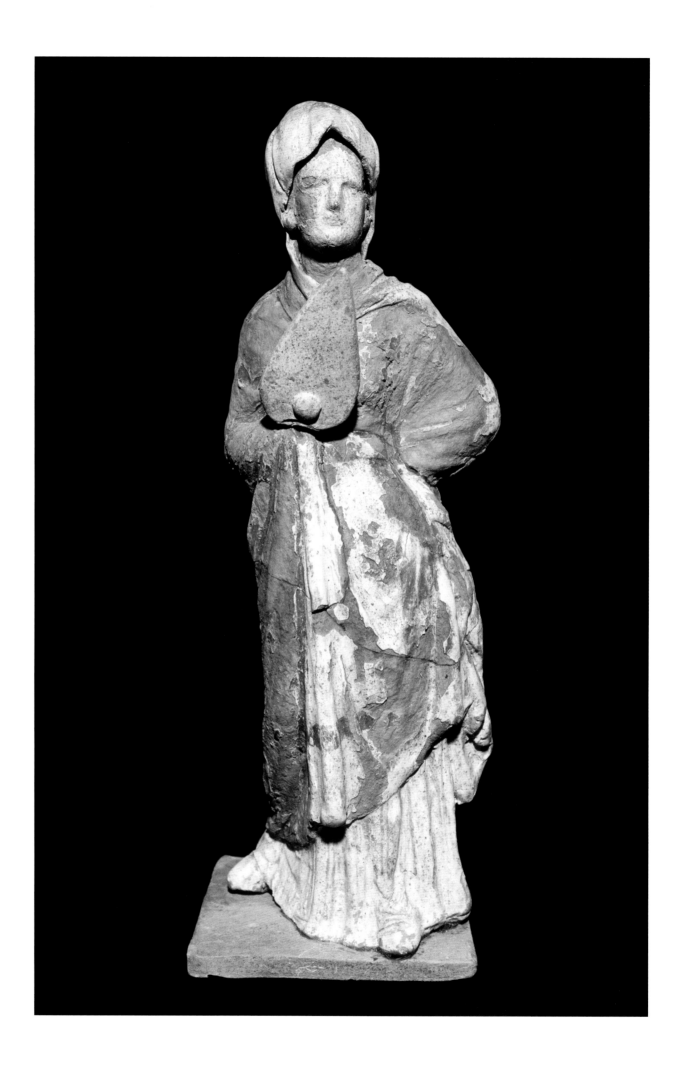

25. PAINTED FIGURINE

ca. 250–200 BC
Terracotta, brown and beige clay, white slip,
mold-made, finished with a stick, painted
H. 29.6; base: 10.3 x 10.3
Museo Archeologico Nazionale di Taranto,
inv. 51678
Taranto, Via Tito Livio, tomb 1, 27–29 May 1996

This draped terracotta figurine holds a large leaf-
shaped fan at her breast with her right hand. She
stands on her left leg, with her right heel slightly
raised. Draped over a red chiton, a heavy
himation covers her head and arms. Traces of pink
paint survive on the fan, and there is a large but-
ton-shaped element near the handle. Red paint
also survives on her lips and earrings. Part of her
himation covers her right hand and flows down
below her knee. Her left hand rests on her left hip.
She stands on a rectangular base. As with the other
figurines in the group, this one was reassembled
from many fragments, has superficial gaps, and
much of the paint has faded or worn off. There is a
squarish vent hole at the back. AD

LITERATURE

A. Dell'Aglio, *Ricordo di una
fanciulla del III secolo a.C.*
(Taranto, 1999), 17, no. 4.

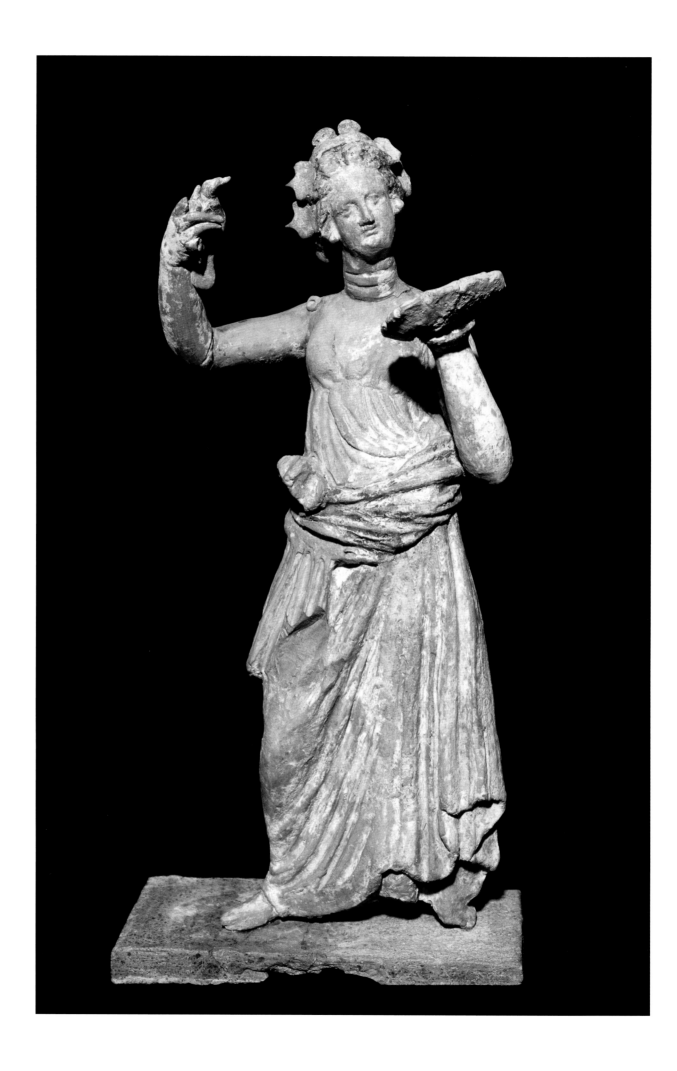

26. PAINTED FIGURINE

ca. 250–200 BC
Terracotta, brown clay, white slip, mold-made,
finished with a stick, painted
H. 27.8; base: 14.2 x 6.5
Museo Archeologico Nazionale di Taranto,
inv. 51679
Taranto, Via Tito Livio, tomb 1, 27–29 May 1996

This figurine of a sacrificial offerant holds a bird in
her raised right hand and phiale in her left hand.
The phiale, which has a *mesomphalos* (hollow
bump in the center bottom) for the thumb, rests on
her palm and is held by her fingers. Radial inci-
sions surround the edge of the phiale. She stands
on her left leg and her right leg is slightly relaxed.
Her chiton is pinned at her shoulder, and the blue
himation draped over her body is tied at her right
hip. Her head is slightly inclined toward her right.
Her hair is brown, arranged in the "melon" style,
and she wears a low chignon or bun and a gold
diadem decorated with ivy berries and large ivy
leaves. Much of the paint has faded or worn off.
There is a circular vent hole at the back of the
figure. AD

LITERATURE

A. Dell'Aglio, *Ricordo di una
fanciulla del III secolo a.C.*
(Taranto, 1999), 18, no. 5.

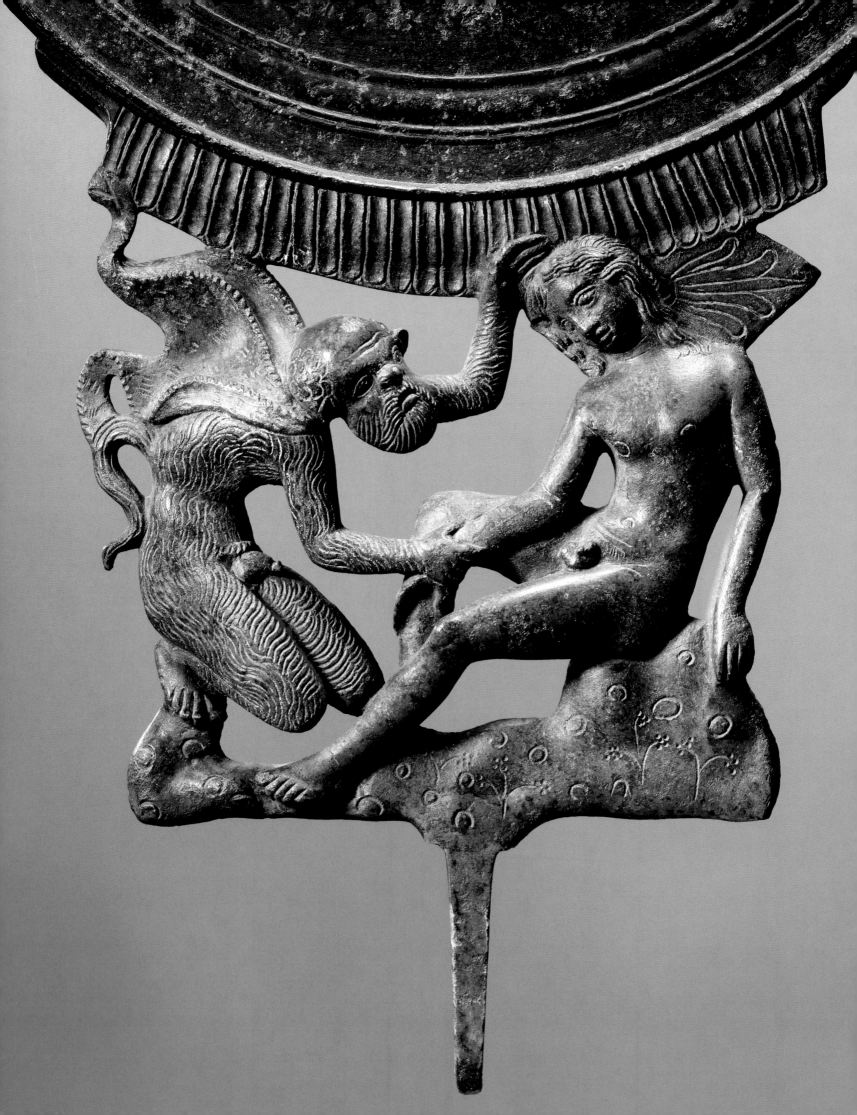

Museo Archeologico Nazionale di Reggio Calabria

Museo Nazionale Archeologico della Sibaritide

REGGIO CALABRIA

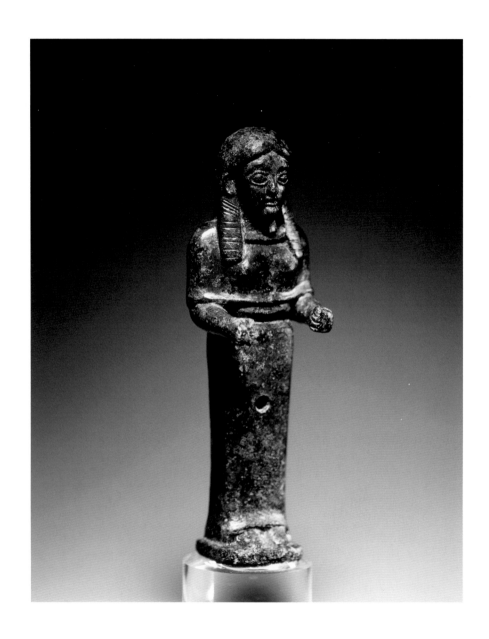

27. STATUETTE OF A WOMAN

ca. 575–550 BC
Bronze, cast, incised
H. 9.7
Museo Nazionale Archeologico della Sibaritide,
inv. 65144
Francavilla Marittima, Timpone Motta, sanctuary
of Athena, area of building 1

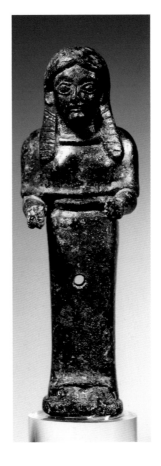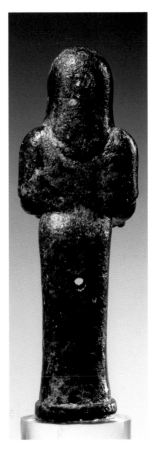

Standing in a frontal pose on a small irregular
plinth with a convex lower surface, this female
figure holds out her forearms, hands closed in fists
with vertical holes, presumably for holding some-
thing. Her smooth belted peplos (long garment)
falls to the base, leaving her feet uncovered in the
front. Visible from the front is either the border of
the *apoptygma* (folded-over section of the peplos)
or the edge of a short mantle covering the arms.
Two raised areas beneath the edge of the neckline
define the breasts. A mass of hair, parted in the
middle, covers her large round head; two flat locks
decorated with horizontal incisions are tucked
behind the ears and fall to the shoulders. The rest
of the hair falls down her back, ending in a curved
line. The figure has a triangular forehead, large
eyes, high brows, short and small nose, drawn
mouth, and rounded chin.

 A hole piercing the body from front to back pro-
vides a clue to the figure's function and identity:
clearly, the hole was designed to accommodate a
pin. This observation, combined with the fact that
the base is unstable and the lower part of the fig-
ure summarily finished, suggests that the figure
may have stood in a chariot. The closed hands
would then have held reins. Perhaps this is Athena
Hippia, or Aphrodite. According to Croissant the
style of the statuette shows both Peloponnesian
(Argive) and Ionian influence. SL

LITERATURE

H. Hellenkemper, *Die neue
Welt der Griechen,* exh. cat.,
Römisch-Germanisches Mu-
seum (Cologne/Mainz, 1998),
137, no. 69.

G. Pugliese Carratelli, ed., *The
Western Greeks,* exh. cat.,
Palazzo Grassi, Venice (Milan,
1996), 236, 670, no. 46 II.

C. Donzelli, *Magna Grecia di
Calabria: Guida ai siti
archeologici e ai musei
calabresi* (Rome, 1996), 74,
fig. 118.

F. Croissant, "Sybaris: La pro-
duction artistique,"in A. Stazio
and S. Ceccoli, eds., *Sibari e
la sibaritide: Atti del trenta-
duesimo Convegno di studi
sulla Magna Grecia* (Taranto,
1993), 552, pl. 38.5.

M. W. Stoop, "Santuario sul
timpone della Motta I: Bronzi,
Francavilla Marittima," *Atti e
Memorie della Società Magna
Grecia* 11–12 (1970–71), 45–
48, pl. 18.

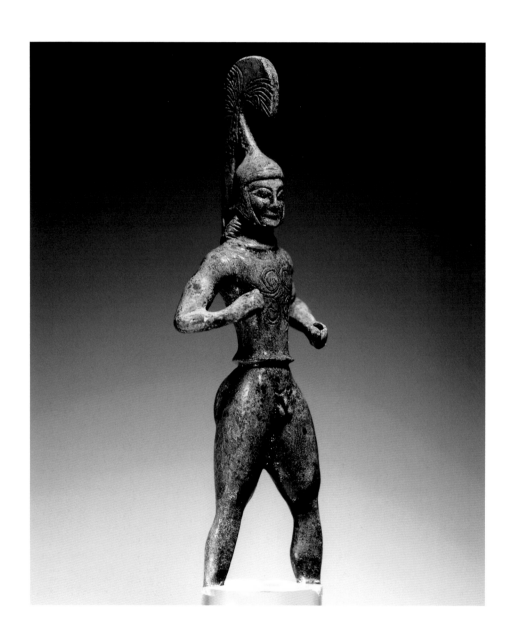

28. HOPLITE STATUETTE

ca. 530 BC
Bronze, cast, incised
H. 12.5, W. 4
Museo Nazionale Archeologico della Sibaritide, inv. 65148
Francavilla Marittima, Timpone Motta, sanctuary of Athena, area of building 1

This hoplite (warrior) is missing its feet and the objects originally carried in his hands, which are pierced vertically. He wears a cuirass without a chitoniskos and a helmet with a *lophos* (high crest). His hair creates a triangle on his back, falling in long, thick locks defined by parallel incisions that are in turn divided by small horizontal incisions. The helmet frames a beardless face, which has wide almond-shaped eyes, a narrow nose, and thin lips. The helmet appears to combine different styles: it lacks forehead and nose protection and the only decoration is an incised line along the edge at the front. Incised lines in a radial pattern decorate the crest, and its metal support is adorned with stamped dots. The cuirass is incised with spirals, four with double outlines on the front and two with single outlines on the back. There is additional incised decoration on the cuirass near the shoulders and a wolf's tooth pattern incised on the lower rim.

From the front the figure appears slim, with the body slightly turned and the head facing to his right. His left leg strides forward, with the right positioned slightly back. The right hand, drawn close to the chest, once held a spear almost vertically. The left hand, near the waist, once held a shield. The elbows are lifted away from the body. In profile, the figure seems less slim, with well-developed gluteus muscles and large strong thighs, flattened at the sides. Two lines curve down from the waist to define the pubic area. The entire back of the figure is well modeled. The composite stylistic features of the figurine suggest a local workshop inspired by Peloponnesian models, especially Laconian. SL

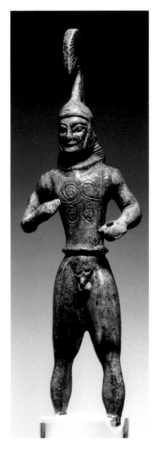
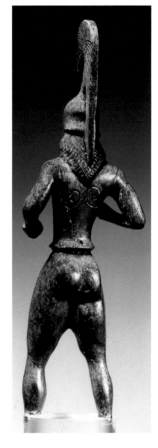

LITERATURE

H. Hellenkemper, *Die neue Welt der Griechen,* exh. cat., Römisch-Germanisches Museum (Cologne/Mainz, 1998), 136, no. 68.

G. Pugliese Carratelli, ed., *The Western Greeks,* exh. cat., Palazzo Grassi, Venice (Milan, 1996), 50, 670, no. 46 I.

C. Donzelli, *Magna Grecia di Calabria: Guida ai siti archeologici e ai musei calabresi* (Rome, 1996), 74, fig. 117.

F. Croissant, "Sybaris: La production artistique," in A. Stazio and S. Ceccoli, eds., *Sibari e la sibaritide: Atti del trentaduesimo Convegno di studi sulla Magna Grecia* (Taranto, 1993), 558, pls. 47.1a–b.

N. De Grassi, *Lo Zeus Stilita di Ugento* (Rome, 1981), pl. 52, figs. d–e.

M. W. Stoop, "Santuario sul Timpone della Motta I: Bronzi, Francavilla Marittima," in *Atti e Memorie della Società Magna Grecia* 11–12 (1970–71), 48–50, pl. 19.

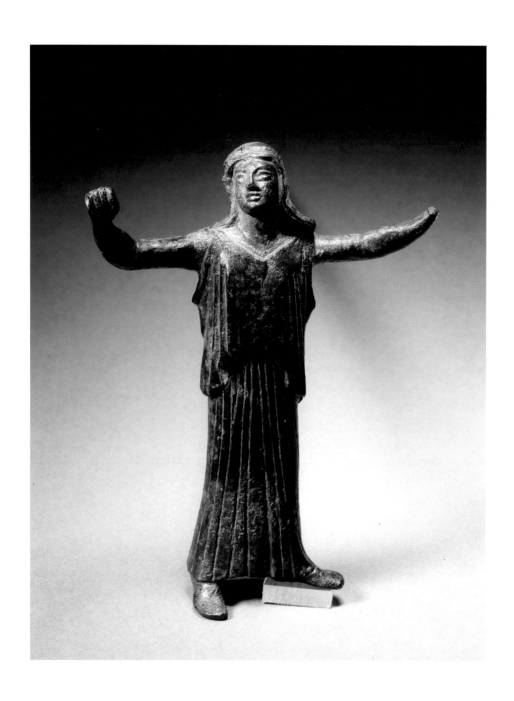

29. STATUETTE OF A DANCING WOMAN

ca. 450–430 BC
Bronze, cast, incised
H. 12.5
Museo Archeologico Nazionale di Reggio Calabria, inv. 8799
Locri Epizephirii, Centocamere district, accidental find, 1953

This female figure stands frontally, arms out and hands uplifted. Her left hand is missing and the right hand is closed in a fist, possibly to hold the ends of a fillet (in both hands) or another object. Her legs are apart, right foot facing front and left foot in profile, suggesting she was about to step to the side. The Doric peplos leaves her arms uncovered. Its apoptygma is smooth at the center, with folds at the sides that fall from clasps at the shoulders. The folds become wider and flatter toward the bottom. The head is turned slightly to the right. Her face is large and round, with hair falling behind her shoulders in heavy masses held by a thin band. The clothing is similar to that of bronze female figures made in Locri in the first half of the fifth century BC, but the naturalism of the head seems to indicate a later date.

The back of the figure is flat and shows traces of a pin at its center. Judging by the figure's subtly curved back and lifted head, it was once applied to another object, such as a piece of furniture or the body of a large vessel. The feet are set at different levels and therefore did not rest on a base. CS

LITERATURE

A. Giumlia-Mair and M. Rubinich, eds., *Le Arti di Efesto: Capolavori in metallo dalla Magna Grecia* (Milan, 2002), 194, fig. 30.

G. Procopio, "Due bronzetti antichi calabresi," *Klearchos,* nos. 57–60 (1973), 47–58.

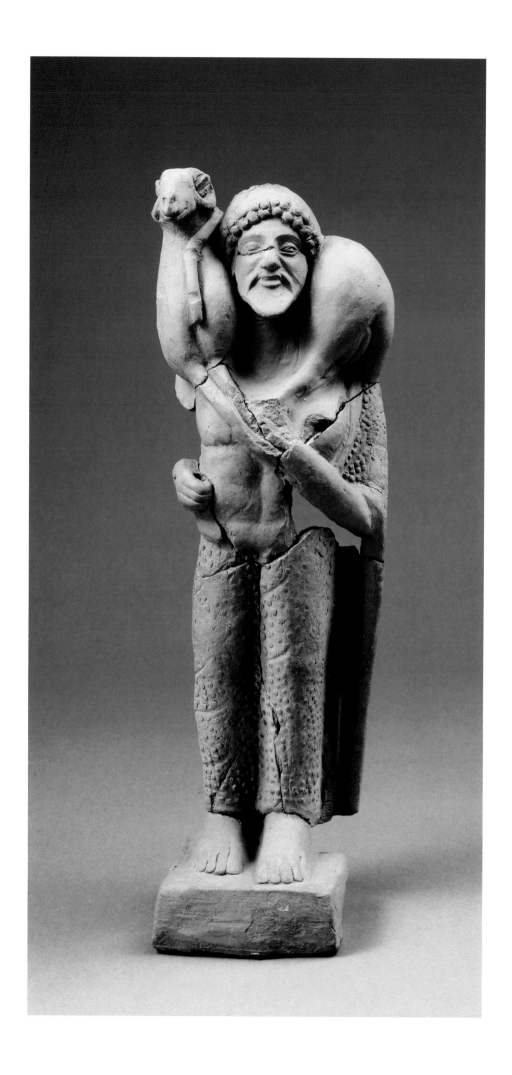

30. RAM-BEARER STATUETTE

ca. 500–450 BC
Terracotta, dark red-orange refined clay, mold-made, hand-finished
H. 38, W. 13
Museo Archeologico Nazionale di Reggio Calabria, inv. 3487
Medma, Calderazzo district, with votive offerings, 1912–13 excavations (P. Orsi)

This statuette of a male figure with a short beard is a *kriophoros,* a ram-bearer. He carries the ram on his shoulders, holding it to his chest by its legs with his left hand, which is now missing. The body of the animal is rendered in the round, but without surface details, while the features of its head are represented with particular care. The man's hair is arranged in the typical spiral curls, set in two rows. A short, tight-fitting chiton covers his torso, and a long mantle decorated with small dots clings to his body, leaving his feet uncovered. His feet, which are set on a solid, square base, are out of proportion with the rest of his body.

Statuettes of ram-bearers found in Medma have been interpreted as votive figures closely associated with the god Hermes, whose cult as ram-bearer has Boeotian origins. Pausanias (9.22) reports that during an epidemic of the plague, Hermes came to the aid of the town of Tanagra, appearing with a ram on his shoulders. In order to celebrate this event, the sculptor Calamis (active ca. 480–450 BC) dedicated a statue of the god to the temple, representing him as a kriophoros.

For other kriophoroi from the 1964–66 Calderazzo district excavations, see R. Agostino, "Medma Contrada Calderazzo: Scavi 1964/1966, Note sui culti e sulla topografia," *Klearchos,* nos. 137–48 (1995), 29–88; see also M. Paoletti, "Medma: Il deposito votivo in località Calderazzo (Orsi 1912–1993)," in E. Lattanzi et al., *Santuari della Magna Grecia in Calabria,* exh. cat., Museo Archeologico di Vibo Valentia and tour (Naples, 1996), 112–15. For other kriophoroi from Medma, see P. Orsi, "Rosarno (Medma): Esplorazione di un grande deposito votivo di terrecotte ieratiche," *Notizie degli Scavi di Antichità anno 1913, Supplemento* (1914), 119–24, figs. 159–65.

For the cult of Hermes in Medma, see Paoletti, "I culti di Medma," in Lattanzi, *Santuari della Magna Grecia in Calabria,* 95–97. MTI

LITERATURE

G. Pugliese Carratelli, ed., *The Western Greeks,* exh. cat., Palazzo Grassi, Venice (Milan, 1996), 703, no. 175.

R. Miller, "The Terracotta Votives from Medma: Cult and Coroplastic Craft in Magna Graecia" (Ph.D. diss., University of Michigan, 1983), 318, no. 157, pl. 12.

G. Foti, *Il Museo Nazionale di Reggio Calabria* (Naples, 1972), 30–31, 73, fig. 32.

31. ENTHRONED FEMALE STATUETTE

ca. 500–450 BC
Terracotta, orange-red refined clay, mold-made,
finished with a stick
H. 41, W. 23
Museo Archeologico Nazionale di Reggio
Calabria, inv. 1127
Medma, Calderazzo district, with votive offerings,
1912–13 excavations (P. Orsi)

This female deity sits on a decorated throne. Her
hair is rendered in three superimposed rows of
heavy spiral curls. Her face has rounded features,
with brows shown in relief and heavy lids sur-
rounding large eyes. The fleshy lips reveal a smile
and the chin is rounded. The earrings are globular
in shape. Her chiton, decorated with close-set
wavy folds in relief that were finished using a
stick, has a wide rounded neckline. The himation
hugs her shoulders and arms, and falls to her feet
in wide horizontal layers. With her right arm
folded on her lap, she holds in her right hand an
object that may be either a jewel case or a piece
of furniture, possibly a miniature model of a chest.
Her left arm lies on her left leg and her hand is
closed in a fist. The feet are represented in great
detail and rest on a high base. The throne is
smooth, has horizontal palmettes on the back of
the seat, and rests on lion's feet. The back is
smooth with a wide vent hole. MTI

LITERATURE

C. Donzelli, *Magna Grecia
di Calabria: Guida ai siti
archeologici e ai musei
calabresi* (Rome, 1996), 19,
fig. 22.

G. Pugliese Carratelli, ed.,
The Western Greeks, exh.
cat., Palazzo Grassi, Venice
(Milan, 1996), 703, no. 172.

C. Sabbione, "Medma," in
E. Lattanzi, ed., *Il Museo
Nazionale di Reggio Calabria*
(Rome, 1987), 122.

R. Miller, "The Terracotta
Votives from Medma: Cult and
Coroplastic Craft in Magna
Graecia" (Ph.D. diss., Univer-
sity of Michigan, 1983), 306,
no. 23, pl. 2.

G. Foti, *Il Museo Nazionale
di Reggio Calabria* (Naples,
1972), 73, fig. 33.

W. Atallah, "Adonis dans la
littérature et l'art grecs,"
Etudes et Commentaires 62
(1966), 167, fig. 31.

G. M. A. Richter, "Were There
Greek Armaria?" *Hommages à
Waldemar Deonna, Latomus*
28 (1957), 422, pl. 59.2.

P. Orsi, "Rosarno (Medma):
Esplorazione di un grande
deposito votivo di terrecotte
ieratiche," *Notizie degli Scavi
di Antichità anno 1913,
Supplemento* (1914), 91–95,
fig. 103.

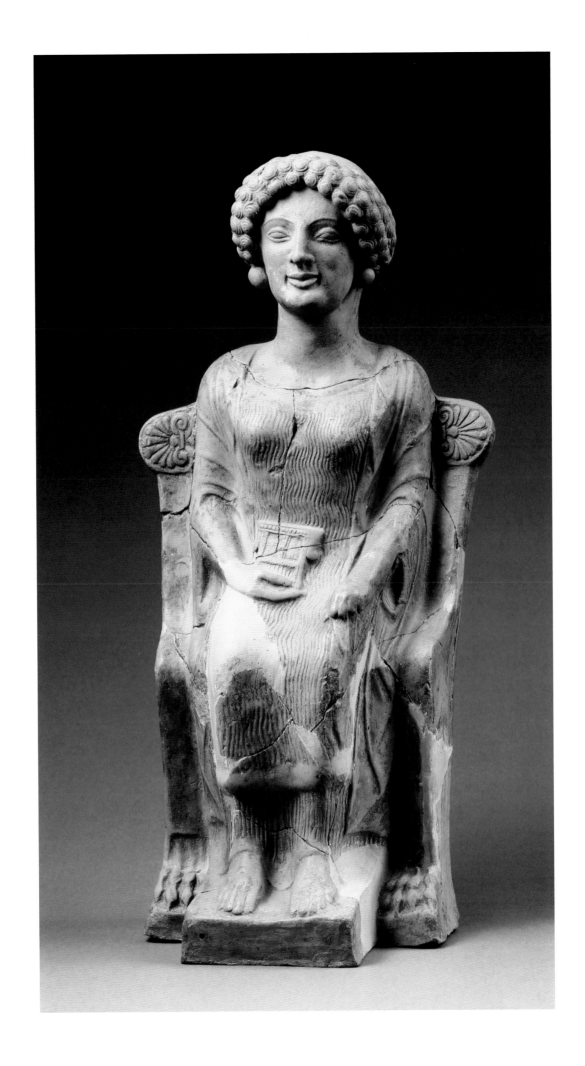

32. STANDING FEMALE STATUETTE

ca. 500–450 BC
Terracotta, dark red clay with white inclusions,
mold-made, finished with a stick
H. 44, W. 16
Museo Archeologico Nazionale di Reggio
Calabria, inv. 1123
Medma, Calderazzo district, with votive offerings,
1912–13 excavations (P. Orsi), now in the Sala di
Medma

The statuette represents a female figure bearing an
offering. The face is round, the hair surmounted by
a high polos and parted in the center of the fore-
head in two bands, falling to the shoulders in long,
thin locks. Horizontal wavy lines give the hair tex-
ture. The eyes are almond-shaped, large, and sur-
rounded by distinct eyelids. The lips are fleshy and
the chin protrudes. She wears globular earrings
and a chiton with thick vertical pleats, visible on
her chest and at her feet. The himation covers only
her right shoulder and passes under her left breast
in a flat band. It is short at the front where it forms
wide and flat folds, while it is longer on the right
side where it covers the body. The right hand is
outstretched, perhaps to hold a phiale, now miss-
ing. In any case, she is presenting an offering
while she lifts the edge of her chiton with her left
hand. The figure rests on a high square base, with
the left leg positioned slightly in front of the right.
The back of the statuette is smooth and has a large
vent hole. MTI

LITERATURE

G. Pugliese Carratelli, ed., *The Western Greeks,* exh. cat., Palazzo Grassi, Venice (Milan, 1996), 703, no. 171.

E. Lattanzi, ed., *Il Museo Nazionale di Reggio Calabria* (Rome, 1987), 119, 122.

R. Miller, "The Terracotta Votives from Medma: Cult and Coroplastic Craft in Magna Graecia" (Ph.D. diss., Univer-sity of Michigan, 1983), 312, no. 99, pl. 9.

G. Foti, *Il Museo Nazionale di Reggio Calabria* (Naples, 1972), 74, fig. 37.

P. Orsi, "Rosarno (Medma): Esplorazione di un grande deposito votivo di terrecotte ieratiche," *Notizie degli Scavi di Antichità anno 1913, Supplemento* (1914), 87, fig. 98.

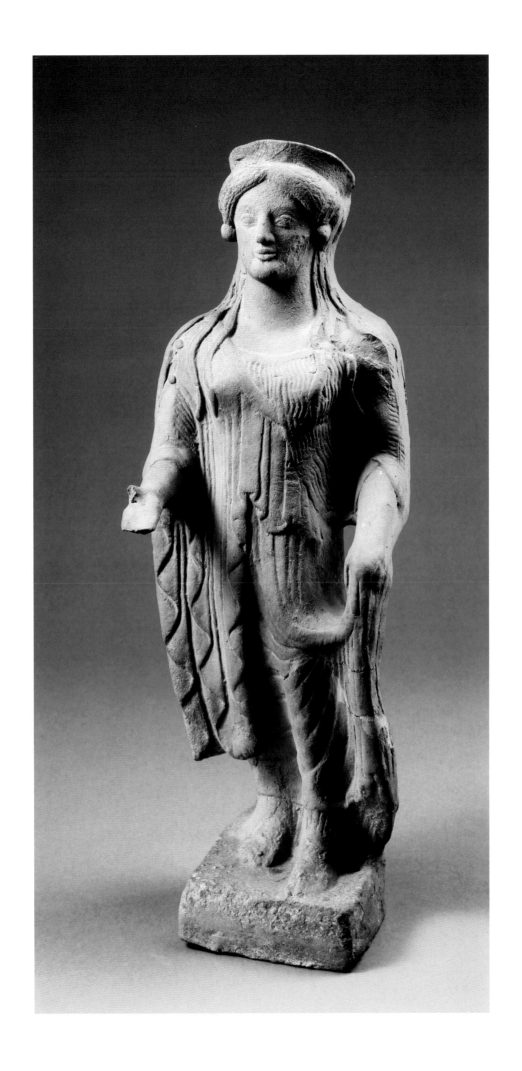

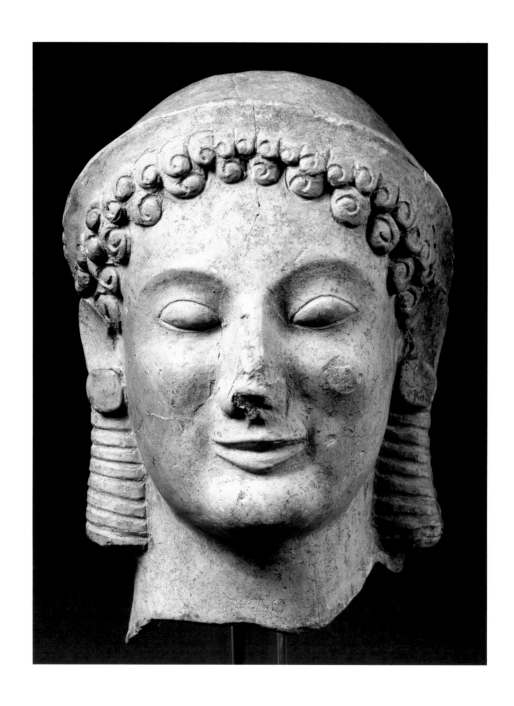

33. HEAD OF A KORE

ca. 500–480 BC
Terracotta, pinkish-yellow refined clay, finished
with a stick
H. 26, W. 13
Museo Archeologico Nazionale di Reggio
Calabria, inv. 2893
Medma, Calderazzo district, with votive offerings,
1912–13 excavations (P. Orsi), now in the Sala di
Medma

Slightly smaller than life size, this female head
has a strongly sculpted face. Langlotz identified
it as the goddess Athena, and part of a temple
sculptural group. A polos, barely rendered, reveals
spiral curls encircling the forehead; the rest of the
hair falls behind the ears in short braids that are
defined by horizontal grooves formed using a
stick. The earrings on the large ears are flat discs.
In the very beautiful face the arches of the brows,
shown in relief, frame the almond-shaped eyes.
The cheekbones are prominent and the corners
of the mouth are slightly raised in the typical
"Archaic smile." MTI

LITERATURE

G. Pugliese Carratelli, ed.,
The Western Greeks, exh. cat.,
Palazzo Grassi, Venice (Milan,
1996), 702, no. 168.

E. Lattanzi, ed., *Il Museo
Nazionale di Reggio Calabria*
(Rome, 1987), 118.

R. Miller, "The Terracotta
Votives from Medma: Cult and
Coroplastic Craft in Magna
Graecia" (Ph.D. diss., Univer-
sity of Michigan, 1983), 391,
no. 924.

G. Foti, *Il Museo Nazionale
di Reggio Calabria* (Naples,
1972), 30–31, 61, 74, fig. 37,
pl. 16.

E. Langlotz and M. Hirmer,
*The Art of Magna Graecia:
Greek Art in South Italy and
Sicily* (London, 1965), 268,
figs. 60–61.

U. Zanotti-Bianco, *La Magna
Grecia* (Genoa, 1961), 98, fig.
96.

S. Ferri, "Teste fittili di
Medma," in *Le Arti* 2 (1940),
162–71, figs. 7–8, pl. 63.

P. Orsi, "Rosarno (Medma):
Esplorazione di un grande
deposito votivo di terrecotte
ieratiche," *Notizie degli
Scavi di Antichità anno 1913,
Supplemento* (1914), 79, fig.
87.

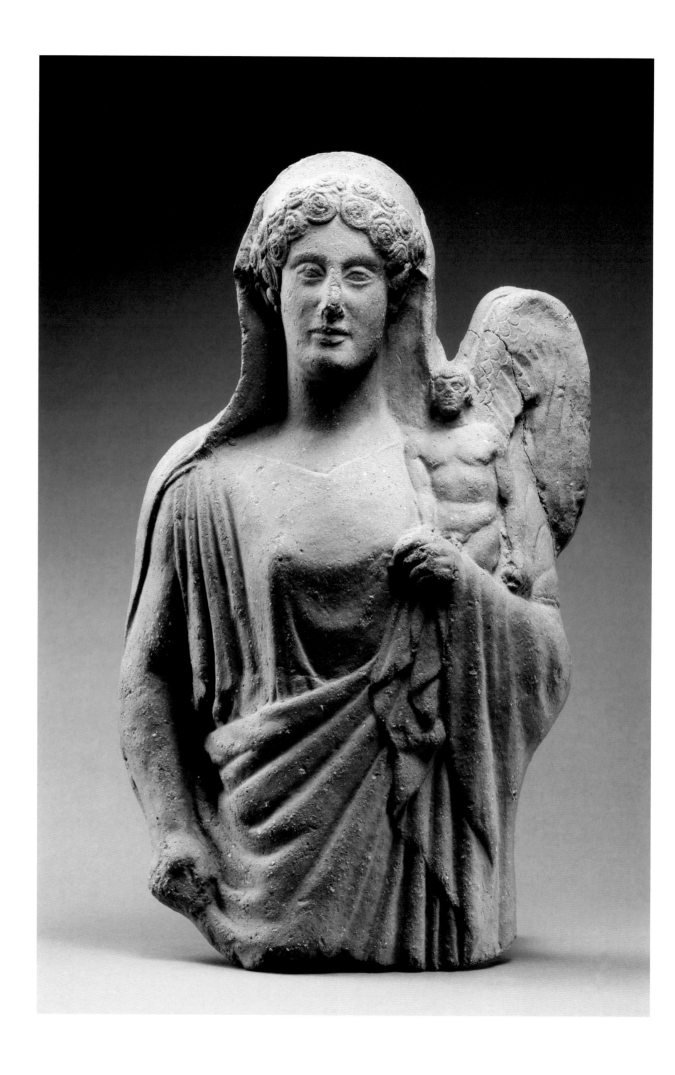

34. APHRODITE WITH EROS STATUETTE

ca. 450 BC
Terracotta, orange-red clay with translucent inclusions, mold-made, hand-finished
H. 33.5, W. 18
Museo Archeologico Nazionale di Reggio Calabria, inv. 607 C
Medma, votive deposit near Calderazzo

This statuette belonged to the collections of the Museo Civico di Reggio Calabria that became part of the Museo Nazionale. It comes from the Medma area, but its exact findspot is unknown.

The figural group represents Aphrodite standing and holding a small winged Eros in her bent left arm. Her head is tilted to her left and covered by a tall polos from which a veil falls down her back and onto her shoulders. Her hair is arranged in two rows of spiral curls. She wears a chiton with a wide neckline that clings to her chest and is gathered in deeply furrowed vertical folds at the right shoulder. Uncovered, her right arm is at her side, her hand holding the himation. The himation covers her left shoulder and drapes over the arm holding the figure of Eros. He is shown nude and seated frontally, with hips and legs turned slightly inward and arms extended along his body. His hair is short and his wings, with fine surface details, are joined together and shown in profile.

For other Eros statuettes, see P. Orsi, "Rosarno (Medma): Esplorazione di un grande deposito votivo di terrecotte ieratiche," *Notizie degli Scavi di Antichità anno 1913, Supplemento* (1914), 127–29. MTI

LITERATURE

H. Hellenkemper, *Die neue Welt der Griechen*, exh. cat., Römisch-Germanisches Museum (Cologne/Mainz, 1998), 173, no. 105.

G. Pugliese Carratelli, ed., *The Western Greeks*, exh. cat., Palazzo Grassi, Venice (Milan, 1996), 488, 703, no. 176.

E. Lattanzi, ed., *Il Museo Nazionale di Reggio Calabria* (Rome, 1987), 126.

P. Orlandini "Le arti figurative," in G. Pugliese Carratelli et al., *Megale Hellas: Storia e civiltà della Magna Grecia* (Milan, 1983), 452, 460–61, fig. 488.

G. Foti, *Il Museo Nazionale di Reggio Calabria* (Naples, 1972), 74–75, no. 39, fig. 39.

E. Langlotz and M. Hirmer, *The Art of Magna Graecia: Greek Art in South Italy and Sicily* (London, 1965), 278–79, pl. 96.

E. Langlotz, *Die Kunst der Westgriechen* (Munich, 1963), 79, pl. 96.

E. Langlotz, "Wesenzüge der bildenden Kunst Grossgriechenlands," *Antike und Abendland* 2 (1946), fig. 22.

N. Putortì, "Terrecotte di Medma nel Museo Civico di Reggio," *L'Italia Antichissima* 4 (1930), 176–77, fig. 1.

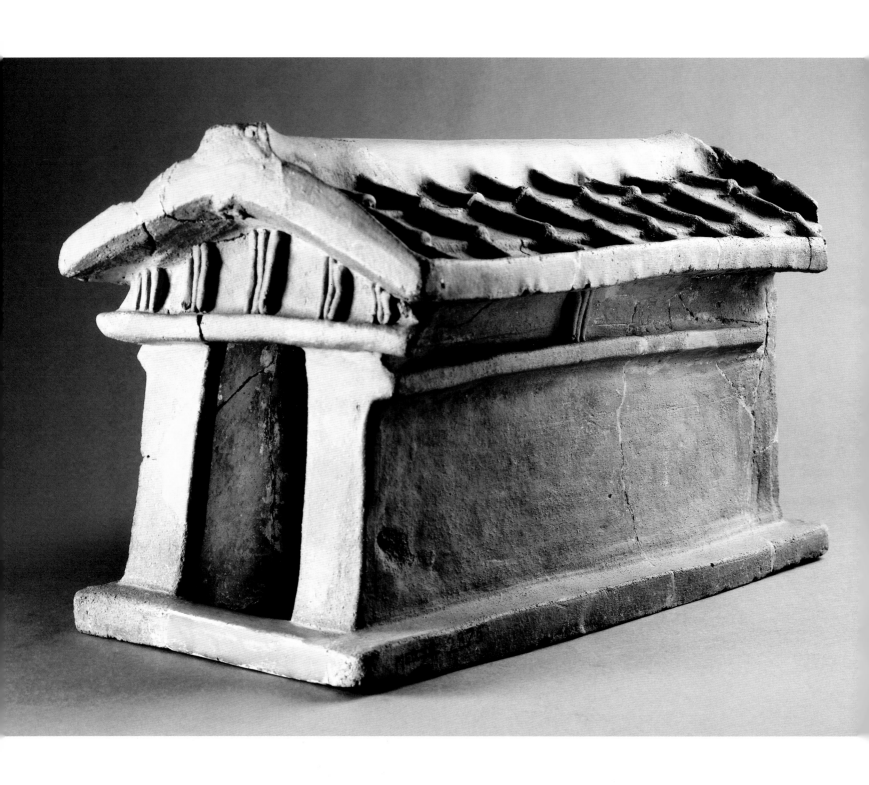

35. TEMPLE MODEL

ca. 510–450 BC
Terracotta, dark red clay with white inclusions
H. 28.9, W. 28.5, L. 50
Museo Archeologico Nazionale di Reggio
Calabria, inv. 2875
Medma, Calderazzo district, votive deposit,
1912–13 excavations (P. Orsi), now in the
Sala di Medma

Orsi found this small temple and another smaller temple during the 1912–13 excavations at Contrada Calderazzo, present-day Rosarno. At the site, which was identified as the Locrian subcolony of Medma, Orsi found an extremely rich deposit with votives dated from the sixth to the fourth centuries BC. This deposit is known for the abundance of the sculpted terracotta objects found there.

This model of a small temple is asymmetrical, with walls that slant slightly inward. It rests on a pronounced rectangular base and has long side walls and a prominent band apparently indicating a frieze under the projecting roof. The walls are smooth, and a single triglyph is positioned off-center on the right band. Possibly each band once had a Doric frieze with triglyphs and metopes. Because these decorative motifs were imperfectly secured to the temple, they probably became detached.

The pitched roof has well-executed flat and barrel-shaped tiles arranged in eight rows on each slope, and each row has three elements. The end tiles on each side have small holes, two per tile on each side of the bottom barrel-shaped tile, which may represent gutters. The roof ridge is surmounted by a series of *kalypteres hegemones* (tile covers), now mostly restored.

The pediment on the facade has a Doric frieze with five triglyphs (one restored), and there are signs of an acroterial ornament, now lost. It was probably a Gorgon. Other small model temples found in the sanctuary of Cofino in Hipponion, present-day Vibo Valentia and the sister city of Medma, have Gorgons, suggesting the same here. The facade has a tall rectangular doorway, while the back wall of the temple is solid except for a small hourglass-shaped opening. This aperture has been interpreted in several ways: Paoletti, Danner, and Demangel suggested a window; Ferri believes it is a technical feature such as a firing vent. MTI

LITERATURE

M. Paoletti, "Medma: Il deposito votivo in località Calderazzo (Scavi Orsi 1912–1913)," in E. Lattanzi et al., *Santuari della Magna Grecia in Calabria*, exh. cat., Museo Archeologico di Vibo Valencia and tour (Naples, 1996), 99–111.

P. Danner, "Tonmodelle von Naiskoi aus Calabrien," *Rivista di Archeologia* 16 (1992), 36–48, figs. 1–26.

E. Lattanzi, ed., *Il Museo Nazionale di Reggio Calabria* (Rome, 1987), 121–22.

R. Miller, "The Terracotta Votives from Medma: Cult and Coroplastic Craft in Magna Graecia" (Ph.D. diss., University of Michigan, 1983), 196, 328, no. 263, pl. 23.

G. Foti, *Il Museo Nazionale di Reggio Calabria* (Naples, 1972), 73, fig. 30.

S. Ferri, "I tempietti di Medma e l'origine del triglifo," *Rendiconti dell'Accademia Nazionale dei Lincei* 8.3 (1948), reprinted in S. Ferri, *Opuscula* (Florence, 1962), 287–93, pl. 10.3–5.

R. Demangel, "Regula," *Bulletin de Correspondance Hellénique* 66–67 (1945), 267–68, fig. 10.

P. Zancani Montuoro, "La struttura del fregio ionico," *Palladio* 4.2 (1940), 49–64, no. 27, figs. 4–5.

P. Orsi, "Rosarno (Medma): Esplorazione di un grande deposito votivo di terrecotte ieratiche," *Notizie degli Scavi di Antichità anno 1913*, *Supplemento* (1914), 68–69, fig. 75.

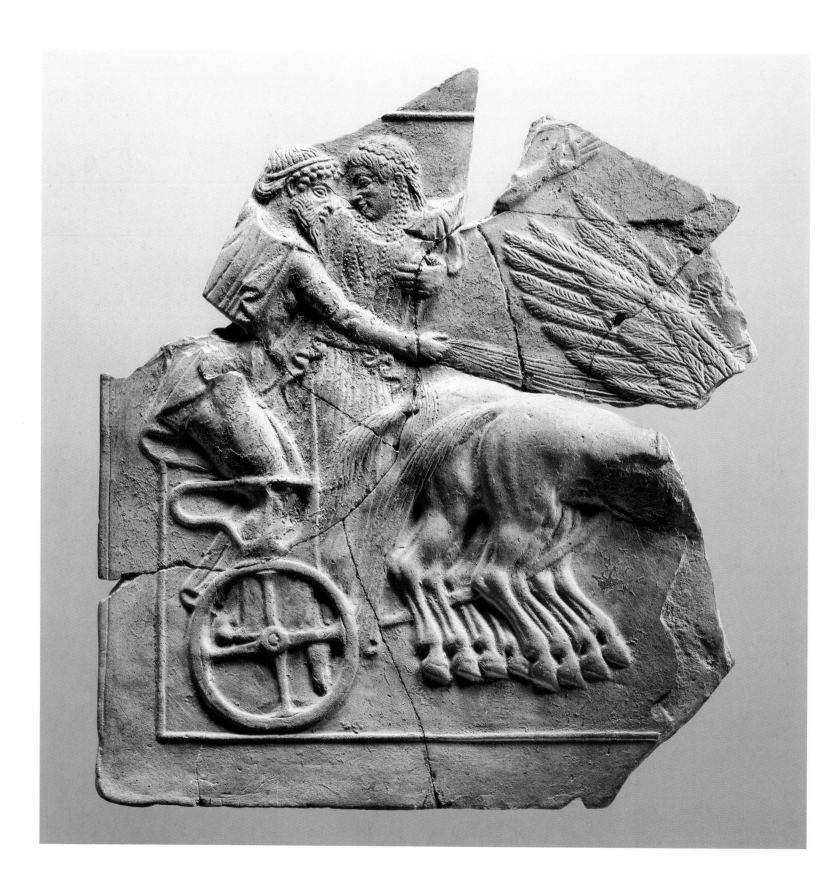

36. PINAX WITH ABDUCTION OF KORE-PERSEPHONE

ca. 490–470 BC
Terracotta, mold-made, hand-finished, painted
H. 21
Museo Archeologico Nazionale di Reggio
Calabria, inv. 58016
Locri Epizephirii, Mannella district, sanctuary of
Persephone, 1908–12 excavations (P. Orsi)

Locrian *pinakes* are terracotta tablets with brightly painted sculptural scenes in relief. The scenes are related to the myth and cult of Persephone (Kore) and other deities. They were produced in Locri during the first half of the fifth century BC and offered as votive dedications at the Locrian sanctuary of Persephone in the Mannella district. More than 5,000, mostly fragmentary, pinakes are stored in the museums of Reggio Calabria and Locri. They are currently being systematically published. The more than 170 types of Locrian pinakes classified so far represent one of the most significant categories of objects from Magna Graecia, both as documents of religious practice and as works of art.

The abduction of Kore by Hades, ruler of the underworld, is the most common scene represented on Locrian pinakes, with more than thirty different figural versions known. Kore and her mother, Demeter, presided over the fertility of nature, making agriculture possible. After Kore's ab-duction, this fertility could no longer be sustained, threatening all living things on earth. Demeter remedied this dire situation by arranging that her daughter (who, as the wife of Hades, assumed the name Persephone) return to earth periodically, thus initiating seasonal regeneration. With Persephone's regular visits between the upper and lower worlds, the myth portrays the seasons as a renewing cycle alternating between life and death.

Type 2/22 in Zancani Montuoro's classification of pinakes shows a bearded Hades riding in a chariot, grasping Kore with his left arm. Kore resists, throwing up her arms in a gesture of alarm. With his right hand, Hades holds the reins of the four winged horses pulling the chariot, and leans forward as the horses leap into the air, taking flight. The modeled detail of the horses' wings is remarkable, as is that of the hair and garments of the protagonists. The number of horses is clearly shown by the repetition of legs.

The numerous pinakes of this type were produced from three molds that differ in the position of the raised borders framing the scene. Additional details distinguish the molds, including the treatment of bridles and of Kore's braided hair and necklaces. This pinax was taken from mold C, in which the handrail of the chariot does not overlap the border of the scene, as is the case with the other molds. CS

LITERATURE

E. Lissi Caronna et al., eds., *I Pinakes di Locri Epizefiri, Musei di Reggio Calabria e di Locri* (Rome, 1999), 793, pl. 222b.

E. Lattanzi, ed., *Il Museo Nazionale di Reggio Calabria* (Rome, 1987), 56.

G. Pugliese Carratelli et al., *Megale Hellas: Storia e civiltà della Magna Grecia* (Milan, 1983), 462, fig. 462.

P. Zancani Montuoro, "Note sui soggetti e sulla tecnica delle tabelle di Locri," *Atti e Memorie della Società Magna Grecia*, n.s. 1 (1954), 71–106.

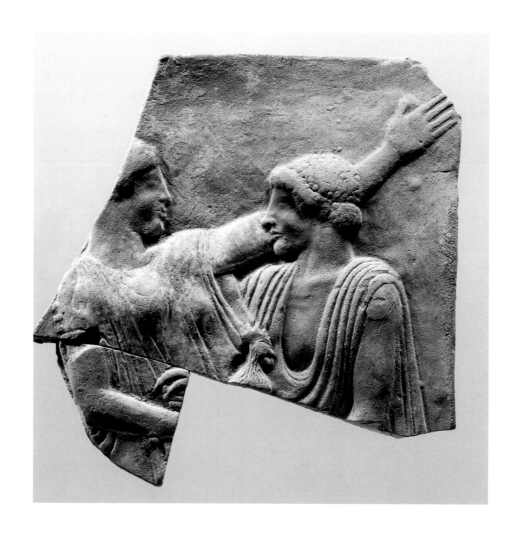

37. PINAX FRAGMENT WITH ABDUCTION OF KORE-PERSEPHONE

ca. 480–460 BC
Terracotta, mold-made, hand-finished, painted
H. 11.5
Museo Archeologico Nazionale di Reggio
Calabria, inv. 54407
Locri Epizephirii, Mannella district, sanctuary of
Persephone, 1908–12 excavations (P. Orsi)

This fragment is part of a type 2/10 pinax in
Zancani Montuoro's classification series. It shows
the abduction of Kore. The missing portion of the
tablet would have shown that she was being taken
in a chariot pulled by two winged horses at the
left. The scene is markedly different from the ab-
duction shown in the type 2/22 pinax [36]. The
contrast may be attributed to the later date of this
pinax and to the way the divine protagonists are
represented in each scene.

Kore wears a peplos, and her abductor is lifting
her up as he steps into the chariot. The goddess
reacts to the violence by raising her left arm and
extending her hand. Otherwise she remains com-
posed, not upsetting the rooster she holds in her
right hand. The rooster, her usual attribute, alludes
to the fertility of nature and symbolizes rites of
passage such as the marriage ceremonies in which
young Locrian women participated. Pinakes were
probably offered as votives at the sanctuary de-
voted to the goddess connected to those rites.

Here, instead of the bearded Hades, a beardless
youth carries Kore off, following a Locrian varia-
tion on the traditional Greek myth not docu-
mented by literary sources. The identity of the
young abductor is a subject of debate. Zancani
Montuoro suggests a divine figure, possibly one of
the Dioscuri, who was directed by Hades to carry
out the abduction, but this interpretive question
remains unresolved.

Portions of the original brightly painted colors
are well preserved. The man's pink complexion
and the woman's white complexion survive, as
well as traces of red on Kore's peplos and in the
hair of the two figures. CS

LITERATURE

E. Lissi Caronna et al., eds.,
I Pinakes di Locri Epizefiri,
Musei di Reggio Calabria e di
Locri (Rome, 1999), 583, pl.
151b.

38. PINAX WITH PROCESSION

ca. 480–460 BC
Terracotta, mold-made, hand-finished, painted
H. 25
Museo Archeologico Nazionale di Reggio
Calabria, inv. 57482
Locri Epizephirii, Mannella district, sanctuary of
Persephone, 1908–12 excavations (P. Orsi)

Processions of female figures, presumably related
to ceremonies conducted in the sanctuary of
Persephone, are depicted frequently on Locrian
pinakes. This type, classified as 5/5 by Zancani
Montuoro, shows a procession of three richly
dressed figures. From the left, a young girl carries
a censer with a pinecone-shaped finial. Next, a
young woman balances a piece of folded cloth, or
perhaps a ritual garment on her head, a method of
carrying still practiced in the Calabrian country-
side. Last comes a priestess whose height indicates
her high status. She wears a tightly pleated chiton
and a himation drapes from her head. She holds a
rod in her right hand, an object of ritual depicted
on other pinakes. In her left hand she grasps a
deep vessel, perhaps of metal, for offering liba-
tions to the deity. The rooster, part of which re-
mains at the bottom of the scene, is a common
element of Locrian pinakes. It alludes to nature's
fertility and to rites of passage, such as the mar-
riage rituals involving young women that were
held in the sanctuary under the protection of
Persephone and were occasions for dedicating
pinakes to the goddess.

For Locrian pinakes in general, see E. Lissi
Caronna et al., eds., *I Pinakes di Locri Epizefiri,
Musei di Reggio Calabria e di Locri* (Rome,
1999). CS

LITERATURE

G. Pugliese Carratelli, ed., *The Western Greeks*, exh. cat., Palazzo Grassi, Venice (Milan, 1996), 701, no. 166 II.

E. Lattanzi, ed., *Il Museo Nazionale di Reggio Calabria* (Rome, 1987), 57.

M. Torelli, "I culti di Locri," in *Locri Epizefirii: Atti del sedicesimo Convegno di studi sulla Magna Grecia* (Naples, 1977), 1: 165, 2: 7.1.

P. Zancani Montuoro, "Il corredo della sposa," *Archeologia Classica* 12 (1960), 41, pl. 3.

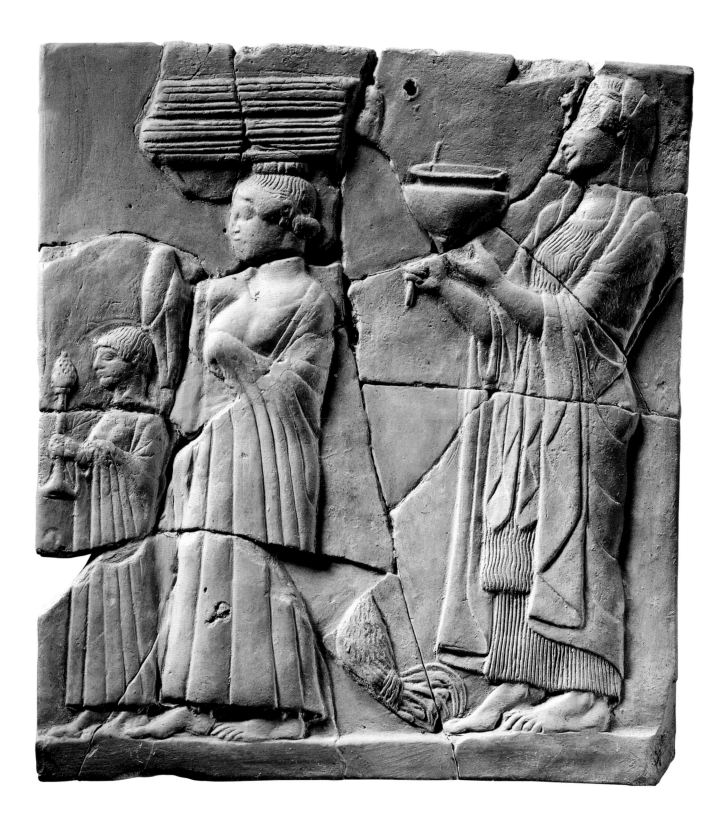

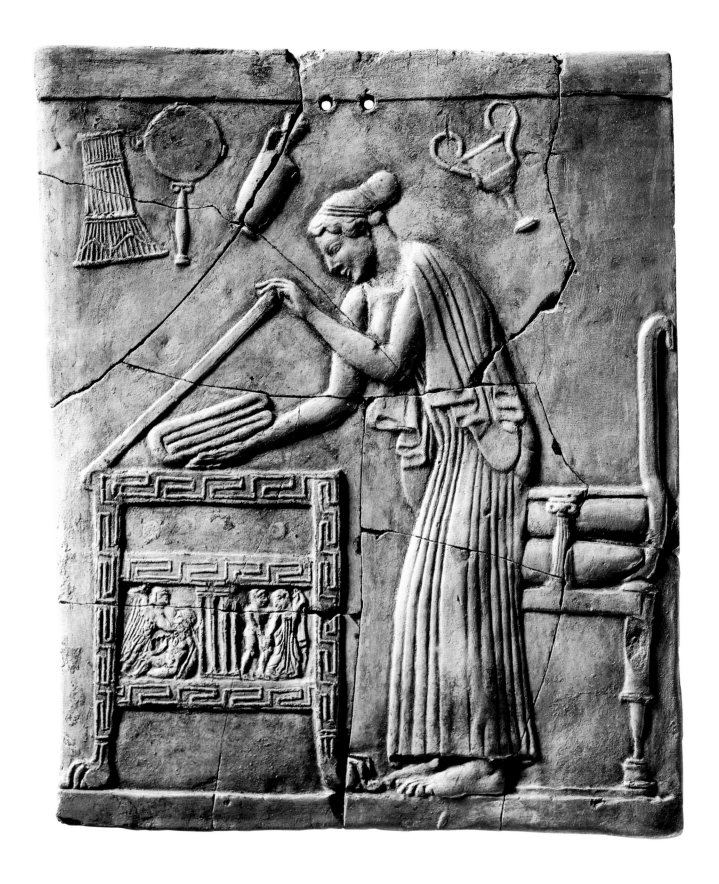

39. PINAX WITH WOMAN PACKING A CHEST

ca. 470–460 BC
Terracotta, mold-made, hand-finished, painted
H. 26
Museo Archeologico Nazionale di Reggio
Calabria, inv. 28266
Locri Epizephirii, Mannella district, sanctuary of
Persephone, previously D. Candida Collection

The scene on this pinax shows a woman in profile facing left. She wears a peplos and her hair is gathered in a sakkos. She bends forward to put a piece of folded fabric into a lidded chest, the legs of which end in lion paws. She holds the fabric in her right hand, while keeping the lid of the richly decorated chest open with her left. A meander border running vertically down the legs and horizontally across the side of the chest divides the surface into two rectangular panels. The lower panel displays two mythological scenes separated by a decorative element similar to a triglyph. At the left, Athena slays the giant Enkelados; at the right are a satyr and a Maenad.

The objects hanging from the wall in the upper background indicate an indoor setting. From left to right they are an upside-down kalathos, a mirror, a lekythos, and a kantharos (two-handled cup). Behind the woman is a throne with lathe-turned legs embellished with carved details. The support for the armrest is in the form of a small Ionian column, and the seat has two thick cushions.

This pinax is classified as a type 5/2, according to Zancani Montuoro. The scene probably represents a ritual with symbolic meaning involving the preparation of a piece of fabric or a dress for a ceremony, perhaps as part of a marriage dowry. The meaning of the scene transcends the apparently ordinary, domestic setting, in which objects of daily life are represented in detail. Similar objects are seen on other Locrian pinakes.

For comparanda, see G. M. A. Richter, "Were There Greek Armaria?" 418–23. For Locrian pinakes in general, see E. Lissi Caronna et al., eds., *I Pinakes di Locri Epizefiri, Musei di Reggio Calabria e di Locri* (Rome, 1999). CS

LITERATURE

G. Pugliese Carratelli et al., *Megale Hellas: Storia e civiltà della Magna Grecia* (Milan, 1983), no. 465.

H. Prückner, *Die Lokrischen Reliefs: Beitrag zur Kultgeschichte von Lokroi Epizephyrioi* (Mainz am Rhein, 1968), 39, 98, 117, pl. 4.4.

E. Langlotz and M. Hirmer, *The Art of Magna Graecia: Greek Art in South Italy and Sicily* (London, 1965), 271, no. 75.

L. Von Matt, *Grossgriechenland* (Zurich, 1961), 132, pl. 145.

G. M. A. Richter, "Were There Greek Armaria?" *Hommages à Waldemar Deonna, Latomus* 28 (1957), 422, pl. 58.1.

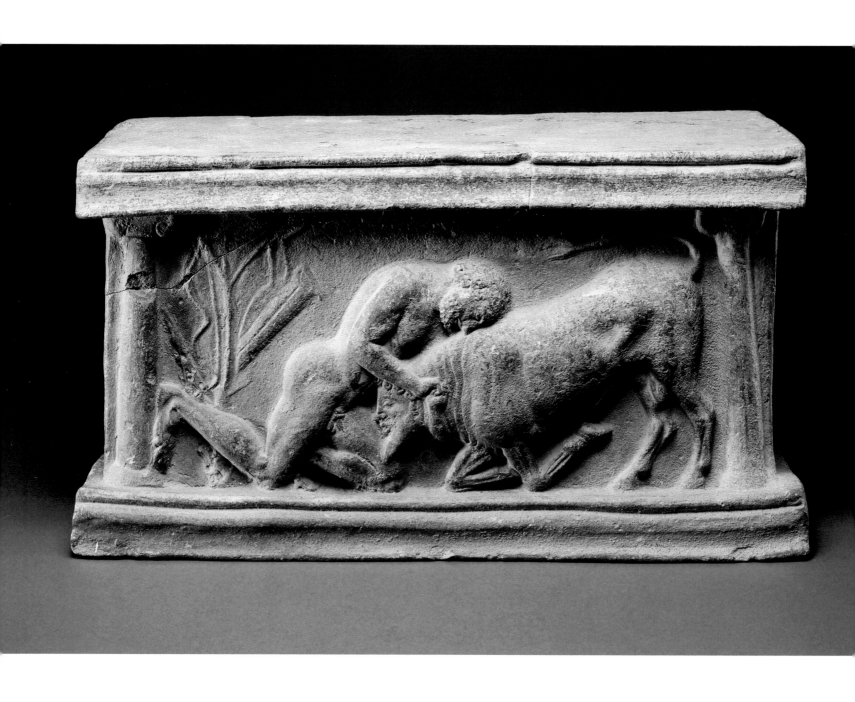

40. ALTAR WITH HERAKLES AND ACHELOOS

ca. 470–450 BC
Terracotta, mold-made, hand-finished
H. 27
Museo Archeologico Nazionale di Reggio
Calabria, inv. 94062
Locri Epiziphirii, necropolis, Lucifero district,
tomb 11, 1956 excavations

This altar is rectangular, with large circular holes on the short sides. It is decorated on the front with the mythological scene of Herakles fighting the river god Acheloos. Two columns with smooth shafts, volute capitals, and rounded bases frame the scene.

At the right, Acheloos is represented in profile, facing left. His bull body is massive and muscular, and his human head has a long beard. Personifications of rivers were typically hybrid creatures, combining human and bovine elements.

At the left of the scene, Herakles bends down and clutches the multiple folds of the bull's dewlap. The hero's body is powerful, his hair curly, and his beard short. He has forced his adversary partially to the ground; Acheloos's front legs are shown folded under his body. In order to apply more pressure, Herakles braces his right foot against the column at the left, against which his club is leaning, while setting his knees firmly on the ground. His bow and quiver hang from a barren tree near the column. The scene is similar to one on an earlier, late Archaic Locrian altar. CS

LITERATURE

H. Hellenkemper, *Die neue Welt der Griechen,* exh. cat., Römisch-Germanisches Museum (Cologne/Mainz, 1998), 129, no. 60.

G. Pugliese Carratelli, ed., *The Western Greeks,* exh. cat., Palazzo Grassi, Venice (Milan, 1996), 685, no. 99.

V. Origlia, "Arule con iconografie varie," in M. Barra Bagnasco and E. Lattanzi, eds., *Locri Epizefiri* (Florence, 1989), 3: 140–44.

G. Foti, *Il Museo Nazionale di Reggio Calabria* (Naples, 1972), 68, no. 7.

I. Novaco Lofaro, "Arule locresi con Eracle e Acheloos," *Klearchos,* nos. 29–32 (1966), 131–40, fig. 2.

A. de Franciscis, *Il Museo Nazionale di Reggio Calabria* (Naples, 1958), 23.

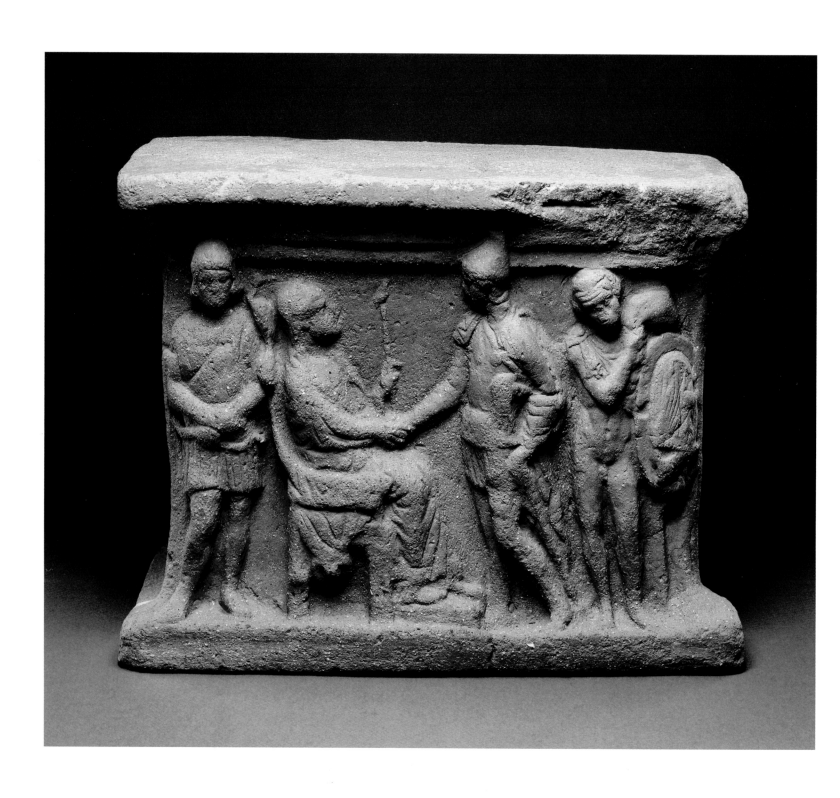

41. ALTAR WITH SCENE FROM A GREEK TRAGEDY

ca. 400–350 BC
Terracotta, orange-red clay with large white inclusions, mold-made, hand-finished
H. 29.3, W. 21.3, L. 40
Museo Archeologico Nazionale di Reggio Calabria, inv. 4083
Medma

This altar was once in the collection of the Museo Civico of Reggio Calabria. It was originally purchased from an individual who reportedly found it near Nolio, ancient Medma. Orsi's archaeological research, confirmed by subsequent excavation, located the necropolis of the city there. Currently, the artifact is on display in the Sala di Medma of the Museo Archeologico Nazionale of Reggio Calabria because the objects once housed in the Museo Civico have become part of its collection.

This medium-sized altar is rectangular with pronounced projecting *listelli* (ledges) at the base and top. The front side shows four male figures, three standing and one sitting on a throne. The last has been identified as Cepheus, king of the Ethiopians. He sits on a throne with legs that end in lion's feet, and a lion pelt hangs from the throne. Wrapped in a mantle with large folds, Cepheus clasps the hand of Perseus, who stands before him. Perseus wears a heavy mantle and a pileus (felt hat). His left leg is flexed and he leans on his long sword with his left arm. Flanking the scene are an archer to the left and a groom to the right. The archer has his hands crossed across his waist and is holding a bow. Part of the quiver is visible at his left shoulder. The groom has African features, holds a shield decorated with a griffin (a composite animal, part eagle and part lion), and carries a knapsack on his left shoulder. The back of the altar is smooth with a large vent hole.

The figural scene refers to the myth of Perseus, who fell in love with Andromeda, daughter of King Cepheus. Perseus promised Cepheus that he would free his daughter from the sea monster sent by Poseidon as punishment for a comment made by Cassiopea, Andromeda's mother and the king's wife. Cassiopea had claimed to be more beautiful than Poseidon's daughters, the Nereids. This myth was the subject of one of Sophocles' tragedies.

The large terracotta altars of Medma are particularly important for understanding the culture of Magna Graecia. Produced during a restricted time span, from the end of the fifth into the early fourth century BC, the altars depict scenes from the Greek tragedies staged in Athens at the time. Some of the more notable include an altar with Tyro (mother of Pelias); an altar with the scene of the departure of Neoptolemus (son of Achilles) from Lycomedes (his grandfather) and Deidamia (his mother), which was inspired by one of the tragedies attributed to Sophocles; and an altar showing Pirithoos (king of the Lapiths), taken from one of the tragedies of Kritias (ca. 460–403 BC).

According to Paoletti, their production seems to have been inspired directly by Athenian models. They do not compare with any similar works produced either in the motherland of Locri or in Hipponion, sister city of Medma.

For a general discussion of the 1914 excavations, see P. Orsi, "Rosarno campagna del 1914," *Notizie degli Scavi di Antichità* (1917), 36–67.

MTI

LITERATURE

H. Van der Meijden, *Terracotta-Arulae aus Sizilien und Unteritalien* (Amsterdam, 1993), 117, 314–16, no. MY 73.

E. Lattanzi, ed., *Il Museo Nazionale di Reggio Calabria* (Rome, 1987), 124–25.

M. Paoletti, "Arule di Medma e tragedie antiche," in P. E. Arias et al., eds., *Aparchai: Nuove ricerche e studi sulla Magna Grecia e la Sicilia antica in onore di Paolo Enrico Arias* (Pisa, 1982), 386, no. 1, pl. 100.

S. Settis, "Bellerophon in Medma," *Archäologischer Anzeiger* 92 (1977), 191, no. 1, fig. 9.

N. Putortì, "Due arule fittili di Medma nel Museo Civico di Reggio Calabria," *L'Italia antichissima* 11 (1937), 13–39, fig. 1, pl. I.

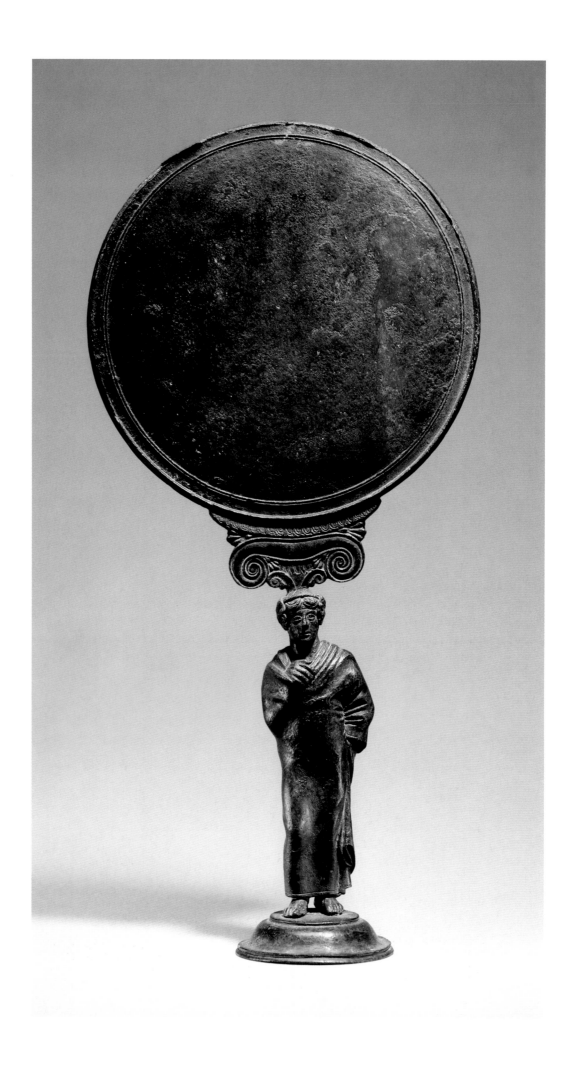

42. MIRROR WITH DRAPED MALE FIGURE

ca. 470–450 BC
Bronze, cast, incised
H. 34.5
Museo Archeologico Nazionale di Reggio
Calabria, inv. 4490
Locri Epizephirii, necropolis, near Lucifero district,
tomb 622

The reflecting side of this bronze mirror has a
raised rim within which are two additional thin
lines in relief. The disc is connected to the handle
by a transitional element decorated with an egg
pattern, two small flanking palmettes, and an Ionic
capital with volutes and an echinus decorated
with a series of eggs and palmettes. This element
surmounts two small volutes that connect to the
handle.

The handle is in the form of a male figure
sculpted in the round and standing on a raised
circular base. His elongated face is framed by an
elaborate hairstyle. His long hair is parted at the
forehead and falls at the sides to cover his ears
completely. Near the nape of his neck, his hair is
rolled around a diadem that encircles his head.

He wears a himation of a thick fabric that com-
pletely covers his body but is left open on the left
side. The contours of his body are visible beneath
the garment. His pose suggests a thoughtful and
reflective state of mind. His left leg supports the
weight of his body, freeing the right leg to step for-
ward and to the side; the bent right knee shows
under the mantle. His right arm is held up close to
his chest; only his hand emerges from the
himation to grasp the pleats gathered at the edge
of the garment near the left shoulder, which fall
onto his back. His left arm is completely wrapped
in the himation, and bent so that the hand, hidden
under the fabric, rests on the hip.

The sculptural treatment of the fabric to re-
semble wool is refined and sensitive. It suggests
the softness of the material and even hints at the
contours of the abdomen. The diagonal folds em-
phasize the pose, which can be fully appreciated
from the back of the figure. The figure appears
monumental despite its small size. It epitomizes
the best of the Locrian "Severe style," showing
echoes of Ionian, Cycladic, and northern Aegean
influences. CS

LITERATURE

A. Giumlia-Mair and M.
Rubinich, eds., *Le Arti di
Efesto: Capolavori in metallo
dalla Magna Grecia* (Milan,
2002), 189, fig. 18.

G. Pugliese Carratelli, ed., *The
Western Greeks,* exh. cat.,
Palazzo Grassi, Venice (Milan,
1996), 394, 700, no. 161 II.

E. M. De Juliis, *Magna Grecia:
L'Italia meridionale dalle
origini leggendarie alla
conquista romana* (Bari,
1996), 164–66, fig. 157.

E. Lippolis, ed., *Arte e
artigianato in Magna Grecia,*
exh. cat., Convento di San
Domenico, Taranto (Naples,
1996), 134.

E. Lattanzi, ed., *Il Museo
Nazionale di Reggio Calabria*
(Rome, 1987), 39.

R. Bianchi Bandinelli and E.
Paribeni, *L'arte dell'antichità
classica: Grecia* (Turin, 1986),
1: 10, no. 427.

G. Pugliese Carratelli et al.,
*Megale Hellas: Storia e civiltà
della Magna Grecia* (Milan,
1983), 433, fig. 453.

I. Caruso, "Bronzetti di
produzione magnogreca dal
VI al IV sec. a.C.: La classe
degli specchi," *Mitteilungen
des Deutschen Archäologi-
schen Instituts Römische
Abteilung* 88 (1981), 48.

E. Langlotz and M. Hirmer,
*The Art of Magna Graecia:
Greek Art in South Italy and
Sicily* (London, 1965), 276–
77, no. 91.

L. von Matt, *Grossgriechen-
land* (Zurich, 1961), 132, pl.
134–35.

A. de Franciscis, *Agálmata:
Sculture antiche nel Museo
Nazionale di Reggio Calabria*
(Naples, 1960), 24, pl. 12.

P. Orsi, "Scavi di Calabria nel
1913 (relazione preliminare),"
*Notizie degli Scavi di Anti-
chità anno 1913, Supplemento*
(1914), 14–15, fig. 15.

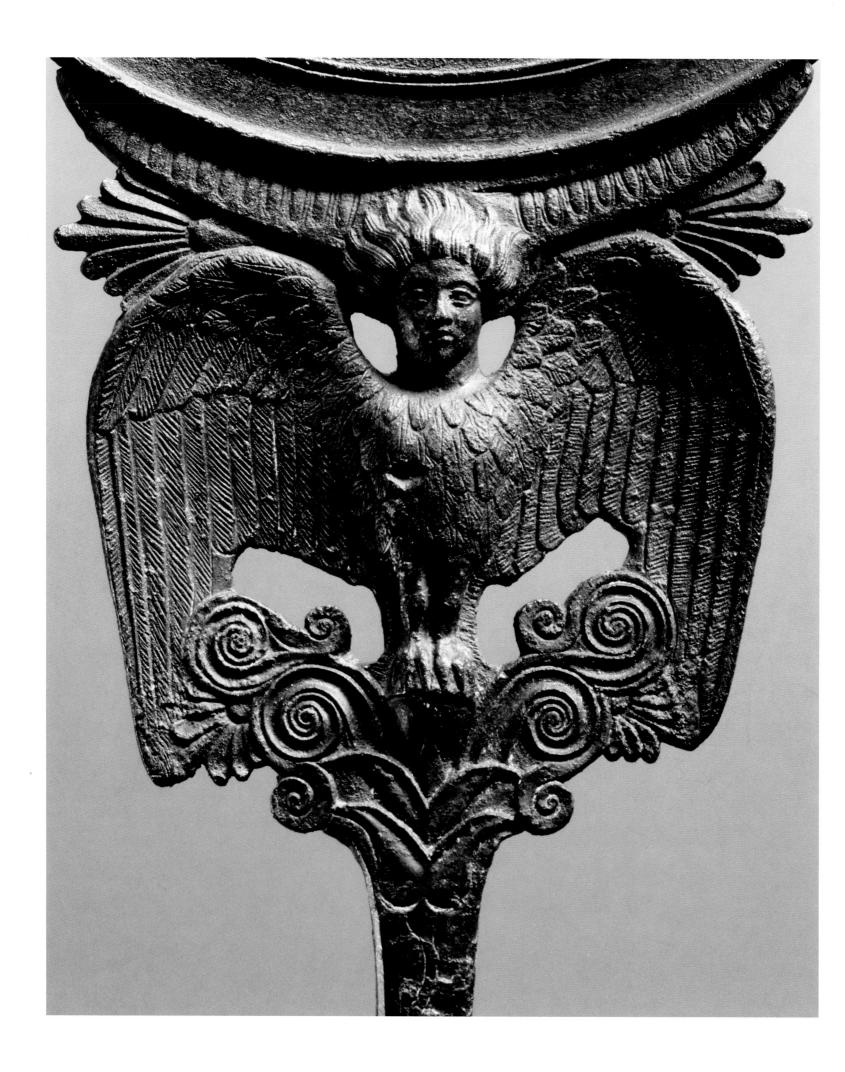

43. MIRROR WITH SIREN

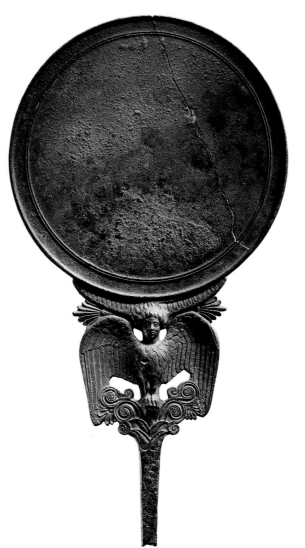

ca. 450–400 BC
Bronze, cast, incised
H. 33
Museo Archeologico Nazionale di Reggio
Calabria, inv. 4496
Locri Epizephirii, necropolis, Lucifero district,
tomb 632, 1913 excavations

The reflecting surface of this mirror has a raised
edge with two thin interior lines in relief. The bot-
tom of the mirror has a flat tang for insertion into a
handle, now missing, made of a perishable mate-
rial. Two lotus blossoms, one on top of the other
and represented in relief, form the top of this
shank. A complex series of symmetrically arranged
volutes with palmettes emerges from these lotus
blossoms, creating a base for the siren's strong legs
and clawed feet. The siren is posed frontally, its
wings spread. Thick feathers rendered in relief
cover its bird-like body. The feathers are especially
visible on the contoured wings, composed of two
rows and joining with the volutes at their bottom
edges.

The siren looks straight ahead, and the hairstyle
is characteristic of the creature. Large wavy locks,
swept up and back as if stirred by the wind, over-
lap a crescent-shaped element merging with the
disc. Two horizontal palmettes above the wings
provide a brace.

The siren handle displays a profound sensitivity
to contour lines. Among Locrian mirrors, it is the
oldest example of a representation on a single
plane with openwork sections incorporated into
the design. This principle will be developed fur-
ther in the fourth century BC. CS

LITERATURE

G. Pugliese Carratelli, ed., *The Western Greeks*, exh. cat., Palazzo Grassi, Venice (Milan, 1996), 700, no. 161 IV.

E. Lippolis, ed., *Arte e artigianato in Magna Grecia*, exh. cat., Convento di San Domenico, Taranto (Naples, 1996), 137.

E. Lattanzi, ed., *Il Museo Nazionale di Reggio Calabria* (Rome, 1987), 41.

G. Pugliese Carratelli et al., *Megale Hellas: Storia e civiltà della Magna Grecia* (Milan, 1983), 435, 457, fig. 459.

I. Caruso, "Bronzetti di produzione magnogreca dal VI al IV sec. a.C.: La classe degli specchi," *Mitteilungen des Deutschen Archäologi-schen Instituts Römische Abteilung* 88 (1981), 13.

F. Cameron, "Greek Bronze Hand-Mirrors in South Italy," *B.A.R. International Series* 58 (1976), 25–26, no. 14, pls. 40, 42.

P. E. Arias, "L'arte Locrese nelle sue principali manifestazioni artigianali, terrecotte, bronzi, vasi, arti minori," in *Locri Epizefirii: Atti del sedicesimo Convegno di studi sulla Magna Grecia* (Taranto, 1976), 1: 547, 2: pl. 83.

E. Langlotz and M. Hirmer, *The Art of Magna Graecia: Greek Art in South Italy and Sicily* (London, 1965), 275, pl. 89.

E. Simon, "Zagreus, Über orphische Motive in Campanareliefs," in M. Renard, ed., *Hommages à Albert Genier, Latomus* 58 (1962), 1418–427.

U. Jantzen, *Bronzewerkstatten in Grossgriechenlandund Sizilien* (Berlin, 1937), 32.

R. Eisler, *Orphische-diony-sische Mysteriengedanke in der christlichen Antike* (Leipzig, 1925), 98.

F. von Duhn, "Funde und Forschungen, Italien 1914–1920," *Jahrbuch des Deutsch-en Archäologischen Instituts* 36 (1921), 143–46, fig. 22.

P. Orsi, "Scavi di Calabria nel 1913 (relazione preliminare)," *Notizie degli Scavi di Anti-chità anno 1913, Supplemento* (1914), 17–19, fig. 18.

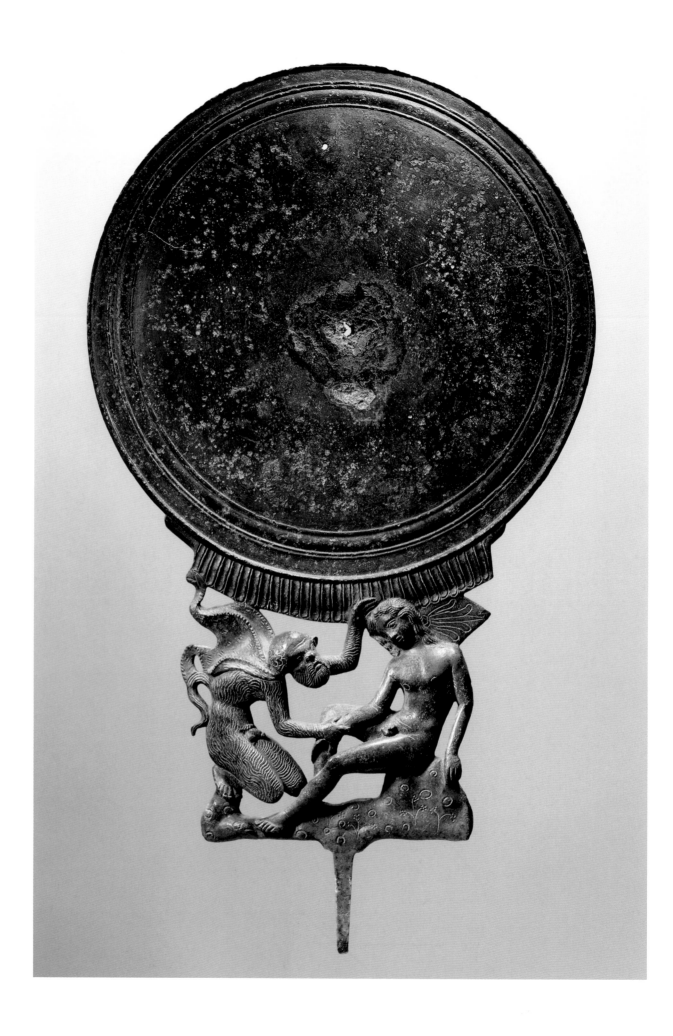

44. MIRROR WITH SATYR AND YOUTH

ca. 400–350 BC
Bronze, cast, incised
H. 29
Museo Archeologico Nazionale di Reggio
Calabria, inv. 5762
Medma, Grizzoso district tomb

This bronze mirror was part of a funerary deposit in a tomb discovered by chance during excavations for a water main in Contrada Grizzoso, on the Meduri property, near present-day Rosarno. The other objects of the deposit are missing.

The edge of the reflecting side of the mirror is adorned with a series of concentric raised lines. The openwork scene is soldered to the disc with a plaque decorated with a tongue pattern; the shank would have been inserted into a handle made of a perishable material. On the left, a satyr, shoulders covered by a pelt flapping in the wind, leans over and caresses a sleeping youth. A network of small lines renders the texture of the satyr's hairy body. The youth's face and legs are shown nearly in profile. His torso is posed more frontally, and his long locks of hair touch his shoulders. His left leg is extended; the right is slightly flexed. The erotic scene, characteristic of a Dionysian theme, is set in the countryside, which is indicated by stylized plants and rocks representing the natural environment and forming the base for the figures. MTI

LITERATURE

G. Pugliese Carratelli, ed., *The Western Greeks*, exh. cat., Palazzo Grassi, Venice (Milan, 1996), 394–96, 700, no. 162.

C. Donzelli, *Magna Grecia di Calabria: Guida ai siti archaeologici e ai musei calabresi* (Rome, 1996), 20, fig. 23.

E. Lattanzi, ed., *Il Museo Nazionale di Reggio Calabria* (Rome, 1987), 123–24.

G. Foti, *Il Museo Nazionale di Reggio Calabria* (Naples, 1972), 30–31, 75, fig. 40.

E. Langlotz and M. Hirmer, *The Art of Magna Graecia: Greek Art in South Italy and Sicily* (London, 1965), 288, pl. 127.

A. de Franciscis, *Agálmata: Sculture antiche nel Museo Nazionale di Reggio Calabria* (Naples, 1960), 25–26, pl. 14.

L. von Matt, *Grossgriechenland* (Zurich, 1961), 100, pl. 105.

G. Iacopi, "Specchio bronzeo da Medma," *Bollettino d'Arte* 35 (1950), 193–200, figs. 1–2.

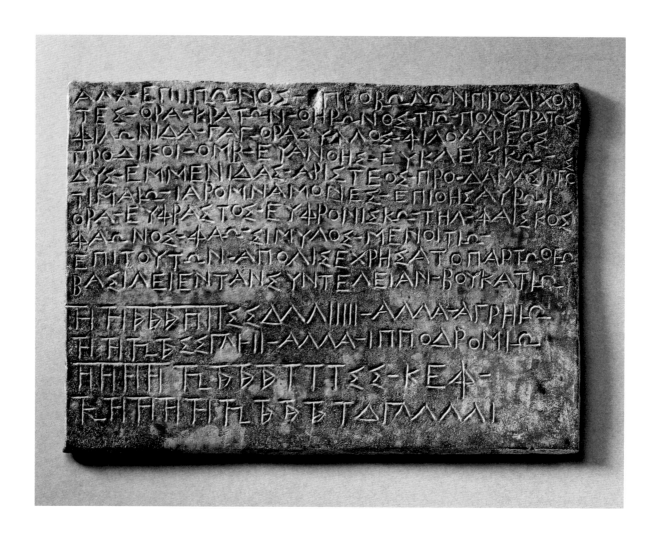

45. INSCRIBED TABLET

ca. 350–250 BC
Bronze, cast, incised
H. 12.3
Museo Archeologico Nazionale di Reggio
Calabria, inv. 40546
Locri Epizephirii, sanctuary of Zeus Olympios,
stone archive container

The chance discovery in 1957 of thirty-seven inscribed bronze tablets from the archive of the Locrian sanctuary of Zeus Olympios proved to be unique. These documents are of exceptional value for understanding the economic and administrative workings of a polis.

Written in the Doric dialect, the texts record financial transactions made by the magistrates who managed the treasury of the sanctuary after the middle of the fourth century BC, when Locri was democratically governed. Withdrawals for civic needs appear on the tablets more frequently than repayments to the sanctuary.

The compositional structure of tablet number 13, illustrated here, is characteristic of these texts. It begins by stating the year when the transactions took place, named after a magistrate, "in the year of Hipon." Then follow the names of other magistrates: three *probouloi* (guardians), three *proarchontes* (chief magistrates), three *prodikoi* (judges), and three *hieromnamones* (religious magistrates) in charge of the treasury. They were in office when "the polis borrowed from the God for the contribution to the *basileus* [king]." The sum was large, almost one thousand talents, indicated by the numbers in the last four lines. It was paid in three installments during the months of Boukatios, Agreios, and Hippodromios.

It is unclear if the word "basileus" is meant to indicate the appointment of a magistrate in Locri, similar to the *archontes basileus* of Athens, or refer to a foreign king such as Agathokles of Syracuse or Pyrrhus, king of Epirus, who developed alliances with Locri during the first decades of the third century BC. For this type of inscribed tablet, see D. Musti, ed., *Le Tavole di Locri: Atti del Colloquio sui testi dell'archivio locrese a Napoli aprile 1977* (Rome, 1979) and A. de Franciscis, *Stato e Società a Locri Epizefiri: L'Archivio dell'Olympieion locrese* (Naples, 1972). CS

LITERATURE

G. Pugliese Carratelli, ed., *The Western Greeks*, exh. cat., Palazzo Grassi, Venice (Milan, 1996), 742, no. 346 II.

F. Costabile, ed., *Polis ed Olympieion a Locri Epizefiri* (Soveria Mannelli, 1992), 254–55, no. 13.

G. Pugliese Carratelli et al., *Magna Grecia* (Milan, 1985), 2: 256, fig. 346.

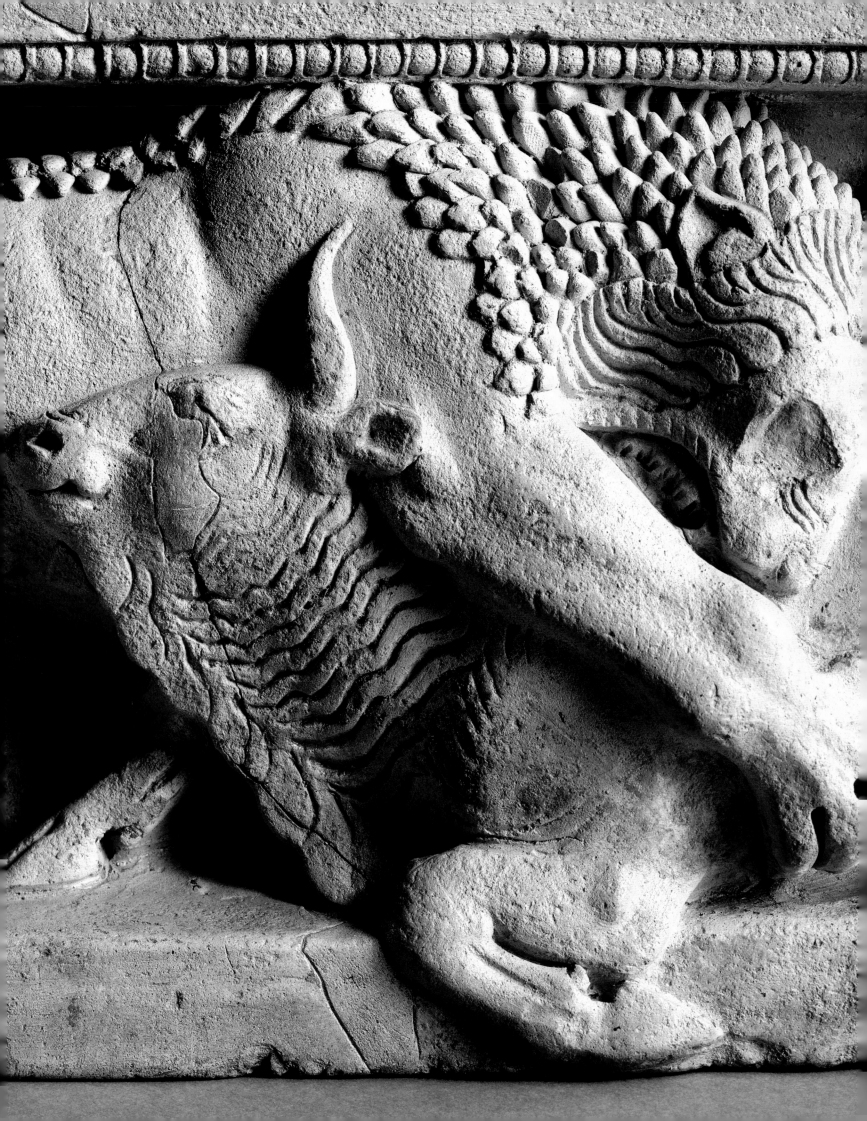

SYRACUSE

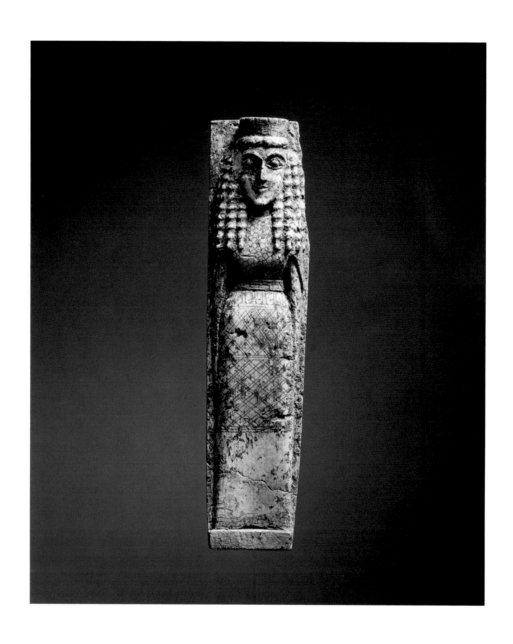

46. KORE BUCKLE

ca. 650–640 BC
Bone, carved, incised, traces of a metal latch on the back
H. 9.3, W. 2.3
Museo Archeologico Regionale "Paolo Orsi" di Siracusa, inv. 84818
Megara Hyblaea, sanctuary south of the agora in a residential area, 1963

Traces of oxidized metal on the back of this carved bone plaque indicate that it is the ornamental facing for a fibula or clasp. The metallic residue was once a fastener measuring approximately 4.9 x 1 cm. The small plaque represents a kore (young woman) standing in a rigid pose, thin arms held at her sides and each hand closed in a fist. The figure is carved in relief and stands on a plinth incised with a braided pattern.

The maiden has large almond-shaped eyes, and her thick arched brows meet at the bridge of her pronounced nose. Her lips are thin and elongated. Eight heavy braids formed of large globular sections fall to her breasts in an elaborate hairstyle. A low cylindrical polos decorated with small incised leaves is set on a crown of spiral-like locks that are parted in the center.

Executed in a mid-Daedalic style, the figure is probably an example of Corinthian workmanship. She wears a chiton, gathered at the waist by a belt with an incised meander motif. Over the chiton a short cape with pointed ends drapes over her arms. The decoration on the chiton consists of fine incised lines and includes scales on the bodice, small tongues below the belt, and a diagonal lattice interrupted by horizontal lines. The lower portion of her dress is smooth with a subtle tongue pattern at the bottom edge.

The figure was reassembled from two fragments. A fracture line runs along the upper right corner of the plaque, and there are small abraded, chipped, and encrusted areas. CC

LITERATURE

H. Hellenkemper, *Die neue Welt der Griechen,* exh. cat., Römisch-Germanisches Museum (Cologne/Mainz, 1998), 100, no. 24.

G. Pugliese Carratelli, ed., *The Western Greeks,* exh. cat., Palazzo Grassi, Venice (Milan, 1996), 401, 668, no. 38.

C. Rolley, *La Sculpture grecque* (Paris, 1994), 1: 151–52, fig. 135.

F. Croissant, "Sybaris: La production artistique," in A. Stazio and S. Ceccoli, eds., *Sibari e la sibaritide: Atti del trentaduesimo Convegno di studi sulla Magna Grecia* (Taranto, 1993), 545, pl. 34.1.

G. Vallet and A. Stazio, *Sicilia greca* (Palermo, 1990), 93, no. 24.

G. Rizza and E. de Miro, "Le arti figurative dalle origini al V secolo a.C.," in G. Pugliese Carratelli et al., *Sikanie: Storia e civiltà della Sicilia greca* (Milan, 1985), 148–49, 168, fig. 151.

Mostra della Sicilia Greca, exh. cat., Tokyo Fuji Art Museum (1984), 120, no. 67.

E. Gabba and G. Vallet, eds., *La Sicilia antica* (Palermo, c. 1980), 2, part 1: 111, pl. 18.

G. Voza, "Cultura artistica fino al V secolo a.C.," in *Storia della Sicilia* (Naples, 1979), 2: 111, pl. 18.

P. Pelagatti and G. Vosk, *Archeologia della Sicilia Sud-Orientale* (Naples, 1973), 165, no. 465, pl. 1.

G. M. A. Richter, *Korai: Archaic Greek Maidens* (London, 1968), 31/15, figs. 66–67.

G. Vallet and F. Villard, "Mégara Hyblaea," in *Mélanges de l'Ecole Française de Rome: Antiquité* (Paris, 1964), 35–36, no. 6.

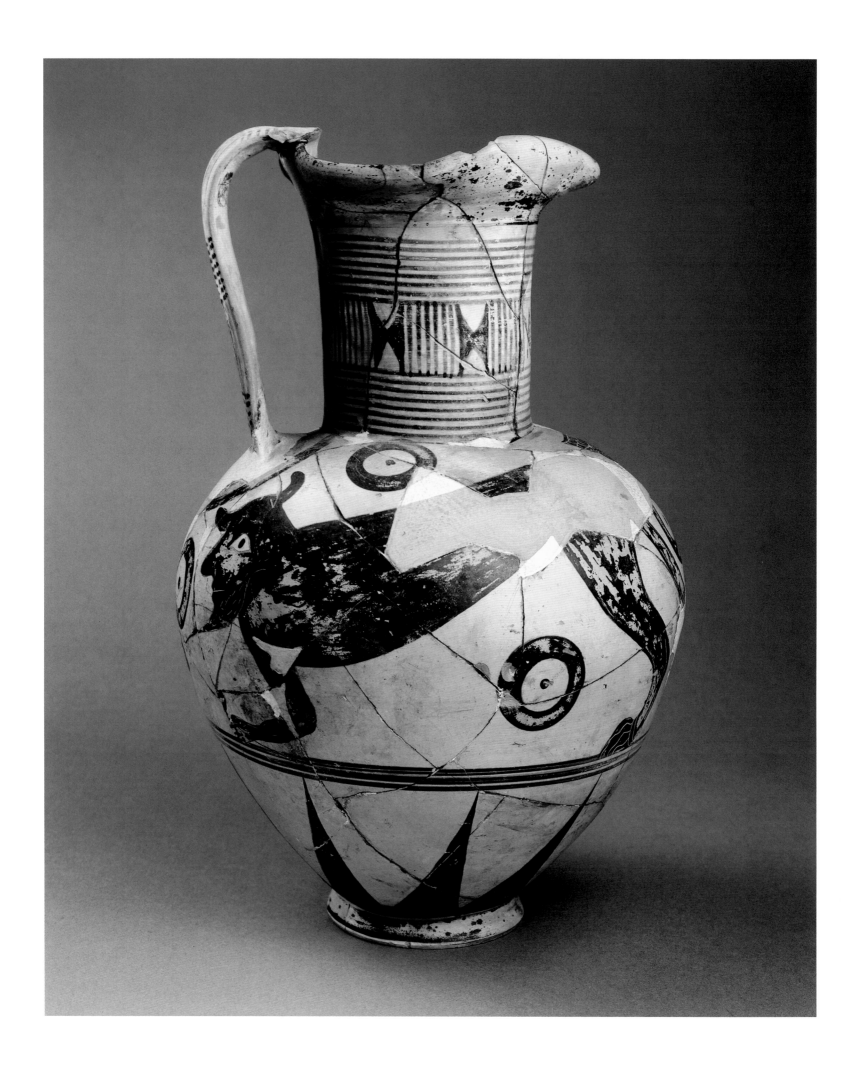

47. PROTO-CORINTHIAN OINOCHOE

ca. 700–650 BC
Ceramic, refined light yellow-beige clay
H. 32.5 (at handle), Diam. 14.2 (at mouth)
Museo Archeologico Regionale "Paolo Orsi" di
Siracusa, inv. 42684
Syracuse, Fusco necropolis, tomb F 428, 1893
excavations

The sarcophagus of tomb F 428 contained the burial of a woman who wore ornamental objects including a necklace, silver earrings, large pins, and a bronze and iron fibula with decorations in bone and amber. The material found outside the sarcophagus included an oinochoe and a number of vases among which were additional Proto-Corinthian ceramics—aryballoi, kylikes, pyxides, stamnoi, and a small vase in the form of an owl.

The trefoil oinochoe has a large cylindrical neck and heart-shaped body. The body rests on a ring base shaped like a truncated cone. The base is concave. The ribbon handle connects the shoulder to the rim above the edge.

A zoomorphic scene is painted in the black-figure technique on the upper part of the body. It depicts Acheloos, the part-man, part-bull mythological figure, in profile with an elongated body. The back paw with incised details is feline, while the front paw is anthropomorphic. The human head has horns and a long pointed beard; incised detail indicates the lips. The almond-shaped eye is in reserve, the pupil indicated by a black dot. The hindquarters are mostly restoration, but some elements have survived. On the back of the vase are part of a wing, with incisions in black paint suggesting feathers, and the neck and head of a bird, eye in reserve with its oblong cut by a large black pupil. The bird turns toward a lion, head in profile, jaws open and tongue hanging out; incised details indicate teeth. The upper profile of its back, the lower left paw with incised details, and the upturned tail are preserved. Filling ornament is composed of circles (3.8 cm in diameter) in brown-black paint with a dot in the center. Deco-

rating the area below Acheloos are three horizontal brown-black lines, with rays at the base above the painted foot. The vase is attributed to the Tolosa Painter.

Reassembled from several fragments with areas of plaster fill on the shoulder and at the mouth, the vase is decorated with brown-black paint, flaked off in places, on a light yellow-beige background. The ornament on the neck consists of two horizontal bands of eight parallel lines between which is a band decorated with a series of six reticulated lozenges separated by groups of vertical lines. The handle has groups of horizontal and vertical lines. CC

LITERATURE

R. Bianchi Bandinelli and E. Paribeni, *L'arte dell'antichità classica: Grecia* (Turin, 1986), 1: no. 81.

J. Boardman, "Acheloos," in *Lexicon Iconographicum Mythologiae Classicae* (Zurich/Munich, 1981), 1: 13, no. 1.

H. P. Isler, *Acheloos* (Bern, 1970), no. 60.

L. Banti, "Tolosa, Pittore di," in R. Bianchi Bandinelli, ed., *Enciclopedia dell'Arte Antica, Classica, e Orientale* (Rome, 1966), 7: 908–9, fig. 1018.

W. A. Heurtley and M. R. Robertson, "Excavations in Ithaca, V: The Geometric and Later Finds from Aetos," *Annual of the British School at Athens* 43 (1948).

H. Payne, *Necrocorinthia: A Study of Corinthian Art in the Archaic Period* (London, 1931, reprinted College Park, Md., 1971), 13, fig. 6.

P. Orsi, "Sicilia, Siracusa," *Notizie degli Scavi di Antichità* (1895), 167–71, fig. 57.

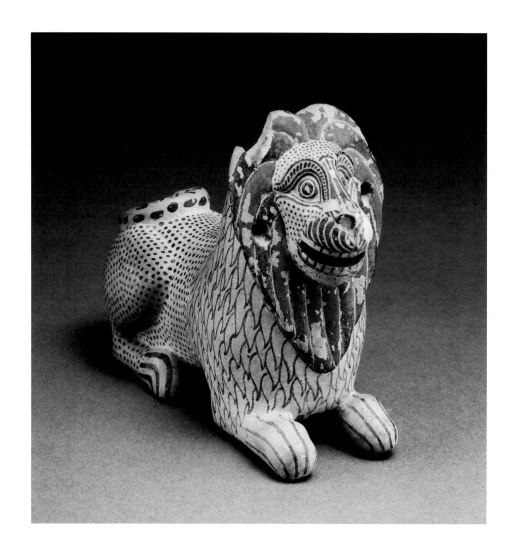

48. LION VESSEL

ca. 600–575 BC
Terracotta, refined light brown and yellow clay, painted
H. 10, W. 4.8, L. 12.5
Museo Archeologico Regionale "Paolo Orsi" di Siracusa, inv. 43332
Syracuse, Giardino di Spagna, tomb 1, necropolis, 1923

This vessel takes the form of a crouching lion, with the rim of the hole on the top of the animal's head outlined in red. Black dots represent the texture of the fur on the body; the head is stippled with smaller dots around the eyes and snout. Part of the thick mane covering about half of the body is shown as a dense pattern of flame-shaped locks on a reserved background. In contrast, around the head the mane consists of long locks, alternatively red and black, that create a heart-shaped frame parted at the front and falling on both sides. Two holes corresponding to ears pierce the mane. The eyes and reddish pupils are outlined in black, and the whites of the eyes left in reserve. The elongated, oval eye sockets are sunken, framed by the arch of the brows rendered in reserved diagonal zones that extend to the temples. A small black arc connects the brows. The nose, large with wide nostrils, has three elongated strokes painted down its length; the one in the middle is black and the two flanking it are red. They may represent folds of skin. The open jaws are painted red; vertical black lines separate the teeth. The fur below the nostrils appears as alternating red and black arched lines. The curled tail rests at the end of the lion's back and is decorated with two rows of large purple dots outlined in black. On the abdomen and the inner part of the shins are additional purple oval dots with black outlines, larger than those on the tail. The bases of the paws are also decorated with purple ovals. Black lines define claws, thinner on the front paws than on the back ones.

Its harmonious proportions and its detailed and refined painted decoration make this handmade object an outstanding piece among similar Corinthian sculptural vessels, for example, the one in the British Museum. See R. A. Higgins, *Catalogue of the Terracottas in the Department of Greek and Roman Antiquities, British Museum* (London, 1959), 2: no. 1671, pl. 28. The schematic use of color defining the features points to a lion of Hittite origin.

The rich grave in which this vessel was found included vases of Eastern and Etruscan *bucchero* (black ware) in addition to Rhodian, Ionian, and Corinthian ceramic vessels. Among them was a particularly valuable large, footed pyxis. In addition, there were an unusual grater made of iron, as well as an ax and large-headed nails, also made of iron.

The vessel is nearly intact. There is a narrow scratch on the front right paw, a missing section from the mane, chips on the snout, and some abrasions of the painted surfaces. CC

LITERATURE

R. Bianchi Bandinelli and E. Paribeni, *L'arte dell'antichità classica: Grecia* (Turin, 1986), 1: no. 99.

E. Gabba and G. Vallet, eds., *La Sicilia antica* (Palermo, c. 1980), 2, part 1: pl. 42.

L. Bernabò Brea and A. M. Fallico, eds., *Siracusa* (Florence, 1970), fig. 33 and cover.

L. von Matt, *Das antike Sizilien* (Zurich, 1967), 25, fig. 14.

H. Payne, *Necrocorinthia: A Study of Corinthian Art in the Archaic Period* (London, 1931, reprinted College Park, Md., 1971), 173, fig. 76.

P. Orsi, "Sicilia, Siracusa," *Notizie degli Scavi di Antichità* (1925), 183–84, pl. 8.

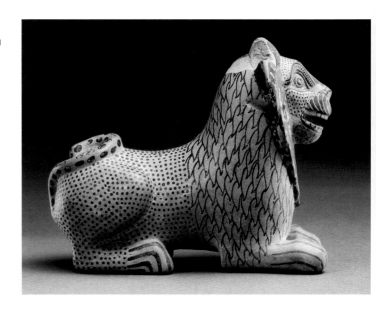

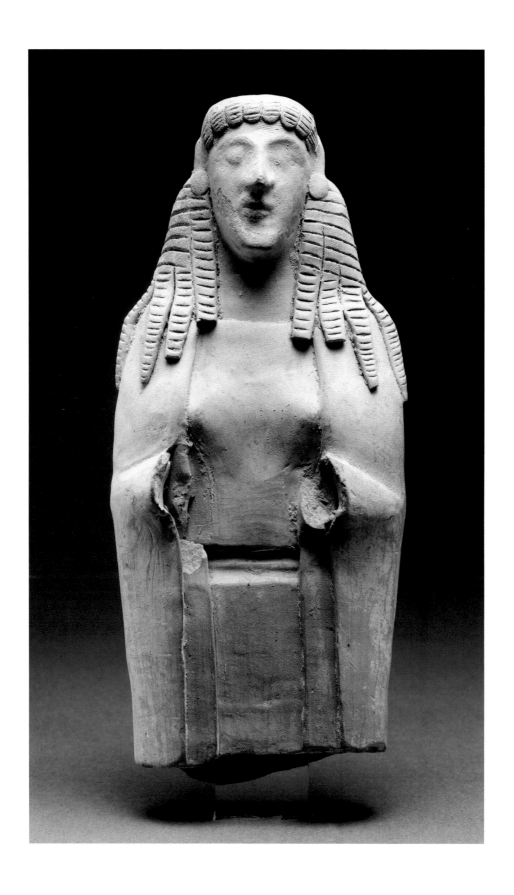

49. FEMALE STATUETTE

ca. 575–550 BC
Terracotta, pinkish interior, brown outside, yellow surface, mold-made, finished with a stick
H. 17.7, W. 7.9
Museo Archeologico Regionale "Paolo Orsi" di Siracusa, inv. 21294
Gela, near the suburban sanctuary of Demeter and Kore, on the hill of Bitalemi, April 1901

This terracotta statuette stands in a frontal pose, her hair gathered in a cap. The curls framing her forehead are small distinct locks decorated with regularly spaced horizontal incisions. Four long flat braids with pointed ends fall along her neck and onto her shoulders. They display horizontal incisions made with a stick. Executed in low relief, the braids grow out of two large locks that emerge from the headdress. In the back, the hair appears as a flat mass terminated at the bottom horizontally. She probably wore a polos, now missing. The features of the elongated face are indistinct. This soft modeling is seen in the eyebrows and eyes, the prominent nose, the fleshy lips slightly parted in an "Archaic smile," and the strong chin. Two large button earrings completely cover her ears.

Anatomical features are only suggested under her thin, belted chiton. A rigid himation covers her shoulders and arms, falling toward her feet symmetrically. Boxy in its proportions, the himation is open at the center. Her arms are bent at the elbows, with forearms held close to her body; her hands are missing.

For the most part the figure is solid; only the central portion is hollow. It has been broken off irregularly at the thighs.

The figurine is of local production, influenced by Ionian archaic sculpture. This Ionian influence is one of the most significant characteristics of ancient Sicilian art of the sixth century BC, indicating connections with Rhodes and Crete.　ES

LITERATURE

H. Hellenkemper, *Die neue Welt der Griechen*, exh. cat., Römisch-Germanisches Museum (Cologne/Mainz, 1998), 91, no. 14.

G. Pugliese Carratelli, ed., *The Western Greeks*, exh. cat., Palazzo Grassi, Venice (Milan, 1996), 669, no. 41 II.

E. Meola, "Terrecotte orientalizzanti di Gela ('Daedalica' Siciliae III)," *Monumenti Antichi della Reale Accademia Nazionale dei Lincei* 48 (1971), 69–70, 76, XX.b.

P. Orsi, "Gela," *Monumenti Antichi della Reale Accademia dei Lincei* 17 (1906), 695–96, fig. 520.

50. GORGON TABLET

ca. 610–590 BC
Terracotta, orange clay with inclusions, pale yellow-beige slip, mold-made, hand-finished, painted
H. 56, W. 50
Museo Archeologico Regionale "Paolo Orsi" di Siracusa, inv. 34540, 34543, 34895
Syracuse, via Minerva, old temple of Athena, near aedicula E, 1913–14 excavations

This terracotta tablet represents the winged Gorgon Medusa, her legs positioned in the "Knielauf" pose, an Archaic convention that represents a figure running at great speed. Her torso is shown frontally and her lower body in profile. Her large wings curl above her shoulders and her winged right boot extends beyond the edge of the tablet. Originally the figure was set in a square black background, and the tablet has been reassembled from several fragments with missing areas restored, especially noticeable on the right side.

With her right hand, the Gorgon grips the belly of the small winged horse Pegasus, tucking the creature under her arm. Pegasus rests his head on his mother's breast. His elongated right eye is outlined in black and his mouth is slightly open. His neck is painted purple, the details of the mane, black. His rear hooves rest on the Gorgon's right foot and his front hooves on her right thigh. The feathers of his lowered wing are painted black and purple, and his long cord-like tail hangs above the Gorgon's foot. Pegasus and Chrysaor were the offspring of the Gorgon and the god Poseidon. Chrysaor's head once rested in the hollow of the Gorgon's left shoulder, but both his head and body are now missing.

The Gorgon's mask is executed in a schematic style similar to other gorgoneia found near the sanctuary of Apollo in Syracuse and temple A in Gela. Her hair is parted in the middle and frames her forehead in spiral locks. Large braids, painted black, fall onto her shoulders, four on each side. Her ears are shown frontally. Her almond-shaped eyes are large and bulging. The pupil of the preserved right eye is painted black. A reconstructed spear-shaped element at the bridge of her large flat nose divides her forehead in half. A painted black line defines the preserved right cheekbone. A wide tongue, originally painted red, hangs over her lower lip and chin.

The Gorgon wears a red chitoniskos. The edges surrounding the neck, the upper arms, and thighs are decorated with small black and red tongues, hook-shaped meanders, and stylized black and red braids. These three motifs are also found on local architectural terracotta elements.

Four holes in the tablet suggest that it was probably attached to a wooden support, a beam of a temple or a metope. An alternative function may have been as decoration for an altar or throne.

This scene of the Gorgon Medusa was influenced by Corinthian architectural sculpture, exemplified by the monumental pedimental group of the temple of Artemis on Corfu. The composition, one of the earliest of its type in Sicily, is also seen on a later altar from Naxos and another recently found at Gela [56]. CC

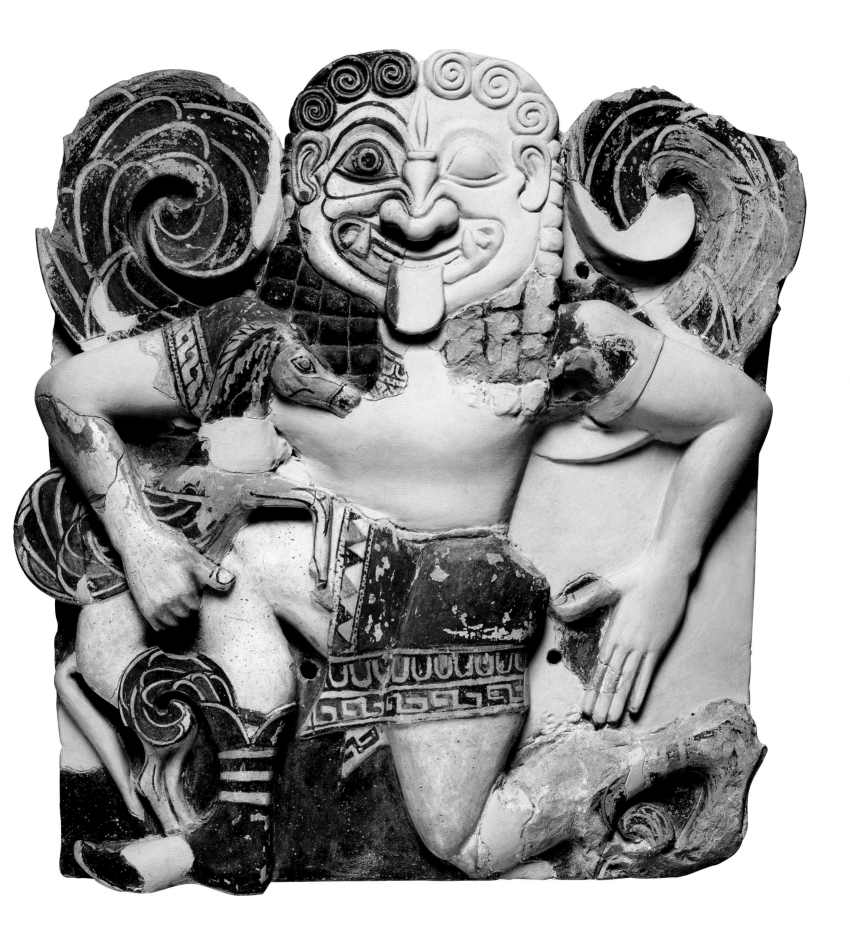

LITERATURE

R. Panvini, *Tiranni e culti della Sicilia in età arcaica* (Caltanissetta, 2001), 19, 21.

C. Ciurcina, "Rivestimenti fittili e coroplastica architettonica dai santuari greci di Siracusa," in *Archeologia, Archéologie, Ricerca e metodologie: Atti IX giornata archeologica, Genova 29 novembre 1996, Università di Genova, facoltà di lettere,* n. s. 171 (Genova, 1998), 22, fig. 22.

H. Hellenkemper, *Die neue Welt der Griechen,* exh. cat., Römisch-Germanisches Museum (Cologne/Mainz, 1998), 102, no. 26.

R. Trevelyan, *The Companion Guide to Sicily* (St. Edmonds, U.K., 1998), 223, pl. 17.

G. Pugliese Carratelli, ed., *The Western Greeks,* exh. cat., Palazzo Grassi, Venice (Milan, 1996), 404–6, 673, no. 56.

M. C. Lentini, "Arule figurate di Naxos," in M. C. Lentini, ed., *Un'arula tra Heidelberg e Naxos,"* Atti del Seminario di studi, Giardini Naxos, 18–19 ottobre 1990 (1993), 35–36, fig. 4.

K. Schefold, *Gods and Heroes in Late Archaic Greek Art* (Cambridge/New York, 1992), 84, 86, fig. 66.

R. R. Holloway, *The Archaeology of Ancient Sicily* (London, 1991), 80, fig. 105.

A. Stewart, *Greek Sculpture, an Exploration* (New Haven/London, 1990), 115, fig. 82.

R. Bianchi Bandinelli and E. Paribeni, *L'arte dell'antichità classica: Grecia* (Turin, 1986), 1: 10, no. 342.

G. Rizza and E. de Miro, "Le arti figurative dalle origini al V secolo a.C.," in G. Pugliese Carratelli et al., *Sikanie: Storia e civiltà della Sicilia greca* (Milan, 1985), 165, 187–88, fig. 179.

J. D. Belson, "The Gorgoneion in Greek Architecture" (Ph.D. diss., Bryn Mawr College, 1981).

E. Gabba and G. Vallet, eds., *La Sicilia antica* (Palermo, c. 1980), 2, part 1: pl. 57.

L. Giuliani, *Die archaischen Metopen von Selinunt* (Mainz am Rhein, 1979), pl. 3.

G. Voza, "Cultura artistica fino al V sec. a.C.," *Storia della Sicilia* (Naples, 1979), 118, fig. 57.

M. Y. Goldberg, "Types and Distribution of Archaic Greek Akroteria" (Ph.D. diss., Bryn Mawr College, 1977), 329–30.

B. S. Ridgway, *The Archaic Style in Greek Sculpture* (Princeton, 1977), 193, no. 8, 213, no. 38.

G. V. Gentili, "Incunaboli coroplastici di stile ionico dalla *Nésos* Siracusana e loro inquadramento nella scuola plastica arcaica di Syrakosai," *Bollettino d'Arte* 58 (1973), 7, fig. 20.

K. Wallenstein, *Korinthische Plastik des 7 und 6 Jahrhunderts vor Christus* (Bonn, 1971), 54, 125, pl. IV b 6.

L. Bernabò Brea and A. M. Fallico, eds., *Siracusa* (Florence, 1970), fig. 23.

E. Langlotz and M. Hirmer, *The Art of Magna Graecia: Greek Art in South Italy and Sicily* (London, 1965), 243, pl. 1.

E. Kunze, "Zum Giebel des Artemistemples in Korfu," *AM* 78 (1963), 79.

A. G. Woodhead, *The Greeks in the West* (London, 1962), 238, fig. 78.

G. Scichilone, "Tre rivestimenti fittili selinuntini e alcuni problemi della produzione siceliota arcaica," in *Annuario della Scuola Archeologica Italiana di Atene e delle missioni italiane in Oriente* 39/40 (1961–62), 190, n. 1.

A. Giuliano, "Gorgone," in R. Bianachi Bandinelli, ed., *Enciclopedia dell' Arte Antica, Classica, e Orientale* (Rome, 1960), 3: 984.

L. von Matt, *Das antike Sizilien* (Zurich, 1959), 25, pl. 16.

F. Villard, *Sicile Grecque* (Paris, 1955), 291, pl. 34.

S. Benton, "The Gorgon Plaque at Syracuse," *Papers of the British School at Rome* 22 (1954), 132–37, pl. 19.

H. Payne, *Necrocorinthia: A Study of Corinthian Art in the Archaic Period* (London, 1931, reprinted College Park, Md., 1971), 84, fig. 23e.

G. Libertini, *Il Regio Museo Archeologico di Siracusa* (Rome, 1929), 70, fig. 20.

E. D. van Buren, *Archaic Fictile Revetments in Sicily and Magna Graecia* (New York, 1923), 158–59, no. 10, fig. 76.

F. von Duhn, "Funde und Forschungen, Italien 1914–1920," *Jahrbuch des Deutschen Archäologischen Instituts* 36 (1921), 181–82, fig. 45.

A. Della Seta, *Italia antica dalla caverna preistorica al Palazzo Imperiale* (Bergamo, 1922), 113, fig 103.

P. Orsi, "Gli Scavi intorno a l'Athenaion di Siracusa, negli Anni 1912–1917," *Monumenti Antichi della Reale Accademia Nazionale dei Lincei* 25 (1918), 614–22, pl. XVI.

P. Orsi, "Sicilia, Siracusa," *Notizie degli Scavi di Antichità* (1915), 177, fig. 1.

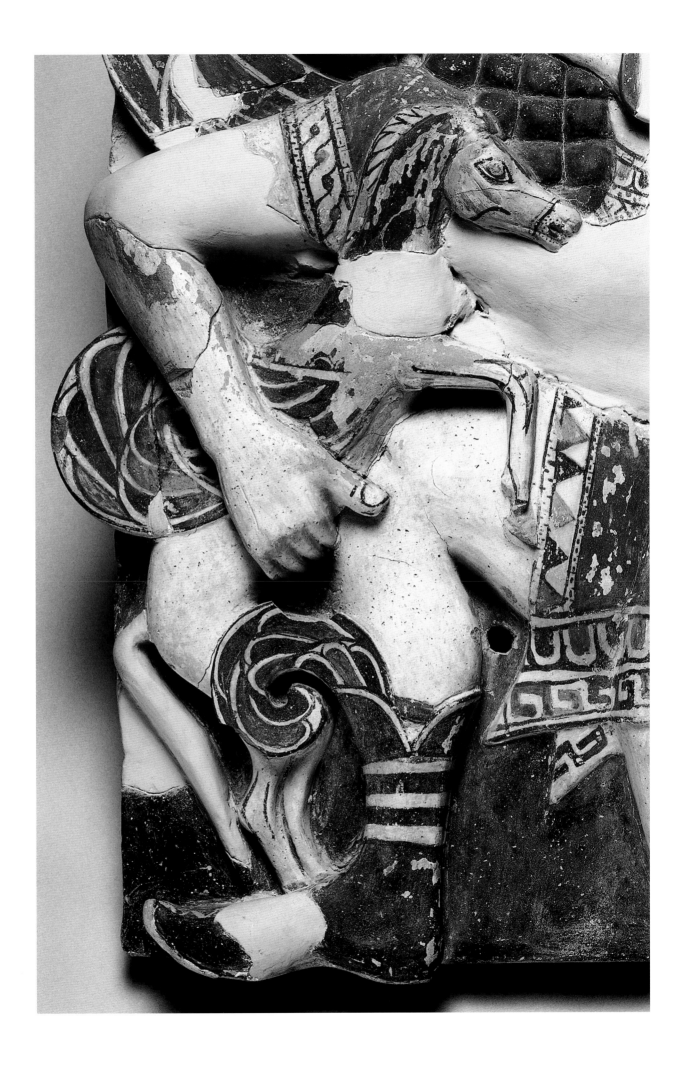

233

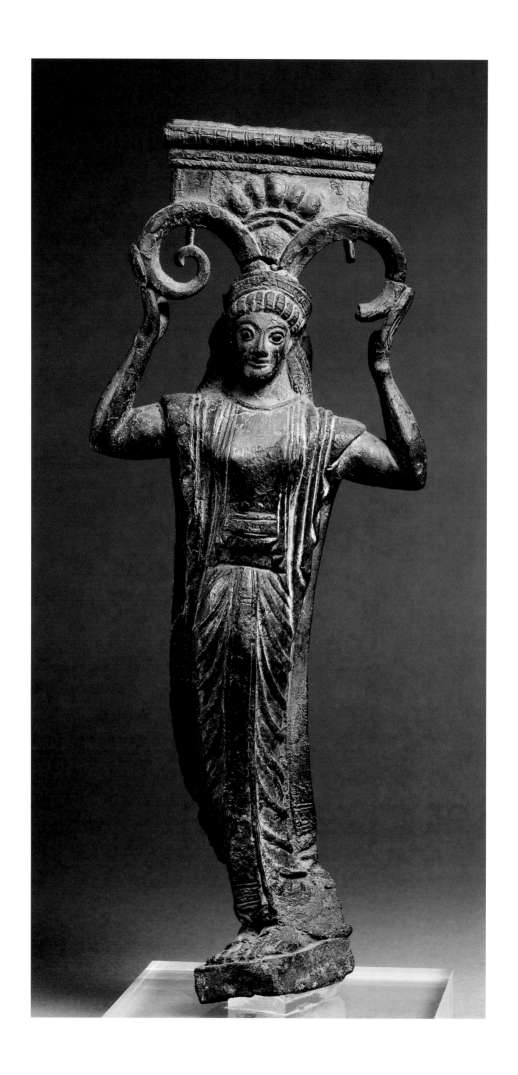

51. FEMALE STATUETTE

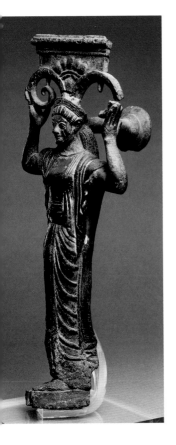

ca. 530 BC
Bronze, cast, incised
H. 32.5
Museo Archeologico Regionale "Paolo Orsi" di Siracusa, inv. 19847
Camarina, Archaic period necropolis at Rifriscolaro

Standing on a small rectangular base with a flat bottom, this kore wears a sleeveless chiton that is gathered and folded at the waist. A series of curved pleats begins at the waist and falls to the hem, adding a sense of movement. Between them is a central panel decorated by an incised meander-like motif. A himation drapes from her shoulders in vertical folds; its edges have a wave-like pattern until the waist area. The rest of the himation, which falls to the figure's calves, is rendered as a flattened band. This section was designed to be set flush against the object to which the figure was once attached.

Some of the features in her oval face show Laconian influence: the pronounced nose, large and round eyes, thick lips with the so-called Archaic smile, hair arranged as rays around the forehead in large locks with horizontal incisions, and heavy braids that fall onto the shoulders. The treatment of the figure is influenced by the tradition of large-scale Greek sculpture.

The diadem on her head, decorated with a meander motif, supports two opposing volutes that she holds aloft, one with each arm. Her long, thin hands touch the ends of the curling volutes. A palmette with five petals sprouts from the volutes and decorates a capital with a series of upper moldings varying in thickness. These moldings have diagonal incisions as well as dentil and astragal patterns.

The figure was intended to be seen from the front. The back is hollow. A cylindrical post (1.8 cm long) with a flared finial (diam. 4.4 cm) protrudes from the back of the head perpendicular to the body. This post probably connected the piece to a vessel or tripod.

The lower part of the figure has been violently twisted, possibly when it was detached from its original position. Part of the volute on the left is missing, and the volute on the right and the hand holding it have been restored. There is some corrosion at the base. The patina is green. CC

LITERATURE

G. Pugliese Carratelli, ed., *The Western Greeks*, exh. cat., Palazzo Grassi, Venice (Milan, 1996), 689, no. 126.

R. Bianchi Bandinelli and E. Paribeni, *L'arte dell'antichità classica: Grecia* (Turin, 1986), 1: no. 348.

G. Rizza and E. de Miro, "Le arti figurative dalle origini al V secolo a.C.," in G. Pugliese Carratelli et al., *Sikanie: Storia e civiltà della Sicilia greca* (Milan, 1985), 195, 209, fig. 219.

Mostra della Sicilia Greca, exh. cat., Tokyo Fuji Art Museum (1984), 187–88, no. 286.

E. de Miro, *I Bronzi Figurati della Sicilia Greca (Periodo arcaico e quinto secolo a.C.)* (Palermo, 1976), 25–28, no. 14, pls. b and 19.

E. de Miro, "Bronzi greci figurati della Sicilia," *Cronache di Archeologia e di Storia dell'Arte* 5 (1966), 16, pl. 7.

G. Libertini, *Il Regio Museo Archeologico di Siracusa* (Rome, 1929), 98, fig. 25.

P. Orsi, "Camarina," *Monumenti Antichi della Reale Accademia Nazionale dei Lincei* 14 (1905), 769–83.

P. Orsi, "Camarina," *Monumenti Antichi della Reale Accademia Nazionale dei Lincei* 9 (1899), 248–49, fig. 38.

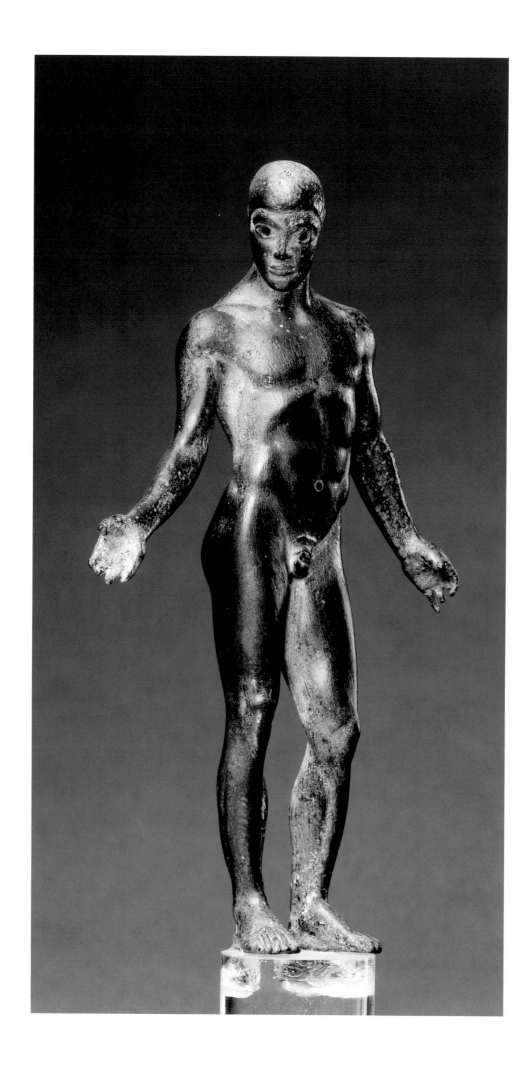

52. EPHEBE (YOUTH) OF MENDOLITO

ca. 460 BC
Bronze, cast, incised
H. 19.5
Museo Archeologico Regionale "Paolo Orsi" di Siracusa, inv. 31888
Mendolito, Adrano, acquired 1911

The expression on the face of this bronze statuette of a nude male youth is one of reflection. He stands, arms held away from his body, with his weight on his right hip, leaving his left leg free to make a small step forward. He looks down with his head turned to the right. Some scholars have suggested that he is an athlete offering a libation in a phiale once held in his outstretched right hand.

The figure's head is narrow, front to back, and his hair forms a compact cap surrounding a short forehead. The arches of his eyebrows join at the bridge of his nose. The empty elongated eye sockets must have been filled, probably with vitreous paste. The sculpted planes of the face are relatively soft, with a moderately pronounced lower jaw. The nose is straight with flared nostrils. The lips are fleshy, and the chin is small. The strength of the neck is more noticeable from the back. The collarbone is subtly modeled. The pectorals are wide, showing a gradual transition to the shoulder muscles. The epigastric arch is in relief, and the abdomen is flat and tight with internal partitions rendered according to Archaic conventions. A small circle indicates the navel, and a deep inguinal groove is shown in relief at each side.

The legs are well modeled with developed calves and protruding kneecaps. The feet are roughly executed with few details, the toes elongated. The two small pegs under the heels were inserted into a supporting base. The figure's arms are held away from the body to express movement in space. The muscles of the upper arms are carefully rendered, the forearms modeled more simply. Parts of the hands are missing: only the little finger on the right hand is intact; on the left only the index finger is complete. The details of the hands are not very realistic, and Paolo Orsi compared the fingers, particularly of the left hand, to "claws."

The execution of the back of the figure is well conceived and organic in its expert modeling of the muscles, which accurately reflect the rhythm of the figure as a whole. The statuette is well preserved and has a fine dark-green patina.

A majority of scholars have identified Pythagoras of Rhegium (active 480–430 BC) as the sculptor, despite the fact that some of the details seem out of character with his reputation for fine precision. Spigo's observation—that works attributed to Pythagoras display an interior awareness transcending the realism of the action described in the representation of the athlete—is to the point.
CC

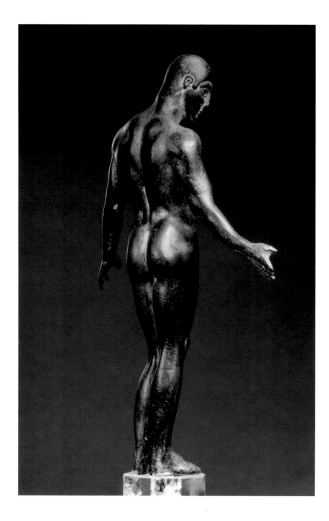

LITERATURE

E. Gabba and G. Vallet, eds., *La Sicilia antica* (Palermo, c. 1980; repr., Palermo, 1992), 2, part 1: pl. 52.

R. R. Holloway, *The Archaeology of Ancient Sicily* (London, 1991), 109, fig. 135.

A. Stewart, *Greek Sculpture, an Exploration* (New Haven/London, 1990), 115, fig. 82.

U. Spigo, "Statuetta di Giovane Atleta," in *Lo Stile Severo in Sicilia* (Palermo, 1990), 120, 244–46, no. 84.

G. Voza, *The Archaeological Museum of Syracuse "Paolo Orsi"* (Syracuse, 1987), 54.

R. Bianchi Bandinelli and E. Paribeni, *L'arte dell'antichità classica: Grecia* (Turin, 1986), 1: 10, no. 434.

G. Rizza and E. de Miro, "Le arti figurative dalle origini al V secolo a.C.," in G. Pugliese Carratelli et al., *Sikanie: Storia e civiltà della Sicilia greca* (Milan, 1985), 225–26, figs. 230–32.

W. Fuchs, *Storia della scultura greca* (Milan, 1982), 44, figs. 39–40.

W. Fuchs, *Die Skulptur der Griechen*, 2d ed. (Munich, 1979), 52–53, figs. 39–40.

G. Voza, "Cultura artistica fino al V secolo a.C.," in *Storia della Sicilia* (Naples, 1979), 2: 126, fig. 77.

E. de Miro, *I Bronzi Figurati della Sicilia Greca (Periodo arcaico e quinto secolo a.C.)* (Palermo, 1976), 50–51, no. 36, pls. g and 52–53.

E. de Miro, "Il 'Guerriero' di Agrigento e la Sculturà di Stile Severo in Sicilia," in *Cronache di archeologia e Storia dell'Arte* 7 (1968), 143–56.

L. von Matt, *Das antike Sizilien* (Zurich, 1967), 158, pl. 175.

C. L. Rolley, *Greek Minor Arts* (Leiden, 1967), 5: fasc. 1, *The Bronzes*, 8, no. 80, pl. 27.

S. Langona, "Pitagora di Reggio, Cronologia e identificazione delle opere," *Cronache di archeologia e Storia dell'Arte* 6 (1967), 7–77.

E. de Miro, "Bronzi greci figurati della Sicilia," *Cronache di Archeologia e di Storia dell'Arte* 5 (1966), 39, no. 36, pl. 14.36.

E. Langlotz and M. Hirmer, *The Art of Magna Graecia: Greek Art in South Italy and Sicily* (London, 1965), 45, 246, 274, pls. 10, 84–85.

K. Schefold, *Meisterwerke griechischer Kunst*, exh. cat., Kunsthalle Basel (1960), no. 234b.

L. Bernabò Brea, *Musei e Monumenti in Sicilia* (Novara, 1958), 48; English/French ed., *Museums and Monuments in Sicily* (Novara, 1960), 52.

L. Polacco, *L'atleta Cirene-Perinto* (Rome, 1955), 25–27, pls. 13, 16.3, 18.2, 19.3.

F. Villard, *Sicile Grecque* (Paris, 1955), 284, pls. 4–5.

P. E. Arias, "Representational Art," in A. V. Giardini, ed., *Vita Italiana* (Bergamo, 1953), 68–69.

L. Rocchetti, "Adrano," in R. Bianchi Bandinelli, ed., *Enciclopedia dell'Arte Antica, Classica, e Orientale* (Rome, 1958), 1: 71, fig. 108.

L. Curtius, "Zu einem Kopf in Museo Chiaramonti," *Jahrbuch des Deutschen Archäologischen Instituts* 59–60 (1944–45), 10.

B. Pace, "La Plastica Arcaica," in *Arte e Civiltà della Sicilia Antica* (Milan, 1938), 2: 59, fig. 62.

U. Jantzen, *Bronzewerkstätten in Grossgriechenland und Sizilien* (Berlin, 1937), 55–60.

B. A. Ashmole, *Late Archaic and Early Classical Greek Sculpture in Sicily and South Italy* (London, 1936), 25, fig. 70 (reprinted from *Proceedings of the British Academy* 20 [1934]).

E. Langlotz, *Frühgriechische Bildauerschulen* (Nürnberg, 1927), 147, pl. 89–90.

F. von Duhn, "Funde und Forschungen, Italien 1914–1920," *Jahrbuch des Deutschen Archäologischen Instituts* 36 (1921), 173–76, fig. 43.

P. Orsi, "Piccoli bronzi e marmi inediti del Museo di Siracusa," *Ausonia* 8 (1913), 44–52, figs. 1, 2, pl. 2.

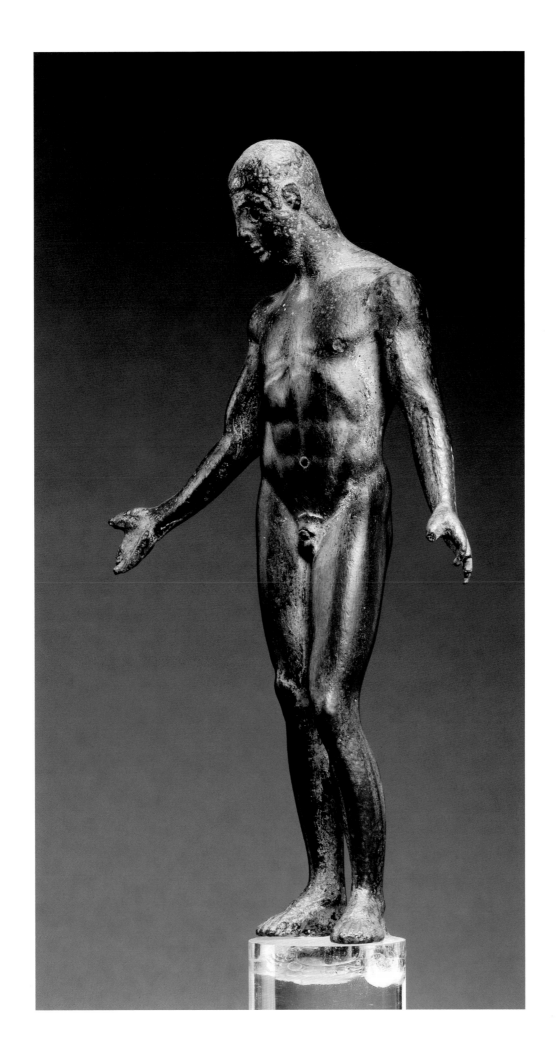

239

53. BULL AND LION ALTAR

ca. 550–500 BC
Terracotta, pale yellow-beige clay with inclusions and slip, mold-made, hand-finished
H. 21.5, L. 51.4, W. 8.8
Museo Archeologico Regionale "Paolo Orsi" di Siracusa, inv. 18670
Centuripe, from the acropolis area at Enna, acquired in 1898

The front surface of this rectangular altar depicts a *zoomachia* (animal fight): a lion attacking a bull. It was reassembled from two fragments and the fill material painted a light gray. The scene is framed by a cornice at the top and a base at the bottom. The bottom edge of the cornice is ornamented with a beaded band. The two animals are sculpted in high relief and shown in profile.

The lion descends on the bull from the left, tail uplifted and flexed forward, pressing against the cornice. Its body is slender and agile, and the musculature of its hindquarters expresses the dynamism of a sudden attack. The back right leg trails behind, paw and claws touching the base. The left leg is in front of the right, closer to the back wall, foreleg on the base. The back legs and paws rest solidly on the ground. Grasping the bull with its extended right front paw, the lion bites into the bull's shoulder and seems on the verge of pinning the animal on its back.

The bull struggles to free itself. Lifting its head and neck, it crouches on both front legs, weight on the right leg, which is firmly placed on the base of the slab. Crushed by the weight of the plunging lion, the bull's left front leg is folded underneath its body and outside the plane of the altar's base. The lion holds the front part of the bull tightly, while its hindquarters remain upright, set against the upper cornice. The surface of the bull's tail is scored by oblique, regularly spaced incisions. It turns back toward its body, rests on the hip, and ends in a split tuft of hair.

The anatomical details are well expressed. Especially powerful are the effects of light and shadow of the animals' pelts. The lion's mane consists of a series of long flame-shaped protrusions along the forehead and teardrop-shaped protrusions along the back and behind the ears. The hair on the abdomen resembles small tongues. The neck and abdomen of the bull are executed with undulating waves.

The back of the slab is unfinished. The upper ends of the sides have parts of a molded attachment. An irregular crack is visible at the top. The base of the altar is well defined.

The origin of the subject is Ionian, as demonstrated by the execution of the anatomical details. This type of zoomachia is a very old motif in the Near East and was assimilated into Greek art in the seventh century BC. It then spread throughout the Western Greek colonies. However, the scene of a lion pouncing on the back of a bull, as shown on this altar, is uncommon. ES

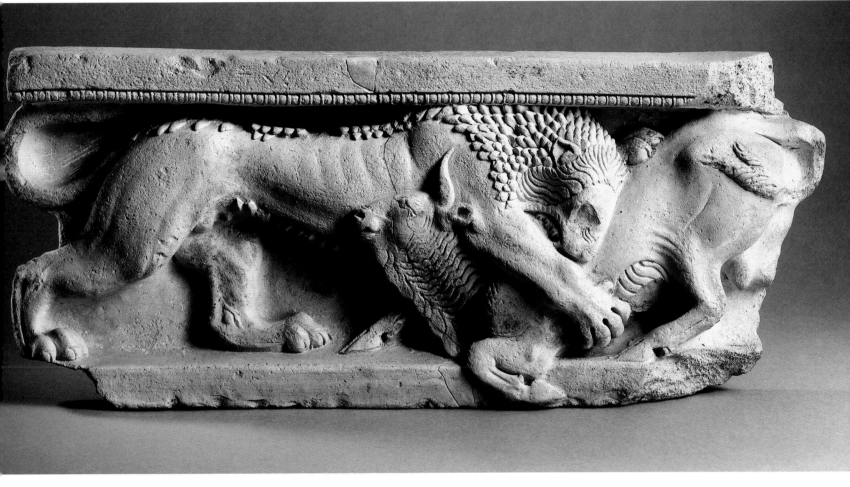

LITERATURE

H. Hellenkemper, *Die neue Welt der Griechen,* exh. cat., Römisch-Germanisches Museum (Cologne/Mainz, 1998), 128, no. 59.

G. Pugliese Carratelli, ed., *The Western Greeks,* exh. cat., Palazzo Grassi, Venice (Milan, 1996), 684, no. 97.

H. Van der Meijden, *Terrakotta-arulae aus Sizilien und Unteritalien* (Amsterdam, 1993), 42–44, 54–61, 257, 373, no. TK 44.

G. Voza, *The Archaeological Museum of Syracuse Paolo Orsi* (Syracuse, 1987), 53.

G. Rizza and E. de Miro, "Le arti figurative dalle origini al V secolo a.C.," in G. Pugliese Carratelli et al., *Sikanie: Storia e civiltà della Sicilia greca* (Milan, 1985), 207, fig. 213.

Mostra della Sicilia Greca, exh. cat., Tokyo Fuji Art Museum (1984), 178, no. 245.

P. Müller, "Löwen und Mischwesen in der archaischen griechischen Kunst" (Ph.D. diss., Universität Zürich, 1978), 270, no. 261bis.

G. V. Gentili, "Incunaboli coroplastici di stile ionico dalla *Nésos* Siracusana e loro inquadramento nella scuola plastica arcaica di Syrakosai," *Bollettino d'Arte* 58 (1973), 6, fig. 12.

J. Charbonneaux, R. Martin, and F. Villard, *Archaic Greek Art, 620–480 BC,* trans. J. Emmons and R. Allen (London, 1971), 257, fig. 297.

L. von Matt, *Das antike Sizilien* (Zurich, 1967), 158, pl. 170.

E. Langlotz and M. Hirmer, *The Art of Magna Graecia: Greek Art in South Italy and Sicily* (London, 1965), 261, pl. 32.

A. G. Woodhead, *The Greeks in the West* (London, 1962), 237, fig. 72.

G. V. Gentile, "Centuripe," in R. Bianchi Bandinelli, ed., *Enciclopedia dell'Arte Antica, Classica, e Orientale* (Rome, 1959), 2: 478, fig. 663.

L. Bernabò Brea, *Musei e Monumenti in Sicilia* (Novara, 1958), 37; English/French ed., *Museums and Monuments in Sicily* (Novara, 1960), 52.

F. Villard, *Sicile Grecque* (Paris, 1955), 288, pl. 24.

G. Libertini, *Il Museo Regio Archeologico di Siracusa* (Rome, 1929), 108, fig. 27.

G. Libertini, *Centuripe* (Catania, 1926), 129, pl. 60.

E. D. van Buren, "Terracotta Arulae," *Memoirs of the American Academy in Rome* (1918), 2: 18–19, pl. 16.

P. Ducati, "Studi e ricerche archeologiche nella Sicilia orientale (Quinquennio 1908–1912)," *Archivo Storico per la Sicilia orientale* 10 (1913), 292, no. 7.

E. Mauceri, *Siracusa e la Valle dell' Anapo* (Bergamo, 1909), 104.

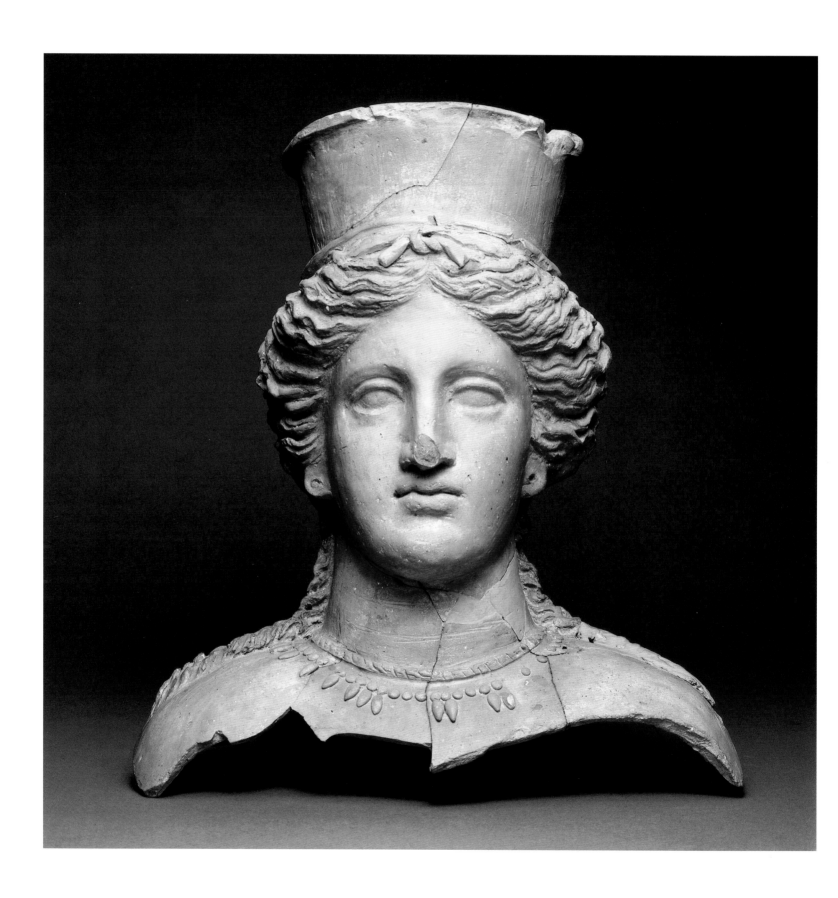

54. FEMALE DIVINITY

ca. 400–350 BC
Terracotta, red interior with calcareous inclusions,
light orange surface, mold-made, hand-finished
H. 37, W. 32
Museo Archeologico Regionale "Paolo Orsi" di
Siracusa, inv. 16085
Agrigento, rock sanctuary below the small church
of San Biagio, acquired in 1896

A tall polos is a major feature of this bust of a
woman. Set on a band tied around her head, the
polos is wider at the top and has a thick, curved
rim. Her hair is arranged in wavy, finely modeled
curls. Parted in the middle, the hair frames her
face and is held by a knotted cord. Two deeply
incised ringlets, modeled with a stick, fall on her
shoulders. The oval face has regular features. She
has almond-shaped eyes with tear ducts and
arched eyebrows that meet at a prominent nose.
Her fleshy lips are slightly parted, with a small
hole at the right corner, and she has a rounded
chin. The ends of her earlobes are pierced, prob-
ably for a pair of metal earrings. At the base of her
stocky neck is a relief border decorated with di-
agonal incisions, perhaps the edge of her garment.
She wears a necklace, which is incomplete, with
small drop-shaped beads. The statuette has been
broken off irregularly below the neck, and there
are cracks in the neck, bodice, and polos. The
bust is hollow, with a vent hole at the back of the
head. The edges of the cracks and other parts of
the surface are chipped. No traces of paint remain.

 This bust reflects Attic sculptural influences,
interpreted by an ancient Sicilian artist. The
production of classical busts, of which this one
is a fine example, is well known. Offered as
anathemata (special gifts to the gods), they were
found not only in Agrigento, but also in such
cities as Syracuse, Grammichele, Centuripe, and
Selinus. They also inspired the production of other
objects of aesthetic merit such as painted terracot-
tas, ceramics, and coins dated through the reigns
of Dionysius and Agathocles. ES

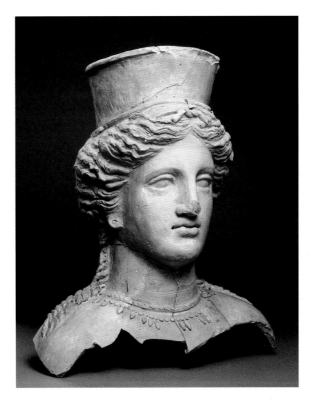

LITERATURE

G. Rizza and E. de Miro, "Le
arti figurative dalle origini al V
secolo a.C.," in G. Pugliese
Carratelli et al., *Sikanie: Storia
e civiltà della Sicilia greca*
(Milan, 1985), 239–40, fig.
276.

M. F. Kilmer, *The Shoulder
Bust in Sicily and South and
Central Italy* (Göteborg, 1977),
103–4, fig. 62.

B. Pace, *Arte e civiltà della
Sicilia antica* (Milan, 1938), 2:
88, fig. 86.

G. Libertini, *Il Regio Museo
Archeologico di Siracusa*
(Rome, 1929),114, fig. 33.

P. Marconi, *Agrigento
Topografia ed Arte* (Florence,
1929), 182, fig. 114.

P. Marconi, "Plastica
Agrigentina—II," *Dedalo* 9
(1929), 653, 656.

A. Della Seta, *Italia antica
dalla caverna preistorica al
Palazzo Imperiale* (Bergamo,
1922), 135, fig. 133.

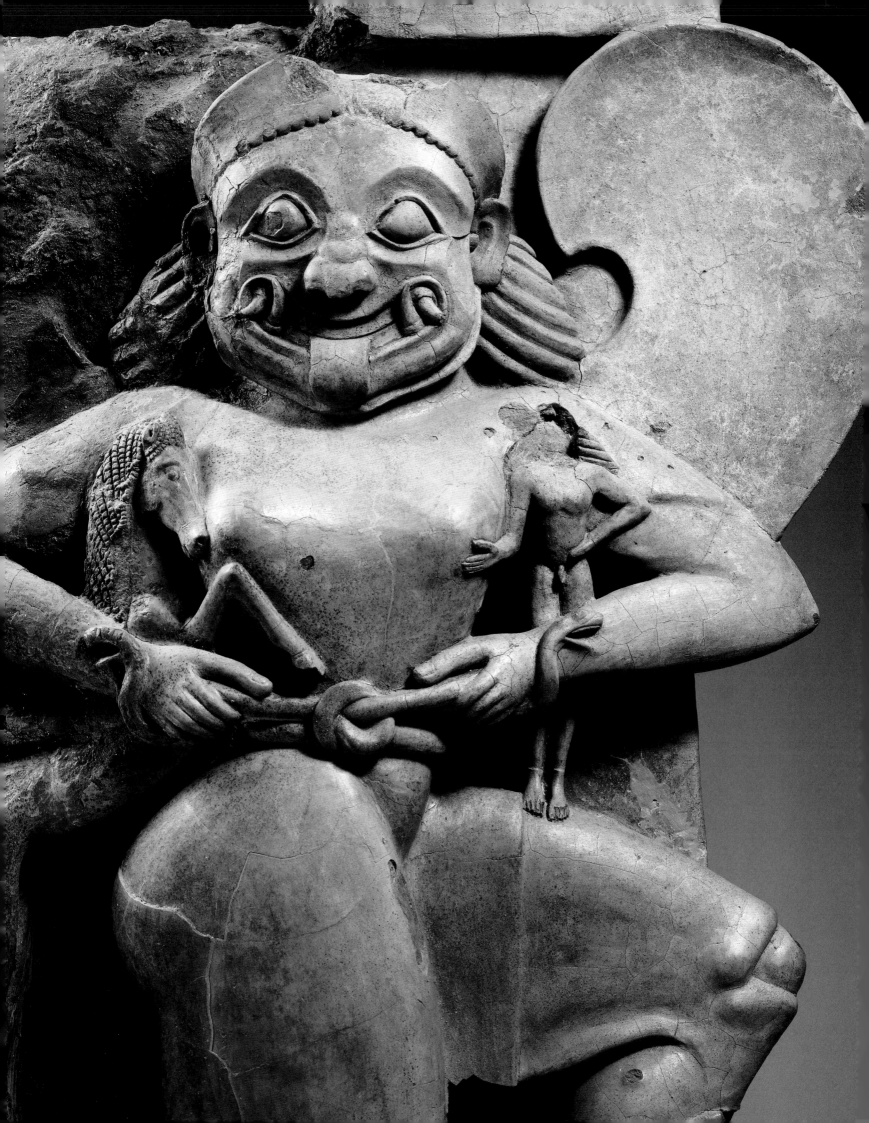

GELA

55. LAMP WITH RAM AND HUMAN HEADS

ca. 630–620 BC
Terracotta, pink clay, white slip, hand-sculpted,
finished with a stick, painted
H. 9.4, W. 24.7
Museo Archeologico Regionale di Gela, inv. 7711
Gela, Predio Sola, sanctuary outside of town,
1959 excavation

The triangular shape of this lamp imitates that of
marble oil-lamps from the Cyclades. Like those
lamps, it was made for sacred ceremonies and
probably suspended with a small openwork
hanger. Supports for this device are preserved on
the sides of the protomes. The lamp consists of six
oil reservoirs on two separate levels. The three
upper reservoirs are connected to the ram-like
protomes, which are used as terminals. The three
lower reservoirs have human protomes located in
the middle of the concave sides decorated with a
rhomboid-shaped lattice painted in red. The hu-
man heads, each wearing a polos, have different
facial features. By contrast, the ram heads are very
similar. MCL

LITERATURE

H. Hellenkemper, *Die neue
Welt der Griechen,* exh. cat.,
Römisch-Germanisches Mu-
seum (Cologne/Mainz, 1998),
98, no. 20.

R. Panvini, ed., *Gela: Il Museo
Archeologico, Catalogo* (Gela,
1998), 181, no. V.21.

G. Pugliese Carratelli, ed., *The
Western Greeks,* exh. cat.,
Palazzo Grassi, Venice (Milan,
1996), 401, 669, no. 42 I.

R. Martin et al., "Le città
greche," in E. Gabba and G.
Vallet, eds., *La Sicilia antica*
(Palermo, c. 1980), 1, part 3:
568, pl. 103.

R. R. Holloway, *The Archaeol-
ogy of Ancient Sicily* (London,
1991), 57, fig. 68.

G. Pugliese Carratelli et al.,
*Sikanie: Storia e civiltà della
Sicilia greca* (Milan, 1985),
145, 167, fig. 144.

E. de Miro, *I Bronzi Figurati
della Sicilia Greca (Periodo
arcaico e quinto secolo a.C.)*
(Palermo, 1976), 69, fig. 4.

E. Meola, "Terrecotte
orientalizzanti di Gela
('Daedalica' Siciliae 3),"
*Monumenti Antichi della
Reale Accademia Nazionale
dei Lincei* 48 (1971), 60–61,
pls. 9–10.

P. Griffo and L. von Matt,
*Gela: The Ancient Greeks in
Sicily* (Greenwich, Conn.,
1968), pl. 35.

P. Orlandini, "Gela: La stipe
votiva del Predio Sola,"
*Monumenti Antichi della
Reale Accademia Nazionale
dei Lincei* 46 (1963), 33–41,
no. 1, figs. 14–16, pls. 8.a–c,
9.a–b.

56. ALTAR WITH GORGON, PEGASUS, AND CHRYSAOR

ca. 500–475 BC
Terracotta, painted
H. 116, W. 35, L. 77 (at base), L. 74 (at top)
Museo Archeologico Regionale di Gela,
inv. Sop. BL 10
Gela, acropolis at Bosco Littorio

This large altar was found in Bosco Littorio in the vicinity of Gela's Archaic emporium, located near the sea, at the foot of the acropolis. It was discovered at a depth of six meters on the perimeter of the old commercial settlement, a mud-brick structure preserved up to the level of the roof beams. This settlement complex is exceptionally important because the walls of the rooms are perfectly preserved. The rectangular rooms, one next to the other, are accessible from the north through a door opening onto a small portico facing an open area. Other groups of rooms open onto this area as well. The rooms functioned as shops, were built according to a single model, and have almost identical measurements (3.3 x 2.5–3.9 meters). A lean-to roof resting on wooden beams had covered the rooms, and individual casings worked into the upper part of the walls held the beams. The perimeter walls are preserved up to 2.7 meters. They are made of sun-baked bricks, set in regular rows, with vertical joints over the middle of the block below, and are coated on the inside by a thin layer of plaster.

Tests conducted by the Department of Geological Sciences at the University of Catania have shown that the altar was the product of a Gela workshop. It was found, together with two other altars with sculptural representations in relief [57, 58], outside one of the shops, among Attic black-figure ceramics attributed to the Lindos Group (490 BC) and the manner of the Haimon Painter (490–475 BC).

This altar is trapezoidal, with jutting ledges at the base and top. Two holes pierce each lateral wall in the same location; these holes were used both to facilitate the firing process and to allow for transport by means of wooden beams.

The front of the altar depicts the Gorgon Medusa, her face transformed into a horrifying mask. She looks straight ahead and runs to her left, holding in her arms Pegasus and Chrysaor, the two creatures born from her union with Poseidon. She wears a diadem studded with small beads, a chitoniskos held at the waist by two knotted snakes, and winged boots.

Originally enhanced by a reddish pigment, which is now visible only as faint traces on the surface, the scene illustrates a myth already represented in the first half of the sixth century BC. Similar scenes appear on the pediment of the Artemision on Corfu, the polychrome slab found in the area of the Athenaion in Syracuse, and a fragmented arula in Naxos. Based on the context in which it was found, however, the Gela altar may now be dated to the beginning of the fifth century BC, although it uses iconographic schemes and motifs of the late Archaic period that derive originally from Corinth. We can assume that such schemes and representations had long been reproduced in artisan shops and were adopted and reused in Gela at the behest of the Deinomenids, the dynastic tyrants of Syracuse. After taking power in his native Gela, in 485 BC Gelon made himself ruler of Syracuse, a city founded by the Corinthians, and established a residence there. In order to advertise the success of Gelon's political agenda, a Geloan artist was likely commissioned to create a large terracotta with narrative iconography, clearly alluding to the emblem of a Corinthian aristocratic family.

On these altars [56, 57, 58] in general, see *Les autels archaïques de Géla: Une découverte exceptionnelle en Sicile*, exh. cat., Musée du Louvre, Paris (Palermo, 2001). RP

LITERATURE

R. Panvini, *Gela Arcaica: Are, divinità, tiranni* (Caltanissetta, 2000), 19–21.

ca. 500–475 BC
Terracotta, painted
H. 114, W. 35, L. 75 (at base), L. 68 (at top)
Museo Archeologico Regionale di Gela,
inv. Sop. BL 30
Gela, acropolis at Bosco Littorio

This altar was found outside one of the rooms of the emporium of the Archaic Greek colony of Gela, next to the Gorgon altar [56] and at the same depth. Below the thick jutting ledge at the top is a figural scene depicting a lioness mauling a bull, a theme that had been circulating for a long time in the workshops producing coroplastics (terracotta sculpture). Two equally spaced holes on each lateral wall serve the same functions as those on the Gorgon altar. Traces of a long stem with a

lotus flower painted in brown are still visible on these sides, while five small holes on the back secured the altar to a flat structure.

The scene on the front is composed of three women standing in a hieratic position. Each wears a polos on her head and a peplos tied at the waist with a belt. The central figure also wears a mantle that drapes from her folded arms; her hands touch the long braids that fall onto her chest. The flanking figures have their long hair flowing behind their shoulders; their arms extend along their sides. The one on the left holds a phiale in her left hand, the other a small crown in her right hand. Traces of a reddish color are visible on their clothes.

The three women likely represent the Meteres, the goddesses Demeter, Kore, and Aphrodite, initially considered the goddesses of nature. Their cult, which originated in Crete, was widespread in Magna Graecia and Sicily. While only conjecture, it is very possible that at exactly the time the Deinomenid family held political power in Gela, the iconography of the Meteres was revived in order to promote the image of Gelon as a devout man. Members of the Deinomenid family were the hereditary administrators of the cult of Demeter and Kore at that time. The iconography of the Meteres was then represented with Archaic characteristics and strictly tied to the cult of these two goddesses, protectors of the earth. RP

LITERATURE

R. Panvini, *Gela Arcaica: Are, divinità, tiranni* (Caltanissetta, 2000), 21–22.

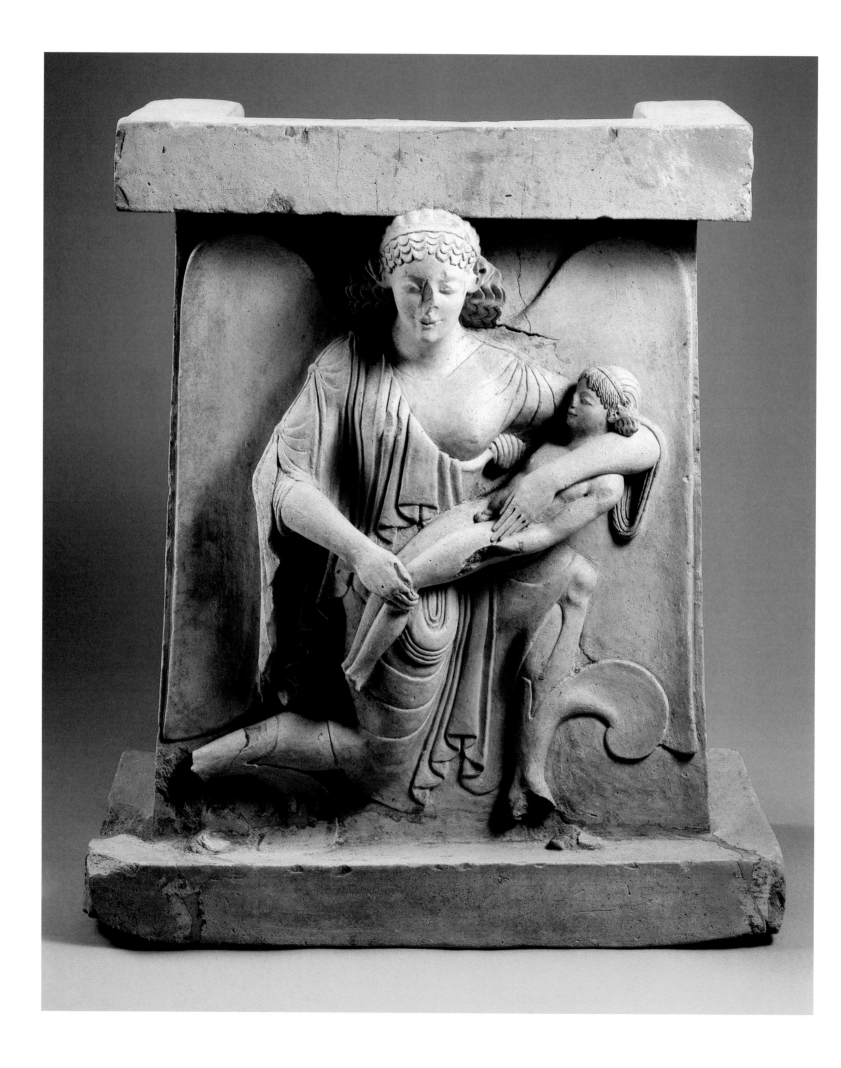

58. ALTAR WITH EOS AND KEPHALOS

ca. 500–475 BC
Terracotta
H. 53; base: 43 x 19.5
Museo Archeologico Regionale di Gela,
inv. Sop. BL 12
Gela, acropolis at Bosco Littorio

This small altar was found next to the two altars described previously and has similar holes in each lateral wall; it also has the same rectangular space on the upper surface as the altar with three figures [57].

The scene depicted is the abduction of Kephalos by Eos (goddess of the dawn), who is shown with her head and torso facing front and her legs in profile, fleeing after she abducted the young hunter. A tainia encircles her long hair, and she wears a chiton, a himation draping diagonally from the right shoulder, and winged boots. The scene represents an episode in the myth commonly illustrated on vases and found on another altar in Gela, in the chthonic sanctuary to the north of the acropolis. The perfect state of preservation of the three altars suggests that they were never used and that they had been commissioned for public display. The small altar, however, might have been intended for a private home.

Current research suggests that the three altars were suddenly abandoned, perhaps because of a traumatic event—an earthquake or landslide—that buried them under a thick layer of sand, three meters deep, preventing their immediate recovery.
RP

LITERATURE

R. Panvini, *Gela Arcaica: Are, divinità, tiranni* (Caltanissetta, 2000), 22–23.

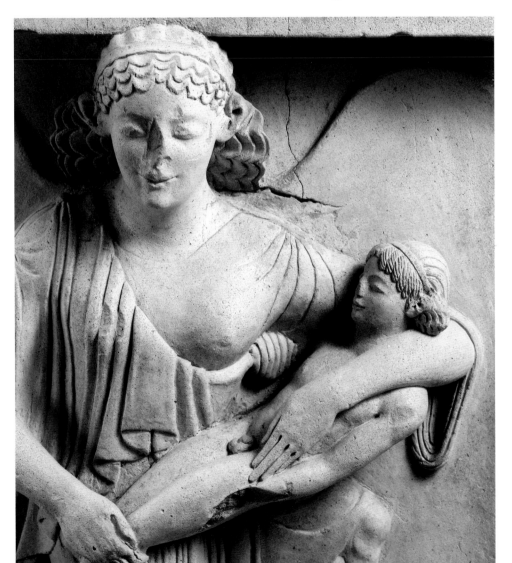

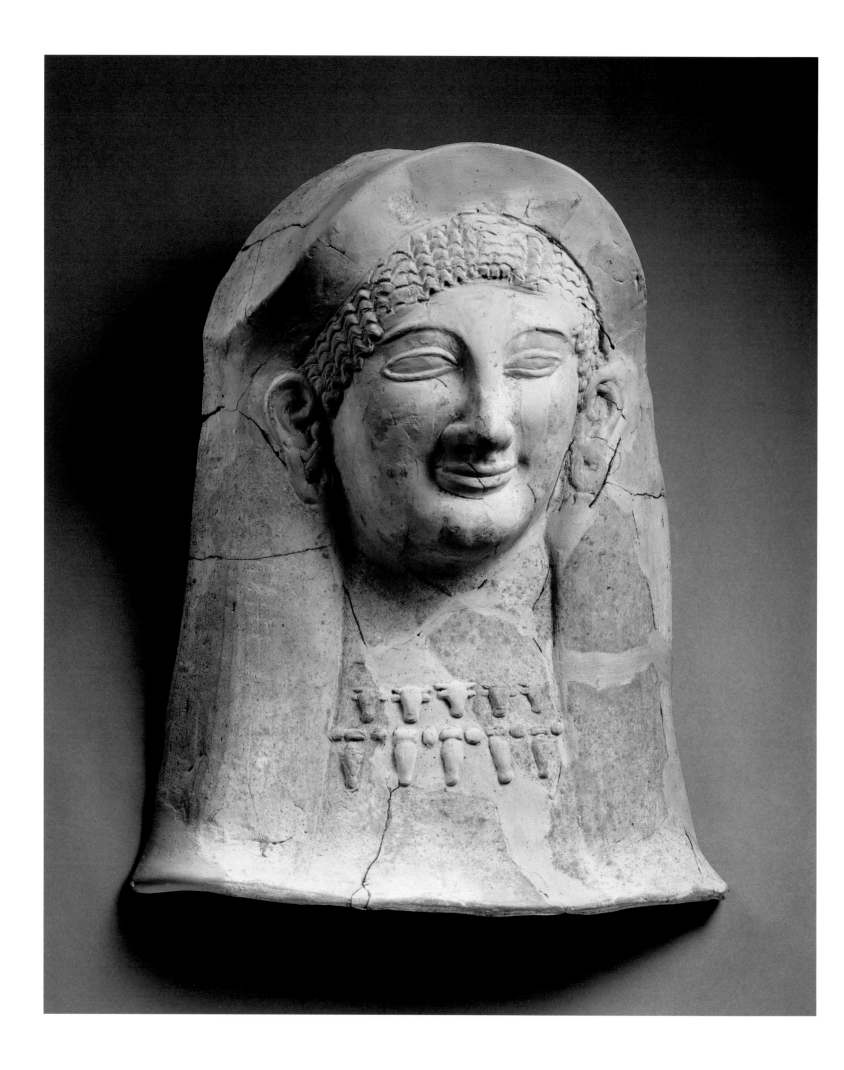

59. FEMALE VOTIVE MASK

ca. 510–500 BC
Terracotta, refined pinkish-beige clay, thin yellowish slip, mold-made, finished with a stick
H. 51.5, W. 42.5
Museo Archeologico Regionale di Gela, inv. 7369
Gela, Predio Sola, sanctuary outside of town,
1959 excavation

This unusually large mask belongs to a distinctive type. The features are those of a plump woman, goddess or mortal, whose high social rank is indicated by her sculpturally rendered necklace of two strands of pendants with *bucranea* (bull heads) and alabastra alternating with round beads. Her head is covered by a veil that, surmounted by a stephane, falls to the sides of her face in two long symmetrical columns. The wide, round face is framed by a band of hair parted in sections differentiated by distinct wavy patterns. These sections suggest an elaborate hairstyle. Finishing touches by hand are noticeable on the left side of the low, lunate-shaped forehead. The narrow eyes are flat and the eyebrows are low and horizontal, with a swollen surface between eye and brow. The large ears protrude and the lobes are adorned with earrings consisting of a large ring from which an alabastron was likely suspended, matching the necklace. The nose is large and prominent with flaring nostrils. The mouth has thin lips that connect softly at the corners with the full, almost puffy, cheeks. The chin is round and prominent, and the neck is long and wide at the base. MCL

LITERATURE

R. Panvini, ed., *Gela: Il Museo Archeologico, Catalogo* (Gela, 1998), 182, no. V.23.

G. Pugliese Carratelli, ed., *The Western Greeks*, exh. cat., Palazzo Grassi, Venice (Milan, 1996), 681, no. 93.

R. R. Holloway, *The Archaeology of Ancient Sicily* (London, 1991), 59, fig. 72.

J. P. Uhlenbrock, *The Terracotta Protomai from Gela: A Discussion of Local Style in Archaic Sicily* (Rome, 1988), 93–94, no. 37, pl. 47.

P. Griffo and L. von Matt, *Gela: The Ancient Greeks in Sicily* (Greenwich, Conn., 1968), pl. 81.

P. Orlandini, "Gela: La stipe votiva del Predio Sola," *Monumenti Antichi della Reale Accademia dei Lincei* 46 (1963), 19–21, no. 31, figs. 11–13.

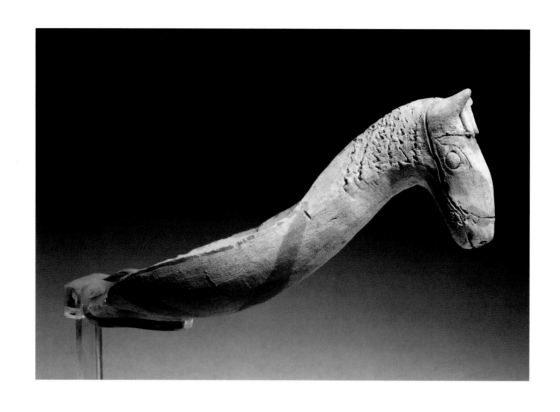

60. HORSE-SHAPED SPOON

ca. 580–570 BC
Terracotta, refined pinkish-beige clay, cream-colored slip, hand-modeled, finished with a stick, painted
L. 10, W. 4
Museo Archeologico Regionale di Gela,
inv. 20339
Gela, Thesmophorion at Bitalemi,
1964 excavation

Wide and deep, this spoon has a handle shaped like the head of a horse. Its delicate features are comparable to those of a horse's head on a sculpted vase from Syracuse (see R. Bianchi Bandinelli and E. Paribeni, *L'arte nell'antichità classica: Grecia* [Turin, 1992], 1: no. 138). The long neck has a mane rendered with wavy incisions that falls onto the forehead between vertically set ears. Incisions and red paint indicate the bridle. The same kind of thin incised lines are used for the eyes, which are oblique in shape with round eyeballs, and for the nostrils. The mouth is rendered with a deep horizontal cut. A cross motif is painted in red on the exterior of the spoon.
MCL

LITERATURE

R. Panvini, ed., *Gela: Il Museo Archeologico, Catalogo* (Gela, 1998), 171, no. V.6.

P. Orlandini, "Lo scavo del Thesmophorion di Bitalemi e il culto delle divinità ctonie a Gela," *Kokalos* 21 (1966), 27, pl. 24.3.

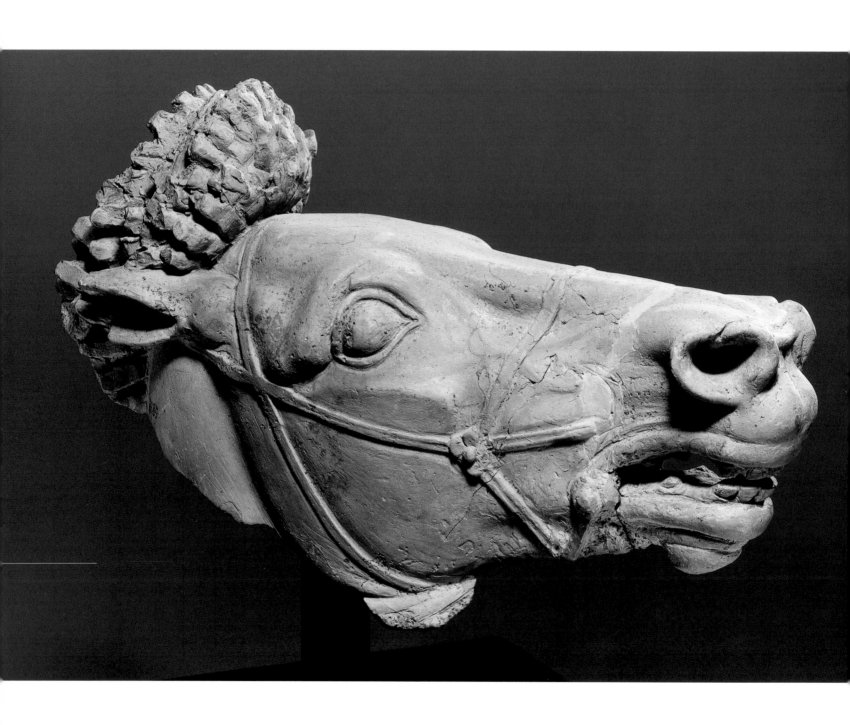

61. HEAD OF A HORSE

ca. 470–460 BC
Terracotta, beige clay with abundant lithic inclusions, slip of the same color as the clay, mold-made, finished with a stick
H. 26.5, W. 44.3
Museo Archeologico Regionale di Gela, inv. 8585
Gela, acropolis, found in a cistern under the museum, 1954 excavation

The only preserved part of an acroterial equestrian group, this horse's head has a thick, upright mane with locks separated by deep grooves. The small ears are set horizontally, expressing movement, as does the tense modeling of the muzzle, with dilated nostrils and lips parted to show the teeth. A well-rendered bridle encircles the muzzle. The eyes are wide and round with well-defined lids.

The discovery of the head of a second horse, identical to this one, and some remains of a sphinx, suggested to Orlandini that the horse heads are part of a heraldic pair of horse-riding Dioscuri, similar in their compositional scheme to those from the later temple of Contrada Marafioti in Locri. MCL

LITERATURE

B. Neutsch, "Cavalli divini," in P. Orlandini and M. Castoldi, eds., Κοινα: Miscellanea di studi in onore di Pietro Orlandini (Milan, 1999), 233, fig. 5.

R. Panvini, ed., Gela: Il Museo Archeologico, Catalogo (Gela, 1998), 67, no. I.80.

G. Pugliese Carratelli, ed., The Western Greeks, exh. cat., Palazzo Grassi, Venice (Milan, 1996), 681, no. 94.

R. R. Holloway, The Archaeology of Ancient Sicily (London, 1991), 79, fig. 103.

Lo Stile Severo in Sicilia (Palermo, 1990), 103.

G. Pugliese Carratelli et al., Sikanie: Storia e civiltà della Sicilia greca (Milan, 1985), 213, fig. 251.

P. Griffo and L. von Matt, Gela: The Ancient Greeks in Sicily (Greenwich, Conn., 1968), 108, pl. 71.

L. von Matt, Das antike Sizilien (Zurich, 1967), 76, pl. 86.

E. Langlotz and M. Hirmer, The Art of Magna Graecia: Greek Art in South Italy and Sicily (London, 1965), 286, pls. 120–21.

P. Orlandini, "Cisterna greca presso il Museo," Notizie degli Scavi di Antichità 14 (1960), 76, fig. 5.

P. Orlandini, "Nuovi acroteri fittili a forma di cavallo e cavaliere dall'Acropoli di Gela," in Scritti in onore di Guido Libertini (Florence, 1958), 123, pl. 3.

J. Bayet and C. F. Villard, Sicile grecque (Paris, 1955), 297, pl. 74.

B. Neutsch, "Archäologische Grabungen und Funde in Sizilien von 1949–1954," Archäologischer Anzeiger 1 (1954), 656–58, fig. 107.

P. Griffo, "Bilancio di cinque anni di scavi nelle province di Agrigento e Caltanisetta," Atti dell'Accademia di scienze, lettere, e arti di Agrigento 3 (1953–54), 18, pl. 9.c.

62. ANTEFIX WITH GORGON HEAD

ca. 450–400 BC
Terracotta, bright pink clay, cream-colored slip,
mold-made, hand-finished, painted
L. 88; plaque: H. 38.5, W. 38
Museo Archeologico Regionale di Gela,
inv. 35688
Gela, acropolis, building VI, 1973 excavation

This antefix is from the apex of the pitched roof
of a sacred building on the acropolis at Gela.
The temple was decorated on the sides by other
antefixes with Gorgon masks as well. The Gorgon-
head plaque closes one of the two ends of the
topmost rounded tile, which is almost circular in
section. The decoration on the top is a black
meander; the sides are decorated with a band of
small tongues painted in alternating red and black,
with bands of black wolf's teeth below.

The face and small portion of the Gorgon's neck
are circular and asymmetrical. Except for the nose,
the surface is concave at the center. The hair—at
the top a row of small ovals painted in black—
creates an upper border and frames the face below
the ears. This sculptural composition plays on
the opposition of flat and rounded surfaces. The
swollen cheeks are in relief, projecting out from
the thin wavy lines of the hair. In contrast, the
mouth—thin lips and a short red tongue hanging
down between regular rows of gnashing teeth—is
a recessed plane. The chin is thin and elongated.
A slight furrow divides the triangular-shaped fore-
head in the center, ending in the wide arches of
the eyebrows. The crossed eyes are large and
closely spaced, with pupils painted in red and
prominent eyelids. The nose is bulky but of regular
proportions, and the well-shaped ears are not
oversized.

While physiognomic traits are exaggerated,
there is nothing monstrous or horrible in this rep-
resentation of the Gorgon. Typical iconographic
elements such as fangs or snakes are absent. In
fact, some feminine traits are emphasized to con-
vey a more pleasing and somehow ironic image of
the demon. MCL

LITERATURE

R. Panvini, ed., *Gela: Il Museo
Archeologico, Catalogo* (Gela,
1998), 44, no. I.52.

G. Fiorentini, "Sacelli sull'
acropoli di Gela e a Monte
Adranone nella valle del
Belice," *Cronache di
archeologia e di storia
dell'arte* 16 (1977), 107–8,
pls. 25.3–4.

63. SILENUS ANTEFIX

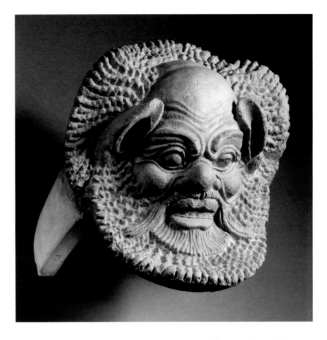

470–460 BC
Terracotta, well-refined red clay with inclusions of mica and anthracite, thick and homogeneous light brown slip, mold-made, hand-finished, painted
H. 23, L. 11.5
Museo Archeologico Regionale di Gela, inv. 8294
Gela, Via Apollo, acropolis at Molino di Pietro, 1951 excavation

The series of antefixes in the form of silenoi (aged satyrs) produced in the workshops of Gela during the first half of the fifth century is among the most famous of Western Greece. This example is without doubt one of the finest and best preserved. The hair, similar to a lion's mane, together with the features of the face effectively express the demonic delight and animal-like spontaneity of the silenoi, who were elemental and extroverted creatures.

The face is small, with exaggerated features, amplified by the play of light and shadow induced by the strong plasticity of the relief and by the incised patterns. The top of the head is convex and bald. Its shape enhances the radiating mass of hair in tight waves that pass, without interruption, to the rounded beard, upturned at its lower end. The forehead is short and furrowed, and divided by three triangular creases that converge at the base of the nose. The prominent horse-like ears are set asymmetrically on each side of the face. The small and oblique eyes are embedded between the protruding brows and the fleshy cheeks. The nose is the most striking feature of the face: large, snub, with flaring nostrils and a large and swollen tip. It droops onto the thick lips of the mouth, which are open to show the teeth and framed by the long mustache, which is superimposed onto, and distinct from, the beard. MCL

LITERATURE

H. Hellenkemper, *Die neue Welt der Griechen,* exh. cat., Römisch-Germanisches Museum (Cologne/Mainz, 1998), 156, no. 85.

R. Panvini, ed., *Gela: Il Museo Archeologico, Catalogo* (Gela, 1998), 50, no. I.59.

G. Pugliese Carratelli, ed., *The Western Greeks,* exh. cat., Palazzo Grassi, Venice (Milan, 1996), 416, 704, no. 184.

R. R. Holloway, *The Archaeology of Ancient Sicily* (London, 1991), 79, fig. 104.

Lo Stile Severo in Sicilia (Palermo, 1990), 256, no. 93.

G. Pugliese Carratelli et al., *Sikanie: Storia e civiltà della Sicilia greca* (Milan, 1985), 213, 229, fig. 253.

E. Gabba and G. Vallet, eds., *La Sicilia antica* (Palermo, c. 1980), 2, part 1: pl. 63.

R. R. Holloway, *Influences and Styles in the Late Archaic and Early Classical Greek Sculpture of Sicily and Magna Graecia* (Louvain, 1975), 13–14, fig. 92.

P. Griffo and L. von Matt, *Gela: The Ancient Greeks in Sicily* (Greenwich, Conn., 1968), 130, pl. 95.

L. von Matt, *Das antike Sizilien* (Zurich, 1967), 76, pl. 95.

E. Langlotz and M. Hirmer, *The Art of Magna Graecia: Greek Art in South Italy and Sicily* (London, 1965), 261, pl. 33.

H. H. Miller, *Sicily and the Western Colonies of Greece* (New York, 1965), 135.

P. Griffo and L. von Matt, *Gela* (Genoa, 1963), 130–31, fig. 93.

A. G. Woodhead, *The Greeks in the West* (London, 1962), 227, fig. 14.

L. von Matt, *La Sicilia Antica* (Genoa, 1959), fig. 95.

L. Bernabò Brea, *Musées et Monuments de Sicile* (Novara, 1958), 140–41; English/French ed., *Museums and Monuments in Sicily* (Novara, 1960), 144–45.

P. Orlandini, "Antefisse sileniche rinvenute in via Apollo," *Notizi degli Scavi di Antichità* 10 (1956), 229–36, figs. 1, 4.

P. Orlandini, "Altre antefisse sileniche in Gela," *Archeologia Classica* 8 (1956), 47, pl. 17.1.

J. Bayet and C. F. Villard, *Sicile grecque* (Paris, 1955), 297, pl. 73.

B. Neutsch, "Archäologische Grabungen und Aufunde in Sizilien von 1949–1954," *Archäologischer Anzeiger* 69 (1954), 659, fig. 104.

P. Griffo, "Bilancio di cinque anni di scavi nelle province di Agrigento e Caltanissetta," *Atti dell'Accademia di scienze, lettere, e arti di Agrigento* 3 (1953–54), 26–27, pl. 13.c.

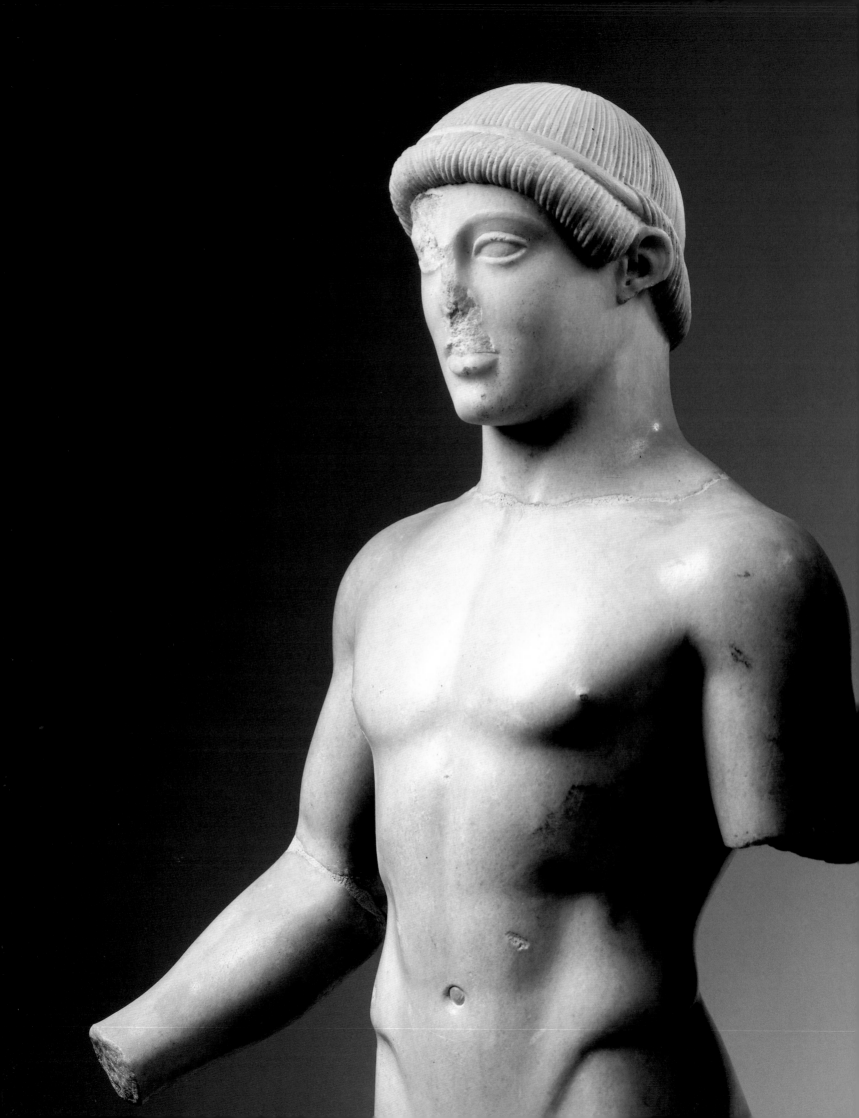

AGRIGENTO

64. PENTAGONAL PLATE

ca. 4000–3800 BC
Terracotta, dark-gray impasto, incised, red clay
applied to the rough surface of the base
H. 6.5, Diam. 33.4
Museo Archeologico Regionale di Agrigento,
inv. AGS 2242
Agrigento, Palma di Montechiaro, necropolis of
Piano Vento, tomb 5, found with a cup (AGS
2243)

This very early type of large plate was used in
funerary ceremonies. It is shield-shaped with five
pointed, raised areas on the rim. The base has a
slightly raised ring. The surface decoration on top
and bottom shows a sketchy floral motif rendered
with double incised lines filled with red clay and
another white substance. A wavy horizontal band
sprouting from a vertical stalk divides the surface
of the plate roughly in half. In addition, both top
and bottom have four diagonal incisions that be-
gin at the rim and extend toward the center, as
well as additional horizontal incisions connecting
with the stem at four different points. Circular de-
pressions appear on both sides. Eight surround a
suspension hole located under one of the five
pointed areas on the rim, creating a solar motif.
Eleven such circular depressions encircle the ring-
shaped base on the bottom. The base is also
flanked by two motifs consisting of a central circu-
lar depression and four radiating lines: two verti-
cal, top and bottom, and two horizontal, left and
right. The plate has been reassembled and small
sections have been filled. GC

LITERATURE

G. Castellana, *La necropoli
protoeneolitica di Piano Vento
nel territorio di Palma di
Montechiaro* (Agrigento,
1995), 104, fig. 69.1, pl. 70.

G. Pugliese Carratelli and G.
Fiorentini, *Agrigento: Museo
Archeologico* (Palermo, 1992),
120, fig. 125.

G. Castellana, *Un decennio di
ricerche preistoriche e
protostoriche nel territorio
agrigentino* (Palermo, 1990),
24, fig. 9.

G. Castellana, "Il villaggio
neolitico di Piano Vento nel
territorio di Palma di
Montechiaro," *Atti il Giornata
di Studi sull'Archeologia
Licatese e della zona della
bassa Valle dell'Himera,
Licata* (Palermo, 1985), 9–68,
24–34, pl. 24, fig. 2.

G. di Giovanni, *Agrigento, La
Valle dei Templi: Il Museo
Regionale* (Viaggio Mosé,
1979), 124.

65. BULL-MAN OBJECT

ca. 3200–2800 BC
Terracotta, incised, hand-modeled, painted
H. 21; body: L. 15.9; base: Diam. 22.2
Museo Archeologico Regionale di Agrigento,
inv. AGS 4737
Agrigento, Palma di Montechiaro, necropolis of
Piano Vento

This object consists of a circular base (or perhaps
a lid) supporting a sculpted figure with both hu-
man and bovine features. The creature is a quad-
ruped, possibly with the hindquarters of a bull and
the bust of a human being. The figure has been
partially reconstructed from fragments, with one
section missing and some sections filled. GC

LITERATURE

G. Castellana, *La necropoli
protoeneolitica di Piano Vento
nel territorio di Palma di
Montechiaro* (Agrigento,
1995), 147–50, figs. 98–99.

G. Castellana, "Le stipi votive
della necropoli dell'età del
rame di Piano Vento presso
Palma di Montechiaro," *Sicilia
Archeologica* 26 (1993), 87–
88, 93–94, fig. 35.

G. Castellana, "Età del rame
ed età del Bronzo," in G.
Castellana et al., eds., *Contatti
e scambi egei nel territorio
agrigentino nell III e II
millennio a.C. I micenei ad
Agrigento,* exh. cat., Museo
Archeologico Regionale di
Agrigento (1993), 17–18.

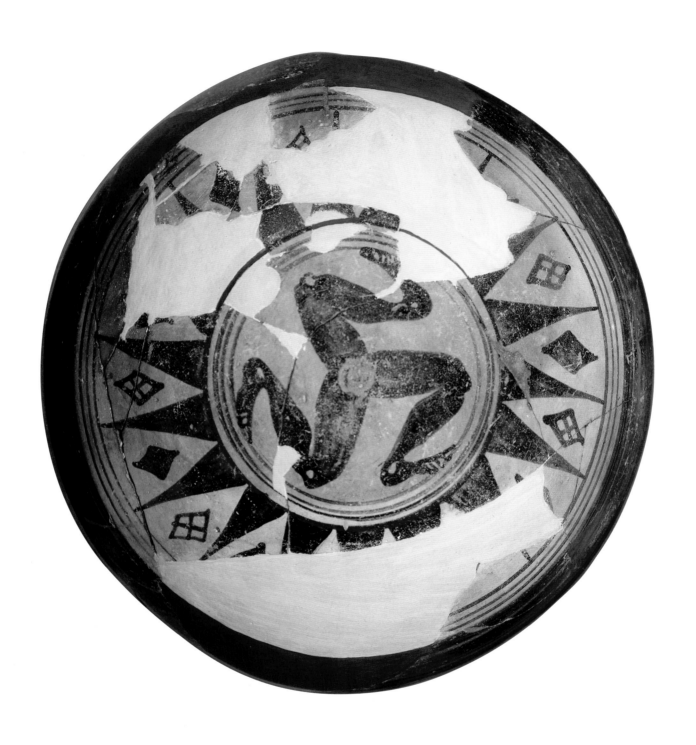

66. TRISKELES DINOS

ca. 610–600 BC
Ceramic, local clay with pink slip
H. 17.7, Diam. 32.5
Museo Archeologico Regionale di Agrigento,
inv. AG 4328
Agrigento, Palma di Montechiaro, near
Castellazzo, accidental find, 1957

This *dinos* (deep mixing bowl) was made in Gela
and is decorated on the bottom with a painted
representation of the *triquetra,* a triangular image
composed of three interlocking arcs. Here, the
triquetra is in the form of three bent legs converg-
ing at the center in a circular reserved area. The
legs and feet of the triquetra face counterclock-
wise. The decoration on the outside of the body of
the dinos is divided into three horizontal zones by
a series of lines and a large band painted brown.
On the shoulder, one side has rosettes made up of

four purplish-red petals alternating with four
brownish-green leaves; the other side (not visible
in the photograph) has a double motif of pointed
triangles. Purplish-red tongues and a metopal
band separate the two patterns. On the body, alter-
nating crossed and filled lozenges are placed
within a ray pattern of reddish-brown triangles. A
Rhodian braid pattern is painted on the rim.

The vessel is a remarkable object inspired by a
Rhodian model. Its maker, however, created an
original work of art, using a combination of differ-
ent decorative motifs in a masterly arrangement.
Most important, he succeeded in expressing the
colonial spirit of the West, symbolized by the
episema (emblem) of the triquetra, which must
have been one of the first geographic symbols of
the island, deriving from the Eastern triskeles
("three-legged" motif). GC

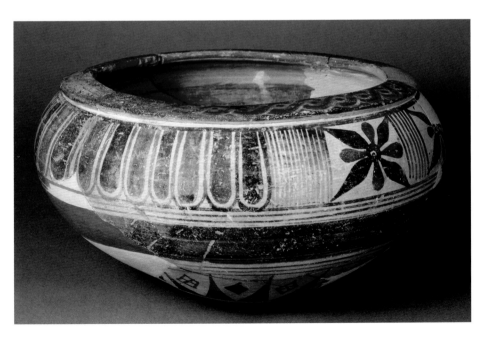

LITERATURE

R. J. A. Wilson, "On the Trail
of the Triskeles: From the
McDonald Institute to Archaic
Greek Sicily," *Cambridge
Archaeological Journal* 10
(2000), 47, fig. 35.

G. Pugliese Carratelli, ed., *The
Western Greeks,* exh. cat.,
Palazzo Grassi, Venice (Milan,
1996), 666, no. 25.

G. Fiorentini, ed., *Introdu-
zione alla Valle dei Templi*
(Agrigento 1996?), 77, fig. 52.

G. Fiorentini, *Breve Guida del
Museo Archeologico Naziona-
le di Agrigento* (Palermo,
1995?), 8, fig. 5.

G. Pugliese Carratelli and G.
Fiorentini, *Agrigento: Museo
Archeologico* (Palermo, 1992),
31–32, fig. 10.

Mostra della Sicilia, exh. cat.,
Tokyo Fuji Art Museum
(1984), 136–37, no. 122.

P. Arancio, *Agrigento: History
and Ancient Monuments,
Temples, Museums, Churches*
(Narni Terni, 1983), 83.

P. Griffo, *Il Museo Archeologi-
co Regionale di Agrigento*
(Rome, 1987), 38, fig. 23.

G. di Giovanni, *Agrigento, La
Valle dei Templi: Il Museo
Regionale* (Viaggio Mosé,
1979), 78.

G. Caputo, "Il triskele arcaico
di Bitalemi di Gela e di
Castellazzo di Palma," *Atti
dell'Accademia nazionale dei
Lincei, Rendiconti* 26 (1971),
3.

P. Orlandini, "Lo scavo del
thesmophorion di Bitalemi e il
culto delle divinità ctonie a
Gela," *Kokalos* 12 (1966), 27.

E. De Miro, "La fondazione di
Agrigento e l'ellenizzazione
del territorio fra il Salso e il
Plantini," *Kokalos* 8 (1962),
48, fig. 3, 129, 132–33, pl. 48.

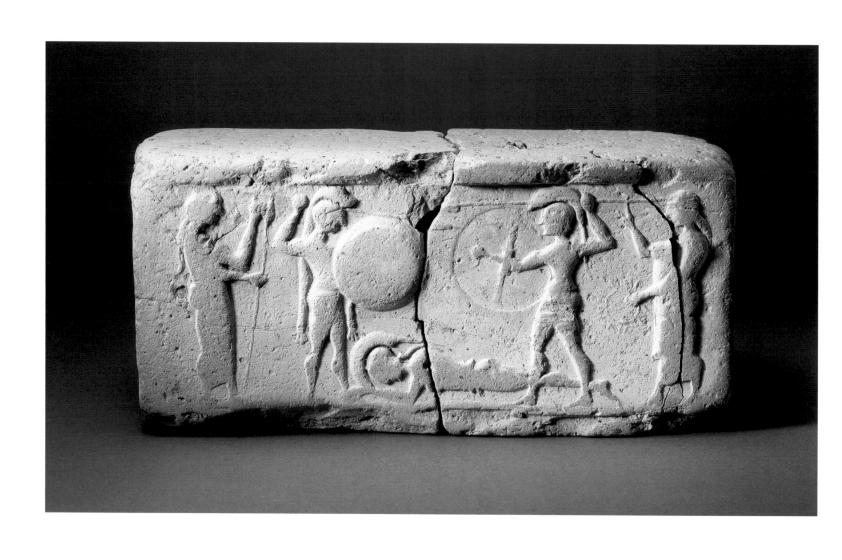

67. ACHILLES AND MEMNON ALTAR

600–500 BC
Terracotta, mold-made, hand-finished
H. 13.5, W. 15.5
Museo Archeologico Regionale di Agrigento,
inv. AG 6078, C 307
Agrigento, from a well north of the temple of
Herakles, formerly in the Museo Civico di
Agrigento

This terracotta altar shows a scene of a duel
between two warriors. On the ground between
them a warrior lies face down. Perhaps the scene
depicts Achilles fighting Memnon. Two female
deities are shown in profile offering assistance in
the battle, one at each side of the central scene.
Reassembled from two fragments, the altar has
scratches and abrasions and a loss at the end of
the right side. GC

LITERATURE

G. Pugliese Carratelli and G.
Fiorentini, *Agrigento: Museo
Archeologico* (Palermo, 1992),
85, fig. 83.

P. Griffo, *Il Museo Archeologi-
co Regionale di Agrigento*
(Rome, 1987), 139, fig. 122.

G. Pugliese Carratelli et al.,
*Sikanie: Storia e civiltà della
Sicilia greca* (Milan, 1985),
185, 207–208, fig. 214.

E. de Miro, *Agrigento: The
Valley of the Temples* (Novara,
1983), 58–60.

P. Griffo and L. von Matt,
*Gela: The Ancient Greeks in
Sicily* (Greenwich, Conn.,
1968), 88–89, fig. 58.

P. Marconi, *Agrigento:
Topografia ed Arte* (Florence,
1929), 191, fig. 129.

P. Marconi, "Plastica
Agrigentina—II," *Dedalo* 9
(1929), 590, 596.

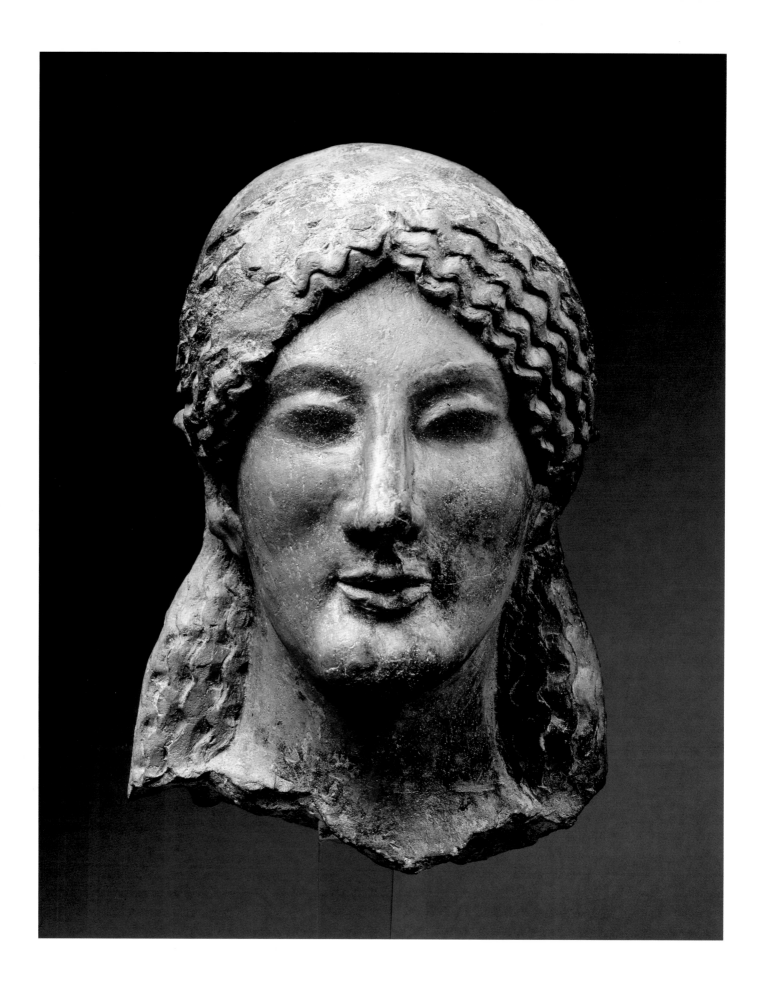

68. KORE-PERSEPHONE HEAD

ca. 500–490 BC
Terracotta, hand-finished with a stick
H. 19.6
Museo Archeologico Regionale di Agrigento,
inv. AG 20508 (previously PA 3450)
Agrigento, rock sanctuary of San Biagio

This terracotta head of a young woman probably
represents Kore-Persephone. Finely modeled and
finished with a stick, it reveals the sensitive hand
of a master sculptor who was expert in the me-
dium of terracotta. A few asymmetric features of
the face, also found in a helmeted head of Athena
and the head of a warrior, suggest that this figure
might have been part of a pedimental sculptural
group. The diminutive head is set on a thin neck.
Her heavily lidded eyes are half closed, and the
left is slightly oblong. The regal nose is straight
and sharp. The mouth is small, with thin lips,
pleasingly arched. The strong chin is divided by
an attractive cleft. The oblong face has pro-
nounced cheekbones. The hair is beautifully ar-
ranged and strongly sculptural, with wavy bands
on each side of the forehead that fall in a tidy
mass at the sides of the neck, down the shoulders,
and below the nape of the neck. Inspired by
Ionian-East Greek models, this work may be
attributed to the same master responsible for the
helmeted head of Athena also housed in the
Agrigento Museum. The head is broken at the base
of the neck, and there are abrasions as well as a
hole at the top. GC

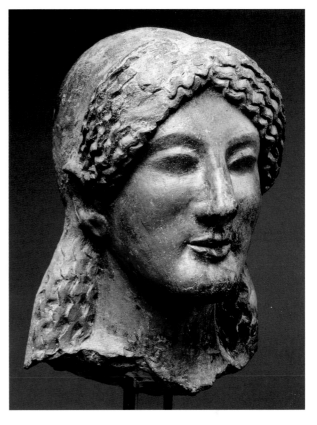

LITERATURE

G. Pugliese Carratelli, ed., *The
Western Greeks*, exh. cat.,
Palazzo Grassi, Venice (Milan,
1996), 410, 412, 674, no. 63.

G. Pugliese Carratelli and G.
Fiorentini, *Agrigento: Museo
Archeologico* (Palermo, 1992),
78–79, fig. 73.

R. R. Holloway, *The Archaeol-
ogy of Ancient Sicily* (London/
New York, 1991), 103, fig.
125.

P. Griffo, *Il Museo Archeologi-
co Regionale di Agrigento*
(Rome, 1987), 118, fig. 102.

G. Pugliese Carratelli et al.,
*Sikanie: Storia e civiltà della
Sicilia greca* (Milan, 1985),
186, 208, fig. 218.

P. Arancio, *Agrigento: History
and Ancient Monuments,
Temples, Museums, Churches*
(Narni Terni, 1983), 95.

E. de Miro, *Agrigento: The
Valley of the Temples* (Novara,
1983), 63.

G. di Giovanni, *Agrigento, La
Valle dei Templi: Il Museo
Regionale* (Viaggio Mosé,
1979), 100–01.

G. V. Gentili, "Incunaboli
coroplastici di stile ionico
dalla *Nésos* Siracusana e loro
inquadramento nella scuola
plastica arcaica di Syrakosai,"
Bollettino d'Arte 58 (1973), 7,
fig. 21.

E. Langlotz and M. Hirmer,
*The Art of Magna Graecia:
Greek Art in South Italy and
Sicily* (London, 1965), 60,
245, no. 8, pl. 8.

L. von Matt, *Das Antike
Sizilien* (Zurich, 1967), 91, pl.
103.

L. Bernabò Brea, *Musei e
Monumenti in Sicilia* (Novara,
1958), 111; English/French
ed., *Museums and Monuments
in Sicily* (Novara, 1960), 115.

P. Marconi, *Il Museo Naziona-
le di Palermo* (Rome, 1936),
52.

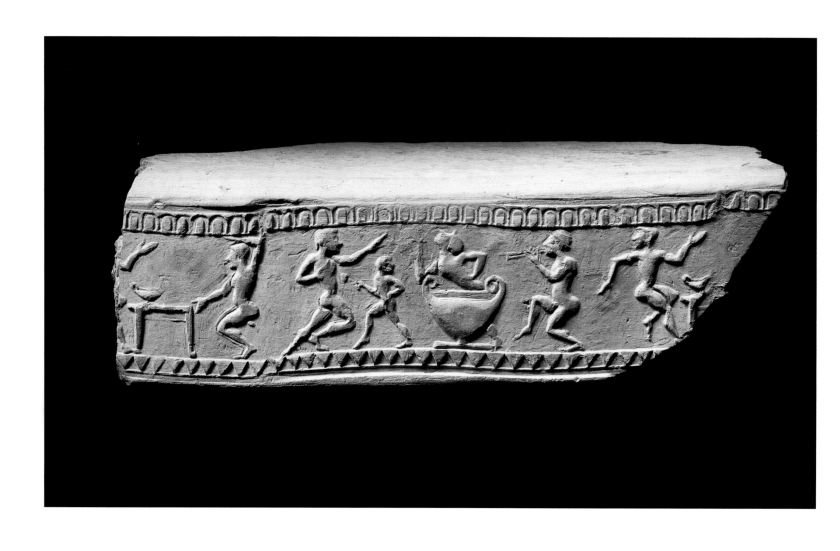

69. KOMAST LOUTERION RIM

ca. 510–500 BC
Terracotta, mold-made, hand-finished
W. 21.8
Museo Archeologico Regionale di Agrigento,
inv. AG 21030
Agrigento, formerly in the collection of the Museo
Archeologico Regionale "A. Salinas" di Palermo
(inv. PA 524)

This large fragment from the rim of a *louterion*
(basin) dates to the end of the sixth century BC (see
illustration at right). Its mold-made decoration de-
picts a *komos* (orgiastic dance). Two young nude
komasts (dancers) are dancing near both sides of a
table, on the top of which is a cup. Their postures
indicate vigorous movement. Only part of the
dancer at the left end of the fragment is preserved.
In the central part of the scene, more komasts,
shown in profile, dance around a large krater. In
this group, a flutist and a youth face one another,
moving wildly in a fit of orgiastic frenzy. The
scene is very animated and spontaneous, and is
infused with a pervasive sense of caricature. GC

Woman in front of a Complete
Louterion. Greece, Melos,
470–450 BC. Terracotta.
Musée du Louvre, Paris, inv.
CA 3003. From S. Besques,
*Figurines et reliefs grecs en
terre cuite* (Paris, 1994), 66,
no. 43.

LITERATURE

G. Pugliese Carratelli et al.,
*Sikanie: Storia e civiltà della
Sicilia greca* (Milan, 1985),
208, 218, fig. 217.

P. Marconi, *Agrigento:
Topografia ed Arte* (Florence,
1929), 206–7, fig. 149.

P. Marconi, "Plastica
Agrigentina—II," *Dedalo* 9
(1929), 589, 594.

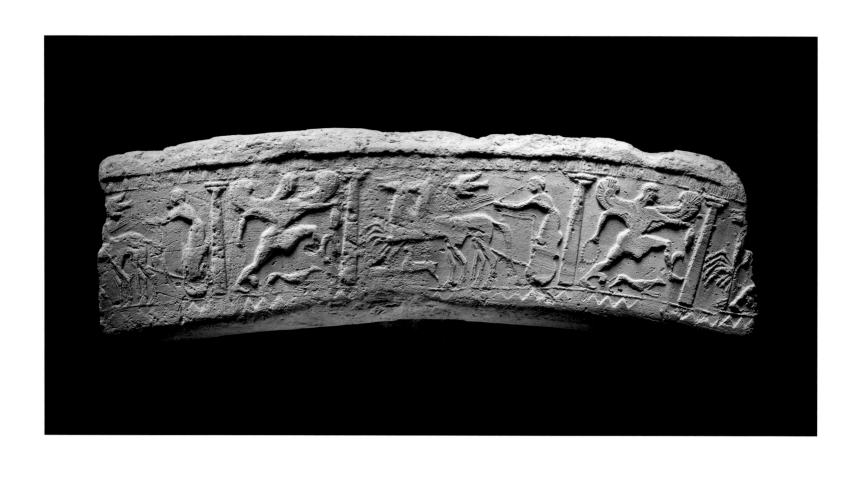

70. NIKE LOUTERION RIM

520–500 BC
Terracotta, red clay with slip, mold-made, hand-finished
H. 8, W. 30; lip: W. 4.5
Museo Archeologico Regionale di Agrigento, inv. C 317
Agrigento, formerly in the Museo Civico di Agrigento

A race involving quadrigae (four-horse chariots) and nikai (winged victories) is depicted on this fragment of a large louterion. The preserved figural decoration includes four columns, two nikai, one complete quadriga (center), the back of the horses and the chariot of another quadriga (left), and the heads and legs of the horses of a third quadriga (right).

The decoration is mold-made. The race is taking place in front of a portico supported by Doric columns, each with a rounded echinus. The nikai are represented according to the Archaic "Knielauf" convention, and each holds a bird. A dog runs between their legs. The charioteers wear long chitons and lean forward in the direction of their movement. The horses are sleek and spirited, with long thin legs and narrow heads. As with the nikai, a dog is shown running between the horses' legs. A bird flies above each quadriga. The nikai and quadrigae alternate, separated by the columns, and they run in opposite directions, the nikai to the right and the quadrigae to the left. At the top is a band of Ionian *kymation* (architectural decorative motif) with egg-shaped border, and the bottom is decorated with a band of "wolf teeth." The joining line of the molds is visible at the far right end on the fragment.

For similar examples, see P. Marconi, *Agrigento: Topografia ed Arte* (Florence, 1929), figs. 137–40. GC

LITERATURE

P. Griffo, *Il Museo Archeologico Regionale di Agrigento* (Rome, 1987), 131, fig. 113.

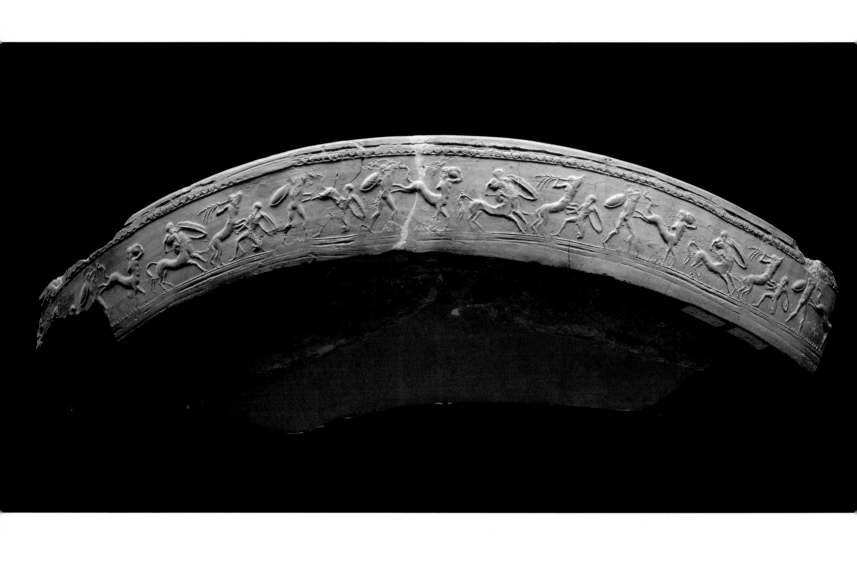

71. CENTAUROMACHY LOUTERION RIM

ca. 425–400 BC
Terracotta, red clay with slip, mold-made, hand-finished
H. 7.4, Diam. (of the conserved fragment) 61
Museo Archeologico Regionale di Agrigento,
inv. C 323
Agrigento, formerly from the Museo Civico di Agrigento

The mold-made decoration on this louterion rim depicts a fight between centaurs and Lapiths (a clan from Thessaly). The composition shows three pairs of warriors that repeat in a sequence. The first at the left shows a centaur using his back legs to kick a Lapith who is in pursuit and preparing to throw a large object, possibly a stone. In the second pair the centaur has seized the Lapith, who is wounding the centaur in the back. The third shows the Lapith with his knee to the ground as he thrusts his sword into the stomach of the centaur, who rears up and brandishes the trunk of a tree. All the Lapiths wear helmets and carry shields. The fragment shows three full repetitions of these fighting pairs. At the end of the first three pairs (viewing them from left to right), the sequence is interrupted by a repetition of the first pair (the pair depicting a centaur kicking a Lapith who is throwing a large object). Two molds therefore must join at this point. After this join, the sequence of the pairs repeats twice before the end of the fragment on the right side. Parallel lines serve as the ground for the relief figures. "Wolf teeth" are present between the feet of the Lapith and the centaur of the first group. The upper rim is decorated with an Ionian kymation. The groups recall those of the metopes and architectural friezes created by the school of Phidias. GC

LITERATURE

P. Griffo, *Il Museo Archeologico Regionale di Agrigento* (Rome, 1987), 131, fig. 114.

P. Marconi, "Plastica Agrigentina—II," *Dedalo* 9 (1929), 649–50.

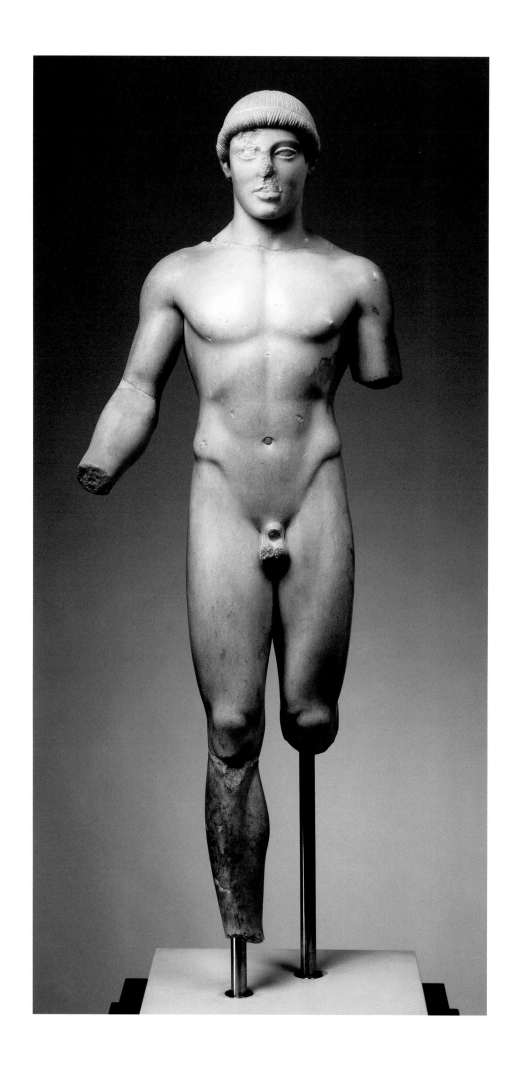

72. YOUTH OF AGRIGENTO

ca. 480 BC
Marble, East Greek
H. 102
Museo Archeologico Regionale di Agrigento,
inv. C 1853
Agrigento, from a cistern at the temple of Demeter
near San Biagio in 1897, formerly in the Museo
Civico di Agrigento

Made of marble, this statue of a standing youth
has his right leg set forward and right arm ex-
tended, possibly to hold a phiale. The type is
likely of Peloponnesian origin in transition to the
mature Classical period, possibly deriving from a
bronze prototype. Particular attention paid to the
statue's modeling reveals a strong plasticity typical
of a Sicilian origin, noticeable especially in the
treatment of the back and in the rendition of the
hair in small locks, twisted in thread-like, parallel
strands to form a smooth cap and rolled into a
large band on the forehead and around the hair-
line. Stylistic traits are characterized by the
thoughtful treatment of the body, the soft modeling
of the face, and the polishing of the wide surface
of the torso, which is devoid of any attempt to de-
pict the superficial anatomical features typical of
the Archaic period. These elements distinguish
the Youth of Agrigento as a clear example of the
Severe style, best demonstrated by the so-called
Kritios Boy found on the Athenian acropolis and
now in the Acropolis Museum in Athens. Partially
reassembled, the Agrigento figure has a fracture at
the base of the neck and is missing its right hand
and foot, and left forearm and leg below the knee.
Areas have been chipped away from the right eye,
nose, upper lip, chin, neck, right shoulder, and
groin. GC

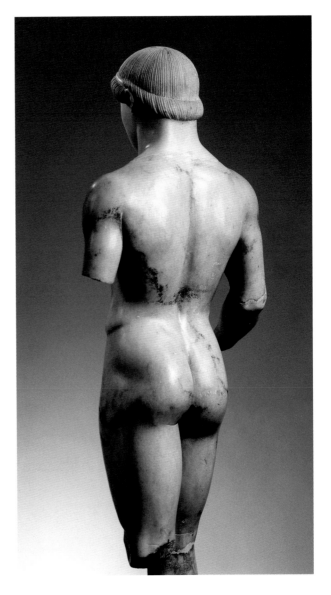

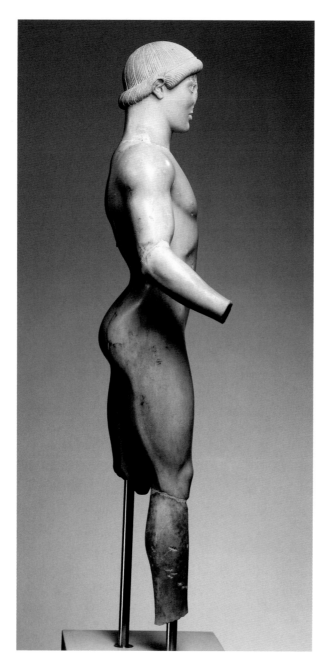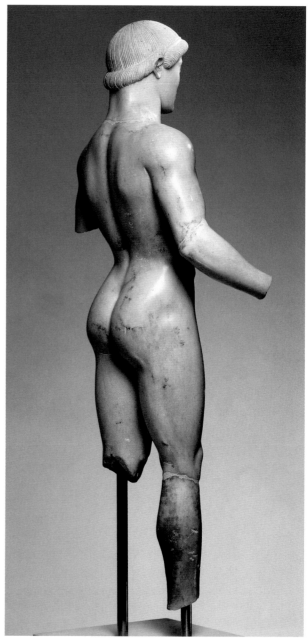

LITERATURE

G. Pugliese Carratelli, ed., *The Western Greeks,* exh. cat., Palazzo Grassi, Venice (Milan, 1996), 413–15, 661, no. 1.

G. Fiorentini, ed., *Introduzione alla Valle dei Templi* (Agrigento, 1996?), pls. 61–62.

G. Fiorentini, *Breve Guida del Museo Archeologico Regionale di Agrigento* (Agrigento, 1995?), 22, pl. 20.

C. Rolley, *La Sculpture grecque* (Paris, 1994), 1: 300–01.

G. Pugliese Carratelli and G. Fiorentini, *Agrigento: Museo Archeologico* (Palermo, 1992), 103, fig. 103.a–c.

R. R. Holloway, *The Archaeology of Ancient Sicily* (London, 1991), 102, fig. 124.

Lo Stile Severo in Sicilia, Dall'apogeo tirannide alla prima democrazia (Palermo, 1990), 158–161, no. 1.

P. Griffo, *Il Museo Archeologico Regionale di Agrigento* (Rome, 1987), 195–98, fig. 166–67.

R. Bianchi Bandinelli and E. Paribeni, *L'arte dell'antichità classica: Grecia* (Turin, 1986), 1: no. 423.

G. Rizza and E. de Miro, "Le arti figurative dalle origini al V secolo a.C.," in G. Pugliese Carratelli et al., *Sikanie: Storia e civiltà della Sicilia greca* (Milan, 1985), 202, 224, fig. 238.

P. Arancio, *Agrigento: History and Ancient Monuments* (Rome, 1983), 99, pl. 44.

E. de Miro, *Agrigento: The Valley of the Temples* (Novara, 1983), 65.

P. Arancio, *Agrigento: History and Ancient Monuments, Temples, Museums, Churches* (Narni Terni, 1983), 100.

E. Gabba and G. Vallet, eds., *La Sicilia antica* (Palermo, c. 1980), 2, part 1: pls. 74–75.

W. Fuchs, *Die Skulptur der Griechen,* 2d ed. (Munich, 1979), 48–49, fig. 36.

R. R. Holloway, *Influences and Styles in the Late Archaic and Early Classical Greek Sculpture of Sicily and Magna Grecia* (Louvain, 1975), 27–28, figs. 156–57.

G. di Giovanni, *Agrigento, La Valle dei Templi: Il Museo Regionale* (Viaggio Mosé, 1979), 113–14.

J. Charbonneaux, R. Martin, and F. Villard, *Archaic Greek Art, 620–480 BC,* trans. J. Emmons and R. Allen (London, 1971), 267, fig. 312.

P. Griffo and L. von Matt, *Gela: The Ancient Greeks in Sicily* (Greenwich, Conn., 1968), 90–91, fig. 59.

L. von Matt, *Das antike Sizilien* (Zurich, 1967), 158, pl. 175.

E. Langlotz and M. Hirmer, *The Art of Magna Graecia: Greek Art in South Italy and Sicily* (London, 1965), 55–54, 267, pls. 54–55.

P. Griffo and G. Zirretta, *Il Museo Civico di Agrigento: Un secolo dopo la sua fondazione* (Palermo, 1964), 55–56.

G. M. A. Richter, *Kouroi: Archaic Greek Youths* (London, 1960), 145–46, no. 182, figs. 547–49.

L. von Matt, *La Sicilia Antica* (Genoa, 1959), 98, figs. 121–22.

L. Bernabò Brea, *Musei e Monumenti in Sicilia* (Novara, 1958), 138; English/French ed., *Museums and Monuments in Sicily* (Novara, 1960), 142.

F. Villard, *Sicile Grecque* (Paris, 1955), 316, pls. 192–95.

G. Lippold, *Handbuch der Archäologie* (Munich, 1950), 5: 127.

E. Langlotz, "Die Ephebenstatue in Agrigent," *Mitteilungen des Deutschen Archäologischen Instituts Römische Abteilung* 57 (1942), 204–12.

P. Marconi, "La scoltura e la plastica nella Sicilia antica," *Historia* 9 (1930), 654, 656, fig. 8.

B. Pace, *Arte e Civiltà della Sicilia Antica* (Milan, 1938), 2: 54–56, figs. 57–58.

V. H. Poulsen, *Der strenge Stil: Studien zur Geschichte der Greichischen Plastik 480–450* (Copenhagen, 1937), 108–10, fig. 72.

P. Marconi, *Agrigento: Topografia ed Arte* (Florence, 1929), 161–63, figs. 89–91.

P. Marconi, "Plastica Agrigentina—II," *Dedalo* 9 (1929), 643–45.

E. Langlotz, *Frühgriechische Bildhauserschulen* (Nürnberg, 1927), 69, pls. 5, 38.

A. Della Seta, *Italia antica dalla caverna preistorica al Palazzo Imperiale* (Bergamo, 1922), 126, fig. 118.

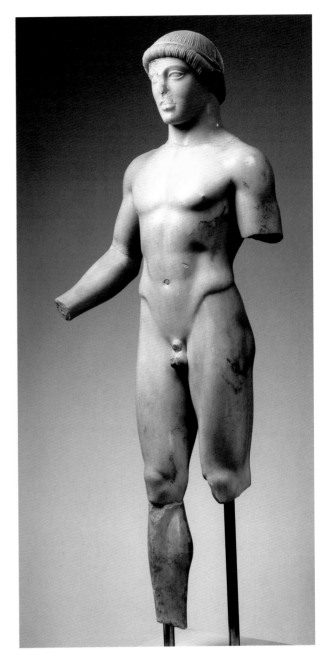

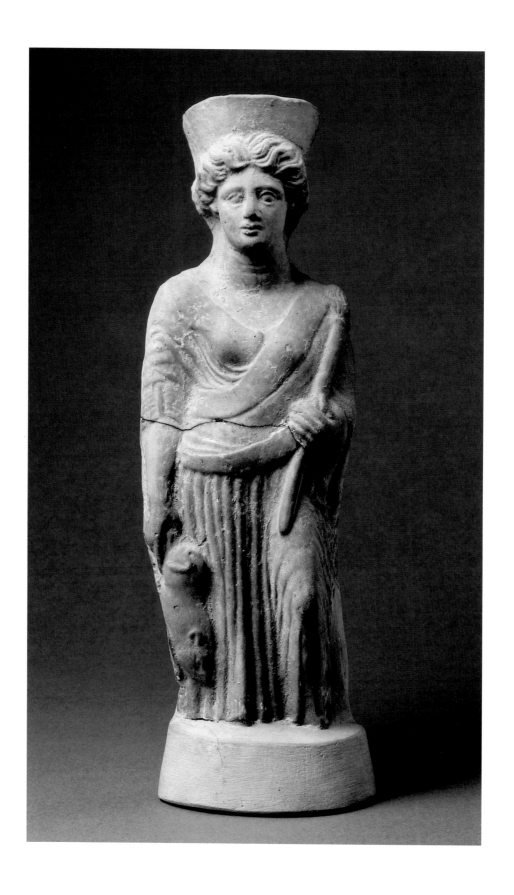

73. STATUETTE OF CHTHONIC DEITY WITH PIGLET

ca. 410–400 BC
Terracotta, reddish clay with slip, mold-made,
hand-finished
H. 24
Museo Archeologico Regionale di Agrigento,
inv. S 926
Probably Agrigento, formerly from the Palermo
Museum

This small female statuette stands on her right leg,
with her left leg deeply bent at the knee. She
wears a sleeved chiton with a deep neckline, and
the garment falls to her right leg in vertical folds. A
himation covers her right shoulder, crossing over
her chest in wide folds. Her right arm is held
straight along her side, and she holds a piglet sa-
cred to the chthonic deities (deities of the under-
world) by its back feet. In her left arm, bent at the
elbow, she holds a torch against her left shoulder.
On her head is a kalathos-shaped headdress and
her face is framed by her wavy hair, parted in the
middle and lifted up. The statuette is similar to
another in the museum (inv. S 659). There is a fir-
ing vent on the back, and the base, feet, and a
small portion of the lower right side are missing.
The statuette has been reconstructed.

For similar statuettes in the sanctuary of the
chthonic deities interpreted as Demeter, not as
offering bearers, see P. Marconi, *Agrigento arcaica:
Il santuario delle Divinità ctonie e il Tempio detto
di Vulcano* (Rome, 1933), 66, fig. 38.1–3, pl.
15.7. GC

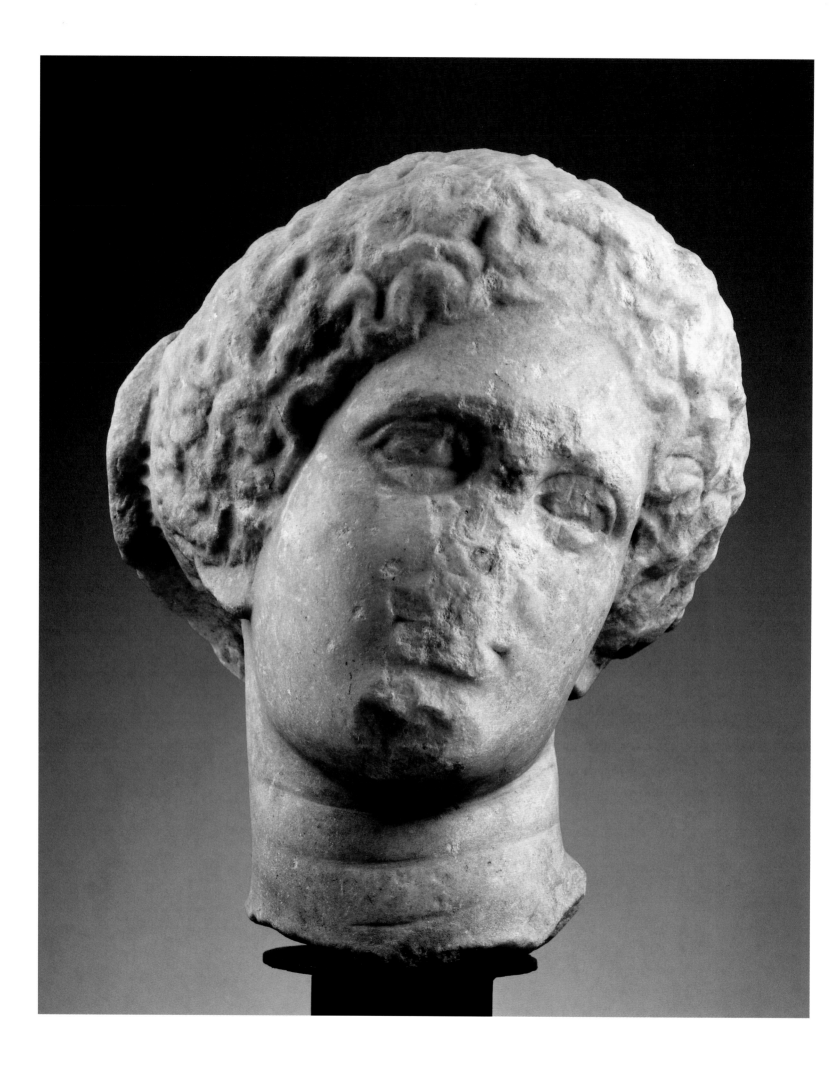

74. HEAD OF FEMALE DEITY

ca. 410–400 BC
Marble
H. 35, W. 27
Museo Archeologico Regionale di Agrigento,
inv. AG 9245
Agrigento, in a cistern inside the temple to the
chthonic deities, 1954 excavations

This head, strongly twisted to the left, is set on a
thick neck. Traces of the points of attachment
around the rim of the veil suggest the presence of
a diadem of precious metal, now missing. The
oval face has full, fleshy lips. The nose is almost
completely missing; two holes at the base and top
of the nose indicate that it was restored in antiq-
uity. The hair is arranged in full, wavy locks on the
forehead and temples. Fractured at the base of the
neck, this head has abrasions and scratches.

The robust structure of the face, the massive
neck carved on the front with the three fleshy folds
often seen on representations of the goddess
Aphrodite, and the intense gaze are all stylistic
attributes indicating a late fifth century BC original.
It was carved by a local artist influenced by post-
Phidian Attic works, particularly those of
Agorakritos. Taking into account the Sicilian
artist's personal interpretation, the closest com-
parisons are two works associated with the temple
of Nemesis: the head in the National Archaeologi-
cal Museum in Athens associated with the statue
base of the Nemesis of Rhamnus, from the temple
of Nemesis, and the Villa Albani metope.

The Agrigento head probably belonged to a
standing statue of the goddess Demeter. This is
suggested by, among other things, iconographic
elements such as the fullness of the mature face,
the presence of a diadem, as well as the site
of recovery. One interesting proposal suggests
that the general pose of the figure is echoed, if
not actually reproduced, in a female sandstone
figure carved in high relief now in the Agrigento
Museum. GC

LITERATURE

H. Hellenkemper, *Die neue
Welt der Griechen*, exh. cat.,
Römisch-Germanisches Mu-
seum (Cologne/Mainz, 1998),
160, no. 89.

G. Pugliese Carratelli, ed., *The
Western Greeks*, exh. cat.,
Palazzo Grassi, Venice (Milan,
1996), 419, 705, no. 188.

G. Fiorentini, *Breve Guida del
Museo Archeologico
Regionale di Agrigento*
(Palermo, 1995?), 19, fig. 16.

G. Pugliese Carratelli and G.
Fiorentini, *Agrigento: Museo
Archeologico* (Palermo, 1992),
88–90, figs. 91a–b.

P. Griffo, *Il Museo Archeologi-
co Regionale di Agrigento*
(Rome, 1987), 142, pl. 131.

G. Pugliese Carratelli et al.,
*Sikanie: Storia e civiltà della
Sicilia greca* (Milan, 1985),
633, pl. A.

Mostra della Sicilia, exh. cat.,
Tokyo Fuji Art Museum
(1984), 183–84, no. 262.

E. de Miro, *Agrigento: The
Valley of the Temples* (Novara,
1983), 64–65.

O. Fuchs, "Archäologische
Forschungen und Funde in
Sizilien 1955 bis 1964,"
Archäologischer Anzeiger 4
(1964), 724, figs. 41–42.

O. Griffo, *Agrigento*
(Agrigento, 1961), 88, fig. 91a.

E. de Miro, "Culture
agrigentine degli ultimi
decenni del V sec. a.C.,"
Archeologia Classica 18
(1966), 192–98.

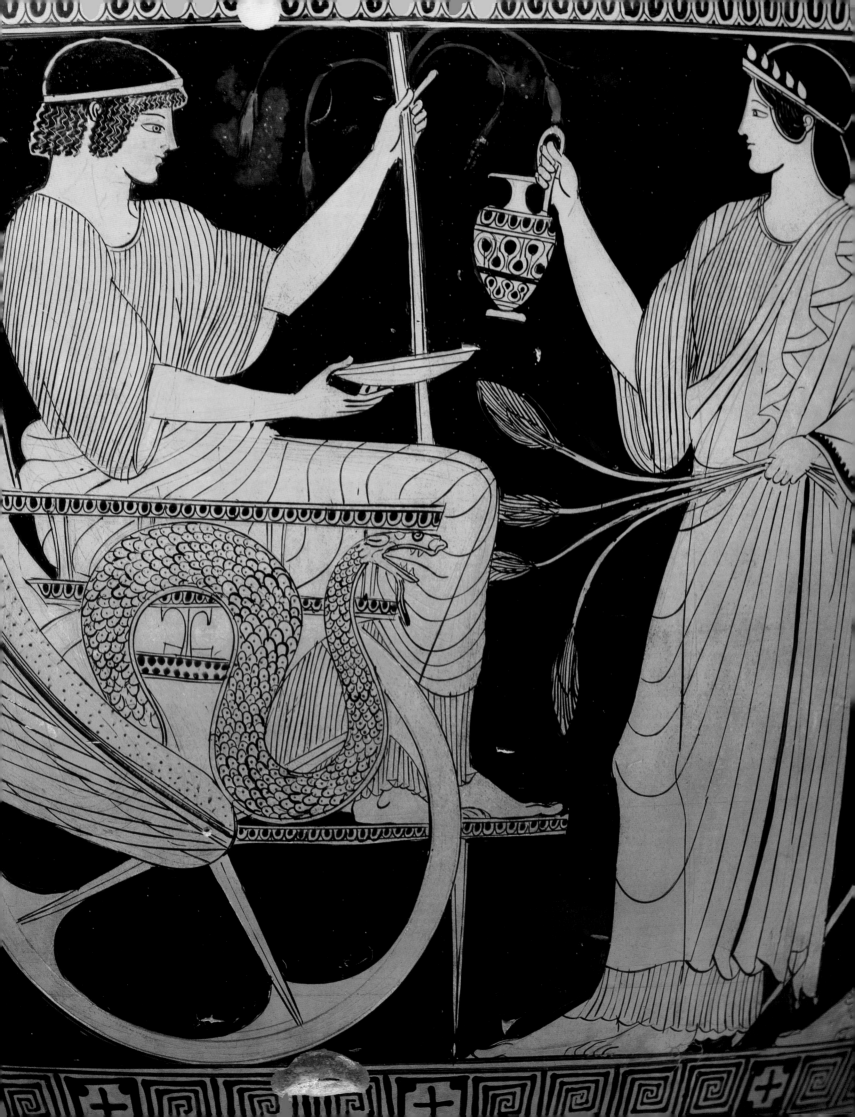

PALERMO

75. DAEDALIC LAMP WITH HUMAN HEAD

ca. 610–600 BC
Marble, white coarse-textured, crystalline
H. 7.8
Museo Archeologico Regionale "A. Salinas" di
Palermo, inv. 3892
Selinus, Malophoros sanctuary, northwest corner
of the temenos of the first megaron, 26 June 1923

This semi-circular lamp has a triangular and elongated face in high relief at the center of its flat side. The face is Daedalic, with a long nose, large eyes with incised irises, and thin mouth. A diadem encircles the hair, which is incised with volutes. Along the curved rim are three spool-shaped knobs pierced with holes for suspension. AM

LITERATURE

H. Hellenkemper, *Die neue Welt der Griechen,* exh. cat., Römisch-Germanisches Museum (Cologne/Mainz, 1998), 98, no. 21.

G. Pugliese Carratelli, ed., *The Western Greeks,* exh. cat., Palazzo Grassi, Venice (Milan, 1996), 402, 670, no. 43.

C. Rolley, *La Sculpture Grecque* (Paris, 1994), 1: 50, fig. 133.

R. R. Holloway, *The Archaeology of Ancient Sicily* (London, 1991), 58, fig. 69.

S. Moscati and C. Di Stefano, *Palermo, Museo Archeologico* (Palermo, 1991), 48.

R. Bianchi Bandinelli and E. Paribeni, *L'arte dell'antichità classica: Grecia* (Turin, 1986), 1, no. 143.

G. Rizza and E. de Miro, "Le arti figurative dalle origini al V secolo a.C.," in G. Pugliese Carratelli et al., *Sikanie: Storia e civiltà della Sicilia greca* (Milan, 1985), 155, 170, fig. 157.

V. Tusa, *La scultura in pietra di Selinunte* (Palermo, 1984), 133, no. 42, fig. 45.

A. Curcio, "Nuove lucerne cicladiche dalla Sicilia Orientale," *Sicilia Archeologica* 7 (1974), 79–84, nos. 24–25.

E. Langlotz and M. Hirmer, *The Art of Magna Graecia: Greek Art in South Italy and Sicily* (London, 1965), 250–51, pl. 2.

M. P. Nilsson, "Lampen und Kersen im Kult der Antike," Skrifter Utgivna av Svenska Institutet i Rom 15, *Opuscula Archaeologica* 6 (1950), 96 ff.

J. D. Beazley, "A Marble Lamp," *Journal of Hellenic Studies* 60 (1940), 22, pls. 4.2–3.

E. Boehringer, "Archäologische Funde von Anfang 1928 bis Mitte 1929," *Archäologischer Anzeiger* 44 (1929), 148, 151, figs. 44–45.

E. Gàbrici, "Il Santuario della Malophoros a Selinunte," *Monumenti Antichi della Reale Accademia Nazionale dei Lincei* 32 (1927), 159, 162–63, fig. 95, pls. 23.1.

E. Gàbrici, "Sicilia, Siracusa," *Notizie degli Scavi di Antichità* (1925), 207.

E. Gàbrici, "Dedalica Selinuntia," *Memorie dell' accademia di Archeologia, Lettere e Belle Arti di Napoli* (1924), 9, pl. 2.1–1a.

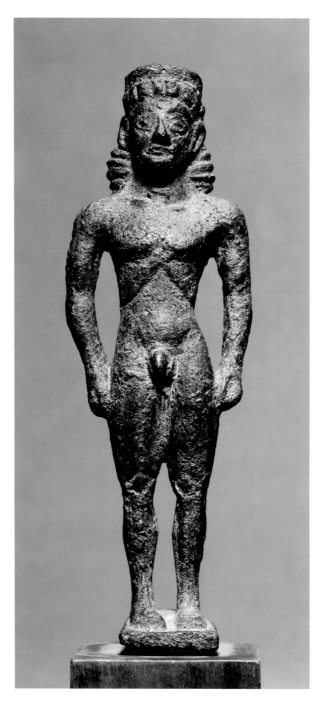
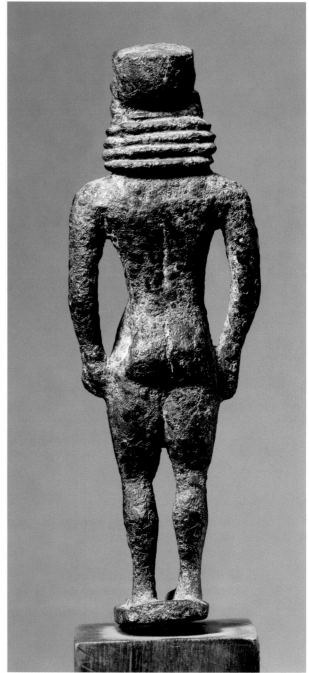

76. KOUROS

ca. 600–580 BC
Bronze, cast, incised
H. 16.1
Museo Archeologico Regionale "A. Salinas" di
Palermo, inv. 8263
Selinus, Malophoros sanctuary

This figure stands in a frontal pose, with legs
slightly apart and heels flat on the base, perhaps
the lid of a lebes (cauldron). The thick, wavy hair
falls to his shoulders in parallel layers. On his
head is a low polos decorated with a band of
small bead-shaped bosses. The face is elongated
and triangular; its features include faintly outlined
eyes with heavy lids, a strong nose, and a closed
mouth. The arms are extended along the sides and
the hands are clenched. GS

LITERATURE

G. Rizza and E. Miro, "Le arti
figurative dalle origini al V
secolo a.C.," in G. Pugliese
Carratelli et al., Sikanie: Storia
e civiltà della Sicilia greca
(Milan, 1985), 159, 172, fig.
167.

E. de Miro, I Bronzi Figurati
della Sicilia Greca (Perido
arcaico e quinto secolo a.C.)
(Palermo, 1976), 17, no. 5, pl.
7.

C. A. Di Stefano, "Bronzetti
figurati del Museo Nazionale
di Palermo," Studi e Materiali
2 (1975), 53, no. 89, pl. 22.

J. Bovio Marconi, Il Museo
Nazionale Archeologico di
Palermo (Rome, 1969), pl. 27,
no. 56.

E. de Miro, "Bronzi greci
figurati della Sicilia,"
Cronache di archeologia e
Storia dell'Arte 5 (1966), 21–
22, 43, pl. 5.

N. Bonacasa, "Recensione
del Volume di G. Richter,"
Archeologia Classica 13
(1961), 281–82.

G. M. A. Richter, Kouroi:
Archaic Greek Youths (Lon-
don, 1960), 58, no. 30 bis,
figs. 108–9.

P. Marconi, Il Museo Naziona-
le di Palermo (Palermo, 1936),
55.

D. Levi, "Trace della civiltà
micenea in Sicilia," in Miscel-
lanea Paolo Orsi (Rome,
1935), 107, pl. 8.

E. Boehringer, "Archäologi-
sche Funde von Anfang 1928
bis Mitte 1929," Archäolo-
gischer Anzeiger (1929), 149,
fig. 46.

E. Gàbrici, "Il Santuario della
Malophoros a Selinunte,"
Monumenti Antichi della
Reale Accademia Nazionale
dei Lincei 32 (1927), 351–52,
fig. 147.

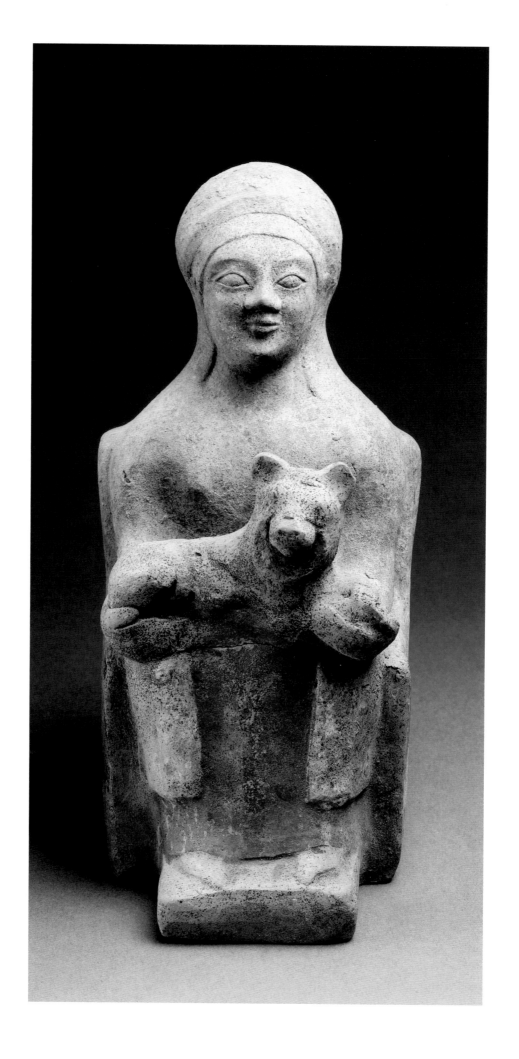

77. ENTHRONED GODDESS WITH PANTHER

ca. 550–500 BC
Terracotta, mold-made, hand-finished, painted
H. 21, L. 10.1
Museo Archeologico Regionale "A. Salinas" di
Palermo, inv. 10302
Selinus, Malophoros sanctuary

An Eastern Greek import, this figurine depicts a
goddess seated on a throne holding a small pan-
ther in her arms. Her eyes are set diagonally in her
oval face, and she has a large nose and fleshy
mouth. The hair, held in a smooth band, falls over
the shoulders and the headdress is a tall polos. She
wears a chiton covered with a himation, and her
garments still preserve a red color. The throne on
which she sits is square; her feet are clad in open
shoes and rest on a low stool. A small panther
with rounded ears, globular eyes, and a prominent
snout crouches on her lap. There is a vent-hole
under the base of the figurine. AM

LITERATURE

H. Hellenkemper, *Die neue
Welt der Griechen,* exh. cat.,
Römisch-Germanisches Mu-
seum (Cologne/Mainz, 1998),
118.

G. Pugliese Carratelli, ed., *The
Western Greeks,* exh. cat.,
Palazzo Grassi, Venice (Milan,
1996), 682, no. 95 VIII.

E. Gàbrici, "Il Santuario della
Malophoros a Selinunte,"
*Monumenti Antichi della
Reale Accademia Nazionale
dei Lincei* 32 (1927), 214–15,
pl. 39.8.

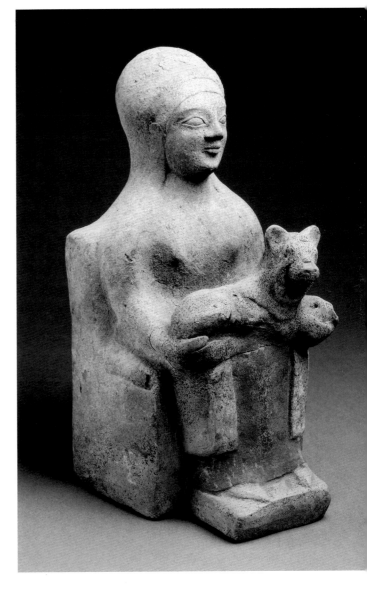

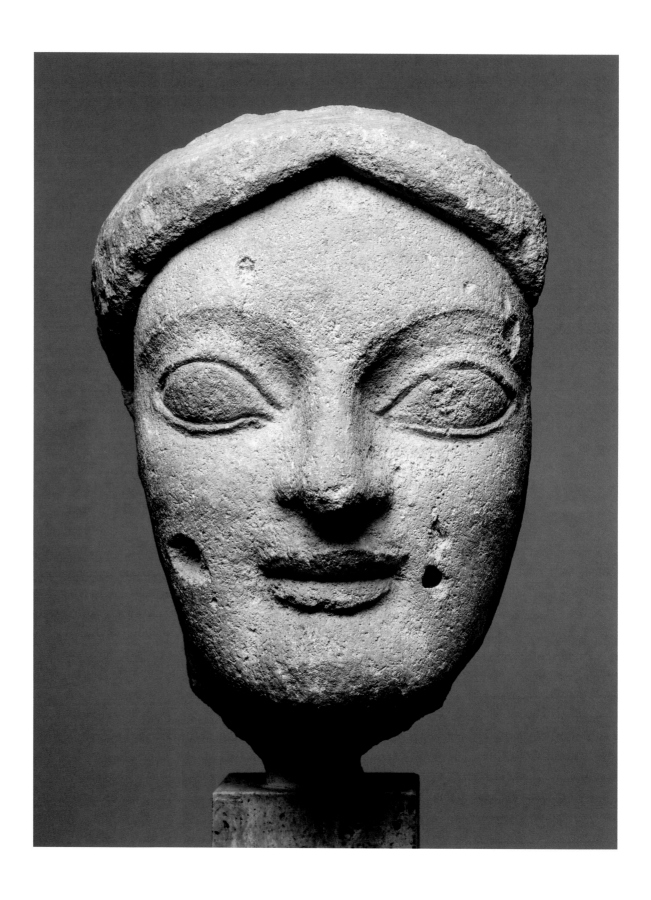

78. HEAD OF A BOY

ca. 530 BC
Limestone
H. 19
Museo Archeologico Regionale "A. Salinas" di
Palermo, inv. 3900
Selinus, temple C, subsequently part of the
University Museum

Probably from a statue of a youth, this male head
has large eyes, high forehead, fleshy lips, and a
strong chin. The complete figure was likely part of
a sculpted metope. GS

LITERATURE

H. Hellenkemper, *Die neue
Welt der Griechen,* exh. cat.,
Römisch-Germanisches Mu-
seum (Cologne/Mainz, 1998),
109, no. 34.

G. Pugliese Carratelli, ed., *The
Western Greeks,* exh. cat.,
Palazzo Grassi, Venice (Milan,
1996), 675, no. 74.

C. Marconi, *Selinunte: Le
metope dell'Heraion*
(Modena, 1994), 79, fig. 3.

V. Tusa, *La scultura in pietra di
Selinunte* (Palermo, 1984),
134, no. 47.

Mostra della Sicilia Greca,
exh. cat., Tokyo Fuji Art Mu-
seum (1984), 142–43, no. 129.

L. Giuliani, *Die archaischen
Metopen von Selinunt* (Mainz
am Rhein, 1979), 32, 34, pl.
7.3.

J. Bayet and C. F. Villard,
Sicile grecque (Paris, 1955),
302, pl. 101.

D. Lo Faso Pietrasanta, Duca
di Serradifalco, *Le Antichità
della Sicilia* (Palermo, 1834),
2: 68–69, pl. 35.3.

79. HEAD OF A WOMAN

ca. 470–460 BC
Marble
H. 22
Museo Archeologico Regionale "A. Salinas" di
Palermo, inv. 3925
Selinus, temple E, adyton, 1865

Turned slightly to the right, the face of this female
head is framed by wavy hair that is parted at the
center of the forehead and held in a diadem. From
under the diadem, the hair falls onto the nape of
the neck, a detail visible on the right side of her
head only because the back left side is unfinished.
The eyes are elongated and the mouth slightly
open, suggesting an excited emotional state. GS

LITERATURE

C. Marconi, *Selinunte: Le
metope dell'Heraion*
(Modena, 1994), 161–63, no.
19, pls. 96–97.

E. Østby, "Selinunte, Metope
del Tempio F, Frammenti di un
fregio ionico, Metope del
tempio E, Frammenti delle
metope del tempio E, altre
sculture selinuntine," in *Lo
Stile Severo in Sicilia*
(Palermo, 1990), 202–3, no.
34.

C. Marconi, "Contributo alla
Conoscenza delle Metope del
Tempio e di Selinunte," *Atti
Della Pontificia Accademia
Romana di Archeologia,
Rendiconti* 61 (1990), 59.

G. Pugliese Carratelli et al.,
*Sikanie: Storia e civiltà della
Sicilia greca* (Milan, 1985),
219, 232, fig. 269.

V. Tusa, *La scultura in pietra di
Selinunte* (Palermo, 1984),
136, no. 52, pl. 40.

L. Giuliani, *Die archaischen
Metopen von Selinunt* (Mainz
am Rhein, 1979), 78, fig. 24.6.

R. R. Holloway, *Influences
and Styles in the Late Archaic
and Early Classical Greek
Sculpture of Sicily and Magna
Grecia* (Louvain, 1975), 23,
figs. 142–43.

W. Fuchs, "Zu den Metopen
des Heraion von Selinus,"
*Mitteilungen des Deutschen
Archäologischen Instituts
Römische Abteilung* 63
(1956), 104, pls. 48.l.e,
51.1–2.

P. Marconi, *Il Museo Naziona-
le di Palermo,* 2d ed. (Rome,
1936), 41, fig. 10.

O. Benndorf, *Die Metopen
von Selinunt* (Berlin, 1873),
60–61, pl. 11.2.

80. RED-FIGURE BELL-KRATER

ca. 470–450 BC
Ceramic
H. 41.5; D. 56.6 (at rim); D. 14 (at base)
Museo Archeologico Regionale "A. Salinas" di
Palermo, inv. 2124
Agrigento, necropolis, 1841

Side A of this bell-krater presents the departure of
Triptolemos, a prince of Eleusis. The hero is de-
picted sitting on a winged chariot decorated with
a serpent, its mouth open and fangs showing.
Triptolemos wears a tainia around his head and a
long pleated chiton covered with a himation. He
carries a scepter and offers a phiale to Demeter.
The goddess wears a diadem on her head and a
pleated chiton with himation, and she holds an
oinochoe and a sheaf of wheat. To the left of
Triptolemos, Kore is depicted wearing a diadem
and a chiton with himation. She offers a phiale to
the prince, while holding a sheaf of wheat. Two

cloaked and bearded figures complete the scene
on the sides: Hippothoon is at the left; at the right,
next to a column, Keleos holds a scepter.

Side B shows Zeus sitting on a lavishly inlaid
stool. He has long hair and a beard, wears the chi-
ton with the himation, and holds a scepter and the
winged thunderbolt. The figure of Eos runs to his
left, lifting the edge of her clothing and holding
out her arm. Her hair is gathered in a sakkos, and
she wears a pleated chiton covered by the
himation. The figure of Thetis runs to his right,
extending her arm while holding her clothing with
one hand. Her hair is gathered at the nape of the
neck and crowned by a diadem, and she wears a
sumptuous peplos covered by the himation. The
name of each figure is painted next to it in Greek.
Above the scene is a kymation with egg-shaped
border, while underneath there is a motif of mean-
ders alternating with crosses. The work is attrib-
uted to the Oreithyia Painter. AM

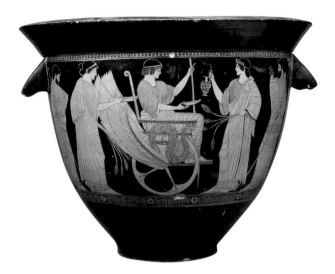

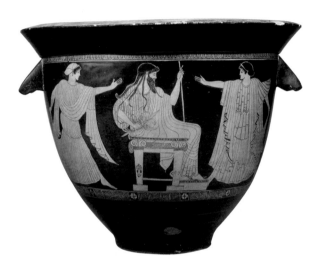

LITERATURE

S. Moscati and C. Di Stefano, *Palermo, Museo Archeologico* (Palermo, 1991), 108, fig. 123.

Lo Stile Severo in Sicilia (Palermo, 1990), 346–47, no. 165.

T. H. Carpenter, *Beazley Addenda: Additional References to ABV, ARV2, and Paralipomena* (Oxford, 1989), 250, no. 496.5.

L. Franchi dell'Orto and R. Franchi, *Veder Greco: Le necropoli di Agrigento,* exh. cat., Museo Archeologico Regionale di Agrigento (Rome, 1988), 56–57, 208–9, figs. 11–12, no. 66.

C. Weiss, "Eos," *Lexicon Iconographicum Mythologiae Classicae* (Zurich/Munich, 1986), 3: 781, no. 296, pl. 580 "Eos 296."

L. Burn and R. Glynn, *Beazley Addenda: Additional References to ABV, ARV2, and Paralipomena* (Oxford, 1982), 122, no. 496.5.

A. Peschlow-Bindokat, "Demeter and Persephone in der attischen Kunst des 6. bis 4. Jahrhunderts," *Archäologischer Anzeiger* 87 (1972), 82–83, fig. 17.

J. D. Beazley, *Attic Red-figure Vase Painters,* 2d ed. (Oxford, 1963), 1: 497, no. 5.

E. Paribeni, "Orizia, Pittore di," in R. Bianchi Bandinelli, ed., *Enciclopedia dell'Arte Antica, Classica, e Orientale* (Rome, 1963), 5: 762–63.

J. D. Beazley, *Attic Red-figure Vase-painters* (Oxford, 1942), 325, no. 5.

J. Bovio Marconi, *Corpus Vasorum Antiquorum, Italy, Palermo* (Rome, 1938), fasc. 1: 18–19, pls. 35.1–2.e, 36.1–6.e, 37.1–3.

A. Cook, *Zeus* (Cambridge, U.K., 1914), 1: pl. 18.

J. Overbeck, *Atlas der griechischen Kunstmythologie* (Leipzig, 1871–78), pl. 15, no. 30.

H. Heydemann, "Vasensammlung des Museums zu Palermo," in *Archäologische Zeitung* (1870), 7, no. 43, pl. 33.

Raoul-Rochette, *Choix de peintures de Pompéi* (Paris, 1867), 5.

T. Panofka, "Zufluchtsgottheitem zum erstenmal ans Liocht gestellt," *Akademie der Wissenschaften, Berlin* (Berlin, 1853), 3: no. 1.

G. Minervini, "Cinque vasi di premio rinvenuti in un sepolcro agregentino nell'aprile del 1841," *Bulletino Storico Napolitano* 1, no. 2 (1843), 15.

R. Politi, *Spiegazione di cinque vasi di premio* (Palermo, 1841), pls. 7–8.

C. Lenormant and J. De Witte, *Elite des Monuments Céramographiques* (Paris, 1837–61), 3: pl. 62.

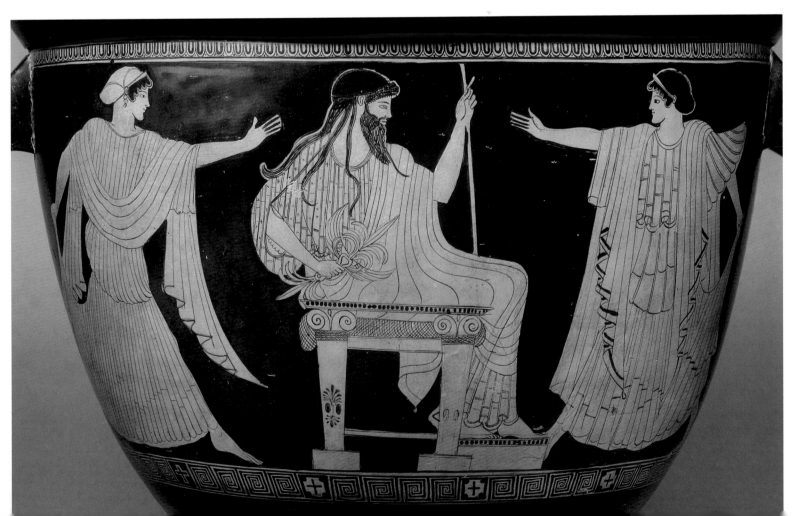

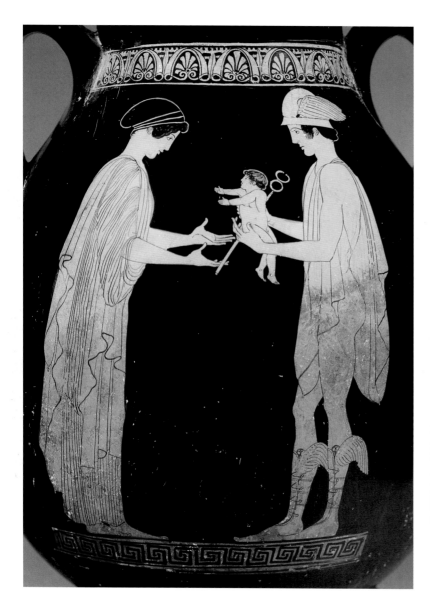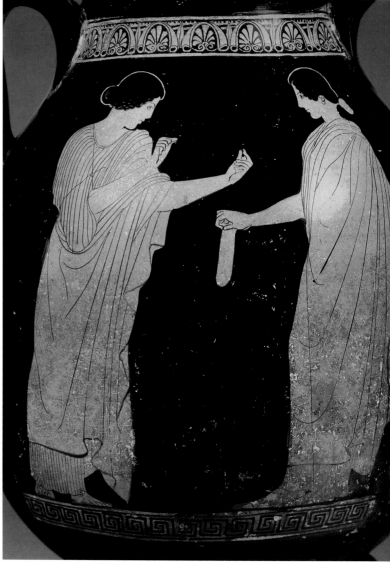

81. RED-FIGURE PELIKE

ca. 450–440 BC
Ceramic
H. 39.6, Diam. 20 (at rim), Diam. 19 (at base)
Museo Archeologico Regionale "A. Salinas" di
Palermo, inv. 2186
Agrigento, necropolis

Side A of this pelike (wine vessel) shows Hermes,
the messenger god, entrusting the baby Dionysos
to Ino, who will be his nurse. Hermes wears a
petasos (wide-brimmed hat), a chlamys (traveling
cloak), and winged boots. He holds the caduceus
(herald's wand) and the infant Dionysos, who is
nude, and extends his arms to Ino. Ino's hair is
gathered in a sakkos and she wears a pleated chi-
ton and himation.

Side B depicts the two nymphs of Nyssa with
their hair gathered at the nape of their necks and
wearing the chiton and himation. The nymph to
the left holds a wreath, the other an alabastron.
The scenes are framed by an upper frieze of
palmettes and lotus flowers, and a lower border of
meanders. The work is attributed to the Chicago
Painter. AM

LITERATURE

L. Franchi dell'Orto and R.
Franchi, *Veder Greco: Il
Necropoli di Agrigento,* exh.
cat., Museo Archeologico
Regionale di Agrigento (Rome,
1988), 214–15, no. 69.

J. D. Beazley, *Paralipomena,
Additions to Attic Black-figure
Vase Painters and to Attic
Red-figure Vase Painters,* 2d
ed. (Oxford, 1971), 399, no.
24.

P. Zanker, *Wandel der Her-
mesgestalt in der attischen
Vasenmalerei* (Bonn, 1965),
pl. 4.

J. D. Beazley, *Attic Red-figure
Vase Painters,* 2d ed. (Oxford,
1963), 1: 630, no. 24.

P. E. Arias, "Storia della
ceramica di età arcaica,
classica ed ellenistica e della
pittura di età arcaica e
classica," in *Enciclopedia
dell'arte antica, classica, e
orientale* (Turin, 1963), 3: part
2, 291, pl. 130.1.

J. D. Beazley, *Attic Red-figure
Vase-painters* (Oxford, 1942),
408, no. 20.

Achaeans. ancient inhabitants of the north coast of Peloponnesus, also the name for the Greeks who fought at Troy

Archaic. period and style of Greek art (ca. 600–480 BC)

acrolith. composite sculpture of stone and wood

acropolis. "upper city," often fortified and protecting major temples

acroterion. roof ornament placed at the pediment's apex and outer corners

adyton. "the place not to be entered," usually the most sacred room at the back of a temple's cella

agneia. temporary purity permitting participation in cult practice

agora. public gathering and market place

Akragas. ancient name for Agrigento; city-state on the south coast of Sicily

alabastron. small oblong vessel

amphora. two-handled storage vessel

antefix. ornamental block covering the end of a roof tile

apoptygma. edge of garment

apotropaic. capable of warding off evil

"Archaic" smile. early Greek sculptural convention

arche. to rule, hold office

arula. altar

aryballos. small globular vessel for unguents

askos. small, irregularly shaped vessel for pouring oil

Athenaion. temple dedicated to Athena

Attic. referring to the region around Athens

attribute. object, animal, or dress that indicates identity of a deity or human being

auriga. charioteer

autochthonous. "sprung from the earth," indigenous, native

Bacchiadae. aristocrats of Corinth (ca. 750–657 BC) who founded Syracuse

basileus. king

bell-krater. bell-shaped vessel for mixing liquids

bezel. top center surface of a ring

biga. two-horse chariot

black-figure. vase-painting technique with figures painted in black and background reserved in red

bothros. ritual burial pit often containing votive objects

bucchero. Etruscan ceramic ware fired black in a reducing atmosphere

bucranium. decorative element in the form of a bull's head or skull

caduceus. wand topped by two intertwining snakes, carried by divine messengers

Caere. ancient name for Cerveteri; city in Etruria

caryatid. support (column) in the shape of a woman

Catania. modern name for Catane; city-state on the east coast of Sicily

cella. interior room of a Greek temple

centauromachy. battle involving centaurs and humans

chalcedony. semi-precious silicate stone

chiton. long garment worn by both men and women

chitoniskos. short chiton

chlamys. traveling cloak

chora. surrounding territory of a Greek city

chthonic. referring to the underworld or earth

cista. cylindrical, lidded container for small objects

Classical. period and style of Greek art (ca. 480–323 BC), when Athens reached its Golden Age

coroplastic. terracotta sculpture technique

cuirass. bronze breastplate

cyma. sloping molding of a pediment

Daedalic. Greek sculptural style (seventh century BC)

Deinomenids. dynastic tyrants of Syracuse (ca. 478–472 BC)

Diadochi. generals and successors of Alexander the Great

dinos. deep, round-bottomed bowl for mixing liquids

echinus. convex cushion-like molding below the abacus of a Doric capital

ekklesiasterion. city assembly hall

emporion. trading settlement or market

entasis. swelling in the center of a column shaft

epigastric arch. stylized outline of male chest anatomy

epithet. phrase expressing a quality or attribute, associated with a name

Etruscans. inhabitants of ancient Etruria

ex-votive. offering to a god

fibula. clasp or brooch shaped like a safety-pin

gamos. wedding

Gelon. Sicilian tyrant (d. ca. 478 BC)

Geometric. early Greek period and style (ca. 900–700 BC)

gigantomachy. battle involving giants and gods

glyptic. technique of engraving or carving stone and other hard substances

guttus. small flask

Hellenistic. Greek period and style (ca. 323–31 BC) following the death of Alexander the Great

Heraion. temple dedicated to Hera

heroon. hero's shrine, tomb, or cenotaph

Hesiod. Boeotian epic poet (active ca. 700 BC)

hieratic. relating to priestly functions

Hieron. tyrant of Syracuse (r. ca. 478–466 BC)

himation. large outer garment worn by men and women, draped diagonally

Hipponium. Roman name for Hipponion; city-state on the west coast of South Italy, modern Vibo Valentia

hoplite. armed Greek soldier

hydria (pl. **hydriae**). water vessel with two horizontal carrying handles and a vertical pouring handle

in antis. temple columns between antae or ends of the cella walls

Ionia. western coast and islands of Asia Minor

Italic. of or pertaining to non-Greeks of South Italy

Italiot. of or pertaining to Greeks of South Italy

kalathos. basket with a narrow base and flared top; krater of similar shape

kantharos. deep cup with high curving handles; attribute of Dionysos

Kerameikos. pottery-making and cemetery district in Athens

kithara. large lyre; attribute of Apollo

kline. couch

"Knielauf" pose. Archaic convention for depicting running

koine. a commonly shared culture

komast. male reveler

komos. drunken dance or revel

kore. Archaic figure of a clothed young woman

kotyle. deep cup with horizontal handles

kouros. Archaic figure of a nude young man

krater. deep, two-handled mixing vessel

kylix (pl. **kylikes**). wide shallow drinking vessel with two horizontal handles and stemmed foot

kymation. architectural decorative motif

lekythos. single-handled oil flask

litra. denomination of silver coinage

Locri. modern name for Locri Epizephirii; city-state on east coast of South Italy

lonchia. spear-shaped necklace element

lophos. high crest of a helmet

louterion. ritual basin

Maenads. women devotees of Dionysos

meander. schematic decorative motif

megaron. central rectangular room of Bronze Age palaces

Messina. modern name for Zancle; city-state on Strait of Messina

Metaponto. modern name for Metapontum; city-state in ancient Calabria

Mycenaean. Late Helladic culture of the Greek mainland (ca. 1550–1100 BC)

mysteries. cults dedicated to a personal god or gods of resurrection

naiskos. small architectonic shrine with antae and pediment

Neapolis. ancient name for Naples; city-state in Campania

necropolis. "city of the dead," burial grounds located outside of town

oikist. founder of a Greek colony

oinochoe. single-handled wine jug with trefoil mouth

olpe. round-mouthed wine pitcher

omphalos. navel or central boss

Orientalizing. Greek period and style influenced by Eastern imports (ca. seventh century BC)

Oscan. indigenous people of Campania; chief language of central Italy

ovulo. convex architectural molding with an egg-shaped profile

Panormus. ancient name for Palermo; city-state on the north coast of Sicily

pantheon. "all the gods"

Pausanias. Roman travel author (active ca. AD 160)

pelike. amphora with neck that flows smoothly into the body, with a sagging profile

peplos. long woman's garment fastened at both shoulders

peribolos. surrounding wall

peripteral. surrounded by columns

perirrhanterion. shallow water basin supported on columnar stand

periskelis. bangle on ankle or wrist

Phalaris. tyrant of Akragas (ca. 570–555 BC)

phiale. shallow libation bowl without handles

Phoenicians. inhabitants of ancient Lebanon, famous as traders and mariners

phormiskos. gourd-shaped rattling vase

pinax (pl. **pinakes**). sculpted and painted terracotta plaque

Pindar. Greek lyric poet (ca. 522–446 BC)

plastic. modeled or shaped

polis. Greek city-state

polos. cylindrical headdress

Polybius. Greek historian (ca. 200–118 BC)

Posidonia. Greek name for Paestum; city-state south of Campania

proleptic. scene that sets up an expected conclusion

propylon. main gate or entrance to a temenos

Proto-Corinthian. Greek vase-painting style (late eighth to first half of seventh century BC)

protome. forepart of an animal or person

Ptolemy I. Hellenistic general and king of Egypt (d. ca. 283 BC)

Punta del Faro. modern name for Cape Pelorus on the north coast of Sicily near the Strait of Messina

pyxis (pl. **pyxides**). covered container for cosmetics or jewelry

red-figure. vase-painting technique with figures reserved in red and background painted in black

Reggio (Greek **Rhegion**). modern name for Roman Rhegium; city-state at the southernmost tip of Italy

repousée. metalwork relief technique involving hammering on sheet metal

sacellum (pl. **sacella**). small shrine

sakkos. woman's hair wrap

Samnites. indigenous people of central Italy

scarab. gem cut in the shape of a scarab beetle

Selinunte. modern name for Selinus; city-state on the southwest coast of Sicily

sema. mark or sign

Sibaris. modern name for Sybaris; city-state on the east coast of Italy, on Ionian Sea

Sicans. indigenous people of central Sicily

Sicel. one of the pre-Greek indigenous peoples of east Sicily

Siracusa. Italian name for Syracuse; city-state on the east coast of Sicily

situla. metal wine bucket with swinging handles

skyphos. deep wine cup with two horizontal handles at the rim

slip. liquid clay layer applied to a ceramic surface

stamnos. high-shouldered vessel with two horizontally set handles

stephane. crown or headband

stoa. long rectangular building with a roof supported by a back wall and columns in the front

symposium. drinking party

tainia. ribbon or fillet

Tarantum (Greek **Taras**). ancient name for Taranto; city-state on the coast of South Italy

temenos. sacred precinct

Theoxenia. festival at which Castor and Pollux, the Dioscuri, entertained the gods

thesauros. treasury

Thesmophorion (pl. **Thesmophoria**). women's autumn festival of Demeter

tholos. circular building or tomb

tripod. three-legged cauldron

triskeles. three-legged device that became a symbol of Sicily

tumulus. burial mound

tympanon. hoop drum; pediment of a Greek building

tyrant. unelected ruler of a Greek city-state

volute. spiral ornament; principal element of an Ionic capital

xoanon. early Greek cult statue

zoomachia. battle between animals

Acheloos. largest river in Greece; personified by a bearded, man-faced bull

Achilles. Homeric hero; son of Peleus and Thetis

Aeolus. keeper of the winds

Ajax. Homeric hero; son of Telamon, king of Salamis

Alkinoös. king of the Phaeacians, the inhabitants of Scheria, the westernmost island on earth

Alkyoneus. giant killed by Herakles

Andromeda. daughter of Cepheus and Cassiopea, rescued by Perseus

Aphrodite. goddess of love

Apollo. son of Zeus and Leto; god of music, poetry, archery, prophecy, and healing; as Apollo Archegetes, the sun god; as Apollo Lykaios, the wolf-god

Argo. Odysseus's dog

Artemis. daughter of Zeus and Leto, twin of Apollo; the virgin huntress

Athena. daughter of Zeus; goddess of wisdom; patron of Athens

Bellerophon. son of King Glaucus of Corinth and Eurymede; killed the Chimera riding Pegasus

Calypso. daughter of Atlas; island hostess of Odysseus

Cassiopea. wife of Cepheus; mother of Andromeda

centaur. composite creature; half-man, half-horse

Cerberus. three-headed guardian dog of Hades

Charybdis. dangerous whirlpool located in a narrow sea passage opposite Skylla in Homer's *Odyssey*; associated with the Strait of Messina

Chimera. composite creature; fire-breathing monster, part lion, snake, and goat; slain by Bellerophon

Chrysaor. son of Poseidon, born from the blood of the decapitated Medusa

Circe. sorceress who transformed Odysseus's companions into animals

Daedalus. legendary early Greek artist-inventor

Deianira. wife of Herakles

Deidamia. wife of Achilles; mother of Neoptolemus

Demeter. goddess of fertility; mother of Kore-Persephone; as Demeter Epilusamene, protector of children; as Demeter Malophoros, the fruit-bearer

Diomedes. Homeric hero; king of Argos

Dionysos. god of wine; as Dionysos Hades or Pluton, of the underworld; as Dionysos Nyktelios, of the night

Dioscuri. Castor and Pollux (Roman); twin sons of Zeus

Eos. goddess of the dawn

Eris. goddess of discord or strife

Eros. winged god of love

Erynies. the Furies, avengers of wrong

Eumaeus. swineherd and companion of Odysseus

Gorgon. one of three sisters, winged she-monsters with snakes for hair; see *Medusa*

griffin. composite creature; part eagle, part lion

Hades. god of the underworld; the underworld itself

Hekate. three-bodied goddess of the underworld

Helle. daughter of Athamas, king of Thebes; fell off the ram with the golden fleece and drowned, giving the name to the Hellespont

Hera. wife of Zeus; as Hera Nympha, of the nymphs

Herakles. greatest of Greek heroes; a mortal who became a god and completed twelve labors; his attributes are a lion-skin, a bow, and a club

Hermes. son of Zeus and Maia; messenger god and escort of souls to Hades

Hippolytos. son of Theseus and the Amazon Hippolyte; Theseus's second wife, Phaedra, fell in love with him

Hyacinthus. Greek vegetation deity loved by both Apollo and Zephyrus

Hydra. many-headed snake monster killed by Herakles

Icarus. son of Daedalus; flew too close to the sun and fell to his death

Ino. daughter of Cadmus; wife of Athamas

Iolaos. younger companion of Herakles; by tradition, led colonization expeditions to Sicily

Jupiter. chief deity of the Olympian gods (Roman); Zeus (Greek)

Kairos. personification of opportunity

Keleos. ruler of Eleusis (*Hymn to Demeter* 96)

Kephalos. Attic hunter who killed his wife, Procris, by mistake

Kokalos. king of Camicos (later Akragas), where Daedalus took refuge after his escape from Crete

Kore (also **Persephone**). daughter of Zeus and Demeter; became the wife of Hades

Kyknos. son of Apollo; changed into a swan

Laistrygonians. giants; cannibals who attacked Odysseus's men, by tradition, in Sicily

Leucothea. epithet of Ino, "white-foamed"

Lotus-Eaters. mythical people, by tradition from North Africa, who ate lotus plants, which caused them to forget

Lycophrone. Homeric hero; son of Nestor; companion of Ajax

Medusa. one of three monstrous sisters, the other two being Sthenno and Euryale; her gaze could turn the beholder into stone; mother of Pegasus and Chrysaor; killed by Perseus; see *Gorgon*

Memnon. son of Eos; king of Ethiopia; ally of Priam, king of Troy

Meteres. goddesses: Demeter, Kore, and Aphrodite

Minos. legendary king of Crete

Neoptolemus. son of Achilles and Deidamia; killed Priam

Neptune. god of the sea (Roman); Poseidon (Greek)

Nereids. sea nymphs

Nessos. centaur killed by Herakles

Nike. winged goddess of victory

nymph. female nature spirit

nymphs of Nyssa. sea nymphs who raised Dionysos

Odysseus. hero of Homer's *Odyssey*

Orpheus. founder of the religious movement Orphism; musician and poet whose songs could charm wild beasts and coax rocks and trees into movement

Pasikrateia. "the all-powerful," another name for Persephone

Pegasus. flying horse born to Medusa and Poseidon, sprung from the blood of the decapitated Medusa

Persephone (also **Kore**). daughter of Zeus and Demeter; wife of Hades

Perseus. son of Zeus and Danae; Argive hero who slew Medusa and rescued Andromeda

Phaeacians. inhabitants of Scheria, westernmost island on earth, ruled by King Alkinoös

Phaedra. second wife of Theseus

Pirithoos. Son of Zeus and Dia; king of the Lapiths; best friend of Theseus

ploutodotas. "giver of wealth"

Polyboea. sister of Hyacinthus

Polyphemos. murderous one-eyed giant who, according to tradition, lived near Mt. Etna; was blinded by Odysseus and his men

Poseidon. god of the sea (Greek); as Poseidon Asphaleios, "steadfast"; as Poseidon Enipeus, he took the form of the river Enipeus

Potnia Theron. mistress of the animals; early form of Artemis

Rhesos. Thracian hero-horseman who fought on the side of Troy; killed by Odysseus and Diomedes

satyr. companion of Dionysos, half-man, half-goat; fond of wine and sex

silen (pl. **silenoi**). aged satyr

Silenus. wise silen who educated Dionysos

sirens. bird-bodied sea nymphs whose song transfixed sailors in *The Odyssey* and led them to destruction

Skylla. six-headed sea monster located in a narrow sea passage opposite Charybdis in Homer's *Odyssey;* associated with the Strait of Messina

Sphinx. she-monster with a winged lion's body and woman's head

Theseus. national hero of Athens

Thetis. sea nymph or Nereid; mother of Achilles

Thourios. giant; opponent of Herakles

Triptolemos. prince of Eleusis; favorite of Demeter; inventor of the plow and agriculture

Troilus. son of Priam, king of Troy; killed by Achilles

Trojan horse. giant wooden horse used by the Greeks to trick the Trojans

Tyro. mother of Pelias, daughter of Salmoneus, and niece of Athamas

Vulcan. god of fire and the forge (Roman); Hephaistos (Greek)

Zeus. chief deity of the Olympian gods (Greek); as Zeus Agoraios, protector of the agora; as Zeus Atabyrios, of a mountain on Rhodes; as Zeus Kataibates, "descending in thunder and lightening"; as Zeus Meilichios, the kindly or well-disposed one; as Zeus Olympieion, of Olympus; as Zeus Ourios, of the favorable winds